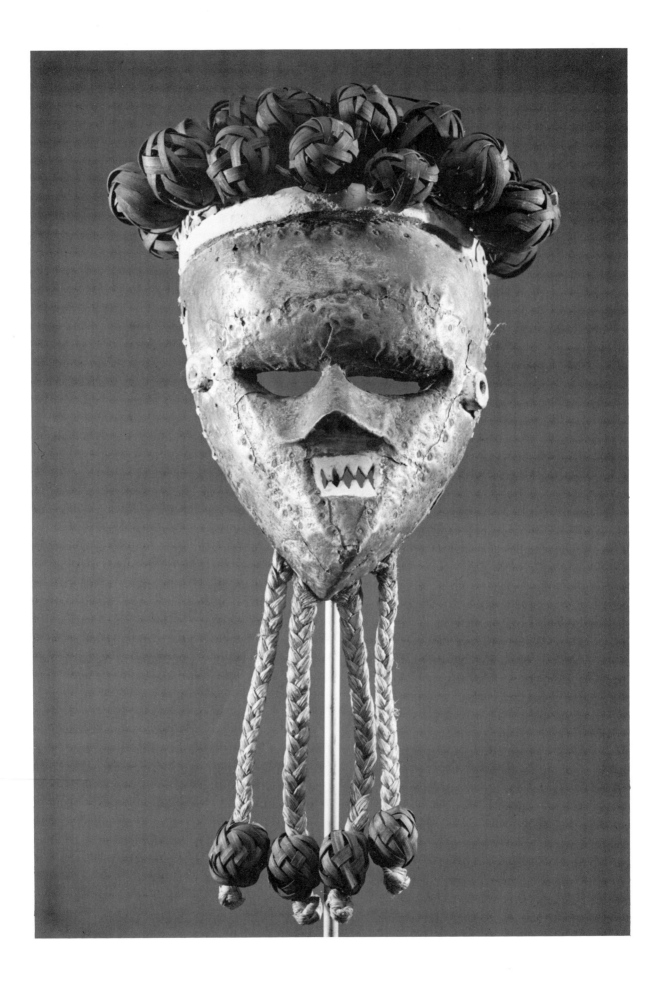

MASKS OF BLACK AFRICA

LADISLAS SEGY

DOVER PUBLICATIONS, INC., New York

Published in Canada by General Publishing Company, Ltd.,
30 Lesmill Road, Don Mills, Toronto, Ontario.

Masks of Black Africa is a new work, first published by Dover
Publications, Inc., in 1976.

International Standard Book Number: 0-486-23181-X
Library of Congress Catalog Card Number: 74-15005

Manufactured in the United States of America
Dover Publications, Inc.
180 Varick Street, New York, N.Y. 10014

CONTENTS

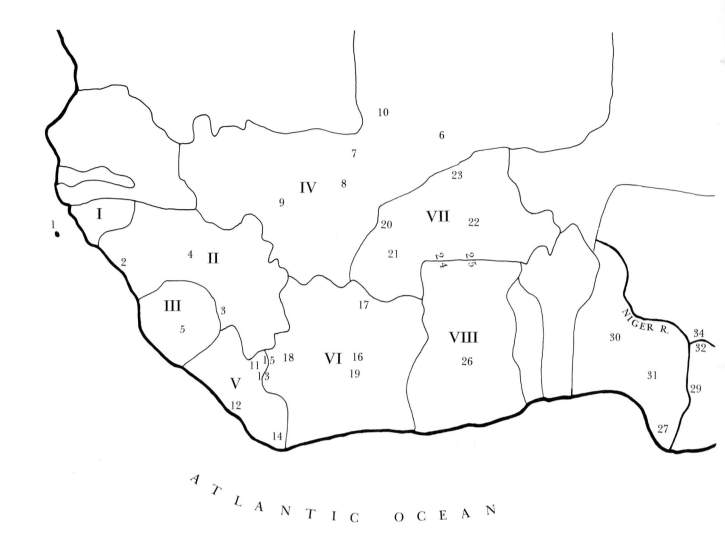

WESTERN AND CENTRAL AFRICA

The countries represented in this book are indicated by roman numerals, the tribes by arabic numerals, in the order of the plates. Variants of tribal names and related tribes are in parentheses. Tanzania and Zambia are not shown.

I. PORTUGUESE GUINEA
1. Bijogo (Bidjogo, Bijugu)

II. REPUBLIC OF GUINEA
2. Baga
3. Toma (Nalou)
4. Landouma

III. SIERRA LEONE
5. Mendi (Temne, Timne)

IV. REPUBLIC OF MALI
6. Dogon
7. Bambara (Bamana)
8. Marka
9. Malinke
10. Bozo

V. LIBERIA
11. Guere (Ngere) -Wobe (Ouobe)
12. Bassa (Basa)
13. Gio
14. Grebo
15. Kra

VI. REPUBLIC OF THE IVORY COAST
16. Baule (Yaoure)
17. Senufo (Siena)
18. Dan (Yakouba)
19. Guro

VII. REPUBLIC OF UPPER VOLTA
20. Bwa (Bobo-Ouele)
21. Bobo-Fing
22. Mossi
23. Korumba
24. Gurunsi (Grunsi)

VIII. GHANA
25. Kulango
26. Ashanti

IX. FEDERAL REPUBLIC OF NIGERIA
27. Ijaw (Ijo)
28. Ibibio (Ogboni)
29. Ibo

30. Yoruba
31. Benin Kingdom - Bini
32. Idoma
33. Mumuye
34. Jompre
35. Igbira
36. Chamba
37. Mama

X. REPUBLIC OF CAMEROON
38. Bekom
39. Bamum
40. Ekoi
41. Mambila
42. Keaka (Kaka)

XI. GABON REPUBLIC
43. M'Pongwe (Balumbo, etc.)
44. Adouma (Badouma)
45. Ambete (Mbete)
46. Fang (Pangwe)
47. Mahongue

XII. REPUBLIC OF CONGO
48. Kuyu (Babochi)
49. Bakwele (Kwele)
50. Bavili
51. Bateke (Teke, Tsaye)

XIII. ZAÏRE
52. Bakongo (Kongo)
53. Muserongo (Solongo)
54. Balwalwa (Lwalwa)
55. Bapende (Pende)
56. Bayaka (Yaka)
57. Bena Biombo
58. Basuku (Suku)
59. Basonge (Songye)
60. Bakuba (Bushongo)
61. Batshioko (Batchokwe, Tshokwe)
62. Basalampasu (Basala Mpasu, Salampasu)
63. Wabembe (Bembe)
64. Wagoma-Babuye (Goma-Babui)
65. Warega (Lega, Balega)
66. Ngbandi (Bwaka)

WESTERN AND CENTRAL AFRICA

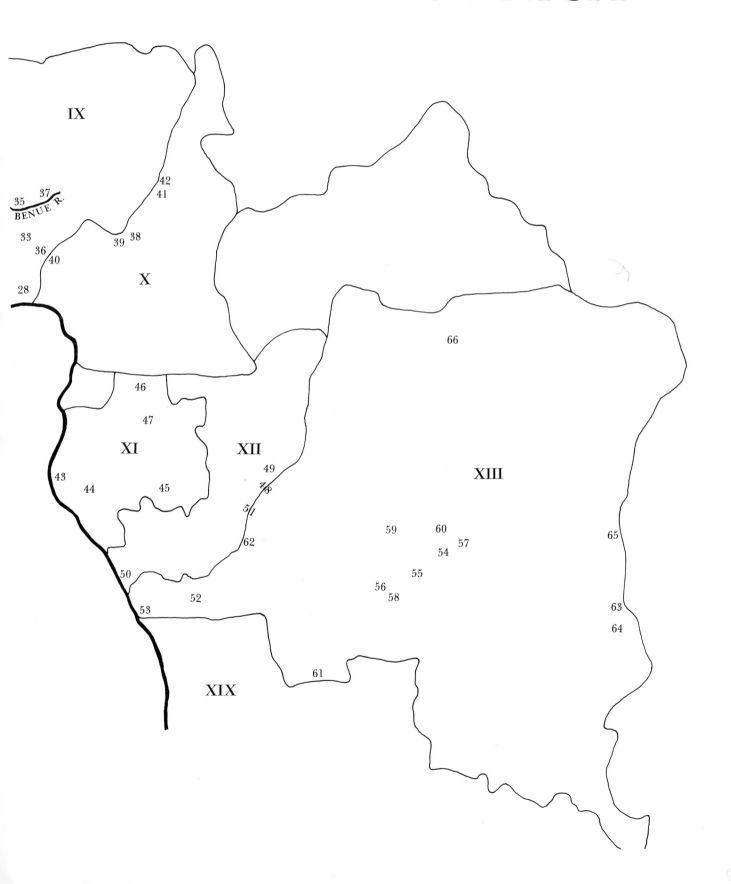

IX

42
41
35 37
BENUE R.
33
36
40
39 38

X

28

46

47

XI

XII

43
44 45

49
48
51

62

50

52

53

XIX

61

66

XIII

59 60
 57
 54
 55
56
 58

65

63
64

INTRODUCTION

GENERAL CONSIDERATIONS

The structure of this book reflects two basic points of view in the study of African masks. The Westerner considers the mask as a work of art. The African considers the mask as a necessary ritual instrument or cult object, a product of his particular culture.

Even for the Westerner, there are two approaches that can be taken. One is the phenomenological approach, which considers any work of art essentially as a part of reality. The onlooker has to contemplate the object as is without knowing anything about it. He has to expose himself to it, surrender all expectations and presuppositions, let the work seize him, and establish a communion with it. If the onlooker has eyes trained to see and a cultivated sensibility (the result of previous experiences with a larger domain of art of various civilizations and periods), he will sense whether the forms and their coordination are authentic and from the hands of a talented artist. As the contemplation of a work of art ultimately must result in a "lived-through experience," this re-feeling is the index, though subjective, of the quality of the work of art.

The second approach is taken when the suspension of presupposition is not possible. Here again there are two possible channels of development. One is to accumulate knowledge which remains arrested on an intellectual level (one may know all the tribal styles but may not feel which carving evokes an emotional response). The second channel is to acquire information about the use of these masks which may help indirectly to enlarge, deepen, and enrich one's emotional response. This occurs when through self-identification information arouses a deeper interest in an object, or when an accurate description of an object gives one a new point of view and enables one to see better what is visually present. Man with his inherently limited perception requires concentration and sustained attention. But if he properly integrates information, it may help to heighten his sensitivity, and he may discover something that otherwise would escape his attention. The word integration is the key, but this is possible only if the observer has the proper disposition to transform observation into emotional response.

For the African, the creator of the mask—a useful object—is an integral part of his own culture. The meaning the African has attributed to the traditional use of masks, which had a mythico-religious logic of their own, is to the scientific mind an admissible rationalization, as it has solved the African's major human and social problems.

Yet, to understand the origin and fundamental significance of specific African masks, and to find meaning for the Western mind, we shall have to

abstract the masks from the African tradition (which we can only describe) and consider the following: (1) the universal historical use of masks, which enables us to compare African usage with that of other civilizations and detect recurrent patterns; (2) the formation of concepts and ideologies as a basic human mental activity (this will enable us to comprehend how the African arrived at his world view); (3) the motivation for the creation of any work of art and the development of styles valid for any civilization; (4) the significance of man's need for religion in general and for ritual in particular (the African customarily used masks in rituals); and (5) universally valid psychological motivations for creative and religious acts.

The creative act and the use of the plastic language of the mask are the subject of our study. Our findings may explain why Western man is able to "feel himself into" the work of the African and achieve a meaningful emotional response to it. The valid plastic idiom used by the African carver acquired its universality because it was based upon commonly shared human experiences with which we can identify, though on an unconscious level. It is the very primary and universal combinations of forms in African sculpture which on an essential level activate our transpersonal unconscious. This results in a preconscious identification drawing us out of the narrow limitations of our subjectivity. The study of the plastic means of doing this is still within the phenomenological approach.

A carving evokes an emotional response, but we enter a different realm when we postulate various psychological motivations for the African's way of life and suggest possible psychological identifications with and emotional reactions of our own to his use of masks in rituals.

In our analytical interpretation we shall consider the Freudian and Jungian approaches and to a large extent the phenomenological insight into the existence of an indeterminate, twilight-zone awareness of reality which Merleau-Ponty called preconscious, preverbal, prelogical and prereflective. Each of these terms indicates a slightly different qualification of the state of primordial perception. This is where intuitive insight emerges from the unconscious into a zone of uninhibited imagery where myths are born. This is where man becomes vaguely aware that on a higher level of preconsciousness he transcends his conscious limitations. We place into this zone the major creative forces of man (in this case, Africans), and this is also the realm where the experiencing of

authentic works of art (including African masks) takes place.

THE UNIVERSALITY OF MASKS

In order to understand the role and significance of African masks, we must first study their use and, second, consider them as a universal phenomenon. Only when we see the persistent use of masks as fulfilling an essential human desire in various civilizations can we understand the African's need for masks.

Independent of any specific use, the mask, or rather the masked person, has his own significance. One's reaction to another person is primarily based upon what one perceives on an immediate, intuitive level from the slightest change in the expression of his face. The old saying that "the eyes are the mirror of the soul" is very true, as the gaze of the eyes, direct, veiled, shifting, or avoiding eye-to-eye contact, as well as the person's movements and the posture of his body in tension or relaxation, express his individuality and identity. They are all, each alone and in combination, expressions of the unconscious mind, and they reveal something of one's motivations and feelings. For that matter, one's speech also has its own significance, for the manner in which a person speaks has a more profound, though unconscious, impact upon us than what he says. It is how someone behaves which constitutes the essence of our reaction. By extension, how a carving is made is the key to its quality.

When a man wears a mask, his face is hidden. His identity is concealed, and the expression of the mask projects a new identity. This change is more impressive and dramatic when the features of the mask are unnatural, grotesque, or frightening, or are abstracted from a human or animal figure. Unable to establish the human identity of the masked man, the viewer is disoriented. The man wearing a mask of exaggerated expression appears strange, unpredictable, sometimes lurking. Because this is beyond the familiar, one is mystified and fascinated, for, in fact, the masked man can deceive the outsider. (Freud analyzed the German word *unheimlich* [uncanny] as meaning "not being at home," or unfamiliar.)

In addition to the characteristics of any masked person, in Africa the rhythmical movements of the masked dancer augmented the effectiveness of his strange costume. Furthermore, when the disguised dancer appeared in a religious ritual,

the mask entered a new dimension of significance, as it fulfilled the role prescribed by tradition, making a great effect upon the public. But the mask and the costume also affected the wearer. As he underwent psychological changes, he adapted his movements to the character he was impersonating.

Although most African masks and statuary are from the same wood-carving tradition, the masks are entirely different in style because of their different functions. The masks are usually bold because, first of all, they represented mythological, legendary, nonhuman beings, often animals associated with the founders of the tribe. To give expression to these spirit-beings according to the oral tradition, the carver used his imaginative powers to create masks often fantastic in appearance. This boldness, furthermore, was necessary to compensate for the distance of the masked dancer from his audience, who actively participated in the communal festivities.

By contrast, masks and statues used in more intimate, private rituals (such as ancestor and magic cults) often have a more serene expression. The statues in strong, immobile, columnar (phallic) form often contain highly sophisticated, refined details.

THE DISTRIBUTION OF MASKS

Europe. In the caves of paleolithic man (about 30,000 B.C.) we find hunting scenes with masked dancers. (The same type of rock painting of masked men also appears in Africa, as we shall see.)

In Greece the first masks were used in rituals. In the cult of Dionysus, for instance, masks represented the spirits of nature (much as they did in Africa), and the people believed that the dancers were possessed by such spirits. There were also masked dancers who took the form of a phallic being, half animal, half god. In Mycenae, gold sepulchral masks covering the faces of the dead have been excavated.

Later, actors in theatrical productions adopted masks with different features to indicate tragic, comic, or satiric characters. Because of the large size of the Greek theater these masks covered not only the face but the whole head. The actor spoke through the mouth, which was a wide opening in the mask. (Stone masks adorned the walls of the Greek theater.)

The Romans adopted the Greek custom of using masks. The medieval church used masks in mystery plays all over Europe. In carnivals there were devil masks. In feudal Europe people wore masks to travel incognito, to joust in tournaments, and, in the republics of Renaissance Italy, to hide their identity in society. Stage masks were common in the *commedia dell'arte* from the fifteenth to the eighteenth centuries in Italy and France, and in the religious carnivals and rituals of southern Germany and Switzerland. In Tyrol, Austria, the masks had branching stag horns. The Slavic peasants held masked festivals around the winter solstice, and in some regions these heathen ceremonies were adapted to Christian celebrations.

Asia. Masks appear throughout the entire history of China, as early as the Chou dynasty, when bronze masks were used. Masks played a role in the Chinese theater in both secular and religious dramas, but the actors often used cosmetics and paint to make their faces appear to be masks. Over one hundred varieties of mask were used in the No drama in Japan to represent human beings, gods, demons, and animals. In India, Ceylon, and Java masks were used in devil-dancing ceremonies and in theatrical performances. In Tibet masks representing gods and demons were used in sacred mystery plays; the devil-dancing aimed at exorcizing malignant demons. In Melanesia, Polynesia, and Micronesia secret societies (similar to the African tradition) used masks carved from bark and wood.

North America. The American Indians—the Hopi, the Zuñi, and the Pueblo, to mention just a few tribes—all used face masks. The Hopi had over 150 kachinas (gods) represented by masks. The Iroquois of New York and Ontario had a False Face society, which used masks carved from living trees for exorcism. The masks had extremely distorted features. Indians of the southwestern United States wore cylindrical helmet masks that rested on their shoulders.

The Pacific Coast Indians of Canada and Alaska excelled in highly complex designs and multicolored patterns. One of the masks (that of a raven) had a double face with the beak of the animal mask opening to reveal the mask of a human face inside.

The Eskimos have wooden masks with various appendages that give them a surrealistic appearance. Compared to these, their animal-skin masks are of the utmost simplicity.

All Indians (much like the Africans) believed that the mask was the abode of a spirit (often

ancestral). The wearer of the mask and his audience believed that he was transformed into a mythical creature which the mask represented.

Mesoamerica and South America. In the ancient system of picture writing in Mexico each character was a grotesque mask representing a different deity, although there is no such actual mask extant today. Some of the buildings are also decorated with masklike stone sculptures. There are in existence a number of stone masks, some highly stylized, some simple. We should make special mention of the wooden masks of the Aztecs, encrusted with turquoise mosaics, works of art of great refinement and beauty.

In Peru (especially Chimú) and Colombia the ancient Egyptian cult of the dead found a correspondence. The body was mummified, and the face was covered either by a wooden or a hammered gold mask.

Flat wooden masks covered with multicolored feathers have been found in Brazil. In Bolivia grotesque masks painted in bright colors and incrusted with mirrors are still used today.

Africa. In ancient Egypt priests used masks to represent gods. Masks were also placed upon the face of the mummies to perpetuate the appearance of the deceased after death or to revivify him. Tutankhamen's mask was made of gold. Similar gold masks dating back to the eighteenth century A.D. were found among the Ashanti kings in Ghana.

Rock paintings of masked men from prehistoric times have been found in the mountains of Tassili in the Hoggar (Sahara) region. The old Bushman rock paintings of South Africa show hunters covered with ostrich heads and animal skins. This illustrates the antiquity of the custom of covering the hunter with the skin and head of an animal to stalk his prey. (The Eskimos still use such disguises in their seal hunts today, and certain tribes of the Cameroon also perpetuate the custom—compare Plate 193.)

In western and central Africa all animistic tribes used masks, whereas in the east and south only a few tribes did so.

Australia. Some aboriginal tribes used masks or, more usually, face paintings as a substitute for masks. (Such face painting is also prevalent in Africa, especially among boys at their initiation ceremony into manhood.)

The role of the mask in changing one's identity is still with us in modern society. We may observe it in the change in the behavior of a person when he steps out of his uniform. The black robe of the American judge and the wig of his English counterpart aim to transform the individual into something larger, to change his individual personality into an impersonal institution of the law. (We find a similar principle at work in Africa.)

Some words of explanation are necessary concerning names of tribes and the selection of illustrations in the present volume.

Tribal Names. Since the publications of Boone in *Zaïre* (African Review) of 1954, the tribal names of Zaïre (Congo-Kinshasa) have changed. Instead of the name Warega, for instance, Balega or Lega is now used. The Batshioko have adopted the name Batchokwe or Tshokwe. In the Sudanese regions the Senufo now call themselves the Siena, and the Bambara, the Bamana.

Those who pursue further studies in the field of African art will find only the former names in the large body of ethnographic and anthropological literature published before the names were changed.

Our procedure (as in *African Sculpture Speaks*) will be to use the well-known former names, and to mention the new names in parentheses.

When discussing the various masks, we shall generally use only the tribal names in order to avoid repeating the names of different, politically defined countries. Furthermore, several tribes live in different regions. Some of the Senufo, for instance, live in Mali and in Ghana, but the majority live in the Ivory Coast. In the captions, however, for purposes of reference, we use the names of the countries where the majority live. The map shows the location of the tribes.

Selection of Illustrations. In Chapter 3 we mention certain masks only to illustrate the various rituals. We have not attempted to list all the known masks related to each ceremony. Moreover, we restrict the number of illustrations because of the limited scope of this book and because our emphasis is on the stylistic development within each tribe.

We have avoided the duplication of any illustration appearing in the author's two previous books, *African Sculpture Speaks* and *African Sculpture,* so that the illustrations of the present volume will complement the material already published.

The author has published in various scholarly journals over the last forty years monographs about tribal institutions, styles, the uniqueness of individual creations within the tradition, and many analytic, interpretative concepts used in our study. To avoid footnotes, we provide a selection of these monographs in the bibliography on page 247.

PART ONE

The African
Point of View

1

MYTH, RITUAL AND DANCE

We can understand the significance of the mask in the African's life only if we consider the structure of his social system.

Man faces overwhelming natural forces which he cannot understand, and his existence is consequently an enigma. Intuitively man has an understanding, a kind of inner knowledge, as to his place in the order of things. This all-embracing, prereflective experience produces an awe-struck, hence religious, attitude toward the external world. The African acted this out in rituals, the framework wherein the mask acquired its vital role (see Chapter 3).

Myths are the poetic verbalizations of preconscious experiences. They provide the background for the sacredness of the ritual, hence that of the mask. Essentially the myth conditioned the masked dancer and his audience as to what to expect. Knowing the identity of each mask and its relationship to the sacred past, the audience also knew its purpose. As the myths are the bases for the rituals, the masks acquired "ritual value" (in the phrase of Radcliffe-Brown). The mask played a vital, visually suggestive role in the ritual along with music and audience participation.

We shall begin by discussing how the African acted out his approach to reality in his rituals; next we shall discuss how myths gave meaning to the rituals and to each mask; and then we shall

proceed to discuss the contribution of the masked dance to the general effect.

THE SIGNIFICANCE OF MYTH

I claim not how man thinks in myth, but how myth operates without his being aware of the fact. (Lévy-Strauss)

The mask is the result of a vast drama; the masked man gives the universal system movement and color. (Griaule)

Rituals were spontaneous acts. They originated in man's need for the spiritual, his need to enter a higher level of consciousness, a state within the domain of poetic imagination. To make his rituals more effective, man used the same poetic means he used to create myths. Only later did the need for conceptualization arise to produce a world view.

In Campbell's definition "myths are not only symptoms of the unconscious but also controlled and intended statements of certain spiritual principles which remain constant throughout the source of human history as the form and nervous structure of the human psyche itself. . . . They are telling metaphors of the destiny of man, man's hope, man's faith and man's dark mystery."

The creation of myth starts with man's "puzzled upward glance" (as Underhill expressed it), a wondering, intuitive insight into the powers of nature, an understanding of the suprasensory reality behind the apparent multiplicity of things in the world. This is the first apprehension of the spiritual side of the unknown. This primordial image which is projected outside onto all-powerful entities points toward a single cause of all reality as man evolves from poly- to monotheism. In this single view all phenomena are united, giving a new dimension to reality and a new direction to man. Myths are the articulate results of an inarticulate primary vision. Through the creation of explanations for what appeared to be chaos, a cosmic order emerges, as if created by invisible, but nevertheless existing, powers. Myths are recitals of sacred traditions bringing unrelated events into relationship, making differentiations and bringing order into an indeterminate world, including man's prescribed place in it. Myths aim to enable man to orient himself, to deal with the enigmatic, seemingly insoluble problems of human existence, including the mysteries of his birth and afterlife. Myths are also the bases of transcendental worship, a mysterious intercourse between man and the invisible powers influencing human existence.

One of the most profound roles of myth is that it declares events, facts, and causes to be sacred (holy) to set them apart from the profane. This sacramental attribute introduces a numinous reality into man's existence.

African myths, very similar to monomyths all over the world, contained cosmogonic explanations, different according to each tribal tradition. (Certain masked rituals included reenactment of primordial events.) By introducing genii or spirits, myths also taught the origin of the tribe, the genealogy of its founding ancestors and heroes, the history of their migration, the institution of initiatory ceremonies, the techniques of agriculture and crafts, food taboos, and so forth.

The mythological hero who represented special valor because of his exceptional services to the tribe in the legendary past was regarded as a model, the embodiment of the best of human potentiality. As descendants of this hero, the living through identification with him derived a special tribal pride which was the basis for their ethnocentrism.

The sacred myths aimed to preserve the wisdom of precedents based on ancestral laws. They became cultural canons limiting life and determining what was unalterable, excluding the unpredictable, giving security and prosperity to the collective life of the community by stressing obedience to the law, the code, and the practical guidelines for behavior and closer fraternal relationships between members of smaller groups. The most significant result of a mythologically framed "constitution" asserting unalterable truth, a system of supreme ethical values and norms, was that it promulgated spiritual and social coherence within the community. Myths were solidifying, stabilizing agents and, last but not least, they resolved the individual's existential dilemma.

As myths connected the ancestral past with cosmogonic events, the larger scope of mythological teaching consisted of reconciling the individual consciousness with the universal will through analogies and comparisons. We shall see that this produced a sense of oneness with nature. The African participating in a ritual sensed this unity more acutely when he witnessed the acting out by masked dancers of the myth about his tribe's past. He was not an observer; he became engulfed and absorbed. He experienced being part of the mythical past. He was able to identify himself with that which was presented to him as permanent and sacred reality. Because of this identification he was able to step out of his ordinary, egocentered daily life. His individual life was depersonalized, elevated. He was able to enter into the realm of the consecrated, into a sublime, spiritual, otherworldly existence. This means that the dancers and their participating audience interacting with each other were able to be a part of a higher order of things in the world of cosmic, natural order (this is the univer-sal will we mentioned earlier). As a result, they shed the fear and anguish connected with the precariousness of their existence. Such participation affected their very being during the ceremonies, and the experience provided a guideline or a rule of conduct for their entire life.

Furthermore, the African's feeling of being part of the natural order of things and each generation's repetition of the same cultic actions rooted in the sacred past indicated the duration of human existence. The African was conditioned to celebrate the order in nature by cyclical, seasonal ceremonies. These, connected with the powers of the ancestral spirits, convinced him that what he witnessed had happened before he was born and would happen after his death. To him the ritual represented a phenomenon of eternal recurrence.

By extension, he became conscious of the eternity of human existence, and enjoyed a sense of duration and continuum supported by his faith that his soul would return after his death in a new form and would also be venerated in accordance with the practices of the ancestor cult.

The unknown powers determining the life of the individual and the destiny of the community, the transpersonal figures (god, genii), came down to earth through the mask, often in animal forms. We shall speak later of animal masks, but we should mention at this time that the myth-makers expressed their unbounded imagination by creating supernatural things and beings through the magic of poetry. This accounted for the exuberant and fantastic appearance of some of the masks which were closely connected with the myths.

A masked dancer incarnated a spirit whose identity was recognizable by the audience familiar with the oral mythical tradition. The dancer appeared mysterious, first, because his identity was hidden, and second, because he brought down to the group invisible but powerful spirits which influenced their lives. As insecurity is the primary characteristic of the human condition, by means of masked rituals the Africans believed they changed the chance element into a reassuring certainty. At sowing, for instance, the assurance was of a good harvest, or at burial, of the survival of the soul (see Chapter 3).

MASKS AS IMPLEMENTS IN RITUALS

As masks all over the world and in Africa in particular were most frequently used in religio-magico-social rituals, we have to investigate the real significance of the ritual itself.

Rituals were common and collective acts, performed on a sequestered and consecrated site and aimed at the invocation of preternatural entities. But by extension rituals were pragmatic instruments, composed of gestures, words, and objects (in this case, masks) in which unseen spirit-powers postulated as sacred were cast into the visible world, often—as in Africa—by means of masks. Being the abodes of these powers, the masks dominated the rituals. Preternatural, life-giving forces were invoked to further the increase of human beings, animals, and the earth (through its climatic or seasonal cycles) and also to guide man through his life crises (rites de passage) in a dynamic affirmation of the union, or oneness, of the external world and man. Rituals were the consecrations of life as continuation and the confirmation of archaic precedents established by one's ancestors to provide a guideline for all human actions.

The immense meaningfulness of the rituals and their evolution into cults evoking awe and reverence were due to their suggestive quality, their power to express, reveal and activate man's need for transcendence and to fulfill one of his fundamental longings—the longing for the mysterious. With his intuition man sensed that mystery did not lie in superhuman agencies but, in fact, identified it in his own dynamic, often contradictory, forces which found a resolution in the ritual.

To understand, first, the genesis of the use of masks used in rituals, and second, their very specific and customary use, we must place the mask into historical perspective.

The universal role of the mask during the entire history of mankind was conditioned by a ritual way of doing things, in which the mask was an indispensable instrument. The ritual as a spontaneous outburst or release of inner stress took place first, and only afterwards was a conceptual (mostly religious) framework created to justify the act itself. Harrison stated that the word for rite in Greek was dromenon (meaning "a thing done"), adding that the ritual was man's intuitive reaction to the mysteries of life, independent of the reasons advanced afterwards to justify it. Eliade confirmed this when he stated that "the primary religious experience . . . precedes all reflection on the world." The mythologizing mind is an archetypal function of man, dreamed in a vision, illuminated by an insight based upon a burning need to invoke supernatural beings (spirits) for protection.

But the essential significance of the mask lies in the fact that formless, invisible archetypes of human existence, perceived intuitively as emanating from invisible powers, acquired concrete form. They were embodied in the mask, the carrier of spiritual reality. Thus what was only desired and vaguely apprehended became real.

It is the ritual, sacred and highly respected, which gives man the opportunity—today as well as in prehistoric times—to reach out beyond his own knowledge, and, as Goethe said, to lift himself up "till he touches the stars with his forehead."

If unconscious action precedes thought and knowledge, this is also true of the human gesture

which makes figures and masks. Sartre said that "each human gesture implies fundamentally a whole world viewThe structure of the whole could be seen in a single gesture." The original, preconscious gesture as a primordial act is, in Merleau-Ponty's words, "the elementary event [which] is already invested with meaning, and the higher function will bring a more integrated mode of existence or more valid adaptation." He added significantly that "art is an act of bringing truth into being." This is the image-making faculty of man: the ability to give body and form to that which is formless and invisible, to signify, suggest, and evoke a reality emanating from the ontological substance of man, the mysterious. About three hundred years ago, Pascal already had this insight when he wrote, "The figure is drawn from the truth" (an inner truth which, invoked, was sensed on a preconscious level, experienced with great impact, but not yet conceptualized) "and the truth was recognized from the figure. It is the figure which contained the truth."

We can apply this concept to our subject. The mask is the "figure," a "thing done," created with direct, spontaneous gestures to contain what man senses to be beyond form. It is a concrete focal point of concentration for the invisible toward which man wanted to reach out with fervor. This "image" or "figure" could be an effigy, even a rough image, but in Africa, it was a structure of expressive forms (this is why we consider it artistic), fused with a secret life of its own, and, as with all authentic works of art, it was born in a style which was unaware of itself.

As spontaneous and unpremeditated as the work (mask) was, it nevertheless concretized not only man's sense of awe and wonder but also his insight that this world has an order, although invisible. This is why the African carving is a system of relationships. It is an ordered configuration. It embodies a "fundamental world view," or "more integrated mode of existence," in Merleau-Ponty's words.

Our contention that action (rite) comes first refers to archaic times, but it is also applicable to all authentic creative acts. Picasso said one day, "If I had known why I made this painting, I would not have done it." The creative act actualizes unconscious elements. The deep involvement the act requires means that the work itself becomes more important than the self-consciousness of the artist, hence the suspension of the concerns of the ego. Consciousness would interfere and would destroy

the immediacy of the unconscious creative impulses which initially spur the artist to create. In fact, the work of art is self-revelatory for the artist himself, just as the onlooker's reaction to any work of art is not a statement of what the work is but a confession about himself. For that matter all psychological investigation starts with the observation of symptomatic action, or patterns of behavior (hence action first), and only later can one find or assume the motivation for the act.

In the case of the African carver, a collective member of his community, his work served religio-social institutions beyond any personal concern. He was—because of the tradition of many centuries and uninterrupted training from generation to generation—a sculptor par excellence. Like many sculptors of the past and in our own civilization, he had a predilection or a particular mind (and talent) for figurative-sculptural expression to unload his inner tension. He "spoke," he created images in a highly refined, sophisticated plastic idiom with an ingenious use of shapes and forms embodying a preverbal experience not yet distorted by interpretation. This is perhaps the reason that African painting (except some symbolic wall signs among the Dogon) never developed and that millions of West and Central Africans never invented a written language. In fact, literacy is not necessarily the mark of a complex civilization. The preliterate people who erected Stonehenge, an astonishing instrument for predicting lunar eclipses, or the extremely complex, highly refined textiles of abstract design in pre-Inca Peru (the Paracas, the Tihuanaco, and so on) are only two examples.

The Africans had no need for a written language. They had a very rich oral literature, prose and poetry, and, in fact, the mythologies themselves were epic poems of highly complex symbolism (see Cendrars's *Anthologie Nègre*, a 1927 collection of cosmogonic, historic legends, various fables, and poetic proverbs). But perhaps the best reason for the African's lack of written script is the fact that his art expressed whatever was essential to the human condition. The fundamentals of the African's existential problems were stated and served within his religious way of life by his carvings.

In summing up, we can say that at the time when the tribes were established in Africa, the prototypes of their cult objects were created first to serve ritual worship, and only later was the explanation of myths and a spirit-animistic philosophy adopted.

It fills us with astonishment and admiration

that at that remote time the need for each tribe to maintain its identity (ethnocentrism) was so strong that the great artists were able to create styles very distinct from each other and to respect the ancient conventions in maintaining the distinction up to the last generation.

The sequence of events which gave birth to masks might be as follows: (1) Motivated by a sense of awe, an inner necessity to unload man's yet unformulated aspiration, man created the ritual. (2) A semiconscious formative process shaped the ideas. (3) Figures and masks were created as focal points in the ritual, as containers of forces sensed to exist but only vaguely perceived. (4) To formulate some justification for the act and to put the figure into the context of the ritual, African man had to create a concept on his own level of consciousness, a system of logic different from ours. The concept became a real framework to him because he experienced it as living and effective. (We shall study this thought process in Chapter 2.)

DRAMA IN MASKED DANCE

What we call "dance" was for the African, except for purposes of amusement, a ritual performance to externalize an élan which language could not convey (similar to the Greek ritual dance performed for sowing, harvesting, rain, and so forth).

Dance in this restricted sense without masks is as universal as the dance with masks. This universality is based upon man's innate need to move his body in rhythm to chanting or music, often in patterns. Group participation not only reinforced the function of dance but also created a sense of community.

Kohler, who investigated the origin of dance, studied the behavior of the anthropoid apes for six years in Teneriffe. He noted that when a white man approached the ape unexpectedly, the ape hopped from one leg to the other, actually creating a type of dance movement. This was his expression of strong excitement (sometimes children jump the same way when excited). Dance is a deep, we may say organic, function of man, an important vehicle for achieving a physical release of emotional tension. Man began to develop his jumps and coordinate his legs with his arms and body. Thus he formalized dance and later channeled it into ritual ceremonies.

In the African dance one of the most important elements was rhythm, created by drums and other instruments in a very sophisticated, syncopated cadence. And as we shall point out, one of the basic structural elements in the African mask was the patterned, rhythmical arrangement of the shapes.

In Africa we must distinguish between various dances with and without masks: (1) religio-ritual dances which were an integral part of the act of worship; (2) socio-communal dances (partly the function of secret societies) closely related to the ritual and often indistinguishable from it and therefore classified as ritual dances—we shall show in Chapter 3 to what degree religious (burial) and social (for example, agricultural and grade-initiation) ceremonies were fused as, in fact, the same masks were used in both—(3) dances widely performed for recreation and entertainment, sometimes developing into theatrical performances. Often masks earlier reserved for ritual were used for profane performances, as we shall observe in the section on the play.

Basically all religio-social ritual dances with masks aimed at social cohesion, the maintenance of a standard of morality and behavior handed down by the ancestors. These dances also reaffirmed man's relationship with the mythological supernatural powers (spirits).

The Dancer. The African ritual dance performed alone or in groups was precisely formulated. In the case of the masked dance not only did each mask have a name (we shall indicate some of them) and a well-defined function, but each rhythmic succession of steps and movements had been traditionally established and was punctiliously performed. The masked dancer himself, mimicking his role, often chanted the purpose of his dance. The dancer needed exceptional physical strength and special skill. Because the dance was technically exacting, he had to undergo arduous training. The heavy weight of many masks, their uncomfortable structure and, in addition, the costume which covered his body in a very warm and often humid climate taxed the dancer to a great degree.

The sacredness of the performance was such that the dancer had to purify himself, observe certain taboos (such as sexual abstinence), and often offer sacrifices to the spirit he was about to incorporate. The audience believed that in the dance the spirit itself appeared and not one of their fellow members who acted out a role.

To emphasize further the nonhuman nature of the spirit, the dancer often wore a voluminous,

vividly colored costume made of raffia, leaves, corn stalks, and cloth with shells and other amulets attached to it. Sometimes this costume was made of a knitted material. The Ibo, Dogon, and Batshioko attached artifical breasts to it. The costume covered the whole body, legs, and hands so that no part was visible. The dancers of the Toma, the Dan, and sometimes the M'Pongwe further stressed their otherworldliness by appearing on stilts completely covered with a woven fabric or vegetable fiber. The dancer not only had to maintain his "impersonality," and be able to handle the spirit, but care had to be taken that no one (except the initiated who helped the dancer to dress in a special hut) touch the mask or the costume because of the danger that their power might enter into another unable to handle it. Very often when the masks were not being used in a performance, they were kept in a special location or hut, sometimes outside the village. In some cases guards were assigned to protect the masks against any possible profanation.

The strict discipline imposed upon the dancer, demanding adherence to sacred ancestral tradition, aimed to reinforce the effectiveness of the dance ritual by assuring that the present action would be a truthful repetition of a long-established rite and that it would be as successful as it had been in the past. Any deviation or innovation would invalidate the efficacy of the dance.

In general, any unquestioning following of prescribed rules of conduct relieves the individual of doubt and hesitation (cf. Catholic dogma).

The Audience. The ritual of the masked dance was rooted in a communal need, and as the participants shared in the experience, the mask became a powerful implement for achieving a homogeneous mass consciousness. The dissolution of the individual into the collective consciousness is the key to the African's way of life.

Because the public understood the meaning of each step and movement and knew that the performance was for their benefit, a sense of promise of resolution was generated. Like every mask and movement of the dance, the music had a rich and hidden meaning for the audience. They were not passive spectators, but excited, involved, active, dynamic participants. They became partners in the ritual. There was a fusion between the dancer and his community expressed in their chanting and hand clapping, supported by drums of various sizes and tonalities and the syncopated rhythm of other musical instruments. The vibrant tones affected

their pulse and their whole body. Alcoholic beverages and sometimes animal sacrifices augmented this state of excitation.

The simultaneous effect of various stimuli upon the participants went beyond what was apparent. Previous knowledge of the purpose of the ritual established a frame of reference and made the audience receptive. But this "understanding" surpassed the knowledge of the legend because it mobilized emotional identifications, established traditional bonds with mythological ancestors and heroes, and achieved a collective consciousness. The visual impact of the mask and the dancer, with his elaborate regalia, were beyond description as the perception of them actualized deep, unconscious elements. The dancing performer with his stamping, swaying, stooping movements made a stronger, more instantaneous sensory impact than the idea for which he stood. The music of different drums and the singing, clapping, often shrieking of the participants did more than create a communal bond; it released unknown individual tensions.

Two sensory (visual and audial) stimuli worked upon a conceptually prepared audience, producing complete absorption. The recognition by the whole community that the dancer was performing "in truth" further augmented the suggestive power of the performance. The dancer's trance-like performance had a mass-hypnotic, exhilarating effect: the participants underwent an overwhelming experience beyond definition or description, and in this state they were able to enter a higher level of consciousness which had an ecstatic, rejuvenating effect.

Actually the ritual dance was dynamic; it was a "happening." The very nature of such an occurrence was that something unpredictable was bound to happen. Often this had a greater impact on the participants than what they could foresee. The performance began to activate unconscious elements, and its effectiveness lay precisely in the fact that the dancer went beyond his own consciousness. He entered into an exhilarating state of depersonalization. He became, or rather was, the spirit. This was possible because by obliterating his self-awareness, the dancer was able to enter into the level on which the spirit was believed to exist and to communicate with it in the here and now.

The audience, being part of the same "event," because of the multiple impetuses, underwent the same process. This is what we call a state of collective consciousness. Not only were unconscious elements released in this significant change in behavior, but the important factor is that this oc-

curred in an orderly manner, according to a prescribed, institutionalized, and sanctified tradition. Here we have perhaps one of the most important functions of the mask—its aiding in the loss of individual identity, the liberation of unconscious elements, the absorption of individuals into a protective group. All this occurred within well-established rules. This collective release of tension was contained within the same collectivity. This was a fulfillment of man's universal need to enter the dimension of the spiritual, the lack of which is one of the tragic prices modern man pays for his excessive concern with material values.

The Play. The anthropological literature often states that masked dancers participated in a "play" following strict roles. For instance, the Yoruba Gelede society (see Plate 152) performed "plays" at the yearly fertility rites and at the funerals of members of the society. The Ijaw in their masked "play" aimed to propitiate the water spirits. In both cases we encounter activities within the province of religion. Among the Ibo about thirty to forty masked dancers participating in the "play" used delicately carved "maiden-spirit" masks (see Plate 140). But, in fact, they also used the same masks incorporating *mmwo* (a spirit) at the beginning of the dry season and at funerals; hence, the profane and sacred were linked in the same mask.

We can observe the same phenomenon in the use of the Bambara *tyi wara* (see Plate 38) in agrarian "plays," but actually this animal representation was linked to a mythological being and was associated with the fertility of the earth, again through religious rituals. The Bapende used their refined masks (see Plate 213) in the *mbuya* "play" in which a large number of masked persons participated, each with his own identity and role, such as old and young men, the hunter, the chief, and his wives. But, most important, many represented ancestors and various spirits. This was, again, redolent of religious practices.

These few examples aim to show that plays for the purpose of amusement were interwoven with religious connotations, although masked performances purely for entertainment also took place.

Huizinga confirmed this fact when he wrote (in *Homo Ludens*) that "ritual as play . . . play-festival-rite is formally indistinguishable [one from the other] . . . as they transport the participant to another world into the realm of the sacred . . . a separation from ordinary life."

2

IDEOLOGY

"The only justification of our concepts is that they serve to represent the complex of our experiences. ...The order is relationship of things among themselves." (Einstein)

In this chapter we shall see how an ideology developed to justify the African's ritual and ultimately to give him his world view.

In Chapter 3 we classify the various specific rituals in which masks were used and indicate the underlying purpose of each. A general concept providing the basis for the African's existence also motivated those particular ceremonies and provided the reason for the use of masks in each ritual.

To shed more light on how the African developed his philosophy of life, we must study how man in general arrived at the formation of concepts. This will show that what motivated the African also motivated other people all over the world.

The underlying world view of people in a particular culture conditions them to behave in a certain manner. A world view motivated the art of every culture and civilization throughout history. This is not an intellectual construct but rather an intuitive, inner truth, a vision of man's relationship to the external world. The inner world of images emerges on a preconscious level: first, acted out in rituals; second, elevated to a higher level of consciousness, creating concepts; and third, externalized and concretized in cult objects which today we call works of art, in this case masks.

Art history has shown that when a new idea (usually religious) based upon a new insight into human nature and the human condition bursts forth, giving man a guideline for a different way of being, new and vigorous artistic activity results. The inevitable outcome is a new style. No artist invents a new style. It is rather the result of a new approach to life which transforms the artist. With his insight the artist is able to function like a magnifying glass focusing the light, reducing the complexities of the human condition to their essence, and clarifying them. He uses his particular gift for artistic creation to give form to the newly promulgated way of being and the subsequent way of doing things.

New ideas gave birth to a direction in art which Faure called expression (its period differs in each civilization). When this new world view lost its fervor, the artist turned toward a style of "perfection" of the forms previously invented. In this process they lost their emotional content and impact. Art declined or completely disappeared following the weakening or decay of the world view of the culture. The ancient art of Mesopotamia, Egypt, the Aegean or Greek civilizations, for instance, disappeared when the inspiring concepts of life (closely connected with political power) ceased to be meaningful. For the past two thousand years we have not had plastic art of any significance from these regions. It can happen, however, that the in-

spiring ideology undergoes changes which the art reflects. We can see, for example, that when Christianity enjoyed its original fervor, it produced nonnaturalistic Coptic, Byzantine, and Romanesque art which we call high periods in art history. With the introduction of new humanistic concepts during the Renaissance, sculpture and painting became naturalistic. No longer did they reflect the religion of Jesus, but they became rather illustrations about Jesus and other personages of the Christian legend.

Historically African art fits into the cyclic high period because it reflects, it is the embodiment of, the strength of an authentic, all-embracing ideology, a nonderivative approach to reality resulting in a basic way of life for the people. The forms in African art were semiabstract. As long as the African carvings served religio-ritual purposes and the carver was a true believer in the survival of the spirit, his work remained authentic. As soon as Western concepts or desire for monetary gain guided his activity, it became a routine act. He lost his inspiration. He carved with his hands, but his heart was not engaged. The result was the decline of African art.

Since creative art is the result of a deeply moving encounter with external reality (which is a construct of the mind) and its subsequent conceptualization, it is important to investigate how ideology evolved and how the African reflected his special response to the encounter in his art. Perhaps the answer may help explain our appreciation of his art.

SENSORY PERCEPTION

We must state again: concepts and ideologies are the results of man's encounter with external reality. The manner in which he confronts it determines the nature and quality of the concept he forms. The confrontation of reality begins with the perception of external "sensory facts." Properly speaking, they are not facts but data, or inputs, which produce an individual "pattern of simulation" in one's nervous system.

The right hemisphere of the brain, which is the seat of artistic ability and nonverbal perception, is more highly developed in some people than in others (The left hemisphere has to do with language and analytic ability.) Hence those of the right-hemispheric type (probably the Africans in general) do create a more artistic culture and, in

turn, may have more talent to perceive artistic forms. In general terms the brain classifies the random inputs into patterns according to a system of evaluation (meaning) based upon memory and permits only selected parts to emerge into consciousness. As a correlative action to that of the signals received and integrated by the brain, the whole organism produces emotionally charged releases such as reflexes, sensations, and feelings, and these constitute the primary experience on the precognitive level.

We shall endeavor to establish the sequence of these events which occur when we confront reality (including a work of art) and apply this process to the African's apprehension of the external world.

(1) What we call a sense impression is not limited by the normal five senses. Rather one perceives with one's whole organic being and transforms this imprint into a primary experience. This is a significant state (even before meditation or discursive reasoning has taken place) because it is a new state of awareness which has come into being. On this level man is able to experience what is beyond knowledge, for instance, mystical consciousness, which plays an important role in the creation of African masks.

(2) This first impression becomes a precept which already has the germs of (3) an idea. This mental impression is the result of the recollection of the first sensory apprehension. The sensory inputs on a prereflective level are related to the integrative function of our neural mechanism, to already existing traces of memory which produce what we call a thought. Hence, reality is interpreted subjectively because of the inclusion of past memories. But the brain aims to order sense impressions with its own nonformulated awareness.

(4) In this state, on a conscious level the formulation of concepts takes place. Depending on which set of assumptions a person adopts, he arrives at different concepts. He pictures (or visualizes) what previously was prereflective and arrives at a mental image.

(5) If a man more consistently observes what he has perceived, he may apprehend a pattern which can be classified, and ultimately, he may arrive at a theory which most often is an assumption. This, in fact, is the analysis of observed data in their relationship to one another and man's relationship to them. Hence, if any datum or man's frame of reference changes, the basis for his relationship to his observation and the speculative explanation of the phenomenon also changes.

(6) Assuming that a person has arrived at such

an explanation, he must integrate it with his u-
nique personality and through this process he may
arrive at a conviction that his explanation was
right.

(7) If the truth (to repeat, one's personal
truth) is transformed into a mode of behavior (a
way of being) and this is fused with the very core of
one's natural self (Being), the personal truth will
become a guideline, a world view. Being subjective,
such a conviction is beyond the category of true and
false, right and wrong.

(8) On a religious level this truth is trans-
formed into faith, which can be independent of or
dependent on dogma. We can postulate that when
the African ancestors who created the prototypes of
masks underwent what we call a primary ex-
perience, immediately and spontaneously creating
the masks and statues, they acted to satisfy their
need to make real what they had already ex-
perienced emotionally. Only later did they fit their
creations into a religio-magico-social ideology. We
believe that the African and most of the prehistoric
and preliterate cultures evolved this way. But we
must also consider that in a culture dominated by
people with a left-hemispheric (analytic) type of
brain structure and a talent for image making less
prevalent than in Africa, the primary experience
was transformed into the formation of concepts
which later and only sometimes were followed by
plastic realizations of the ideas. (This does not
apply to Jews or Moslems, whose religious credos
simply prohibited image making.)

THE AFRICAN'S WORLD VIEW

A world view (Weltanschauung) is a conceptualiza-
tion of man's reaction, or his approach, to the ex-
ternal world. But the individual, being the product
of a particular culture, integrates this world view,
which is usually based upon a central belief (such
as monotheism), producing a conviction (faith) in
order to arrive at his own personal truth. This
shared central belief provides a guideline, a mean-
ing for one's existence resulting in a way of being,
or in a life style.

It is possible to trace present-day Western civ-
ilization to Socratic, Platonic, and Aristotelian con-
cepts predicated upon man's intellect, his logical
thought processes, which evolved into a prag-
matic, scientific, materialistic outlook. The African
cultures followed another path similar to the
spiritual teachings of the Hebrew prophets,

Buddha, Lao Tzu, or Jesus, and produced another
way of life based upon man's spiritual needs, a
socio-religious, well-ordered, communal (and not
individualistic) integrated way of life.

Adopting a phenomenological approach and
suspending all presuppositions, we can understand
the virtues of the African's value judgments and his
customs on their own terms without comparing
them to our own institutions. This approach does
not concern itself with good or bad, but only with
differences.

The degree of the vigor of the African's in-
tegration of his cultural conditioning and achieve-
ments with his existential needs is best documented
by the magnificence of his art. Great art is the con-
sequence of and can emerge only from a great
culture.

Levels of Consciousness. The great difference
between the Western and the African approach to
reality is the difference in the level of consciousness
shared by all the members of the community. The
African was conditioned from early childhood and
by initiation into adult society to experience the
world around him on its essential level transcen-
ding physical phenomena, cosmogony, and on-
tology (state of Being). Western terminology might
label this state of consciousness metaphysical. It is
beyond the rational. It is "beyond reason but not
contrary to reason," as Merleau-Ponty defined it.
It has its own reality, its own kind of rationale
within the traditional conceptual framework of
Western thought.

This different state of consciousness is of es-
pecial contemporary interest in view of the new in-
vestigations of the mechanism of perception (phe-
nomenology), the meaning of existence (existen-
tialism), and the unexplored dimensions of the
mind—the possibility of producing altered states of
consciousness. All these investigations are based
upon the recognition of man's potential (which he
can realize by recognizing it) to transcend ordinary
rationality. What is so remarkable—and it proves
to what degree this apprehension, or new dimen-
sion, of consciousness is basic to human nature—is
the fact that the African, without being conscious of
its existence, fully utilized it and integrated it into
his life, making it the basis for the production of
great art.

To shed more light on these statements, let us
make a few remarks about the phenomenological
approach to ontology. To oversimplify the ap-
proach, it assumes that beyond man's intellectual,
logical, conscious mental processes, there exists a

twofold part of his unconscious: his ontological, natural self, his Being, his state at birth, and his psychological self conditioned by his environment. From these two unconscious layers emerge preconscious, and eventually conscious, levels.

There is a clear distinction between preverbal and conscious apprehension. On a conscious level one's neural mechanism interprets what one has apprehended and relates all inputs in this process to one's subjective memories. This results in what we generally and habitually accept as reality, but it in fact is not what reality on an essential level is. It is rather our opinion of it. The direct, prereflective awareness cuts short, or stops, this mental construct of reality and lets man sense or grasp (to the degree that it is humanly possible) the real "reality" before he falsifies it by interpretation. The basis of this reality is the preconscious awareness, and, as Merleau-Ponty so well formulated, "When I begin to reflect, my reflection bears upon the unreflected experience."

This unrecognized part of man's psyche below the threshold of consciousness, defying understanding in terms of causality, is our main interest. This is the domain of Being, the transrational, transpersonal, nondimensional region of the mind in which man's intuitive faculties are rooted. By reanimating his Being, man is able to sense and experience that essential part of reality which is numinous, which being beyond phenomena gives a sacred dimension to his existence. All men have the potential to "take Being out of concealment," as Heidegger put it.

By "letting go," or letting Being function, the African, conditioned by his tradition, was able to thrust forth in a vital way beyond the immediately ascertainable toward the spiritual. He made his openness to what *is* a way of life and a meaningful existence. He created an inner truth which formed the foundation of his world view, the very basis of his artistic, creative activity.

Fused Oneness.

This apprehension of the external world raised the African's consciousness to a new level, achieving a harmony with nature in contrast to the Western approach, which consists of trying to dominate nature. One attitude is to let the outside world seize man; the other is to try to seize it. The former requires surrender to the experience, the harmonizing of the individual self with the greater rhythm of existence, resulting in a fusion of identity of the external with the internal. This is a state of fusion with all things, living and dead, with

natural and cosmic forces and the ultimate spontaneous yielding to let nature act through one. (The Chinese *wei wu wei*, meaning "to do things without doing," is an expression of this idea.) Einstein called this cognizance that the earth is part of the cosmos and man is part of the natural order on this planet "cosmic religious feeling," and Freud coined the expression "oceanic feeling."

The result of such a fundamental experience for the African (for that matter, for all mythologizing people) was a sense of oneness, an infinite unity with and wholeness of the order of things, a supreme reality beyond the everyday routine of existence. Maritain's "inexhaustible and incomprehensible mystery of reality" epitomizes this attitude. It is a "primordial state of amazement which sets all creative forces of the soul to work," in Buber's words.

We have been tracing the mechanism of perception, but the encounter with and confrontation of the unknown forces of nature, only the manifestation of which is perceptible, sets into motion a series of emotional responses evolving from one to another or experienced simultaneously. A sense of wonder in one person can become a vague dread of the unknown in another, producing a sense of awe (the awe-struckness of Otto). If combined with amazed perplexity, it may generate reverence, which in turn consecrates the experience. This reverence is the core of any religious attitude, as it implies submission to a higher power helping to transform ego-connected fear into an unmediated perception of a higher order and of the coherence of the hidden aspects of reality, the universe, nature, and man's place in it. Man further experiences (and later conceptualizes) this pantheistic emanation as part of an immaterial, spiritual reality which raises human beings to a higher level of consciousness, revealing a new dimension of existence often called cosmic consciousness. Because of the sacred nature of the world (and all religions confirm this), especially because the African connected it with the spiritual power of the souls of his ancestors upon whom his daily existence depended, he was able to experience a new dignity, the sacred nature of his destiny.

Mystical Participation.

The submission to and union with the higher power take place on the ontological level (Being) of man beyond his consciousness. To quote Meister Eckhart, this part of man is "the pure heart or soul's core." The Buddhists call it the universal, natural, or spiritual

nonself (to distinguish it from the ego-self). The Gnostics called it *pneuma* (spirit) in contrast to *psyche* (soul).

We could draw another distinction between kinds of knowledge. One is the inner knowledge of a phenomenon or an event as is; the other is information about the phenomenon. (Applying this distinction to our study, we see that one approach is to face the mask and experience it; the other is to know about its function.)

On the ontological, non-ego level the fusion or integration of man with the overall scheme of the world takes place. Man, including the pragmatic Westerner, at a very basic level has a need, a hunger, for immaterial, spiritual reality (and the need to believe in it) when facing the inconceivable immensity of the universe and his place in it. He senses that he is able to transcend his self-centeredness; he has the capacity to experience a mysterious otherworldliness in exultation. Plotinus said, "Each being contains in itself the whole intelligible world. Therefore, all is everywhere When he ceases to be an individual, he raises himself again and penetrates the whole world."

Usually this sense of oneness, called mystical participation, is associated with the Christian or Islamic mystics. It has, however, much broader implications. As transcendence is a capacity of all men, modern man, wherever he lives, is able to experience its integrative effect upon his existence, as many students of mysticism confirm. Underhill said, "Mysticism is the art of union with reality We know things only by uniting with it, by assimilating it." Russell said that "mysticism in essence [is] a belief or insight against the discursive, analytic knowledge A conception of reality behind the world of appearances . . . an element of wisdom to be learned from the mystical way of feeling." Einstein noted that "the most beautiful and most profound emotion we can experience is the sensation of the mystical. To know what is impenetrable to us really exists . . . this feeling is at the center of true religiousness." Otto's comment that the essential element of mystical feeling is "losing one's individuality with the transcendental reality . . . a unity with the numinous elements," confirms our opening statement and also what Plotinus said.

One can achieve this mystical participation alone by contemplating the marvels of nature. But ritual, communal life and mass suggestion enable man to be absorbed with what he witnesses and to abandon his own individuality.

The contrast to modern man is apparent. He is "condemned to be free," as Sartre so well expressed it, and lacks a central vision, a unifying truth. His life is fragmented. He lives estranged from his true self and in search of his identity.

Group Identity. The African, a conformist and a traditional member of his society, unconcerned with questions of personal identity, naturally adapted to group identity. If identity means having an existence which is identical with one's true self and one's aspirations, the African was able to establish an identity between his Being and his existence, as the religio-magico-social institutions supplied him with a code of conduct. Leonard's observation that the people of the Niger delta had no word for religion in their language best indicates the degree to which there was a fusion of principles resulting in a way of life. When a Dogon was asked what religion he practiced, he replied, "I am a Dogon." This union of his Being with his way of life (which also included his art) gave him a sense of security, a sense of belonging to a group and their interdependence upon one another.

Although we maintain that the question of individual identity did not arise in the African's consciousness, nevertheless, because of genetic distribution and the unique endowments of each human being, he manifested his individuality unconsciously in his carvings. This very trait is the collector's key to the artistic quality of a mask.

The Concept of Soul, a Vital Energy. Our discussion has centered on the fact that reality and man's conscious participation in it are a mental construct. But his most significant encounter with the external world occurs on a preconscious level, resulting in a "lived-through experience." For the African this preconscious world is intimately connected with something real and vital which, in Western terms, we call the psyche or the soul. Apart from psychoanalytic insights, our concept of the soul is manifold. It is the unknown essence, substance or animating principle of life within the body of man. According to many religious concepts (including the traditional religions of Africa), it is immortal and separates from the body at death.

The Western differentiation between consciousness and unconsciousness did not exist for the African. The African's world (similar to the world of man's natural self, the Being) was undifferentiated. This soul concept became an all-embracing, mysterious vital potentiality. Because it

could also be located outside the body (and his soul could be separated from his body) it became an entity—a force or spirit. The Egyptians called it *ka*; the Polynesians, *mana*. The Africans invented different names, such as *nyama* (Dogon), *sassa* (Ashanti), *jok* (Luango), *evur* (Fang) and *kele*, always for this same concept of psychic energy. This *nyama* (to adopt the Dogon name) is universal energy, the dynamic spirit or vital breath. The simplest definition is that everything has an indwelling vital energy. The Germans call it *Lebenskraft*, or "strength for living." It is invisible but always present. It is feared but can be appeased and gained for the service of man by means of offerings and/or sacrifices. It is eternal and can be reincarnated in other individuals (one's offspring, for instance) or contained in a cult object.

Everything in nature, including man, possesses this indwelling power. There is a link between man and animal, the vegetable and mineral realms, all being part of the natural order. The Africans conceived of most of the natural forces affecting man's existence, such as the sun, the moon, rain, lightning, and the fertility of the earth, as possessing this essence in the shape of some magnified, supernatural being dwelling somewhere else. Often they personalized them as anthropomorphic gods, goddesses, demigods, genii, spirits, and animals to make them approachable in order to deal or communicate with them.

The personalized genie is universal and as old as man. The genie for the earth, for instance, was usually female, as man conceived of the earth as a womb holding the seed, or grain. The Yoruba called her Iyala. Her ancient Egyptian name was Geb, and she was Gala to the Greeks. As the fertility of the earth was the crucial concern of agricultural societies, they had multiple goddesses. The Yoruba had Oko for farming and the harvest; the Egyptians, Nepri, the corn god; the Greeks, Demeter, the goddess of the fertile, cultivated soil.

Animals had their own spirit, and we shall see to what extent the heads of animals appeared in African masks. Here again we find that the reverence for animals is universal. The Assyrians, Babylonians, Canaanites, ancient Egyptians, and Cretans worshiped the bull. They also deified the ram, and we find a number of African masks with ram's horns (see Plate 117), not to mention the Ibo statues (*ikenga*) or the Ishan and Bini heads from Nigeria. The Bambara usually represented the antelope in its totality (though in a delicately stylized form), but the slender antelope horns appear on many masks of various tribes.

In contrast to the worship of animals in Egypt, in Africa they were not the subject of individual cults. Animal heads in the form of masks, often with added features, used ritually most frequently represented mythological beings.

By the process of man's sharing the vital, reproductive energy of the external world, a fusion takes place. This very exchange is the vital support for man's mysterious feeling of sameness evolving into oneness with all things of the natural world. This means that not only is there a concept, but man actually experiences being part of nature and nature being part of him. Further, man believes that he can partake of the universal energies, and as life is an uninterrupted continuum, he is part of the dynamic process of growth. Griaule wrote of "the continuity of life through death and through the tangible renewal of an essence that cannot become visible"

The concept of a continuum also had a direct existential meaning for the African. He believed that after death he would return among the living as a respected and active participant in his family (ancestor cult) and, furthermore, that he would survive in his offspring and their children in generations to come. The important effect of this faith was that it was able to remove the fear of death so widespread in Western civilization.

To illustrate the real, concrete survival of the soul as not only the African, but also many early civilizations conceived it, we shall cite only one example. When a king or a chief died, his wife, slaves, and often his horse were killed and put into the grave together with his weapons and daily utensils, so he would be equipped for and served in the land of death. (It is noteworthy that various useful objects were found in the ancient tombs of Egypt, especially that of Tutankhamen, which give us an idea of what life in those times was like.)

Animism. Although there is a divergence of views as to the usage of the word animism, there is agreement that the cult objects of the African were retainers, or containers, of spirit power, vessels and dwelling places for invisible forces, abodes of the soul of the ancestors; that they incarnated the invisible vital energy and that natural forces inhabited them. The cult objects (in this case masks) were not symbols of abstractions; they were instruments by which man was able to participate in the power and virtues actually existing within the material container. If we take animism to mean the belief that an inanimate object has a spirit, we cover all the various descriptions cited above, in-

cluding the fact that it was not the carving which was subject to worship but the forces which it contained. In this sense we can state that animism was for the African the basic, unifying principle of human existence, the foundation for most of his religio-magical rituals. Masks were "spirit traps" (as the African called them) aiming at all times to control the function of the spirits for the benefit of the living, the stimulation of the will to live, and the consecration of life. Ultimately masks gave the African a tried and working modus vivendi in a given social framework.

Animism is a religious concept, but when we speak of the African's religious life, we have to suspend our usual concept of religion. Religions are usually organizations with their sacred books (*Upanishads*, *Tao Te Ching*, Bible, Koran), a powerful founder (Buddha, Confucius, Lao Tzu, Moses, Jesus), and sacred buildings for worship (a church, mosque, pagoda, temple). Such highly knit religious organizations with their complex hierarchy did not exist in Africa although secret societies had their religio-social function.

The fact that the African religion did not evolve into a highly organized institution (such as the Catholic Church) with its hierarchical functionaries, the fact that it did not arrive at the rigidity or, we may say, fossilized state of other religions, only shows that it was able to maintain its primary, original, uncomplicated dynamism. And this spontaneous mystical élan (the true sign of religiosity) left its mark on the art of Africa monumentalized in the mask.

INDEX OF CULTURE

We have previously been using data (the nature of the African's religion) to recognize characteristics in his art. But we can also pursue a morphological investigation and, suspending all previous knowledge, start with the work itself as an index of culture.

If we recognize the unified wholeness of a work of art, we can assume that it is the result of a unifying concept. In general, we can postulate that such a work of art can reveal not only a profound experience resulting in a state of mind and a certain way of doing things but also a particular culture with its prevailing ideologies (religious, in this case) of which the artist is the product. It means, again taking religion as a basis, that a spiritual

energy (conceptualized as ideology) is fused with its product (the work of art), which in turn becomes the carrier of that spiritual essence. In short, we can consider the work of art as an unwritten document or index of its culture. It can reveal to us, independently of any knowledge we may have about its origin and use, the type of civilization in which it originated.

The guiding principle is that the more simple the configuration (archetypal form) of the work of art, the more basically human is the underlying need to create and, as a result, the more universal is its message. The more complex the structure of the work is, the more multifaceted the culture or the ritual is, and the more particularized and localized the message.

To illustrate, we shall compare the African masks with those of other cultures. If we look at the majority of the masks of Oceania, Indonesia, Tibet, Bolivia, or the Northwest Coast Indians, we discover a complexity of structure with vivid, multicolored designs which often appear decorative. We may assume that a complex ideology is responsible for the intricacy of those masks. We can contrast the greater number of African masks as being of simple construction. They have balance and harmony within the limits of the tree trunk of which the masks were carved, and the expressiveness of these elements only reflects or corresponds to the straightforward and fundamental religious concept of animism. There were a large number of spirits, as the religion had to cope with multiple forces, but sculpture was based upon the single, overriding, unifying concept of the vital force (or spirits) being trapped in the object.

For example, as soon as a highly structured, hierarchic society in the Benin Kingdom with its numerous functionaries superseded the direct, personal relationship of the African to the embodied spirits, the court art became institutionalized, creating highly complex but rather sterile, conventional works (see Plate 162). The Bini people, however, outside the life of the court maintained their artistic freedom in their masks (see Plate 164).

The Effect of Religiosity on Art. We must extend the principle that art is the document of a culture, see in a more detailed and specific way the application of this principle to the African mask, and relate the principle to our reaction to it.

Considering the fact that the African depended on his cult objects, that his whole security was based upon gaining the benevolence of their indwelling powers, we must now ask: how did this

concept find expression in the African's artwork in general and in his masks in particular?

First, his oneness with the external world resulted in a profound experience, overpowering his whole being and producing a need to discharge the excess emotion and the subsequent intangible concept into a tangible reality—his carvings. But each carver was also the product of an agricultural society of great internal consistency, rooted and sustained in one place for many generations.

Second, because the African so deeply felt his human experience, and his traditionally trained talent for carving was so great, he intuitively chose significant, coordinated forms linked by the intensity of his commitment. We may say that he invested matter with spirit.

Third, he was guided by a conceptualized, emotional experience. This unifying principle gave the forms significance, an unswerving appropriateness, an inevitability. Significant forms and their coordination are the products of the creative mind penetrating essences. Such forms are due to a compulsive, expressive urge, we may say, an inner necessity. Having a trained sensibility, the observer in contemplation of the work senses whether the interrelated, coordinated forms and shapes were intrinsic and necessary to achieve a coherence within the work.

Artistic talent is not enough. First, the creative artist must be what Aristotle called a "greatsouled person" to be able to experience life in the deepest part of his Being and to be able to grasp the very essence of an experience in order to distill what is significant and necessary. Second, the artist must have an exceptional talent in order to use the plastic idiom. This type of artist reaches a pitch enabling him to concretize a deeply rooted faith in the communally shared concept of "trapping" the powerful spirit in the mask. Only if the carver achieves a full integration of his internal experience with an inspired execution of structured forms will the work be highly charged with the intensity which prompted its creation. This will be manifest in the coherence of its parts.

Western man, having developed a refined talent for reading the universal plastic language of significant configurations (Gestalt), can suspend all knowledge about the work and share the intensity of the very experience which gave birth to the African mask. His experiencing of the expression of the essence in the structured form of the work of art will be highly charged with emotion. This is why we stress the importance of form: this is the plastic means by which essential emotions and concepts can find their expression.

In fact, such a communion with the work of art on the part of the observer is self-revelatory. The magical power of the plastic language—and this is still a mystery—is such that it may touch or open up the depth and richness of man's unconscious world, a sublime realm of his emotional experiences often bordering on the mystical (the original etymology of this word is *muein*, meaning "to close"; hence it refers to an uncommunicable experience).

In man's primeval unconscious also lies his capacity for religiosity rooted in his basic nature as *homo religiosus*. As this mystical sense is connected with a sense of awe experienced also at times by modern man, we can assume that the deeply felt religiosity of the African, so miraculously expressed in his cult objects, is able to reveal to modern man his own religiosity although he is completely unaware of its existence. Perhaps this is one of the most significant parts an authentic African carving can play in our contact with it.

Because of the havoc and anxiety caused by constant change, challenge, and competition in our society, the religio-magical way of life acquires a special significance. The African's mode of existence was not subject to change; he did not need to force himself against his own nature to adapt. Applied to African art, no change in life style meant no change in art style. As soon as the African's life style changed, his art style changed and produced confusion and the deterioration of his art. As soon as new religions and material values were introduced into Africa, removing the fundamental, ancient need for religious ritual, the quality of the African's art declined. The present-day production consists mostly of copies of authentic pieces. We may simply say that the carver applies his hands, but not his "heart," to his work, and consequently it has become soulless.

In this context we may add that when a collector prefers an "old" African carving, he most frequently refers to a superficial quality, patina, signs of use and so on. This often depends, however, upon the conditions to which the object was exposed and does not give any indication as to its age or its artistic quality. What we really mean by the word "old" is that a piece originated in a period when Western influence was felt less, when the carver worked exclusively for purposes of the ritual, and, hence, his concentrated artistic intensity had a better chance of being incorporated into the work,

producing an authentic, successful configuration, provided he had exceptional talent.

In simple terms, an old African carving produced by an untalented carver may not be of high artistic quality. We could also say that a very talented contemporary carver could produce a work of high quality if it were the carver's talent which counts. However, this is not so, as experience has shown. If the carver is not the product of a coherent, deeply religious community, or if monetary concerns influence him, his work may be technically of a high order, but it will lack the suggestiveness of great art.

3

THE USES OF AFRICAN MASKS

In Chapter 1 we described the framework within which the mask functioned, and in Chapter 2 we outlined the ideology responsible for the mask. We should bear all this in mind in the present chapter as we classify the various specific customary activities in which the mask played an important role, based upon long-established and continually observed tradition.

The mask had two main functions in Africa. One was its public function at agricultural or funeral rites, for instance, with audience participation. The second function was private, known only to the members of the secret society (in initiation ceremonies, for instance, although at the end of some initiations the new members gave a public performance).

This survey will show that because of the African's ideology requiring the same conventions to surround all the functions of the mask, there are more similarities than differences in its uses. We can distinguish a few major rituals although very often they are related, as we shall demonstrate. The following were common:

(1) Rituals of cosmogony, myth and mythological or legendary heroes and animals.

(2) Fertility rituals.

 (a) Rituals for increase.

 (b) Agricultural festivities.

 (c) Funerals or burials.

 (d) Ancestor cults.

(We shall show the interrelationship of all the fertility rituals.)

(3) Initiations.

(4) Related ceremonies.

Examples of the various categories will be given by referring to certain plates and their captions, where the uses of the specific masks are given along with the physical descriptions.

RITUALS OF COSMOGONY AND MYTH

In Chapter 1 we outlined the significance for the African of mythological beings, culture heroes, and tribal founders represented by masked dancers.

The emphasis on one or another aspect of a given myth varied with the tribe, but we can discern recurrent patterns which permit us to make the following subdivisions.

Cosmogonic Myths. These were to be found among the Dogon (Plate 13), Bambara (Plate 22), Bwa (Plate 104), Ekoi (Plate 186), and Bateke (Plate 208).

Moon Rituals. These obtained among the Mambila (Plate 189) and M'Pongwe (Plate 194).

Mythological Heroes. The three most important Bakuba masks are all associated with mythological heroes (Plates 223, 224, and 229). Other examples occur among the Toma (Plate 9), Dogon (Plate 16), Korumba (Plate 122), Senufo (Plate 78), Bekom (Plate 175).

Mythological Animals. These are found among the Dogon (Plate 15), Bambara (Plate 38), Baule (Plates 70 and 71), and Kuyu (Plate 202).

FERTILITY RITUALS

Fertility and increase, whether of human beings, animals, or the earth, were among the most vital concerns of the African. In this section we shall enumerate several rituals in which the general fertility concept prevailed.

In addition, we shall demonstrate that fertility also played a part in the agricultural and burial ceremonies. They were based on the concept that through the appropriate rituals man could conjure up the vital forces dwelling in the mask by gaining the benediction of his ancestor in order to promote fertility and thus achieve protection and basic security.

Rituals for Increase. These are found among the Baga (Plates 2-5), the Yoruba (Plates 152, 153, 155, 156, 159), the Mama (Plates 172 and 173), and the Bapende (Plate 215).

Agricultural Festivities. The Africans celebrated agricultural rituals at different stages of the growing season, or crop cycle, starting with the clearing (and often charring) of the land, followed by the planting, the reaping of the first fruits, the harvest, and the filling of the food stores.

The basic concept underlying these festivities was the sacredness of the soil, which belonged to the ancestors, or the "masters of the soil"; hence, the successful harvest depended on the benediction of these ancestors, or, in some instances, upon the good will of the goddess of the earth.

Masks were used in agricultural festivities by the Baga (Plates 2-5), the Dogon (Plate 15), the Bambara (Plates 27 and 30), the Bozo (Plates 45 and 46), the Baule (plate 69), the Senufo (Plate 74), the Bwa (Plates 104 and 105), the Bobo-Fing (Plate 110), the Mossi (Plate 120), the Gurunsi (Plates 126 and 127), the Ibo (Plates 140, 141,

147), the Bekom (Plate 174), and the Mambila (Plate 189).

In the Bwa and Bobo-Fing rituals the guiding principle was that the fertility of the fields could be assured by the peaceful existence of the ancestors in the land of the dead. Part of the aim of the rituals was to procure this assurance.

FUNERALS

Death cults, especially those dedicated to the survival of the soul, are among the most widespread rituals in the world. Perhaps the most magnificent and monumental document of ancient times is the Pyramids, the burial grounds of Old Empire Egyptian royalty and nobility. Many Eastern religions support the belief that the deceased soul rejoins its family in heaven. Visiting tombs today is still an accepted custom all over the world.

For the African the cult of death began with the burial rites. These were related to a wide range of extremely important occurrences, for example, the fertility and the increase of the earth, animals, and human beings and the cult of ancestral spirits.

Funerary Rituals. The Africans constantly endeavored to maintain relations with the immortal soul of their ancestor, to petition him, and to gain his benediction. A blood sacrifice made to the mask incarnating the *nyama* of the deceased aimed to nourish the spirit so as to increase its vitality and efficacy in helping the living.

Most of the funerary rituals took place at burial and were based upon the concept that after death a man's spirit was liberated from his body and had to be induced to join his previous ancestors in the land of the dead (known as *manga* to the Dogon, *ebe mmo* to the Ibo); otherwise it might harm the living.

To assure that the soul found its way into the land of death, it was necessary to observe precisely all details at the funeral. This was an all-important filial duty. (Often a childless man complained that no offspring would arrange his funeral. For this reason special associations assured the faithful execution of such ceremonies according to tradition.) Beyond this family duty a much broader, ritual obligation was involved, namely the maintenance of the belief in the sacredness of the ancestor's power so as not to upset the equilibrium of the existing social and spiritual, mystical and metaphysical order.

The belief in the effectiveness of the ritual also assured the survivor that when he died the very same traditional care that he had extended to his father would be extended to him. His belief that he would return to the living as a respected spirit partly eliminated, or at least alleviated, his fear of death.

A recurrent note in the ritual was its aim to appease the wrathful spirit of the ancestor. This indicates that the spirit could harm the survivor. There is a seeming contradiction here. On the one hand, the benediction of the ancestor was invoked while, on the other hand, the same spirit could be vengeful. There is a strong indication that the petitioner assumed he had committed some offense against the spirit of his father or forefather. Rationally, we may attribute this feeling possibly to neglect of filial duty. But this feeling of neglect may have been only a rationalization to cover up some unconscious motivation. Here a general knowledge of human nature may give us the key. It is part of the basic, unconscious element in man that for some unknown reason he carries a sense of guilt in his unconscious. Being free-floating (as Freud indicated), the guilt attaches itself to some apparently valid reason.

The Africans used masks at the end of mourning, apparently to limit the period of deep sorrow by announcing with ritualistic approbation man's right to forget about the death, although he maintained his relationship with the spirit of the dead, thus forming the basis of the ancestor cult.

Ancestor Cults. The funerary rituals were public manifestations in which the masked dancers performed their ceremonial function with the participation of the audience. By contrast the ancestor cult was a more private matter. Family members performed their own petitionary devotions to a large number of ancestor statues kept in a special hut.

There were also a number of masks that are known to have been used in the ancestor cult although they also played a role in the funerary rites.

Masks were used in funerary rituals and ancestor cults among the Dogon (Plates 13 and 15), the Guere-Wobe (Plates 47-60), the Bassa (Plates 61 and 63), the Baule (Plates 66, 69, 72), the Yaoure (Plate 68), the Senufo (Plates 74, 78, 80), the Bobo-Fing (Plate 117), the Korumba (Plates 122, 124, 125), the Ibo (Plates 140 and 141), the Yoruba (Plates 155 and 156), the Idoma (Plates 166 and 167), the Mumuye (Plate 168), the Cham-

ba (Plate 171), the Mama (Plate 172), the Ekoi (Plates 183 and 188), and the M'Pongwe (Plate 194).

INTERCONNECTION BETWEEN VARIOUS FERTILITY RITUALS

Actually, each mask had multiple meanings and acquired a specific significance in each separate ritual based upon the established oral tradition. The participants in the ritual inferred its conceptual basis from historic, mythic, ethic, or social data learned from childhood and emphasized in the initiatory teachings.

Within this multiplicity of uses and meanings, one of the patterns recurring most often is the use of the same mask in fertility, agricultural, and burial ceremonies. This phenomenon is so often repeated that we must assume the existence of a basic, underlying ideology which prompted this multiple usage.

Every ritual aimed at the realization of the people's wishes. Any irregularity (for example, lack of rain or food or the sterility of females) disturbed the order of nature beneficial to man's existence. Consequently the African performed rituals to correct or eliminate any interruption of the secure existence which he desired.

All three ceremonies which used the same mask had one common aim: fertility. The word itself had three different meanings. First it meant the fertility of the earth and the seeding with all the agricultural connotations. Second, it referred to breeding, the fusion of male and female producing offspring. This included human and animal fertility and, symbolically, the fertility of the earth. Third, since in the African's mind the fertility of the earth and human beings was connected with the ancestors' spirits, he maintained contact with these spirits at burials and rituals of ancestor worship.

The fecundity of the earth had a strong female connotation, as the earth goddesses were all female. Planting was symbolically the placing of grain in the "womb" of mother earth. (We may recall the Dogon granary doors with female breasts on them, linking the increase of grain to human fertility.) To illustrate the degree to which the African associated the fertility of the earth with human fertility, we merely cite the fact that in a certain tribe in Nigeria man and wife copulated on the fields after sowing.

The male's participation in the fertility of the earth was clearly defined in ancient times in Africa and in other parts of the world. The priest-king, the direct descendant of the tribe's founding ancestor who was considered the "owner" of the land, was responsible for the fertility of the earth. Because the tribe feared that the decline of his potency would cause the failure of the crop, he was subject to sacred and compulsory death without the spilling of blood.

The dead man's (ancestor's) spirit became associated with the fertility of the earth through two interconnected and mutually reinforcing ideas: (1) Because the Africans believed that the land belonged to their ancestor, they sought his benevolence in influencing the fecundity of the earth. In modern times the governments trying to resettle land encounter great difficulties because the people hold tenaciously to their ancestor's land. (2) The role of the ancestor was based upon the concept that the soul of the deceased resided in the land of the spirits. As the African attributed the cause of all manifestations of the natural order affecting the productivity of the land (rain, a good harvest, and so forth) to a specific spirit, he believed that the departed soul-spirit could intercede on behalf of the living to turn the external forces (rain, for instance) to his own well-being and increase.

The African maintained continuous contact with the dead man's spirit, first, through the burial ceremony, and second, through the ancestor cult. The masked man impersonating the deceased at his burial made manifest the presence of such a spirit (as demonstrated by the Yoruba Egongun and the Ibo Mmwo societies). Members of the ancient Benin Kingdom acted out another version of communication with a spirit. At the moment the king wanted to send a message to his ancestor, a slave was killed in the belief that his liberated soul would fly with the message to the land of the spirit.

The ancestor was often associated with human fertility. When a child was about to be born, for instance, the Yoruba consulted their Ifa diviner to find out which ancestor would return in the body of the baby, and, accordingly, the infant received the ancestor's name. This may be an unconscious extension of the concept that man merely opened his wife's womb during sexual union, and it was the ancestral spirit who impregnated her. Some tribes symbolically associated the fertility of the earth and that of human beings by burying the body in the fetal position, thus acting out the life cycle from the womb of the woman to the womb of the earth. The

Bible says, "Dust thou art, and unto dust shalt thou return" (Genesis 3:19). (Pottery, the creation of concave containers, was the role of the women. In contrast, sculpture was exclusively a male activity.)

INITIATION CEREMONIES AND THE ROLE OF THE SECRET SOCIETIES

Masks used in performances by the secret societies and in various initiation ceremonies were kept secret. But when masked members of the society patrolled the villages to maintain order, when masked guards protected the enclosure where the initiation took place, or when the initiated performed after the closing of the ritual, the masks appeared in public.

There were different types of secret societies, but the main purpose of all of them was to maintain and enforce the laws and exercise social and political control over the communal activities. Because the African's way of life was religious, there was no division or separation between the religious and the social functions. It was within such societies that the *rites de passage*, usually considered as religious functions, took place. These societies had a hierarchy of functions (mostly male with few exceptions). One type of mask functioned in one role, other masks were assigned to other ceremonial roles; and each office was transmitted from generation to generation.

The most widespread activity of such societies was the initiation of the adolescent into adulthood. In certain communities (such as the Bambara), initiation was gradual from one age group to another. Less frequent were societies for adults only (the Yoruba Ogboni and the Warega Bwami, for instance) in which members advanced from one grade to the other.

Initiation of the Adolescent. Man undergoes various *rites de passage* as he passes from one phase to another in his life cycle. None of these transitions is more important than the one from adolescence to adulthood when the young person becomes a responsible member of his society. Passing from one age group to another confers a new social status but also brings about major psychological

changes. To make this new, adult role more dramatic and binding so as to influence a man's whole life span, the African created an initiation ceremony.

Outside the village in an isolated place (in the bush, as it is called) the adolescent, together with others of his age group, underwent seclusion, the duration of which was different in each tribe. The initiate received instruction in the traditional doctrines, respect for the elders, the prescribed details of various rituals, and, in addition, learned a secret language. The initiate had to take an oath of secrecy which was a protection against degeneration or the altering of the tradition.

He had to submit to initiatory tests or trials which included circumcision (and sometimes flagellation). The neophyte had to endure this painful operation with silence to show his courage.

He underwent "ceremonial death" and "resurrection" (in Western terms)—a symbolic death of his attachment to his family—and became a newly born member of his group with a new name and a new identity. This process had two main consequences. First, it had a social significance: the youth willingly consented to pass along to the next generation the ancestral laws and customs of his tribe as the basic tenets of an integrated, communal society. This consequently influenced his formation and defined his individual existence. Perhaps one of the most important functions of the society was that it socially recognized, safeguarded, and protected the transformation from childhood to adulthood.

The second and perhaps more fundamental, though less apparent, significance of the youth's symbolic rebirth is that at an early and impressionable age he was conditioned emotionally to enter a religious (or spiritual) realm transcending his quotidian existence. As discussed earlier, this resulted in his fusion with the natural forces, his feeling of being at one with nature.

The masks used in the initiation ceremonies, in addition to embodying genii, were the abodes of the spirits of the forefathers who taught man his code of behavior. The mask which the elder wore hid his identity, enabling him to assert his authority in an impersonal manner. He *was* the Law. Hence the line of conduct derived from such a "teacher" became consecrated and firmly binding. The mask was not only an instrument of power but also an abstract symbol of law and order.

What becomes so evident and meaningful in our study of the African mask is that from early childhood until burial, it played a constant, sacred role in the life of the individual. It was an instrument without which he could not live in his culture.

Masks were used in initiation ceremonies by the Bambara (Plates 22, 23, 26, 27), the Marka (Plates 41 and 42), the Guere-Wobe (Plates 47-59), the Senufo (Plates 82 and 83), the Bwa (Plate 103), the Korumba (Plates 122 and 123), the Ibibio (Plates 132 and 134), the Ibo (Plates 140 and 141), the Yoruba (Plate 156), the Chamba (Plate 171), the Mama (Plate 172), the Bekom (Plate 174), the Ekoi (Plates 183 and 188), the M'Pongwe (Plate 194), the Bakuba (Plate 224), and the Batshioko (Plate 231).

Masks were used outside the initiation compound, after the return to the village, by the Bapende (Plate 213) and the Bayaka (Plate 217).

Adult Secret Societies. These societies had several grades, the members advancing over a period of years, each time with a great expenditure of wealth to celebrate with a feast the acquisition of a higher title. Masks were used as insignia. There are many such societies—for example, the Ogboni of the Yoruba and the Ekpe of the Ibibio, but we shall discuss only a few objects (masks) used in the Bwami Society of the Warega (see Plates 239 and 240).

The unusual feature of the ivory, bone, or wooden masks of the Bwami society is that they were worn on the face, skull, back of the head, temples, shoulders, or knees; attached to a pole or to a fence; placed on the ground to form a pile; or held by their "beards" and dragged on the ground or swirled around during the ceremony. The masks (as well as small statuettes) were indispensable implements in the highly complex, multigraded initiation ceremonies. Each mask had an intrinsic significance, maintaining a link between the living and the dead, thus promoting the continuity of the ancient tradition. The society aimed to uphold the moral codes, social relations, and ultimately social cohesion and solidarity. Each mask (owned individually or collectively) had multiple meanings, accentuated by proverbs and aphorisms, depending on the ceremony in which it played a part.

There were numerous female secret societies dedicated to the initiation of adolescent girls and the protection of women's rights. Examples are those of the Baga (Plates 2-5), the Mendi-Temne (Plates 11 and 12), and the M'Pongwe (Plate 194).

OTHER FUNCTIONS

Most of the religio-social ceremonies previously described aimed at the maintenance of the cohesion and well-being of the community. The mask, respected as embodying a spirit, was untouchable. It (and not the wearer of the mask) had the authority to enforce the law and uphold the traditional customs.

There are a number of masks which, in addition to their other uses, were known for their specific social functions. In connection with initiation ceremonies we cited the Guere-Wobe masks used by the Poro society, which was widespread throughout Guinea, Liberia, and the Ivory Coast. In addition to the elders' wearing the mask when teaching the boys the tribal customs, the masks had important roles outside the enclosure in the village connected with the maintenance of cleanliness, the proper functioning of fireplaces in the huts, the control of lightning and rain, the protection of pregnant women and twins, the diagnosis and cure of illness, and the apprehension of thieves. Masked officers acted as judges in disputes and set the local, customary laws.

Miscellaneous functions of masks in this book, cited by tribe names and plate numbers, are as follows:

Law Enforcement and Judging Disputes. Mendi-Temne (Plates 11 and 12), Guere-Wobe (Plate 56), Fang (Plate 198), and Bakuba (Plate 223).

Healing, Divination, Exorcism, Fighting Sorcerers. In many instances the medicine man and the diviner (who not only forecast the future but also diagnosed disease) wore masks to make their functions appear superhuman. They thus acquired, on the one hand, the vital force incorporated in the mask, and on the other, the suggestion of unearthly power. Bambara (Plate 23), Guere-Wobe (Plate 60), Bassa (Plate 63), Senufo (Plate 74), Bapende (Plates 215 and 216), and Basonge (Plate 220).

Protective Amulets. Baule (Plate 73), Bapende (Plate 216).

Casting Spells. Guere-Wobe (Plate 53).

Social Control and Sanitation. Ekoi (Plate 183).

Presenting Petitions. Guere-Wobe (Plate 57), Ijaw (Plate 130).

Averting Disaster; Welcoming Chiefs and Visitors. Basonge (Plate 232).

Social Well-Being and Mutual Aid. Guere-Wobe (Plate 55), Ibibio (Plate 134), and Basalampasu (Plate 232).

Fire Warning. Dan (Plate 92).

Hunting. Bamum (Plate 176).

PART TWO

The Western
Point of View

4

THE CLASSIFICATION OF AFRICAN MASKS

We have classified African masks according to their use by and meaning for the African. Now we shall classify the masks as they appear to the Westerner, by differentiating among the various forms, shapes, and sizes that show the African's inventiveness in creating an abundance of varieties of masks, and by describing the materials and tools used by the carver, his social function, the facial characteristics of the masks (Chapter 5). The tribal styles are discussed in the captions to the plates.

FORM AND SHAPE

A few examples will illustrate the various shapes.

Face Coverings. These masks were not attached directly to the dancer's head but were part of a head covering (Plate 50) or part of a costume (Plate 24).

Helmet Masks. Various types of helmet masks covered the head. Helmet masks were three-dimensional sculptures in contrast to the two-dimensional face masks.

The first type was carved from the full trunk of a tree (often nine to eleven inches in diameter) and

was hollowed out. It covered the entire head, with the rim of the helmet resting on the wearer's shoulders. Some masks had one human face (Plate 11); some, three faces (Plate 186); and some, four faces (Plate 234).

The second type covered the back half of the head like a skullcap. The front of the mask covering the face had human features (Plate 143). A variant of this type looked like a Greek or Roman casque with a crestlike hairdo (Plate 110).

The third type of helmet mask was similar to the first, but represented animals or a combination of different animals and was most frequently worn horizontally, the dancer looking through the open jaw of the animal (Plates 70, 78, 80).

Headdresses. The dancer often wore a headdress. Because a costume covered his whole body (the dancer looking through an opening in the material), he appeared unnaturally tall, in support of the belief that he was a supernatural spirit.

Plates 72 and 152 show that the masks appeared to look toward the sky.

Plate 156 shows a three-dimensional carving of a human head; Plate 202, a clublike ornament; and Plate 188, a complete human body covered with animal skin.

Plate 2 shows a different type of headdress

produced only by the Baga, the well-known *nimba* fertility figure carried over the shoulder. The second type (Plate 4) was carried over the head and, as usual, a multicolored garment completely covered the wearer.

The Senufo created a headpiece (*kwonro*, Plate 87), used by the Lo society. It consisted of a cap surmounted by a large flat board with an openwork of figures, animals, and other designs with mythological or legendary connotations.

The highly stylized antelopes (*tyi wara*) were unique to the Bambara. An integral part of this headdress is a raffia, or fiber, attachment which covered the face and often the body of the dancer (Plate 39).

Masks with Prominent Breasts.

The northwestern tribes of Yorubaland and the Fon in Dahomey used a very unusual masklike body covering. Men dressed like women in multicolored costumes wore them with the Gelede mask on their head for fertility and the exorcism of malevolent spirits.

The prominence of breasts and their association with fertility are notable in many other instances and support the thesis that a unity of various natural phenomena (such as human beings, animals, and the earth) existed in the mind of the African.

The *nimba* shoulder mask of the Baga (Plate 2) played a specific part in the fertility rites for women and the earth. The Ibo and the Dogon, as well as the Batshioko, as indicated earlier, used in their initiation ceremonies, in addition to masks, costumes to which they attached artificial breasts. The Dogons also carved exaggerated breasts on the forked posts of their resting places and on some of their granary doors, again linking the fertility of the female with the fruits of the earth. Several Bambara statues also had exaggerated breasts.

Small Masks as Amulets.

The Bapende carried small masks on cords around their necks (Fig. 216). Other tribes carried masks in their hands or garments (Plates 63, 93, and 94). The Ashanti and the Baule used gold masks as ornaments.

Masks as Insignia of Grade.

The Bwami secret society of the Warega used ivory (Plate 239) or wooden masks (Plate 240) in addition to small statues of these materials as insignia of their grades.

Crowns Made of Beadwork.

The Yoruba crown made of beadwork (Plate 161) is rather unusual. It had two faces in the front, suggesting ancestral power and at the same time covering the face of the king or chief to indicate his loss of his identity and incarnation of mythical power. The king also wore a beadwork veil (Plate 160) to cover his face, again suggesting his otherworldliness.

Other Forms.

The Benin kingdom used a brass mask as a buckle (Plate 163). The Ashanti used such masks for weighing gold (Plate 129). The Poro society often did not wear the masks but displayed them as depositories of the spirit.

Size of the Masks.

Masks varied in size. Some were smaller than the human face (Place 134); some, about life size (Plate 88); and some, many times life size (Plate 5). Masks representing animals were also of various sizes, ranging from the Guro animal mask (Plate 100) to the Senufo (Plate 78) or the Baule (Plate 71) bush-cow heads. Masks with superstructures ranged from two to ten feet in height, the tallest being perhaps the Dogon Great Mask, which was about ten feet high. Amulet masks ranged from two to three inches, and insignia masks, from three to five inches in length.

The large size of the masks permitted the carver to use bolder shapes and expressions. As the public usually saw these masks, the aim was to make them more visible and dramatic. A mask about twenty inches high would suggest a man twenty-four feet tall. The dancer appeared to be a giant embodying a supernatural force, contributing to his suggestive powers.

MATERIALS

Wood.

The largest number of masks were of wood because of the abundant forest in Africa. The carver selected the different kinds of wood with various considerations in mind.

First, the African believed that the tree as living matter was best suited to carry a life force. Second, he believed that the tree possessed an indwelling spirit. Before the tree was cut down, the woodsman often consulted the diviner, underwent purification ceremonies, and offered a sacrifice so as to appease the spirit of the tree in advance. It is reported that as soon as a Basonge had struck the first blow with his axe, he sucked some of the sap so

as to achieve a sort of brotherhood with the tree. Often after cutting the tree, he left it on the ground so that the spirit could find a new abode elsewhere. Some trees, such as the coconut, were considered sacred and could not be cut down, as they were thought to provide man with life and nourish him. In addition, in believing that the wood itself had a force of its own, the African also believed that this force was transferred to the carving and increased its power. In certain cases the use of a specific tree was prescribed for a particular carving.

The talented carver was a master technician. He had a strong feeling for the wood itself, its grain, its structural patterns. The very problems inherent in wood carving in some degree influenced, limited, or controlled the result. Often this very limitation was a challenge to the carver's ingenuity and skill, at the same imposing on him a discipline (stemming partly from the tribal stylistic tradition).

This contributed to the coherence of his work. Respect for the rhythm of the wood was often the reason for the natural flow of the shapes of his masks, but the carver never took advantage of the particularity of the grain to create superficial effects. Many years of experience had shown that such an understanding of the nature of the wood was responsible for the prevention of cracking (especially in statuary), which often occurred in the drying process. If a piece should crack, the carver took care that the crack should occur on the back of the work and not on the front.

Like the neolithic stone-axe makers, the African carver had a sense of and took pride in what was well made. His technique was of a high order. He never used his dexterity in complex work for the sake of manifesting his virtuosity but rather always at the service of a formal concept. He did not make any concessions to what may appear to us as technical difficulties in spite of the simple tools he used.

Observing the fragile, slender, curved horns and complex superstructures carved from one block of wood (instead of being attached to the masks), we must realize the carver's deep respect for the wholeness of his material—the tree trunk. At the same time his art became a document of this very natural but nevertheless disciplined dedication with which he worked according to a traditional, artistic plan. He fused together strong and expressive forms with a high degree of sophisticated inward knowledge of artistic means.

Usually fresh (green), soft wood was used because it was easier to carve. Sometimes the carver rubbed the wood with palm oil so that it would dry slowly. He used harder wood for the smaller items (such as the Bakuba cup and the very thin Dan masks) or for objects exposed to adverse weather (such as the Dogon statues, but not the masks). He used ebony only for such objects as the Benin head copies after the large bronze heads, intended for the tourist trade. Most of the masks were stained or colored with vegetable and earth dyes, and the Dan often bathed their masks in mud to color them. The carver softened the surface of the wood with leaves, animal skins, sandstone, pieces of glass, or hot irons. Often the surface shows sacrificial materials such as chewed cola nuts or blood, the blood with its vital energy increasing the efficacy and the power of the mask.

Ivory. Only a small percentage of the existing masks are carved in ivory. The reason for this is that in the past the tusks of the killed elephant usually had to be delivered to the king or chief, who used them as a medium of exchange when trading with outsiders. Exceptions are few. The Oba (Benin king), who received all the ivory, had his own court craftsmen create highly elaborate, low-relief carvings from large tusks and other ivory pieces, such as the pectoral in Plate 162. The Warega had a great abundance of elephants, which they had to kill to prevent the destruction of their plantations. However, because of the tribe's isolation they sold their tusks to the Arab traders only in the late nineteenth century (Plate 239).

The difference in style between the Warega and the Benin ivory masks lends itself to a comparison with and confirmation of what we have already advanced under "Index of Culture" in Chapter 2. Usually ivory carving, especially in the eastern countries, shows that the carver took advantage of the nature of the ivory, which lends itself to intricate carving. The majority of the objects of this type were used for secular and decorative purposes. The Benin mask, with its extremely refined features and complex row of Portuguese heads above and below the face, shows a high degree of naturalism, already a sign of decadence. But we also know that the Oba wore this mask on his ceremonial dress. A political chief considered to be of divine origin, the king thus combined the sacred and profane elements. But even if we did not know the origin and actual usage of this ivory carving, we could state with certainty that it is a reflection of the complexity of the Benin kingdom. In contrast, the Warega mask serving as an insignia of a grade

in a simpler culture, has simplified features reminiscent of the wooden masks. It impresses the Westerner with its emotional impact, in contrast to the Benin carving, which evokes in us admiration for its technical perfection.

The Bapende produced the smallest ivory mask, known as *ikoko* (Plate 216), the refinement of which is probably due to its very small size.

Other Materials. The Benin (Plate 163), Senufo (Plate 76), and Ashanti made masks of brass for use as ornaments on their ceremonial swords or as gold weights (Plate 129).

The Ashanti and the Baule (Plate 73) made small gold masks used as ornaments commemorating the spirits of the kings and chiefs killed in war.

Many tribes used knitted fabric in various forms. Plate 233 shows a Basalampasu mask made entirely of knitted material with fiber hanging from the rim. Plate 242 is a Ngabandi mask with knitted material attached to the top. Plate 246 is a mask from Zambia with the head and the neck cover made of knitted material, but the face itself made of fiber and cloth.

Plate 222 is a Basonge mask made entirely of basketwork.

Twigs and painted bark are the materials for Plate 245, a mask from eastern Zambia. The Batshioko used similar materials in their *cikungo* mask.

Beads were used extensively in the Cameroon, both for masks and to cover calabash containers, but perhaps one of the most elaborate masks with beadwork is a Yoruba headdress (Plate 161) in which not only two masks can be distinguished on the front but also several human figures and a bird, all covered with small, multicolored glass beads.

Combination of Materials. Plate 223 is the Bakuba *mashamboy* mask made of five different materials: cloth, raffia, cowrie shells, beads, and wood for the nose and ears. (This technique is comparable to the present-day system of *assemblage*, a development of the early collage invented by the Cubists.)

Additional materials, such as teeth, hair, bone, berries, vegetable fibers, pieces of metal or cloth, were added to many wooden masks. The main purpose for these materials was to increase the efficacy and power of the mask. Some examples follow. Plate 60 is a Poro society mask covered with

red cloth. Plate 54 is another Poro mask with fur. Human hair adds more naturalism to the Ekoi headdress which was covered with animal skin (Plate 183) and also to the Makonde head (Plate 243). An interesting example is Plate 50 from the Poro society. Here we see not only fiber and bells attached to the mask itself, but a whole superstructure made of fabric covered with cowrie shells and fur and forming part of the costume that covered the dancer's body.

Stone was not used for masks; only in isolated instances was it used for statuary.

THE CARVER

The young apprentice had to work under the guidance of a master carver, whom the former had to pay for his instruction for two to three years. Very often the knowledge of carving was transmitted from father to son through many generations, but often a young man was selected because he had evinced a gift for carving. He started by imitating, that is to say by carving existing prototypes, so as to learn respect for the traditional tribal style. One of the reasons for this strict adherence to style was the concept that the spirit would not recognize his abode if it were different from the conventional forms, not to mention the fact that the client often insisted on a typical carving for a specific purpose.

The carver's status differed according to local custom. Among the Sudanese people the blacksmith was usually the carver because they believed that the man who understood the fabrication of iron tools knew best how to use them. The blacksmith was often associated with occult powers, as he was able to extricate metal, a sacred entity in itself, from the earth. For this reason he was often feared. The Bambara made him live in an isolated quarter of the village.

Usually the wood carver was a professional, the exception being the Dogon dancers, who made their own masks. With a few exceptions, the carver was a respected member of his community. Among the Senufo, however, the carver belonged to the lowest caste; he lived isolated from the village, and only another from his caste could become a woodworker. In other communities the carver enjoyed great prestige and long ago worked for a fee or bartered his products. Sometimes (for example, among the Baule) a talented carver became well known, and people outside his village ordered

works from him. In the Dogon myth the carver was a cultural hero, and for this reason he often achieved a high social position, as did the ivory carvers and the bronze casters of the Benin kingdom and the wood carvers attached to the court of the Bakuba king. In other parts of Africa (especially in Zaïre) the carver was a farmer who worked off season.

To acquire the proper power, the mask or statue had to be consecrated by the priest, the medicine man, or the magician, whose profession was to serve the people by mediating between man and the spirit. This ritual consecration (often with the addition of magical ingredients to the carving) gave the mask its proper power. On an essential level the priest's incantation confirmed the belief of his client that the carving became the abode of the spirit. When a man separated himself from the statue or mask, the work had to undergo a desecration process to remove its power.

The carver was an artisan able to serve his public because he shared, he was part of, the socio-magico-religious order in which his community lived. He derived the inspirational elements from his deep conviction, his reverence for his mission to give form to an all-powerful, spiritual being, and, in this capacity, to fulfill his special social responsibility. As soon as this religious faith, the basis for his way of life, degenerated, his work, despite its obvious technical achievements, became lifeless and of inferior artistic quality.

The professional African carver became an artist for us for two reasons. First, his work showed a coherence because of his unifying, all-embracing, religious concept, and second, he had a particular endowment which we call talent. The artistic quality of each piece depended on the interrelationship of his faith and talent. In the best cases he belonged to a class of exceptional sculptors who thought directly in form. The spontaneous extension of their way of being to their labor (gestures) produced a work of art of great authenticity.

TOOLS

The most frequently used tool was the adze in various forms and angles. The carver used the same handle to charge the adze best suited to the particular shape to be carved, or he used the adze as a knife, often without a handle. When we consider that the Western carver used the adze for rough work, especially in the building of wooden boats, it is amazing that the African was able to use the adze with absolute accuracy even for small details. He used single or double-edged knives with shorter and longer handles for finer work, the long handle resting in his armpit, so that his bodily movements gave special rhythm and accuracy to the cut.

Less frequently the carver used the chip, or cross-cutting, axe for the large cuts to outline the mask. Some carvers, among the Dan, for instance, used hollow chisels mostly to carve out the inside of the mask. Some used iron tools to burn and smooth the surface or to make holes on the rim of the mask.

The carver believed each tool had its own indwelling power. Before he started work on a mask, he performed special sacrificial rituals with the tools. In some instances, when the master carver died, his best pupil inherited his tools. As the African believed that such tools also contained some of the skill of the master, a special rite was performed on these occasions.

5

FACIAL CHARACTERISTICS

Not only the forms and the materials used in masks but also their facial characteristics show astonishing diversity. But despite this variety, certain features recur all over west and central Africa because of a common ideology.

We shall distinguish masks with:

(1) Naturalistic (or Negroid) features.

(2) Idealized human features.

(3) Frightening expressions.

(4) Abstract features (semi-abstract and highly abstract).

(5) Animal features or a combination of animal and human features.

(6) Superstructures.

HUMAN MASKS

Masks with Naturalistic Features. Perhaps the most remarkable "portraits" in African art are the refined, naturalistic Ife heads. In the large body of African masks, only a limited number have decidedly Negroid features, as the intent of the African was not to duplicate observed reality but rather to provide an abode for a spirit, for which a nonnaturalistic style was most suitable.

Plate 243 is a mask of the Makonde tribe in East Africa with strong Negroid features. To enhance its natural style, human hair was attached to the head and fiber to the chin. Some Ekoi heads covered with animal skins also have human hair. Plate 47 is a Poro society mask. Plates 152 and 153 are Yoruba masks, used in the Gelede society. Plate 134 is an Ibibio mask with a movable jaw.

Masks with Idealized Features. We place into this category masks falling between the naturalistic and the more abstract masks. This category represents the next development from visual to conceptual reality. For purposes of classification we may call these types of masks stylized, idealized, humanistic images. Sometimes they have serene, spiritualized expressions. In general, the facial expressions on African carvings are rather impersonal, and they do not express any human emotion.

Three masks will serve to exemplify this style. Plate 66 is a Baule mask, Plate 96 is a Guro mask, and Plate 142 is an Ibo mask. These three masks show the change from naturalism to stylization. If we compare them with the three Negroid masks, we can see that instead of a heavy nose, they show elongated, thin noses; instead of a fleshy mouth there are slits, and the same pattern is repeated in the eyes.

The following masks within the Dan style illustrate the various trends toward stylization. They all have smooth, polished, domed foreheads and sensitively carved mouths. Plate 88 has round eyes. Plate 89 has slit eyes. Plate 90 is a rather excep-

tional mask with oval eyes. Plate 93 shows a face composed of two flat planes and, where they meet, two slit eyes. Plate 94, with a long nose continuing straight into the forehead without any indentation, two slits for eyes and one for the mouth, already shows a trend toward semi-abstraction.

Masks with Frightening Expressions. Some of the African masks appear frightening to *us*, so we use this classification to show their rich expressiveness. From the African's point of view each mask had a specific function. Although some in this category were used to repulse malevolent spirits (as in exorcism), others were considered comic and were used in plays.

Plate 57 is a Guere-Wobe mask with tubular protrusions and animal horns. Plate 55 is a Guere mask with monkey fur attached to it. The moving jaw in the dance contributed to the lifelike appearance of the mask. Plate 138, an Ibibio mask, has a distorted nose, probably in imitation of a bone disease that destroys the cartilage of the nose.

ABSTRACT CARVINGS

When we discuss the abstract quality of African art in general and that of the mask in particular, we describe how it looks to us in terms that have become current in the last five or six decades. We believe that the study of this matter at some length may give us a significant key to the understanding of the true artistic quality of African art in general, which is the first concern of the art connoisseur.

For the African the use of nonnaturalistic forms of greater or lesser degrees of abstraction was natural, as it was a spontaneous correspondence to his intention to give form to something beyond visual reality, namely to incarnate a spirit. Sometimes these forms have definite symbolic meaning or refer to mythological events. But the astonishing fact is that in spite of the African's motives for producing abstracted forms, he produced such universally recognizable configurations that we are able to "read" them, proving both the universality of human nature and that of the ability of the plastic language to convey meaning. It is also a confirmation of the thesis that twentieth-century abstract art is not an intellectual exercise but is based upon man's natural need to express his inner world in appropriate abstract forms.

Throughout history, from the neolithic period to the present day, man has created abstract art. The main trend in twentieth-century art since Cézanne, in spite of many deviations, is toward two kinds of abstraction: the spontaneous (Surrealism, for example) and the geometric (Cubism). In discussing abstraction in African art, we always refer to geometric style. To depart from naturalism, to create forms and their combinations in an abstract style, are, in fact, man's attempts to concretize his fears and cravings—as essential as they are to his existence and as intangible as they remain—emanating from his innermost self.

Abstract forms are tangible correspondences to the intangible, inner world. What was before vague and ambiguous becomes something concretely present and real. As one's inner vision has no counterpart in the visible world, it is logical for the creative individual to discard any naturalistic object as a means of symbolic expression and to produce forms and their configurations in accordance with the abstract nature of his inner image.

It was the nonnaturalistic, semi-abstract quality of African ritual objects that the Fauve and Cubist artists first recognized in Paris about 1905. A new aesthetic, a new frame of reference, which considered African carvings as works of art for their plastic structures, came into being. Apollinaire defined it very well when he stated that the artist endeavored "to create new units based not upon reality but upon knowledge." We have already applied this precept to African art. He further added: "The painting has an autonomous existence, something of its own, independent of the subject matter."

This is perhaps the very beginning of the contemporary approach to art and confirms our previous contention that we have to see the African mask as a work of art and not as a cult object, which is the anthropological approach. The true art connoisseur collects and has a communion with African art not because it comes from Africa, or because he knows in what ritual it was used, but because of its very plastic, structural quality, the ability of the coordination of the shapes and forms to stir and stimulate him. We can admire a work of art and appreciate its artistic qualities, but we enter a different realm when we expose ourselves to a meaningful experience. We do not collect objects; they only serve as an external stimulus to evoke deeply moving experiences which are our own. We collect those experiences; we endeavor to assimilate and integrate them within ourselves, and the sum

of those subtle but very important experiences enriches our existence. Only works of art of high artistic quality have a magic that makes them meaningful for us. By the proper use of plastic language they can inspire and move us to the depths of our beings. They can activate our inner resources, which illuminate our inner lives.

It is noteworthy that the abstract quality of African art has fascinated many writers not concerned with its study. Because they had no knowledge of these objects, but grasped them visually, their insights are significant.

Here are a few of their statements selected at random. Worringer, who as early as 1908 spoke of abstraction and the process of feeling oneself (*Einfühlung*) into a work of art, wrote: "The urge to abstraction is the outcome of a great inner unrest inspired in man by the phenomena of the outside world. . . . The sensation of fear may be also assumed as the root of artistic creation." This is applicable to the African, for he concretized in his carvings the very spirit he feared, and worked out a strategy (through rituals) to remove its threatening power and conjure up the spirit to protect him, using this process to dominate life and escape determinism. Rank said: "Primitive art must be abstract in order to reproduce [an] idea of the soul as faithfully as may be." (This refers to what we discussed in Chapter 2.) Camus said: "We turn to primitive arts in which stylization" [and we take this for abstraction] "is the most intense, and unity, the most provocative." Faure, the art historian, wrote: "African art is a rhythmic reality, never a description of truth." We can associate this statement with our previous description of the rhythmic nature of the rituals acccompanied by drums, imbuing the African with his special temperament. We shall show later how this was transformed into the rhythmic configuration of shapes in his carvings. Another art historian, Hauser, who was interested in the social significance of art, said: "Geometricism is connected with a tendency to uniformity or organization of stable institutions." We know to what degree the African absorbed the unity of his old social institutions, based upon a single vision of life, and expressed this coherence in his carvings. For Neumann, abstractions have a "numinous and utterly different" reality, "a reduction of the spiritual essentials of the realm of the spirit." We have seen to what degree this is applicable to African masks.

Naturalism in art is a style that imitates the appearance of things as they look at the moment from the point of view of a single observer. Consequently, it is not a depiction of what things really are but rather projections of an individual interpretation. Abstraction, on the other hand, consists of forms and shapes (with or without color) which are not copies of what is in nature. Abstractions are visible projections of what goes on in man's inner life. Because of his concentrated engulfment in the creative act and the resulting intensity of the experience, the configuration of such forms is endowed with additional vitality and meaning. Such art embodies the experience itself. It is not a symbol; it is real and alive. For this reason it is not appropriate to speak of artistic expression but rather of a state of being of the artist that extends into his work. But there are also works of art that use symbols to suggest something other than what the symbols literally represent. We can say that in contrast to the naturalistic and/or symbolic art aiming at an expression *about* an experience, abstract art *is* the direct rendition of an inner experience in the plastic idiom.

Abstraction for the African, as well as for modern man, is based upon an innate and urgent need to resolve his fears and anxieties, which he externalizes in or projects onto concrete forms. His visual confrontation with his own creation makes him believe that his inner world is real, that it has a form. The very nature—we may say, the advantage —of the plastic language in using abstract forms is that it is silent, nonverbal, on the same level as the original, unconscious experience. Although the external world bewilders the artist, if he has a special affinity for the plastic idiom, the forms and their coordination will be the carrier of an order and a stability for which man strives (even though his striving may transcend any conscious awareness).

We indicated such a process in Chapter 1 when we assumed that the original creators of the tribal prototypes proceeded spontaneously, conceptualization thus following creation.

But conceptualization is just as important. It is the expression of man's need to comprehend his experience by verbalizing, representing, or conceptualizing it. The image thus becomes the consequence in this mode of thinking. In fact, after the original model was created, it conditioned subsequent generations of Africans from childhood, eventually producing an ideology and creating the background for the function of the masks.

But the formation of concepts also evinces a need for abstraction. Concepts are by their very nature formless, hence abstract. In order to give

form to them, man had to invent correspondences for the very inner reality or internal image, something never seen, something "wholly other," as Otto called it—to repeat, something abstract.

The African carver being a conformist in his society, his work became the reflection of a communal, or collective, unconscious. If he had talent, a mysterious, individual endowment, his work would be a universally valid document of man's never-ending search for resolution.

There is a third tendency of abstraction, especially in the case of African art. This is to concentrate attention on those parts of the subject which tradition considers relevant. In the animal masks, for instance, the African used general, essential features not apparent in every animal. In another case he adopted mythological attributes or combinations of these from various myths. This trend produced one of two results: either masks of extreme simplicity or masks of great complexity.

It is remarkable that the African carver combined his spontaneous need to create with the disciplined tradition of his tribe. His work did not harden into formulas, as did, for instance, late Byzantine art, which expressed the rigid Christian dogma rather than the fervor of the Christian faith. As long as communally shared central vision permeated the daily life of the African, he produced suprapersonal imagery, which acquired its strength, its inescapable suggestibility, from the cultural dynamism of which the individual was an integral part.

As much as we believe that the structured, abstract quality in African art is its highest achievement and closest to contemporary creative tendencies, we must yet realize that the average viewer has difficulties in appreciating abstractions in art. He is conditioned to see in works of art images of realistic objects. They evoke in him associations with similar, familiar objects, and he relates them to the very subjective traces of his memory. Hence, abstraction, being unfamiliar and inconsistent with past experiences, does not fit into the conventional categories, and for this reason it is most frequently rejected. To be able to grasp the general significance of abstraction, one must suspend all preconceptions and be able to admit a new, external stimulus in order to experience a new consciousness. This process is not only applicable to abstract art forms, but in general it is connected with man's ability to grow, to evolve in the process of becoming. People with an inflexible, arrested inner development reject any newness not because

it is unfamiliar (from the root word family), but they perceive it as uncanny, and this in turn may create a sense of anxiety.

If, however, one is able to open up to the new stimulus, the nonnaturalistic (or abstract) forms may invoke undefinable experiences from the depths of man's unconscious, as it is an innate capacity of man to react to forms and their coordination. Perhaps the best proof of this is that nonliterate people whose perceptions have not yet been distorted by conventional formalism have produced abstract works with the greatest naturalness. The importance of experiencing art on this level is that it constitutes a channel by which one is able to escape the mundaneness of existence into another, vitally alive dimension, an all-important, basic part of man though it is beyond full consciousness and definition.

The Mask as Structure. It is usually admitted that forms and their combinations have emotional connotations. In order to see these combinations in their true nature, we have to suspend our familiar associations and see a mask, for instance, not as a mask representing a human being or an animal, but as a structure of forms.

The African knew this intuitively, and for this reason in his best work he was able with an exceptional creative power to imbue his forms with boldness and rhythm. This in turn evoked a vibrant sensation, a stirring pulse of vitality, and made a strong impact on the well-attuned Western viewer. This was due (in addition to other conditions already mentioned) to the African's ability to structure his work, to establish a system of relationships between the parts within the totality of his work.

The proportions of any art of high achievement endow it with a suggestive quality resulting in a configuration prescribed by a unifying principle. In contrast to the Egyptian canon of proportions or the Greek's visual precepts, the African's sense of proportion goes to the very essence of the principle of creating a configuration in his work. He did not subscribe to any canon of proportions, but the unifying principle of his world view led him intuitively to follow the very principles of abstraction adopted by various contemporary schools of art, especially in modern sculpture. This entails using masses and shapes as the predominant means of expression and coordinating them in such a manner that they have a meaning of their own because they stem directly from man's unconscious experience. (This, as pointed out earlier, is one of the reasons for

modern man's full refeeling of the essence of African art.) Each part plays its role, interrelates with and influences every other within the coherent, ordered but nonstatic, unified wholeness and compactness of the design. What emerges is the content of the art, independent of any subject matter the work may or may not represent. This means that this organization of plastic masses and shapes has a rhythmical dynamism. Such balanced totality would seem to cause the component parts to lose their identity, but they actually interact so as to maintain the general character of the whole.

What we witness is the interaction between the abstract forms as if they had a primary purpose, a sort of inevitability tending toward order. This configuration (again, with or without the subject matter) has a life of its own although its vital significance is beyond definition. This may be difficult to grasp for those who have not yet experienced communion with a work of art. This meaning is imminent; it only exists potentially as a point of orientation. Those who are able to penetrate the mystery of the plastic idiom can infer or re-experience it on a prereflective level of awareness, but what is captured within each individual remains incommunicable on an essential level.

To illustrate the inherent meaning in plastic structure, let us choose from the many systems of proportion that of symmetry. Although bilateral symmetry is evident in the African mask, this symmetry is never static. The three-dimensional mask does not reveal itself in one single vision. The small irregularities in its composition (perhaps expressions of man's frailties) result in a symmetric, dynamic equilibrium. The overall balance between the right and left sides results in a harmony and serves what is so predominant in African art— order. But symmetry has further implications. As Weyl pointed out: "It is a unifying power in the realm of thought," which is so completely characteristic of the African world view. If we look, for instance, at a Dogon mask (Plate 15) we may recall Mondrian's statement: "Geometric forms are neutral . . . express not what is the appearance of reality but the true reality and true life . . . indefinable but realizable in plastics"

Perhaps one of the most important implications of these plastic structural principles, the relationship of the parts to the whole found in the African mask, is that those who can decipher the code language of plastic art see that it actually reflects, manifests, man's relationship to the things, forces,

and ideas of his society and shows a resolution of these relationships. (This is what we said in Chapter 2 about the index of culture.)

We may recall that the African's world view was based upon a sense of oneness with the order of things which included his overall approach to life, the system of relationships to natural forces and to his fellow men. We must now relate this central vision to what we said about the relationship of the parts within the whole of a work resulting in an order, in a line with a unified existence, in a consistency of style. Consistency means that each mask has a character, much as one's handwriting has consistency and character. If, for instance, the basic idiom is the interplay of round and angular shapes suggesting tension, this particular rhythm is carried out with consistency to its ultimate unity— the wholeness of the work. We may carry this thought further to suggest that there might be a correspondence between the African's syncopated music, the dance-ritual rhythm, and the patterned, plastic structure of his art.

Ultimately, in order to understand the African carvings we must realize that the carver fused with the greatest, most effortless naturalness his way of being and his way of doing things, including the making of his masks. This is the resolution of man's search for identity, for an authentic existence means that man's Being and his existence are identical.

In order to illustrate what we have advanced, we shall discuss a few of our illustrations, which we have classified in two groups, semi-abstract and highly abstract masks. The selection also aims to show that within one tribal style there are different degrees of abstraction due partly to local tradition, partly to the individual inventiveness (within the tradition) of the carver.

Semi-Abstract Masks. To demonstrate the development of semi-abstract forms, we shall use only a few examples from two groups of masks, those of the Guere-Wobe tradition and those from the Dogon tribe. Here we shall give a fuller account of the variances in the style of both tribes.

In the Guere-Wobe group: Plate 51 is composed of triangular patterns, emphasized by the shape of the eyes, in interplay with other shapes that are round. Plate 49 is a mask carved on a flat surface with two round shapes for the eyes, a triangular form for the nose, and scarification marks on the cheeks. Plate 58 is a symmetrical composition of six horns with semicircular eyes, the

nose and mouth forming a very well balanced counterpart to the domed forehead.

In the Dogon group: Among the many Dogon masks there are two main semi-abstract designs, the triangular and the rectangular. Plate 13 is the *kanaga* mask, in which the face is composed of strong triangular patterns against which the superstructure counterposes a right-angle design. Plate 15 is composed of vertical and horizontal masses accentuated by the rectangular shape of the eyes. Plate 19 is a rather exceptional combination of angularities. The chin, the eyes and the "nose," all of the same squareness, meet a very bold curved shape (the beak of the hornbill) at the top of the mask to form a rectangular-triangular configuration.

Highly Abstract Masks. In this group we mention a few masks in which the abstract tendencies were carried to a higher degree, but in each of them human and animal features are detectable.

Plates 126 and 127 show two renditions of the same type of mask by the Gurunsi. One has square forms with two holes for the eyes and one for the mouth. In the second, the same eye and mouth formation is adopted but is more pronounced.

Plate 208, a Bateke mask, consists of a round, flat surface with different patterns.

Plate 69 is another round mask, of the Baule, with the eyes and mouth indicated.

Plate 235, a Wagoma mask, is a shield-like structure with two oval shapes for the eyes and a protruding mouth.

Plate 234 is a Wabembe helmet mask with four faces.

Plate 204, a Bakwele mask, has eyes and a nose and, on the appendage of the mask, the same eye formation twice again.

Plate 197, an Ambete mask, has an extremely elongated flat surface for the face, small incisions for the eyes, a smaller one for the mouth, and the nose continuing into the forehead without any indentation.

Plate 196 is an Adouma mask. There is only a suggestion that the upper part may be horns and the lower part a jaw or beak of an animal.

Plates 172 and 173 are two renditions of the Mama mask. We can assume that the head is of an animal (buffalo) because of the horns. The second shows more elongation of the horns (antelope) and an open jaw. The small head has two eyes carved in low relief.

ANIMAL MASKS AND HEADS

As we indicated in the Introduction, masks with animal features or a combination of animal heads and human features were common throughout the world

As early as 35,000 years ago, in the Upper Paleolithic period, human figures with animal heads (or masks) appeared on various rock and cave paintings. Gidion called them hybrid animal-like figures and observed that one of their most prominent characteristics was the indetermination between the real and the imaginary. They are, in Gidion's words, the "means to give expression to the relation with the supernatural . . . a never-ending search to give form to [man's] religious impulses." He also assumed that by taking the form of a certain animal (often considered a demon), the wearer transformed himself, not in appearance only but in essence, into another being and was able to gain increased power. Being an animal-demon, he was able to dictate what he wanted the other animal-demons to do for the benefit of man.

This description and interpretation of prehistoric man's actions are applicable in the main to the African. But, as we have already indicated, the use of masks had for the African an additional significance, owing to his belief that men and animals had the same spiritual energy (*nyama*), which was transmittable through the proper rituals. Man could also acquire certain qualities attributed to particular animals, such as the force of the lion, the vital (male) power of the bull, or the agility of the antelope. It was the oral transmission of the myths describing certain supernatural beings in the form of animals that provided the basis for the animal masks. The same tradition was also responsible for an identification, an affinity, and an alternation of personality between man and animal, establishing a mysterious link between them. This was not a bond of conceptual assumptions, but it was a primary and essential oneness, a mystical, sacred unity, an intricate system of relationships and related meaning acted out in rituals. The Indians of the west coast of Canada ingeniously realized the fusion between man and animal by creating a mask of a raven which opened by a concealed cord to reveal inside a human face mask. In general terms the animal mask became the container of a suprasensory reality (hence its abstract design). When the dancer wore such a mask, he did not act out a role, but he was the spirit

itself, and he actually underwent a transfiguration. The dancer also repeated the well-known movements of the animal (the leaps of the antelope among the Bambara), but if the mask represented an extinct or a mythological unknown animal, the dancer was unable to characterize his movements, as he was not able to observe previously the animal his mask represented.

The characteristics of an animal based upon legends and myths were manifold. It played a role in the creation of the world, and it was associated with the origin of the ancestor. But most commonly a particular animal helped the founder of the tribe in his journey to occupy the territory on which the tribes now live and also taught man some essential knowledge. One example is the dog that helped the Dogon people locate the water holes concealed by the Tellem people. The second example is the *tyi wara*, the mythical antelope that taught the Bambara people how to cultivate the soil.

This strong and mystical connection with the legendary ancestor made these animals tutelary, or guardian, spirits under whose protection human groups were formed. This had a strong "bonding" effect upon the clans, constituting a strong, socially unifying force. This alliance, however, was not totemistic: the clan or tribe did not trace its origin to a certain animal. There are a few exceptions, and we cite only the Dangbe (or Danhghwe) python cult in Dahomey with its priestesses whose union with man resulted in an offspring considered to be a "snake." One aspect of totemistic cults, however, was widely observed, namely the prohibition of the killing and eating of the guardian animal.

Another meaning of the African animal mask in some instances is again based upon the concept of *nyama* residing in the mask. It was believed that when an animal was killed, its *nyama* was liberated, and such a wandering spirit (very similar to the soul of a deceased man) might take revenge upon the hunter. For this reason a mask was made to capture such a spirit, which would then submit to the hunter's control.

We shall cite only a few examples of two classes of masks: the first representing an animal and the second, the combination of human and animal features—the latter type expressing the strong identity, or fusion, between man and animal.

Masks with Animal Features. Plate 79 shows a Senufo mask of a hyena.

Plate 80, used by the Korubla society of the Senufo, combines the jaw of the crocodile, the horns of the antelope, and the tusks of the warthog with a chameleon and a bird.

Plate 10, a mask of the Landouma tribe worn nearly flat on the head, may represent a bush cow.

Plate 97, a Guro *zamble* mask, combines the features of the crocodile and antelope.

Plates 101 and 102, both Guro masks, represent an elephant. The first shows a somewhat more naturalistic rendering; the second has ornamental elements.

Plate 172 is a Mama buffalo mask, worn on the top of the dancer's head.

Plate 174, a Bekom mask, shows a bush cow with knobbed horns.

Combination of Human and Animal Features. Plate 5 is a Baga *banda* mask. From four to six feet long, it was worn horizontally. It combines human features with those of the crocodile, antelope, and other animals, incorporating the spirit of nature.

Plate 68, of the Yaoure tribe, is a human face surmounted by stylized horns, often with an animal or a standing human figure.

It is worth noting that there are a few statues in animal form or with animal heads, such as the Senufo hornbill (*porpianong*), the Baule monkey statue (*gbekre*), some heddle pullies of the Guro and Senufo, and some crossbolts of the Bambara, not to mention the antelope heads of the Bambara (*tyi wara*) or of the Korumba, which being headgear are considered masks. A large number of this type of carvings represented supernatural beings. The poetic imagination of those who originally created the myths was not bent upon reproducing natural appearances; thus the carver was permitted a wide range of artistic fantasies. The masks of this class had the same freedom. They became bold, sometimes very large, appearing strange, occasionally monstrous, and presenting an image of creatures from out of this world.

MASKS WITH SUPERSTRUCTURES

When we classify certain masks as having superstructures, we exclude those with horns and other small protrusions.

One of the most interesting types of masks is one that has a high planklike board carved from the

same block of wood as the mask itself and sometimes pierced with geometric patterns.

In Plate 14, which is only about four feet high, the plank is similar to the so-called Great Masks of the Dogon, which often attained a height of 25 feet, although the Great Masks were generally not used in dances.

Plate 13 is the Dogon *kanaga* mask. The vertical plank is carved from the same piece of wood as the mask, but the two horizontal bars are attached to it, as are the two small flat pieces.

Plate 120 is a Mossi mask with a vertical plank and two horns. (There are also Mossi masks surmounted by a human figure.)

Plate 114 is a Bobo mask with a flat face. It is to be noted that the Dogon, Mossi, and Bobo are close neighbors, and it is possible that the use of these planks derives from a single source (perhaps the Dogon) and was adopted by the two other groups.

Another type of planklike mask was made by the Gurunsi (Plate 126) and by the Nafara. It is possible that these masks were further adaptations of the planklike concept.

Masks Surmounted by Human Beings. There are a number of these creations, but we mention only three: Plate 16 is a Dogon *satimbe* mask. Plate 152 is a mask from the Gelede society of the Yoruba. Plate 155 is a Yoruba Epa mask, which also had a superstructure in several layers with human and animal figures, some reaching 70 inches in height and a weight of about 80 pounds. Some have an equestrian figure, surrounded by a large number of other human figures.

Masks with Animals as Superstructures. Plate 20 is a Dogon mask with a white monkey on the top. Plate 18 is another Dogon mask with the beak of the hornbill and a bird on top. Plate 26 is a Bambara mask with six horns and the head of an antelope. Plate 121 of the Mossi has a bird on top. Plate 166 is a mask of the Idoma tribe with a crocodile as its superstructure. Plate 144, an Ibo mask, has four animals on top.

Masks with Other Types of Superstructures. Plate 143 is an Ibo mask with the hairdo formed into three planks. Plate 150 is another Ibo mask. Plate 217 is a mask of the Bayaka tribe; protrusions are made of twigs, fiber, and cloth.

6

TRIBAL STYLES:
A CONSECUTIVE
GUIDE TO THE PLATES
BY COUNTRY AND TRIBE

Tribal styles are discussed in greatest detail in the captions to the plates. The present brief chapter serves as a geographical guide to the plates in which some further connective information is provided. We shall use for the sake of convenience the name of the country in which the majority of a tribe lives. For instance, the Guere (Ngere)-Wobe masks can be found in the Ivory Coast and Guinea, but the majority are in Liberia. The Senufo living in the Ivory Coast, Upper Volta, and Mali are classified under Ivory Coast, as the largest number of them live in this territory.

As we already studied in *African Sculpture Speaks* (3rd ed., 1969) the location of the tribes, their interconnection with others, and their art, we strictly limit this section and the captions to the morphological study of a few masks from each tribe.

More rewarding is the illustration of the diversity of each class of masks within a given tribal style and a demonstration of the evolution of one basic plastic construction into another. We present this as evidence of the astonishing vitality and inventiveness of the individual (though unknown) carver—the very qualities which place African art at its best among the great art of mankind.

We can appreciate the inventive genius of the African carver if we bear in mind that he worked primarily under the strict discipline of a strong tribal style. In spite of this strict tradition he was

able to manifest his individuality in slight variations upon the main theme. These differences in each work are what the art connoisseur apprehends, and this, in fact, constitutes its artistic quality, provided the carver was talented.

Compared to African statuary with its columnar, closed forms, the great variety and boldness of the masks, which often had complex structures based upon various mythical and symbolic elements, is all the more obvious.

In spite of the apparent complexity of some masks, if we analyze their underlying structural components, we find shapes and masses. Among the many methods available to the sculptor, the reduction of a configuration to masses is the simplest and the strongest. The remarkable fact—and we find this in the archetypal figures throughout the history of art—is that as deep as the fundamental experience which inspired the artistic creation was, as simple as the means used by the authentic artist were, he nevertheless arrived at an understatement. (This is applicable not only to the fine arts, but also to poetry, philosophy, and, for that matter, to the simplification of equations in physics.) The understated work of art contains, or rather suggests, something that is not said. This internal secret gives it a mystery and is often the reason for its survival. One can complete, hence contribute to, something that is left unsaid. What is overexplained or overdetailed leaves no room for

imaginative participation. Although the contemplation of a work of art may appear to be a passive pastime, without this internal participation of the viewer he does not have a meaningful experience.

The geographical sequence follows, the country or area preceding the tribal names, which are italicized.

Bissago Islands (Portuguese Guinea): *Bijogo* (or *Bidyogo*; Plate 1).

Republic of Guinea: *Baga* (Plates 2-5); *Toma* (this tribe, as well as the *Nalou*, extends into the Ivory Coast and Liberia; Plates 6-9); *Landouma* (Plate 10).

Sierra Leone: *Mendi* (*Mende*) and *Temne* (*Timne*; Plates 11 and 12).

Republic of Mali:
Dogon (Plates 13-21). This tribe had over 75 different types of masks representing animals (birds, mammals, and reptiles), Dogon personages, and "strangers" (non-Dogon people). The most sacred masks, the Great Masks, ranged from fifteen to sixty feet in height. The *sirige* mask was twelve feet high. There were two main plastic groups, one cubistic with the face composed of triangular patterns, and the other consisting of vertical and horizontal masses (representing the neoplastic principle in modern art). Plates 13 and 14 are examples of triangular construction. Quadrangular masks are shown in Plates 15 and 16. Plates 17-20 illustrate the extremely large variety of Dogon animal masks representing hyenas, hares, antelopes, white and black monkeys, storks, ostriches, and hornbills, among others. In Plates 17-19 we use the hornbill to show the great variation in the same representation.
Bambara (*Bamana*; Plates 22-40). The Bambara masks show great variety in representing animals or the combination of human and animal features (horns, for example). Plate 22 was used by the Komo secret society, Plates 23-26 by the N''Tomo society, Plates 27 and 28 by the Kore society, Plates 30 and 31 by the Kono society. Plates 38-40 show the *tyi wara* mask.
Marka (Plates 41 and 42). This tribe is an ethnic group independent of the Bambara, but their masks reflect the Bambara influence, except that parts of the carvings are covered with metal sheeting.
Malinke (Plates 43 and 44).
Bozo (Plates 45 and 46). The masks of this tribe show a Bambara and Marka influence, es-

pecially in the use of metal sheeting for ornamentation.

Liberia:
The *Guere* (*Ngere*)-*Wobe* (*Ouobe*) group (Plates 47-60). Various tribes such as the Guere, Wobe, Mano, Kono, Gio, Geh, Kran, Kpelle, Bete, and Bassa produced a group of masks showing recurrent styles and patterns. Although the region extended from Guinea to the Ivory Coast, most of the tribes lived in Liberia. The homogeneity of the style is probably due to the function of a supratribal male secret society, the Poro, which maintained the religious and social traditions. Included are examples of more or less naturalistic human masks (Plate 47-50), geometric masks (Plates 51 and 52), and masks involving animal features (Plates 53-59), among which Plates 57-59 have horns.
Bassa (Plates 61-63); *Grebo* (Plate 64); *Kra* (Plate 65).

Republic of the Ivory Coast:
Baule and *Yaoure* (Plates 66-73). The Baule tribe produced several very distinct styles, illustrating our thesis that in a more personal cult (such as the ancestor cult) the style tended to be more naturalistic than that of the masks used in spirit (Goli) cults.
Senufo (*Siena*; Plate 74-87). This tribe lived in the northern part of the Ivory Coast and extended into Mali and Upper Volta. The Senufo masks can be classified in three main groups: face masks, helmets, and headdresses.
Dan (Plates 88-95). The Dan call themselves Danpome (Dan-speaking people), and they are also known as Yacouba. The Toura, Wobe, Guere, and Diula people who live in the same territory have adopted the Dan style. In fact, we should consider the Dan masks in conjunction with the Guere-Wobe group (Liberia). They were characterized by an idealized human face and a smooth, polished surface.
Guro (Plates 96-102).

Upper Volta:
Bwa (Plates 103-109). This is the northern group (Bobo-Ouele) of the Bobo tribe, and extends into Mali.
Bobo-Fing (Plates 110-119). This is the southern group of the Bobo tribe. Both groups are close to the Mossi and also have as neighbors the Bambara, Dogon, and Senufo. This accounts for many cross influences in the styles of these tribes' masks.
Mossi (Plates 120 and 121). The Mossi call

themselves Nionossi and trace their origin to the ancient Korumba tribe.

Korumba (Plates 122-125). The Korumba trace their origin to the Tellem people, the ancestors of the Dogon. The best-known Korumban headpieces represent the head and neck of the antelope.

Gurunsi (Plates 126 and 127). This tribe lives partly in Ghana, with which country they are sometimes associated. Masks similar to those of the Gurunsi were made by the Kulango and Abron of the Ivory Coast and the Nafana from there and from Ghana.

Ghana: *Ashanti* (Plate 128). It is noteworthy that despite the very rich carving and casting industry of the Ashanti they had no face-covering masks. The *Kulango* mask (Plate 129) we have placed in Ghana, although part of this tribe lives in the Ivory Coast.

Federal Republic of Nigeria (to facilitate the classification of the large number of Nigerian masks, we shall divide the country into parts):

Southeast Nigeria. On the Guinea Coast live the *Ijaw* (or *Ijo*; Plates 130 and 131); dwelling in the creeks and mangrove swamps of the Niger Delta and depending upon the river, the Ijaw developed the *imole* water-spirit mask. Their neighbors to the east in the Calabar region are the *Ibibio* (Plates 132-139). North of these two tribes are the *Ibo* (Plates 140-151). There is a close relationship between the art styles of these tribes.

Southwest Nigeria. *Yoruba* (Plates 152-161); *Bini* (Plates 162-164; we distinguish, however, between the art of the Benin Kingdom—court art—and the art of the Bini people).

Benue River Region. On both sides of the Benue River there are small tribes, the northern group reaching the Bauchi Plateau; the southern, the Adamawa region. Their masks are characterized by bold abstractions. (Although part of the Ekoi of the Cross River region also live in the southern region, the largest number of them live in Cameroon, so we shall describe them in that section.) South of the Benue we find the *Idoma* (Plates 165-167), the *Mumuye* (Plate 168), the *Jompre* (Plate 169), the *Igbira* (Plate 170), and the *Chamba* (Plate 171). North of the Benue we find the *Mama* (Plates 172 and 173). Although the Mambilla live partly in the region south of the Benue, their masks are classified under Cameroon.

Federal Republic of Cameroon (there are various areas in Cameroon where different tribes produced definite styles of their own):

Grassland. The masks of this region are harsh, sometimes grotesque, different from the usually sophisticated masks of the other West African tribes. The apparently similar style of the masks of the various tribes is probably due to a common mythological ancestor and common sacred rituals practiced by most of these people, such as the Bamileke, Bamum, Bekom, and Bamessing. *Bekom* (Plates 174, 175, 180); *Bamum* (Plate 176); unidentified tribes (Plates 177-179, 181).

The Cross River Region. This extends into Nigeria, where the Ekoi and part of the Mambilla live. The Keaka, Anyang, and Banyang in Cameroon proper also adopted the Ekoi masks. They consist of face masks, helmet masks, or whole figures carved in wood and covered with tanned animal skins, with a basketwork cap as the base for the dancer's head. *Ekoi* (Plates 182-188); *Mambila* (*Mambilla*; Plates 189-191; their bold style resembles that of the tribes living south of the Benue River); *Keaka* (Plate 192; south of the Mambila); unidentified tribe (Plate 193).

Gabon Republic:

M'Pongwe (Plates 194 and 195). This tribe and many other tribes in the Ogowe River region (the Balumbo and Bapunu, for example) have adopted the same style of mask.

Adouma (*Badouma*; Plate 196). It is remarkable that the masks of this tribe are so different in style from those of the M'Pongwe living in the same Ogowe River region.

Ambete (Plate 197); *Fang* (Plates 198-200); *Mahongue* (Plate 201).

Republic of Congo (Congo-Brazzaville):

Kuyu (*Babochi*; Plate 202).

Bakwele (*Kwele*; Plates 203-205). This tribe is known for their highly abstract face masks.

Bavili (Plates 206 and 207).

Bateke (*Teke*; the latest name is *Tsaye*; Plate 208). This tribe is known for their various statuary styles, but their masks, some of the great abstractions in African art, are entirely different.

Zaïre (Congo-Kinshasa; extending over one million square miles, this country is divisible into four main areas, the lower, middle, and eastern, and northern territories):

Lower Zaïre.

Bakongo (*Kongo*; Plates 209 and 210). This tribe made more statues than masks, but both types of products are naturalistic in style.

Muserongo (*Solongo*; Plate 211). The masks of this tribe are less well known.

Balwalwa (*Lwalwa*; Plate 212).

Bapende (*Pende*; Plates 213-216). The Bapende

have many distinct styles in their masks. Our plates include only three.

Bayaka (*Yaka*; Plates 217 and 218).

Basuku (*Suku*; Plate 219).

Middle Zaïre. *Basongo* (*Songye*; Plates 220-222); *Bakuba* (*Bushongo*; Plates 223-229); *Batshioko* (*Batchokwe*, *Tshokwe*; this tribe extends widely into Angola; Plates 230 and 231); *Basalampasu* (*Basala Mpasu*, *Salampasu*; Plates 232 and 233).

Eastern Zaïre. The masks of the Wabembe, Wagoma, and Babuye, a group of small tribes next to Lake Tanganyika, form a certain stylistic unity with an emphasis on abstract features. *Wabembe* (*Bembe*; Plate 234); *Wagoma* (*Goma*) and *Babuye* (*Babui*; Plates 235-238).

Warega (*Balega*; *Lega*; Plates 239 and 240).

Northern Zaïre. There are various types of masks in this region. Perhaps the best known are those of the *Ngbandi* (*Bwaka*) tribe (Plates 241 and 242).

East Africa (Tanzania and Zambia; the statues and masks of East Africa are rather limited in number, and most of them at present are in public museums):

Tanzania. *Makonde* (Plates 243 and 244).

Zambia. Unidentified tribes (Plates 245 and 246).

7
PSYCHOLOGICAL MOTIVATIONS

Nature culture . . . [is a] mirror which other civilizations still hold up to us . . . [to study] this image of ourselves . . . (Lévy-Strauss, 1965)

Most of the anthropological observations on the use of masks are empirical. These observations describe the masks but do not raise the question of their conscious or unconscious motivation. Mauss rightly stated that we must translate empirical reality in order "to penetrate to the more profound structural reality [of] their unconscious form . . . to uncover the underlying nature and order of events [and] the innate structure of the human mind."

We have attempted already to study the more apparent psychological motivations for masks, the specifically African principles and ideologies, and the relationships and similarities between seemingly separate phenomena (the different uses of masks, for instance).

This approach was justified because we cannot know the genesis of the particular concept behind the mask and the African institutions observed in field studies. Nonliterate people follow their tradition unquestioningly; they have their own magico-mythical reasoning, and they are not concerned with any analysis of their internal motivations.

As we do not have any information on the birth of any specific African tradition concerning the creation and use of the mask, we must return to

the general principles governing men under similar conditions all over the world at various periods in history. The basis for this comparative study is the fundamental assumption that the human species has not changed significantly in the last fifty thousand years and that all men have the same brain structure determining their cognitive capacities as well as their unconscious and preconscious levels of awareness. Motivations originating in the deepest stratum of man's unconscious are revealed only in action, and this is why Lévy-Strauss stated that what we discover in the observation of other cultures is ourselves.

All small children experience a feeling of lostness, and memories formed in early childhood, though inaccessible, may control future behavior. The feeling manifests itself in an attachment to parental figures and a need for protection to alleviate the child's sense of insecurity. Later, the same early experience also forms the basis for existential anxiety and fear. Every culture (religious or otherwise) tries to provide guidelines for a subsequent resolution of these conflicts, many of which are ambivalent. There are more basic similarities than differences between men of different cultures, climates, and historic periods.

The important difference depends upon a value judgment as to which truth—based on a central and fundamental theme or vision of the overall order of events and man's relationship to them—

51

and which events and behavior patterns a group considers to be meaningful. In the case of the African, the social value of a thing was the measure of its worth—whether it promoted the well-being of society. Whatever had social value also made the individual's existence meaningful. The social and individual values reinforced one another and were unified.

Most of the psychological investigations into man's essential nature accept the universality of his behavior and the motivations for it. Jung, who was especially concerned with this question, suggested the existence of a collective unconscious, which we have already discussed in connection with the community and ritual. Jung has demonstrated that mythical themes and plots, archetypes of the past, form recurring patterns in modern man's dreams, fantasies, imagination, and instinctive behavior. Jung stated that "the archetypal motivations presumably start from the archetypal patterns of the human mind which are transmitted by tradition and immigration, also by heredity."

The fact that despite the great diversity of cultures masks have dominated the daily life of people all over the world is already a confirmation that some universal constant is operating. Another constant, especially among illiterate people, is the use of the mask in religious rituals. Thus masks became sacred and their effectiveness unquestionable, as they were part of the ancestral tradition.

On an essential level we must ask why masks were used in religious ceremonies and go further to investigate man's need and capacity for religion. We may apply our findings to the African.

Religiosity is an élan of the soul to reach out with wonder, awe, and reverence toward the primeval causes of the natural, cosmic scheme in which man finds himself. This takes two directions, petitionary and transcendental, based upon the postulate that some higher power, deity, or spirit-entity is the cause of those happenings.

Petitionary. Man petitions a deity or spirit to grant him a wish or protection (the subject of wish projection will be studied further). Offerings and/or sacrifices (a universal practice) were made to secure results. If one gives away something of value, one can expect a return. We may say that the act of offering constituted a sort of "bribe" to induce the spirit to help, or more properly, to assure in advance by making a payment that one's wish would be granted. In a broader sense, the offering eliminated the chance element. The petition finds

its most appropriate expression in Africa in the ancestor cult. This, as outlined, is rooted in a desire for protection and is based upon the child's make-believe world in which he endows his parents with power in order to make himself feel secure. (The significance of the doll in the child's life is due to his animistic projection.)

Transcendental. The second and, in fact, the true religious élan is disinterested transcendental worship in which, in constrast to the ego-centered petitionary prayer, self-abandonment takes place in devotion. This submission to or fusion with the deity or the forces attributed to genies is redemptive, as it cleanses the worshipper of self-centeredness. This is where the mask plays its most important role. Through the mask man is able to transcend his identity. He escapes his ego-centeredness and becomes someone else by the process of transfiguration. This process, especially in Africa, starts with the fact that every mask had a name, and its features helped the participants in the rituals recognize the identity of the spirit which they believed dwelled in the mask. The mask in its ritual function was for the dancer the embodiment of the spirit; the dancer was charged with its intense force as if the spirit had taken possession of his body. The dancer entered into a relationship with ancestral, mythical, or natural forces in an attempt to establish man's position in the order of things. In some burial ceremonies, for instance, the dancer transcended his existence and entered into a relationship with the spirit of the dead.

Petitionary and transcendental religious actions do not occur simultaneously, but they are both part of man's mental make-up, and sometimes a clear distinction cannot be drawn.

The projection of fantasies and irrational aspirations (abstractions) is the basis of myth. The creative adult imagination realized its fantasies and aspirations in nonhuman, supernatural, abstract masks. Masks were a means by which man strove to transcend his existence toward the spiritual.

The wearer of the mask undergoes a series of alterations of his behavior which in turn psychologically affects his audience. A transfiguration occurs when the dancer becomes the spirit itself, fulfilling the purpose of a particular ritual. Under the disguise of the mask, the dancer is also able to escape the confines of his own self, at least that part of himself of which he is consciously aware. (An ineffectual, vulnerable person, for instance, can,

using the power of the mask which he incarnates, overcome his insecurities to become bold and aggressive.)

A more profound, existential change can also occur. By losing his inhibitions the masked person becomes what he truly is (his true identity) and not what he thinks he is, is supposed to be, or what the spirit he represents might be, and he uses this disguise to "let himself go."

In summary, in the petitionary religious act man submits to a higher power for his own benefit. In transcendental self-forgetfulness he enters a higher level of consciousness, the true state of religiosity. As Meister Eckhart said, "When you pray for *something*, you are not praying. . . ."

THE SYNCRETIC THOUGHT PROCESS AND WISH PROJECTION

To achieve the abandon necessary in religious ritual and to support the belief in the efficacy of the mask, the African utilized two kinds of "logic": a syncretic way of thinking and wish projection. Neither is unique to the African; both are part of the neural mechanism of all men. The study of these thought processes is appropriate to our search for the motivation for the African's use of the mask in rituals.

Syncretic Thought Process. Syncretism refers to man's unconscious mental ability to unite harmoniously several manifold, originally different, often simultaneously occurring, overlapping, diverging, sometimes inconsistent, concepts or relationships between things, actions, and emotions. Man establishes correspondences by drawing analogies between and making metaphors for different inanimate materials and organs of the body as, for instance, in relating rocks to the bones of a skeleton or red clay to human blood. As man is able to perceive a link between the vehicle and the content, so the existence of an immaterial spirit in the image (or mask) is evident. So also can man fuse experience and inner and external reality by neglecting the details and grasping the totality in one undifferentiated mental structure. The relationship between fear and reverence, flight and fight is that of conflicting concepts of equal value. They are all considered as interlocking, complementary qualities, held in balance by the syncretic thought process.

This apparently nonrational thought process begins in childhood and leaves indelible traces on the memory. Since the traces are imbedded in our unconscious, they are not alien to us in adulthood. In fact, under stress many of our actions, the results of unconscious (unknown) motivations, appear absurd to us. This very absurdity forces many people to seek insight into and help for their neurotic behavior.

The syncretic view is applicable to the African mask. A large number of unknown creative (artistic) geniuses in many tribes invented these masks in the remote past. This accounts for the great variety and often uniqueness of the tribal styles. The presently known examples are in all probability similar in their overall style to the originals, for the tradition forced the carver to use prototypes transmitted from generation to generation. He had to come as close as possible to the original. He was completely engulfed in the untrammeled fantasy incorporated in the tribal myths. The carver was in unison with an undifferentiated, comprehensive, total vision of the world, a result of his spontaneous and nonanalytical, syncretic mentality. He translated this vision into art, in this case, into the mask, which—as pointed out in Chapter 5—is a coordinated construction and an organized whole transcending visual reality. The syncretic mental process aimed at synthesis, unity, and order. The carver's gestures in the creative act fused vision with action and incorporated in the structure a vitally coherent, balanced configuration.

Wish Projection.

To believe in God is to desire His existence, and what is more, to act as though He existed. (Unamuno)

It is not the image we create of God which proves God. It is the effort we make to create His image. (du Nouy)

A significant ability of man—and this is again intimately connected with the mask—is his capacity to produce an unconditioned faith, a faith that hope cannot fail, a willed assent to a proposition which is known to be unverifiable. He has faith not in what he can actually observe, but in what he projects into the external world. He projects a wish which, in fact, is an idea or a concept and invents a whole strategy to make real what he wishes to be real.

A wish can be unconscious, resulting in an action, but it can also be vague without having any expression in action (one may want something

without knowing exactly what). The wish can be conscious, and this can be twofold in nature. One type is the emergence of unconscious elements rooted in the ontological being into consciousness, producing a volition and action in harmony with one's true nature. The second is the emanation from the psychological being of a motivation for an action under the illusion that the wish is authentic, though on an essential level it is a fabrication of the mind (wishful thinking) supported by wrong reasoning, i.e. by rationalization.

We are at this time concerned with man's unconscious belief that ideas (hence, creations of the mind) are real, what Freud called man's capacity for the "omnipotence of thought." This mental process can produce fantasies that result in disappointment. But what is remarkable is that the same thought process can also produce an imagination (and volition) enabling the African to believe that he can influence and control the chance element. As irrational as this may appear, he uses rationalization to fight the hazards of life. Rationalization is a thought process that occurs prior to systematic, rational thinking. Through rationalization man was able to attribute an action to a seemingly rational and credible motivation, without adequate analysis or a deliberate intellectual inquiry into the true reason. Such action based upon faith-in-hope can produce an autosuggestive sense of security (self-confidence) and can often be practically effective as a self-fulfilling prophecy. In fact, the significance of the mask was due to its becoming a "tool" for man's wish to believe that what he projected into the mask was, in fact, true.

We shall trace the individual's process of projection as it was applicable to the ritual, which was a communal acting out of a mass expression of faith.

(1) Man facing the unpredictable, external world undergoes an emotional experience, such as anxiety, for instance, which is rooted in his infantile insecurity. To escape from this unconscious, free-floating state, man transforms the emotion into fear. This serves to replace the unknown with a known or imagined cause.

(2) The process of knowing something involves formation of the concept (a frame for one's fear), which in Cassirer's definition does not "express the nature of things but the nature of the mind." The African attributed the cause of fear to a specific spirit (appropriate to the circumstances). By naming it, he raised it to the domain of reality. The Asiatic civilizations (see Introduction) personalized the unconscious force as a demon or devil

(at least such Western terms are used in descriptions) embodied in the mask. The process of exorcism with the aid of the mask clearly points to our modern concept of the neurotic working of the unconscious and is comparable to the practice of relieving man's psychosomatic ailments with a placebo.

(3) The unconscious is externalized in a concept (making the unknown known). The next step is to localize and concretize the known by believing in spirits in order to deal and cope with it as a concretely present reality. The mask or statue becomes the container of man's wish.

(4) Having made tangible the intangible concept, having put the formless into form, or having created an image of the imageless, man then activates the mechanism of faith. It produces its own mental construct, namely the concept of the existence and vital influence of the spirit upon the individual and his community's destiny with its redeeming effect upon each and all. (Suzuki formulated this process well: "It is not God who gives us faith, but faith that gives us God.") This faith is at the very basis of the African's existence, the basis of his openness to grasp what may appear to be irrational as an experienced, intuitive truth. This in turn helps him to order and resolve his existential problems.

The process reduced to its simplest terms is the following sequence:

EMOTIONAL ⟶ CONCEPT ⟶ CONCRETI- =
EXPERIENCE ZATION OF
 CONCEPT
(anxiety) (spirit) (carving)

FAITH IN ⟶ CONFRON- ⟶ REASSURANCE
THE TATION OF
CONCEPT THE CONCEPT (emotional
(animism) (ritual) experience)

The process begins with an experience by which man becomes aware of the mysteries of external reality and his place in it. The process ends with man's having found a *modus vivendi* with the same external conditions which started the process. The mask, for the African, was a focus, an indispensable tool without which the process could not be effective. But ultimately there is nothing but the creation of the human mind.

As the quality of the projected wish is of great importance, a distinction between ontological and psychological motivation becomes paramount. The

nature of the wish depends upon the depth of man's unconscious and the urgency with which the wish emanates from it. The wish for success or material reward, for instance, can become a psychological overcompensatory projection. Although it can be strong because it stems from insecurity, nevertheless it aims at self-aggrandizement. In contrast, the wish to concretize in a sacramental object a mystical experience generated by an intuitive attunement with the order of nature is a more direct, we may say primary, projection originating in ontological-spiritual knowledge, and, importantly, not in the self-conscious personal self which is part of one's complex psychological make-up.

This is an important consideration for the art of any period. Assuming one has artistic talent, if the need to create originates in the depths of one's unconscious, there is a basis for an authentic work of art. This means that creativity is not connected with sublimation, but that artistic creation occurs in spite of neurosis.

The African's individual transcendence acquired an additional dimension because he participated in a communally shared, sacramental, otherworldly experience. That means that what he experienced was supported or confirmed, hence elevated to a higher level of certainty. The mask became not only a tool, but a sacramental object. If a man who undergoes such a mystical experience is an "artist," a person with a special endowment for using artistic language for communication, in this egoless state he can (by means of his carving tools) project into coordinated shapes the same spirituality that guides his life. The essential condition for realizing a state of ego-forgetfulness in both religious and creative activity (or any other field, especially scientific research) is that one feels the subject to which he relates or the process in which he is engaged to be more important than the I-self. The process is its own reward; the result which one may or may not achieve is only a by-product. It is not the reaching of the peak, but the climbing, that matters.

To use a metaphor, we can say that the carver becomes the means (medium) through which an immaterial spirit is materialized (we may say "spiritualized") in the mask. (The sculptor Lipchitz once said that God guided his hands in the creative act.) On an essential level the creative act is man's preconscious and unconscious projection stemming from the very ground of his Being, transcending his conscious state.

We are dealing here with four unknown (we may say mysterious) capacities of man. (1) He is able to reach beyond himself, and the very energy with which he reaches "illuminates" the object of his projection (the work of art). (2) He can create a coordination of shapes which permits the concretization of a concept of superhuman power. (3) The object (his own creation) is able to illuminate him and all those who participate in the sacramental ritual. (4) A plastic structure created under these conditions has the capacity to stir us emotionally.

In summary, the African experiences the existence of the spirit as real because of his unshakable faith in his projected wish or idea, which the mask incorporates. We are dealing here with a reciprocal action. The mask could not be created without the initial wish projection, but the wish could not work as an autosuggestive, self-fulfilling prophecy if the initial act (as spontaneous as it was for the African) were not concretized by artistic means which, in fact, gave the mask its suggestive power.

The intensity of the psychic power projected from the depths of human experience into the mask influences our relationship to the mask. The African depended upon his carved object (although it was his own creation) because his unconscious conditioning was more powerful than his conscious will. The carver underwent an overwhelming, all-embracing emotional experience which surpassed our ability to identify it. But this process resulted in art imbued with spiritual energy. If, for instance, fear and the expectancy of wish fulfillment through the spirit embodied in the mask produced tension, the interplay of round and angular shapes on many masks suggests to us, too, a tension created by sheer plastic means. This, however, is an oversimplification, for if we are properly attuned to the universal plastic idiom, we can identify this tension in our unconscious, which stores the archetypal correspondences. The power of the structure of a coherent whole (the mask) is such that it is able to elucidate emotional reactions, to disclose the authentic self which one hides or represses in one's unconscious.

The mask with its powerful expressiveness becomes an external stimulus that works like a catalyst, enabling us to experience the same process of becoming aware on a preconscious level of the existence of archetypal images within us. The true experience is self-revelation which is beyond definition. This fact is valid for our encounter with the art of all the different periods and civilizations. If the initial creative impetus (assuming it is in the

hands of an authentic artist) is deeply experienced, the resulting plastic structure will convey this involvement, and it will have a stirring effect upon the observer. If the impetus is less authentic, the work will be superficial and our reaction will be less profound.

THE MASKED MAN
WITHOUT A MASK

Although people are apt to talk today of the "image" of a man, a corporation, a public figure, still they do not fully realize that what is presented to them is not "real" but an image fabricated by professionals using techniques to make them believe in it. The image of a personality, like any consumer good, is fabricated, packaged for merchandising, and projected for the effect or result it may produce.

This process has a devastating effect on the average man in his daily life. He is conditioned to think that this image is the real and ideal one he is supposed to emulate and toward which he must strive as society (or his family) expects.

To play a role, or play-act, unconsciously or consciously is to wear a nonmaterial mask which Jung called the persona, the Latin word for mask. (Sartre and Genet have shown dramatically that this play-acting is the result of a lack of identity.) As man imagines his counterfeit identity, he can change from one personality to another, confusing reality with imagination. The confusion is so great that when a man "loses face," he feels ashamed or, more precisely, he experiences a deep sense of anxiety, not because his adopted identity was not acceptable but because he becomes aware of having no identity.

This nonidentity is a void, the result of nonfunctioning, or of repressing one's true self. Man tries to become somebody who he is not. But since this is impossible, he becomes nobody.

To be as one is, to act as one is, means to have an identity and an authentic existence. But to manipulate oneself, to wear an image-mask, means also to live according to unauthentic values, ideas, and ideals. Man must play a role according to the rules of the game of the materialistic, status-conscious society that distorts human values by attaching them to success, objects, wealth, or social position and suppressing all innate aspiration,

producing the most widespread contemporary crisis, the crisis of identity, the problem of who each individual truly is. The pragmatic necessity for results ("the bigger, the better") has replaced the belief in the act for its own sake wherein the reward or satisfaction of self-realization has its own internal value.

The real human tragedy occurs when the image becomes so strong, often exaggerated by overcompensation, that the individual is not conscious of the fact that his true self is not identical with his persona-mask. He is under the delusion that the face he puts on is really himself. Being a no-person, he becomes extremely vulnerable and suspicious because of external pressure. He becomes vaguely aware that he plays a counterfeit role; he is unable to abandon it because he is unable to face the emptiness of nonbeing. Through an intricate rationalization he convinces himself that he can cheat in his interpersonal relationships, but actually he does not realize that he is cheating himself out of an authentic existence. That means that he is estranged, not only from any true human contact (one who does not love himself cannot love others), but mainly from the roots of his true self. This situation is beyond his comprehension and control. Because he is unable to fall back on his inner resources, he experiences a void. Suffering from an intangible, often intolerable, malaise, he tries to escape from his despair into hyperaction or mind-blurring addiction. This is what we mean by a state of nonbeing. It is not actual death, but worse, the slow death of one's inner self, causing existential anxiety, a feeling of having wasted one's whole life, and at the same time of having neither the energy nor the time to reexamine one's situation and begin one's existence again. The person realizes—and this is the internal death—that he never acted, felt, or thought as he is and that he has become one of the "hollow men of the wasteland" (T. S. Eliot).

In Africa the wearing of the mask was a conscious, socially sanctified act, permitting man to transcend the confines of his ego-centeredness, enter a higher realm of consciousness, and resolve his existential problems.

The Westerner wears a "mask" for unconscious reasons to hide his insecurity, to reinforce by false means a "fake" identity. By living a fragmented, alienated existence, he enlarges the schism between who he is and how he acts, blocking all attempts to resolve his existential problems. He suffers the agony of nonbeing.

THE PLATES

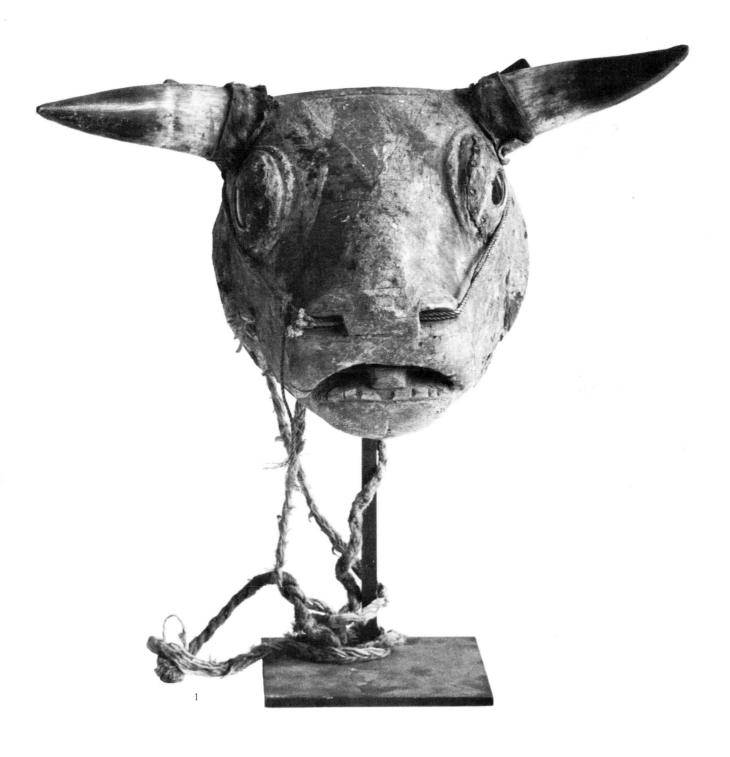

1 *Bijogo, Bissagos Islands, Portuguese Guinea, 36".*
The mask represents a buffalo (*ja-re*). The eyes are made of pieces of glass, and real buffalo horns are attached.

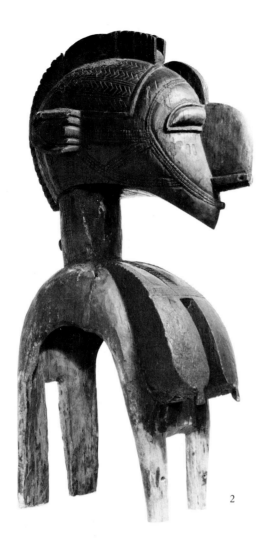

2

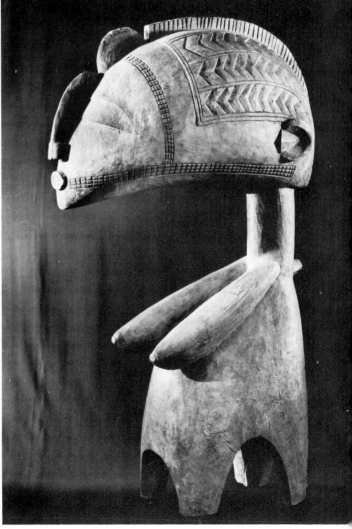

3

2 *Baga, Guinea, 50".*
This is a *nimba* fertility figure, one of a group of masks from
three to six feet tall which were carried over the shoulder.
The exaggerated, pendulous breasts are typical of this group
of masks, which had a double function: sterile women in the
Simo society invoked it as a goddess of fertility, and it was
used at the first-fruit (rice) rituals, symbolically associating
female fertility with the increase of the grain.

3 *Baga, Guinea, 38".*
Another *nimba* shoulder mask.

4 *Baga, Guinea, 33".*
This mask, a *nimba pefete*, with its emphasis on the breasts,
was also associated with the fertility cult, but the dancer
carried it high above his head in the young girls' initiation
ceremony.

5 *Baga, Guinea, 40".*
This *banda*, or *boke*, mask is one of the large masks (from four
to six feet long) worn horizontally by the Simo society,
which considered them symbols of a higher rank. It shows
the prominent jaw of a crocodile, a human "face," and an
elaborate rendition of antelope horns for the superstructure.
In addition to its use in the general fertility rituals of the
Simo society, it also played a part during the dry season,
after the rice harvest, and at funerals.

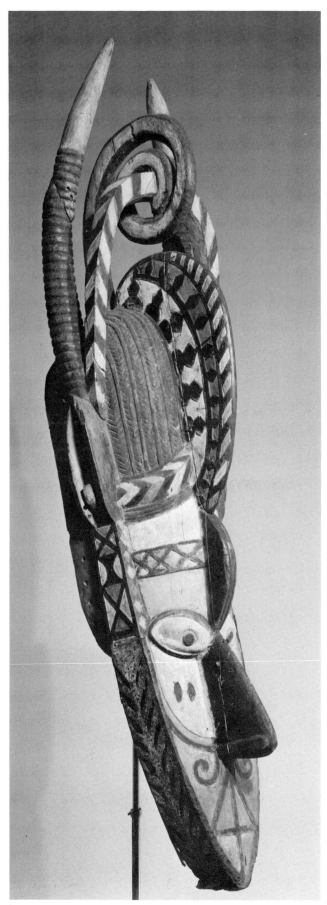

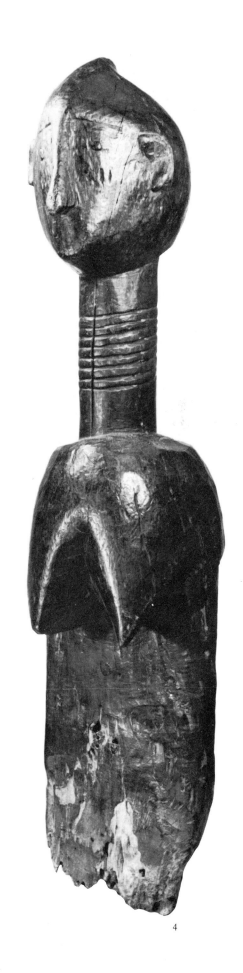

5

4

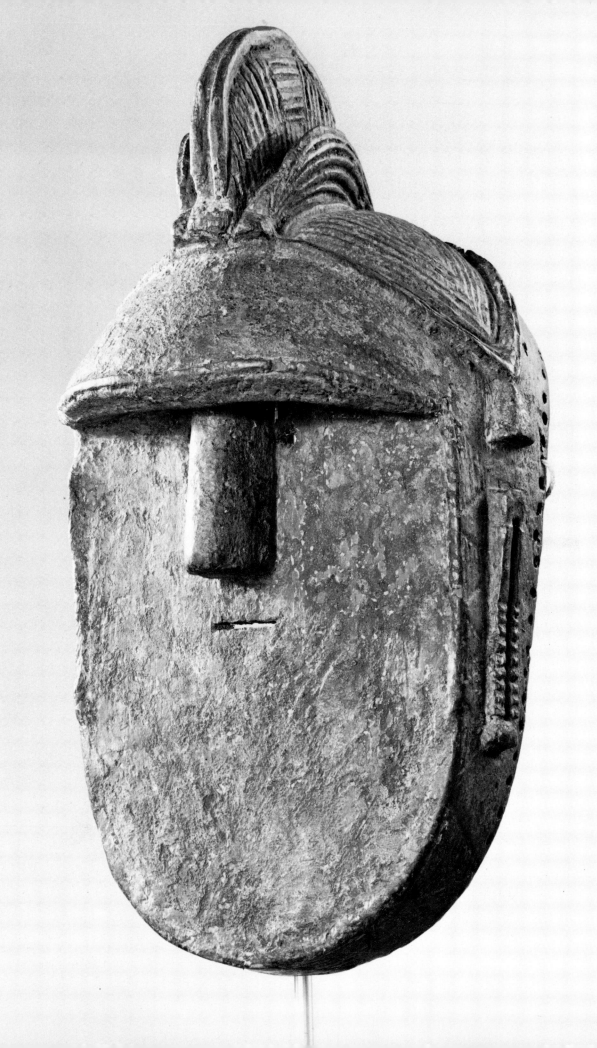

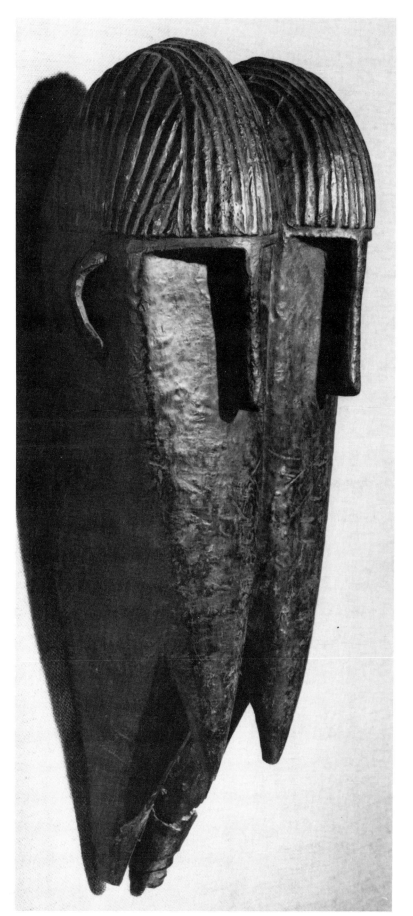

6 *Tomo-Nalou, Guinea, 19 1/8".*
This is the most typical of the *landa*
masks, composed of a flat surface with
an angular nose and a domed
forehead.

7 *Toma, Guinea, 21".*
Similar to the preceding, but with a
double face. The Vienna Museum at-
tributes this to the Baga.

6 7

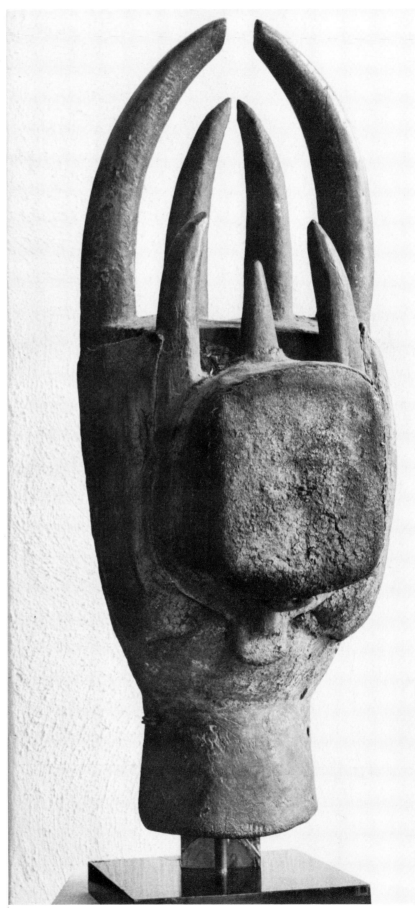

8 *Toma, Guinea, 29".*
This type of mask ordinarily had a flat surface and multiple horns. An unusual feature here is a reliquary, containing the remnants of ancestors' bones, attached to the forehead of the mask.

9 *Toma, Guinea, 27".*
This mask has a flat surface but tends toward concavity. Two horns protrude from the forehead. It is ornamented with incrusted beads and has a patina of sacrificial blood. It combines animal and human features to represent a mythical hero.

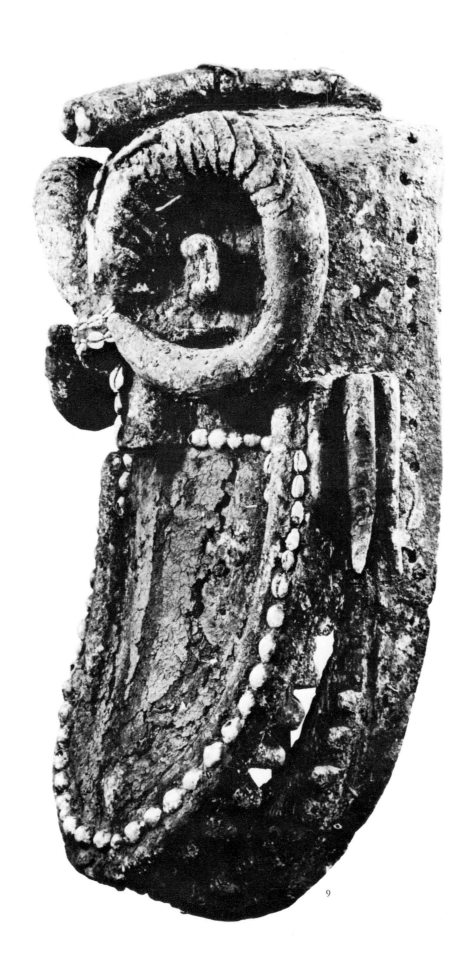

9

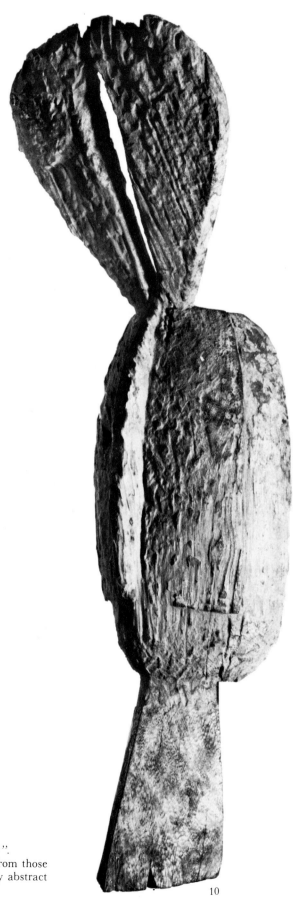

10 *Landouma, Guinea, 15½".*
A mask entirely different from those
of the Toma, with a highly abstract
beak and horns.

10

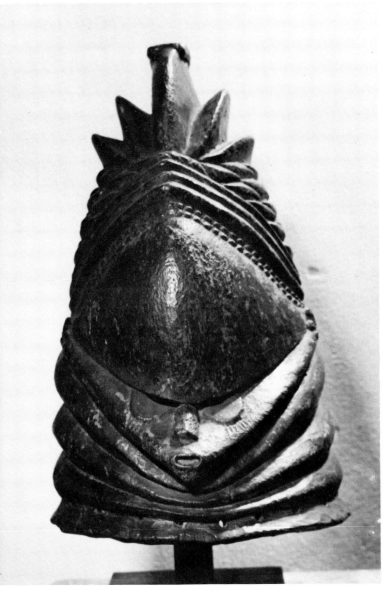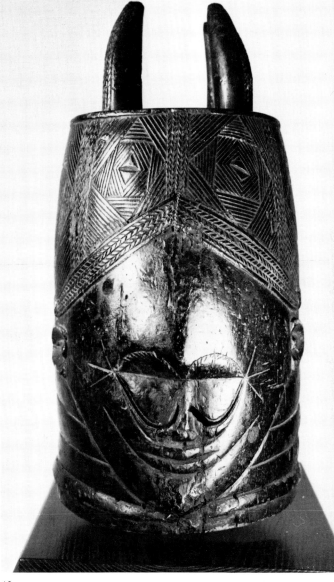

11 12

11 *Mendi-Temne, Sierra Leone, 15" (diameter 9").*
Both the Mendi and the Temne used helmet masks known as *min* (spirit) in their Bundu female society, as did the Sande society of the Vai and Bassa in Liberia. These helmets were carved from the full trunk of a large tree. They were worn over the head with the rim resting on the shoulders. There are helmets with one, two, and four faces. A collarette made of fiber was attached to the rim, and a costume covered the whole body, including the hands and feet. These were sometimes described as "devil" masks. The role of the Bundu was to educate girls at the age of puberty for their roles in society (as wives and mothers mainly). Officers of the society wore these masks to protect the women of the tribe. They also wore them when arresting violators of the Bundu laws and taking them before the chief to be fined. This plate shows a typical example with a large forehead, a conical hairdo, a depressed face, and rings of fat below.

12 *Mendi-Temne, Sierra Leone, 15" (diameter 9").*
Another version with four horns. The design on the face follows the curvature of the eye slits.

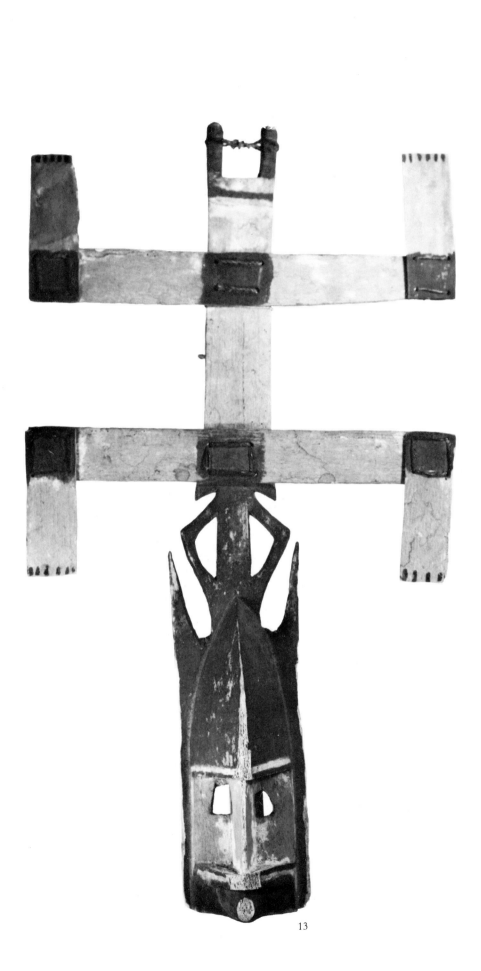

13

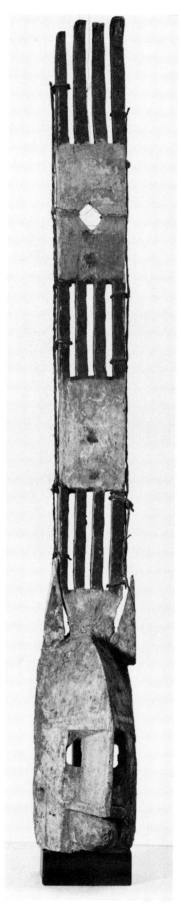

14

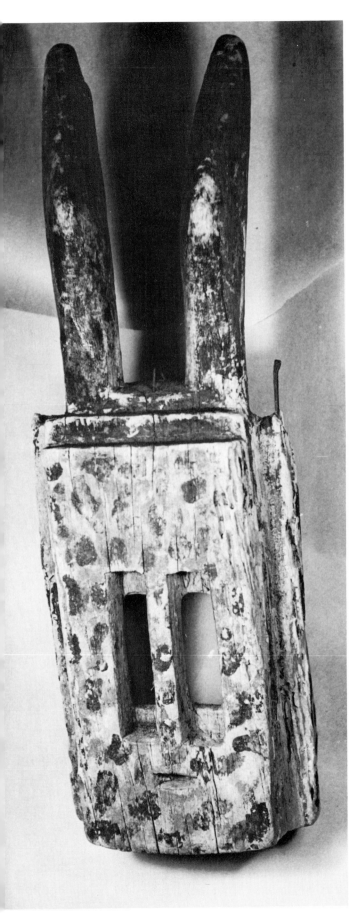

13 *Dogon, Mali, 37".*
This is the *kanaga* (bird) mask, the face of which is triangular in structure. The cross-of-Lorraine type of superstructure actually represents the outstretched wings of a mythical bird, the *kommondo*. The triangular shape on the face of the mask is the upper jaw of the bird, and the conical form below is the tongue. (According to certain myths, the superstructure was "the hand of god.") The two small figures at the very top represent the first human couple to which the Dogon traced their origin. (Similar couples appear in Dogon statuary.) Members of the Awa society wore these masks when dancing on the roof of the house of the deceased in order to lead his soul (*nyama*) to its resting place, and at the same time to defend the survivors from the harm a wandering soul might inflict upon them. After the ceremony they considered the deceased man an ancestor. The masks were also worn at the end of mourning and on anniversaries of deaths. (At the present time dancers performing with the same type of mask provide entertainment for tourists, especially in Sanga.)

14 *Dogon, Mali, 47".*
This is the *ammata* mask, with a plank-like superstructure, similar to the so-called Great Masks, which were considered the most sacred. The superstructure symbolized the means by which the mythological hero descended to earth. Masks of similar construction are also known as *sirige.*

15 *Dogon, Mali, 23".*
This is the *wilu (walu),* an antelope or gazelle mask with two horns and a boxlike composition for the "face." The Dogon associated this mask with the first animal they killed in the days when they were hunters, and, by extension, with their first ancestor. They used it in funerary "plays" and cyclical agricultural rites.

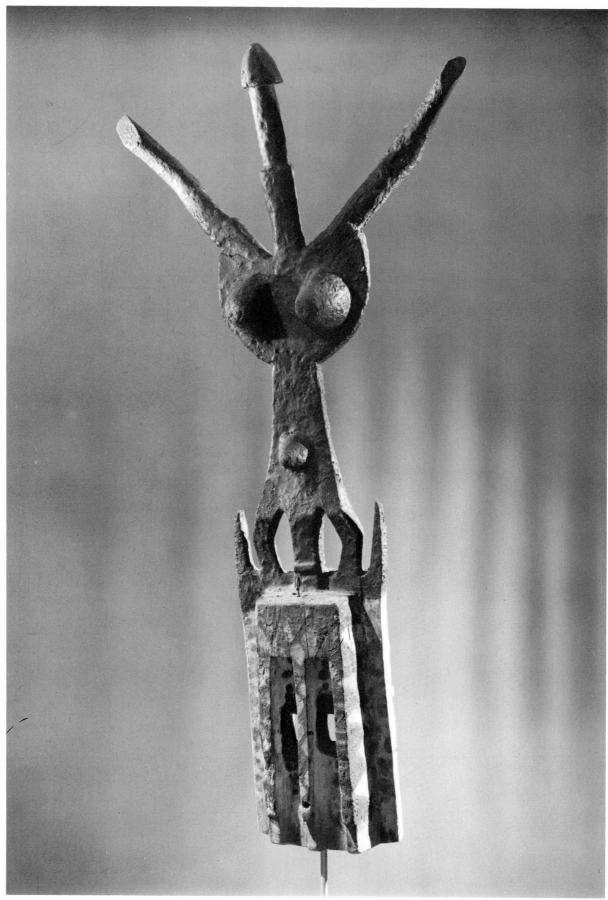

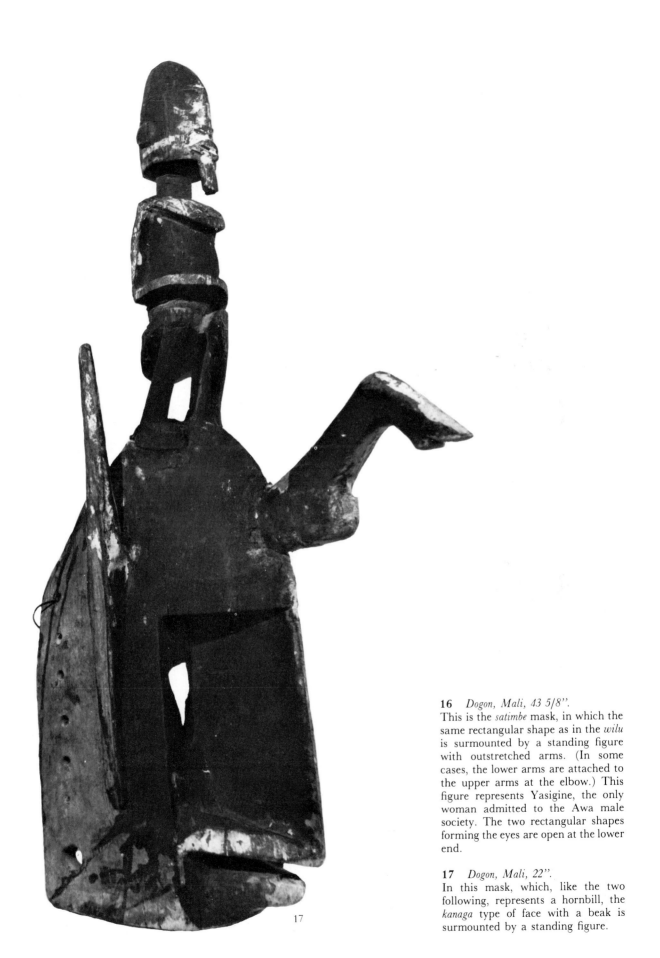

17

16 *Dogon, Mali, 43 5/8".*
This is the *satimbe* mask, in which the
same rectangular shape as in the *wilu*
is surmounted by a standing figure
with outstretched arms. (In some
cases, the lower arms are attached to
the upper arms at the elbow.) This
figure represents Yasigine, the only
woman admitted to the Awa male
society. The two rectangular shapes
forming the eyes are open at the lower
end.

17 *Dogon, Mali, 22".*
In this mask, which, like the two
following, represents a hornbill, the
kanaga type of face with a beak is
surmounted by a standing figure.

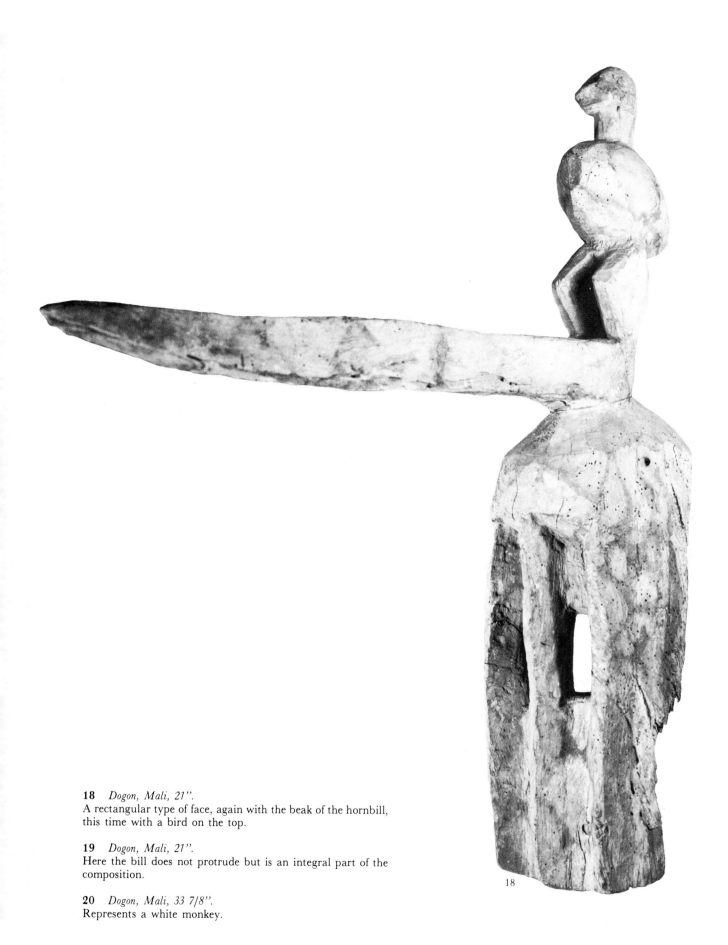

18 *Dogon, Mali, 21''.*
A rectangular type of face, again with the beak of the hornbill,
this time with a bird on the top.

19 *Dogon, Mali, 21''.*
Here the bill does not protrude but is an integral part of the
composition.

20 *Dogon, Mali, 33 7/8''.*
Represents a white monkey.

18

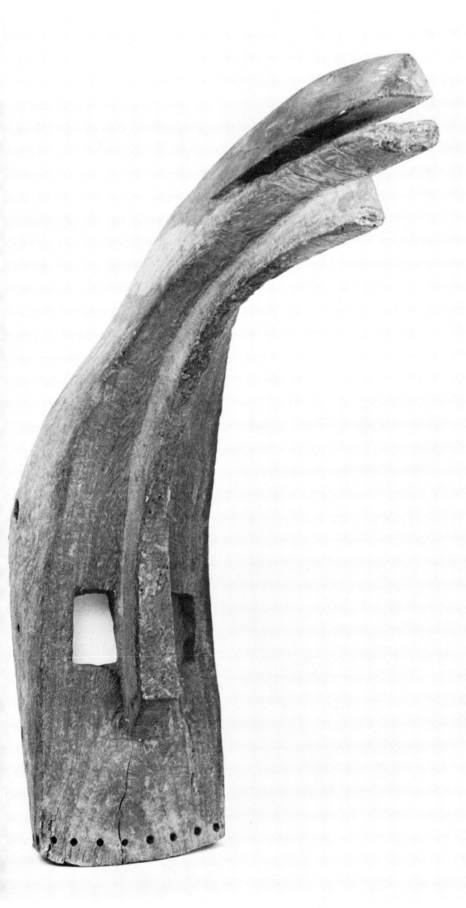

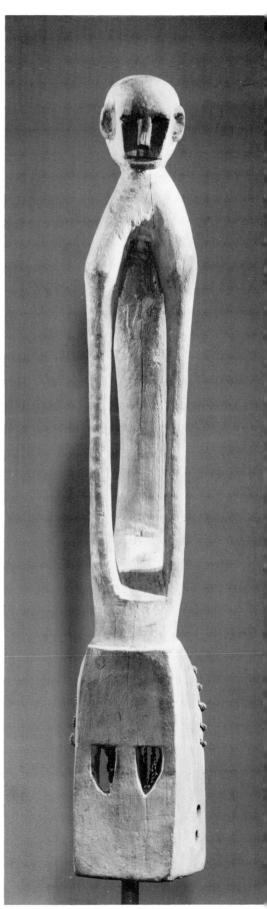

19 20

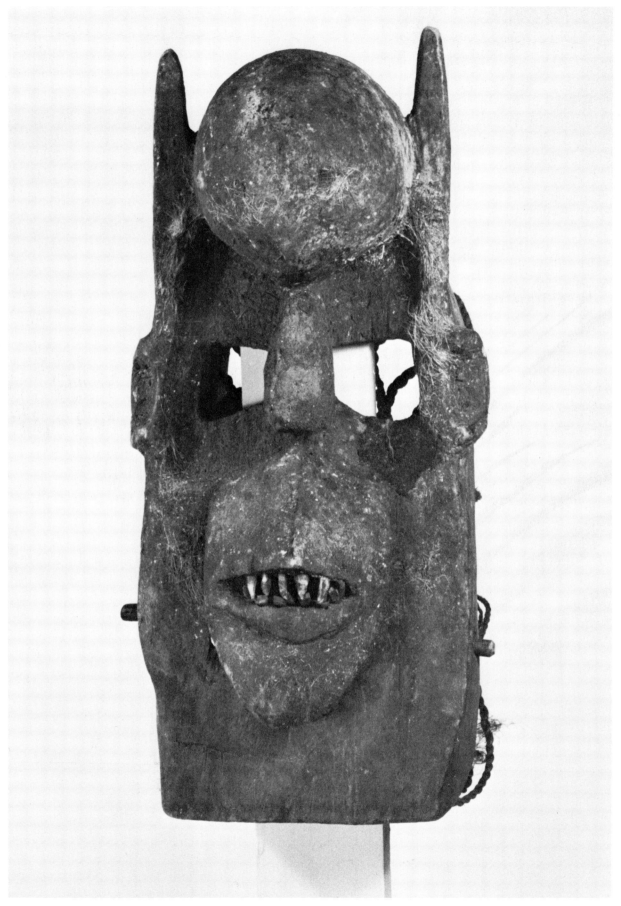

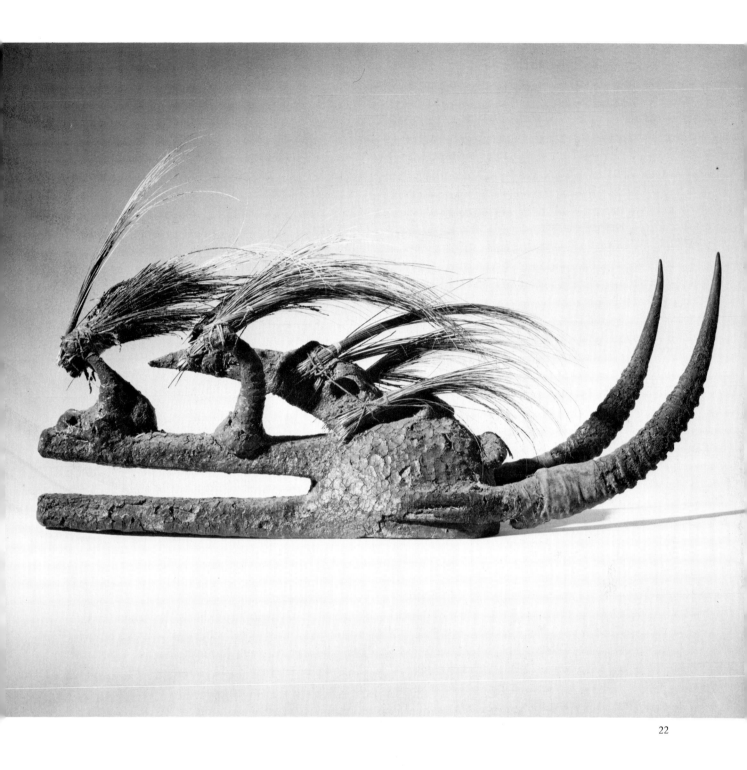

21 *Dogon, Mali, 14".*
Represents a personage known as "the hunter," with bulging forehead and with animal teeth inserted into its mouth. Sacrificial patina.

22 *Bambara, Mali, 33 3/4".*
This is a cap-like structure worn horizontally by the Komo (adult society). It was made with mud, porcupine quills, sacrificial blood, and various other materials. The mask symbolized heaven, earth and the waters. The Komo, the most powerful of the Bambara societies, had the authority to enforce the law.

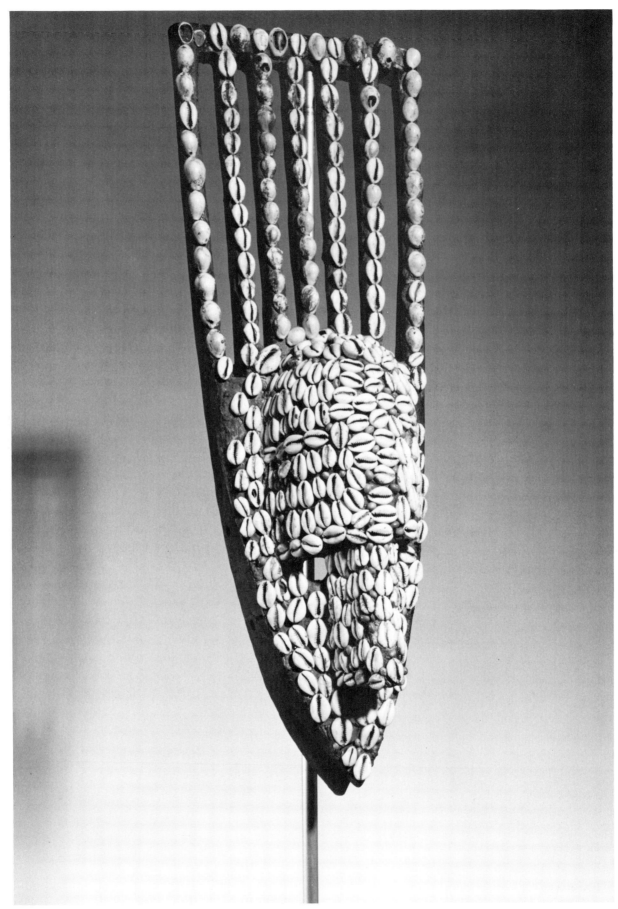

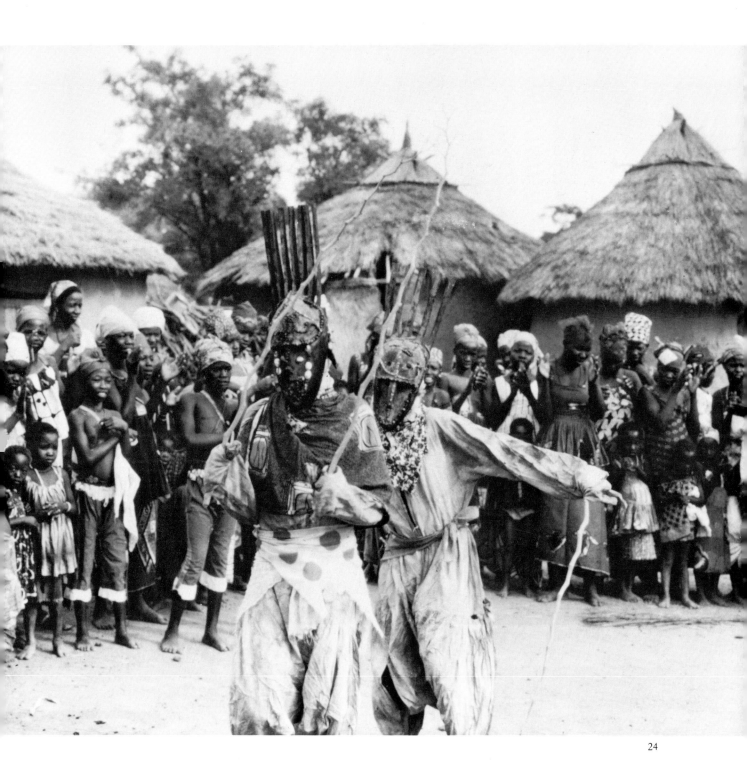

23 *Bambara, Mali, 23 5/8".*
A mask of the N'Tomo, a male society of grades based on age.
This shows a human face with several horns. Cowrie shells and
often beads or dried red berries covered the mask and horns.
The mask was also used at agricultural festivities, in communal
work and to prevent illness.

24 *Bambara, Mali.*
Two dancers with N'Tomo masks.

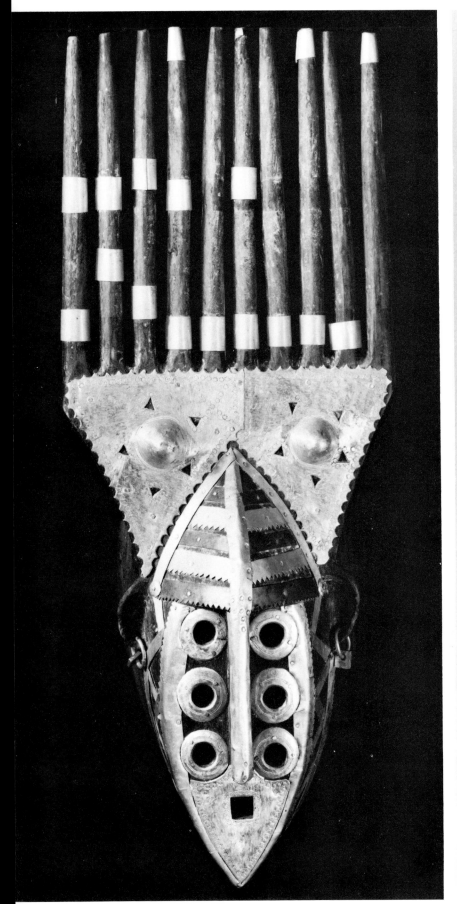 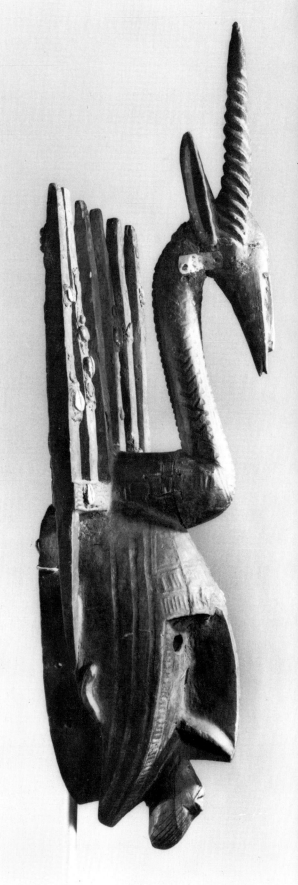

25 26

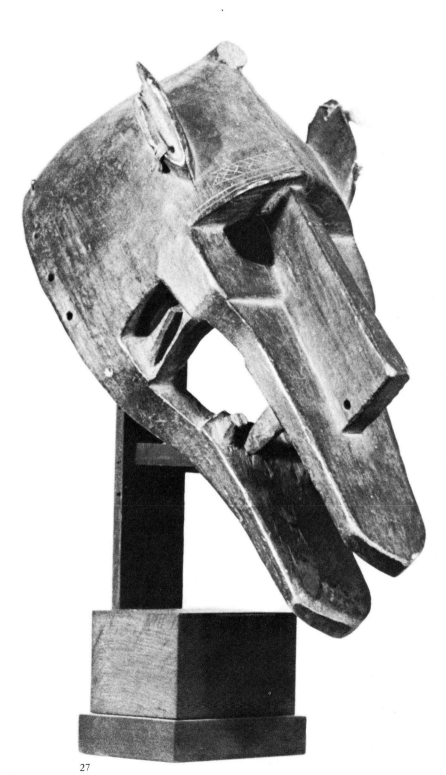

27

25 *Bambara, Mali, 23".*
The same type of mask as the preceding but of more recent origin. It has ten horns adorned with aluminum sheeting; an incised design; and three pairs of eyes framed by metal rings.

26 *Bambara, Mali, 29".*
The second type of N'Tomo mask: a human face with a superstructure composed of the head of an antelope (sometimes a standing human figure) and six horns. Such masks were used mainly at the end of the initiation ceremonies.

27 *Bambara, Mali, 18½ ".*
A hyena mask used by the agricultural Kore society; the hyena was the society's guardian animal. A hemispherical forehead and a flat face with a long, angular protruding nose characterize this type of mask. It was used both at initiations and at agricultural festivities, in supplications for the fecundity of the earth and sometimes for rain.

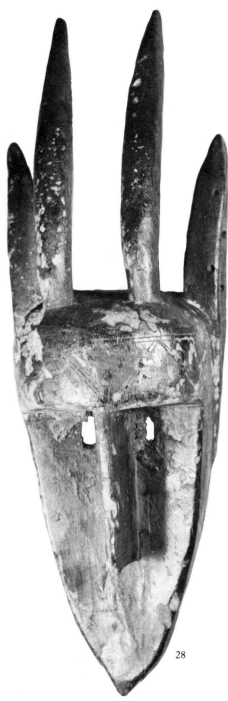

28

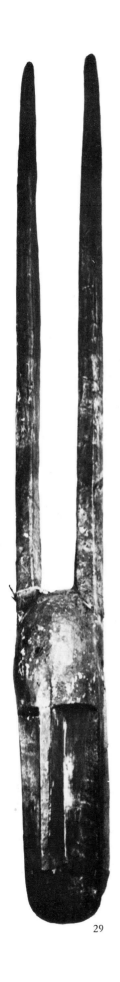

29

28 *Bambara, Mali, 20½ ".*
Another version of the preceding, with horns and ears.

29 *Bambara, Mali, 33".*
An extremely simplified type of mask with two long horns.

30 *Bambara, Mali, 35".*
A large animal mask with a long, open snout and a forehead having a protrusion made of sacrificial material. It was worn horizontally by the Kono soceity in their rituals for a good harvest.

31 *Bambara, Mali, 24½ ".*
A different rendition of the Kono mask, embodying the domed forehead and the angular nose of the Kore masks.

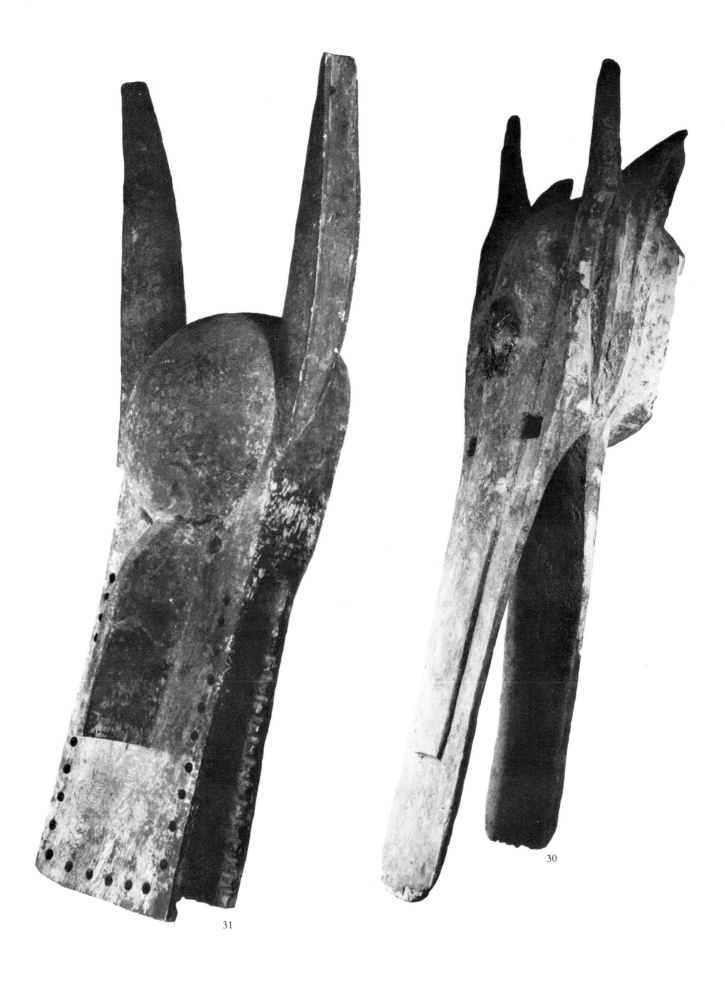

31

30

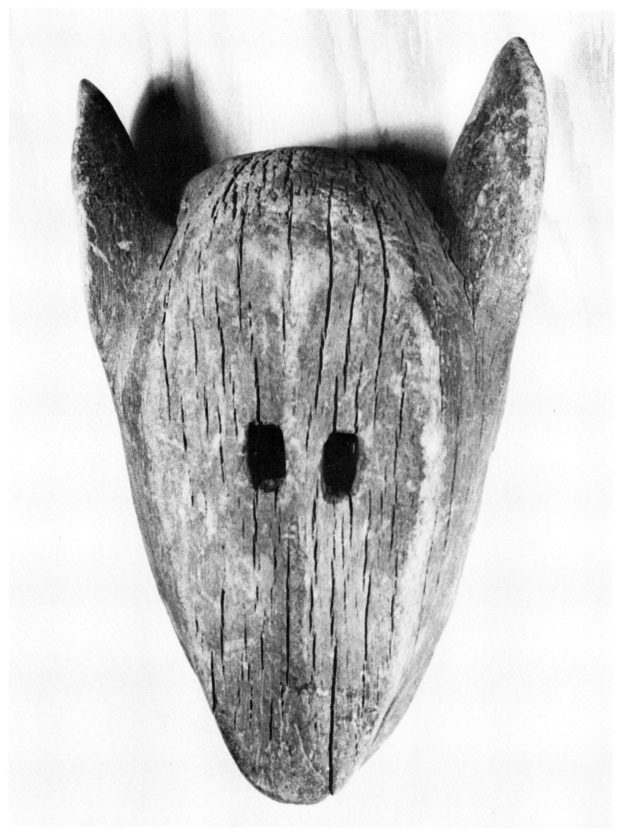

32

33

32 *Bambara, Mali, 12½".*
Probably represents a monkey. Extremely simplified, the
face has two holes for eyes, and there is no indentation
between the nose and the forehead.

33 *Bambara, Mali, 15¼".*
Another monkey mask, with more human features.

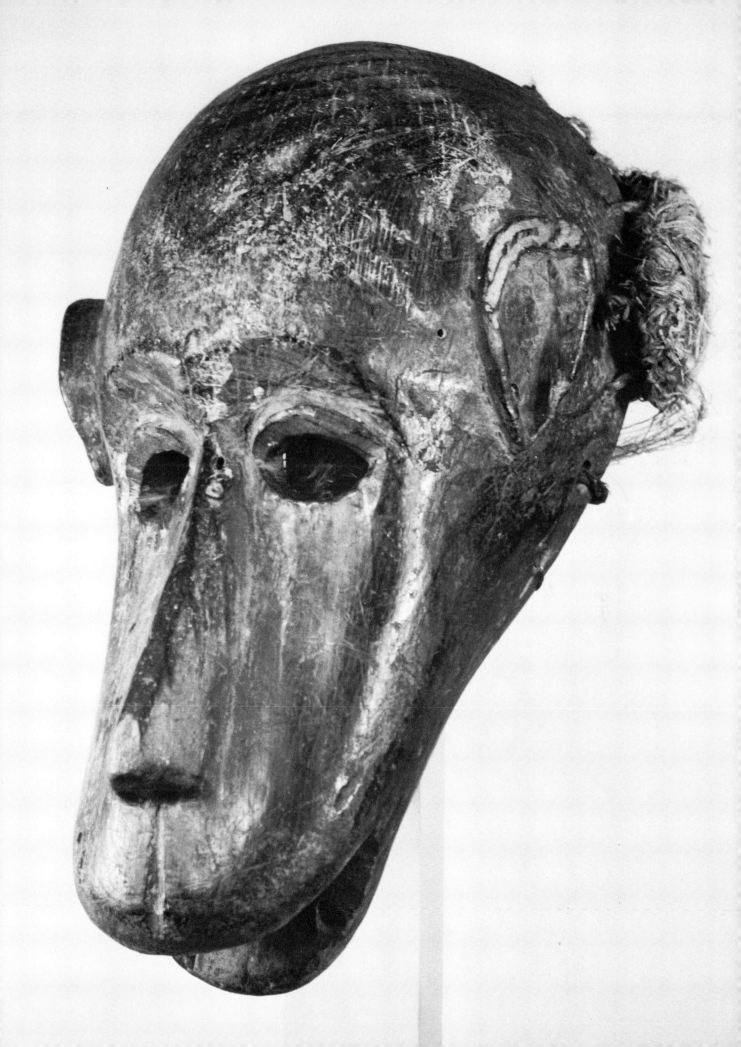

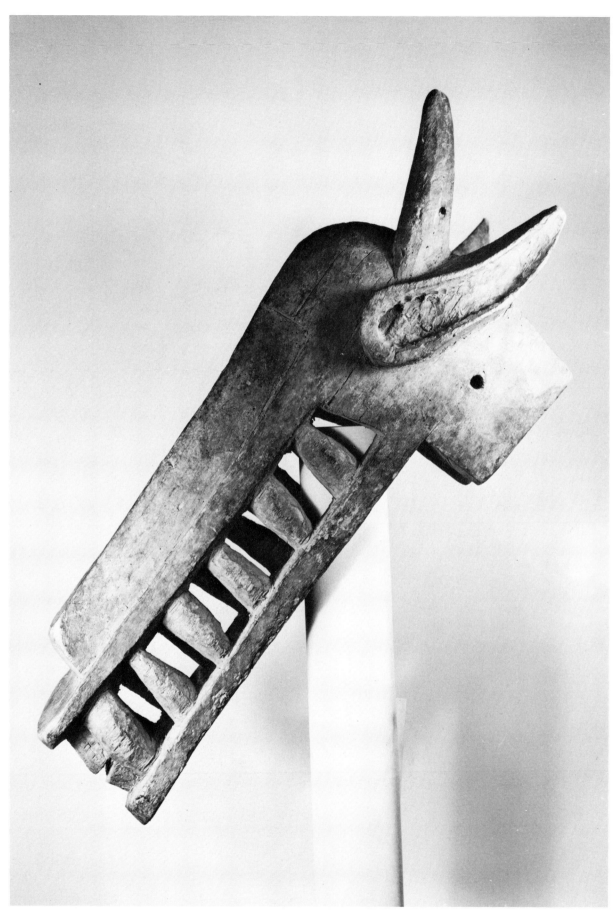

34 *Bambara, Mali, 23½ "*. A crocodile mask.

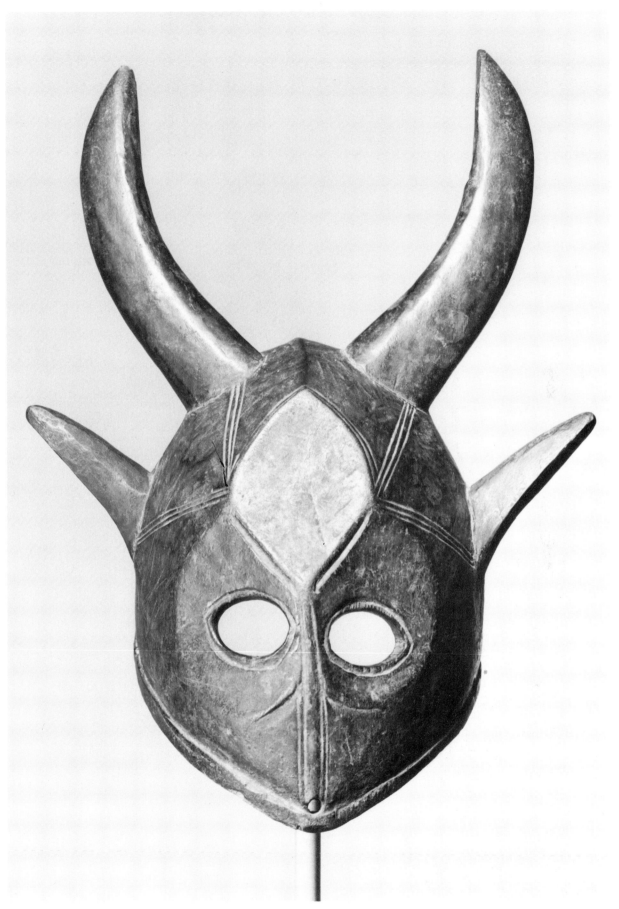

35 *Bambara, Mali, 10 7/8".* A helmet mask with horns.

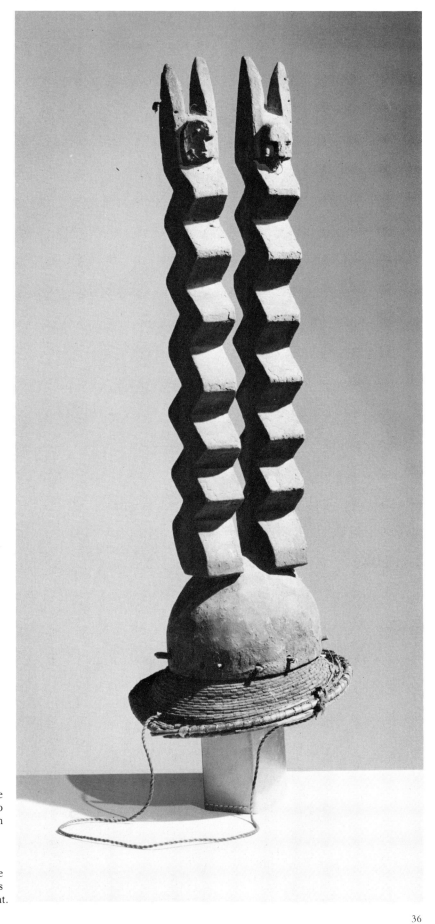

36 *Bambara, Mali, 20 3/4".*
This helmet mask is a headpiece consisting of a cap surmounted by two poles in a zigzag pattern ending in human faces.

37 *Bambara, Mali, 15 3/8".*
This semi-helmet mask is the only one in this group in which human features without animal attributes are evident.

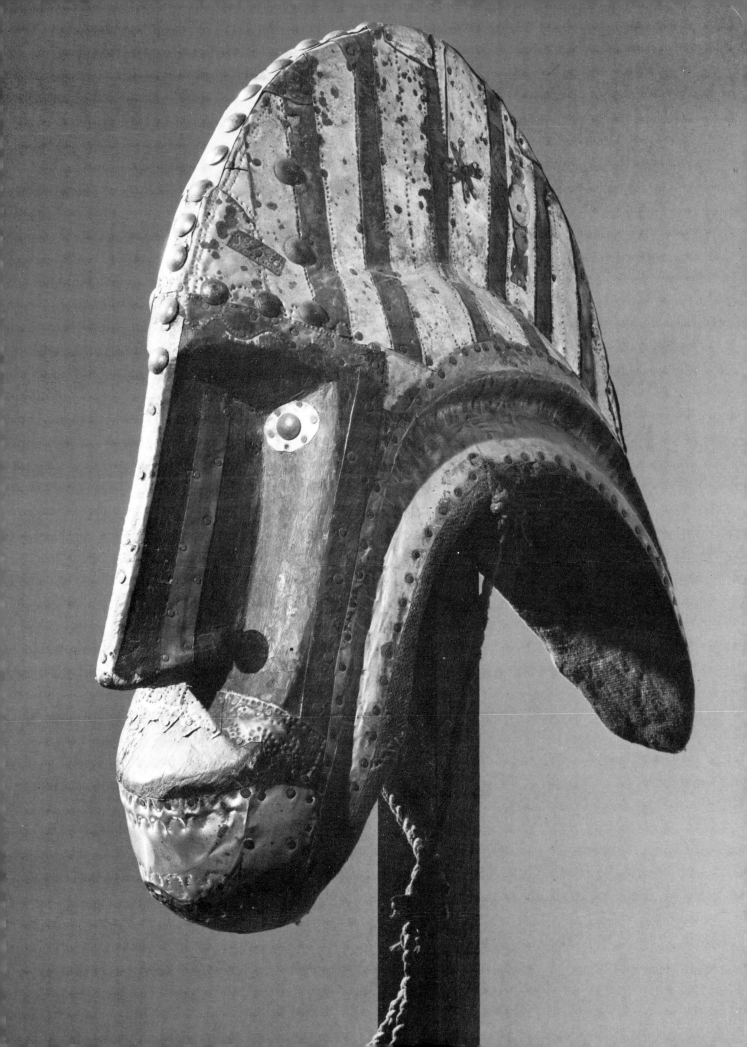

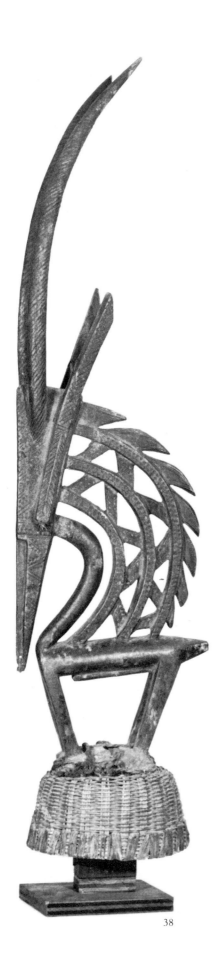

38

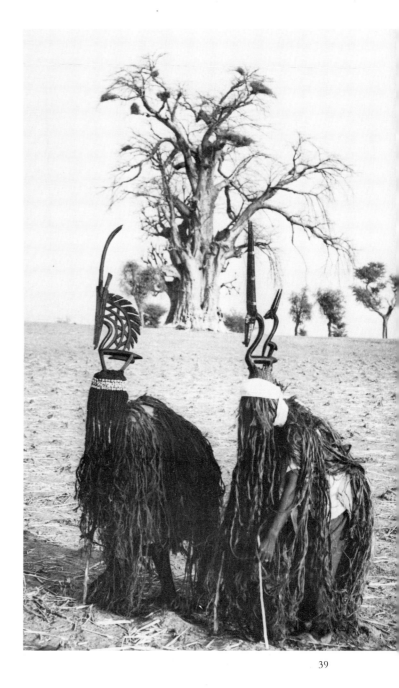

39

38 *Bambara, Mali, 40''.*
The stylized antelope mask *tyi wara*, representing a mythical
being who taught man how to cultivate the soil. This is the most
typical of the many versions, with openwork, a mane and long
horns and ears, showing also a basketwork cap by which it was
worn on the head of the dancer.

39 *Bambara, Mali.*
Two dancers, one with a male *tyi wara* and the other with a
female on the back of a larger one. To promote the fertility of
the fields, the dancers, their faces and bodies covered with
vegetable fiber, appeared usually in pairs (male and female)
imitating the leaps of the antelope. This photo shows how well
the costume disguised the dancer.

40 *Bambara, Mali, 26'' and 16''.*
Two different versions of the *tyi wara*, both extremely simplified.
One also has a human face.

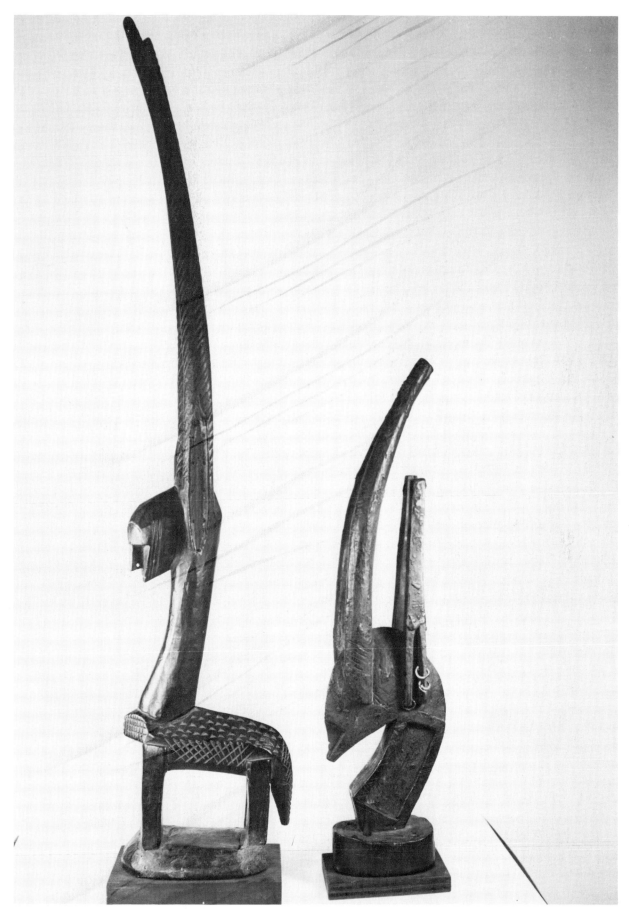

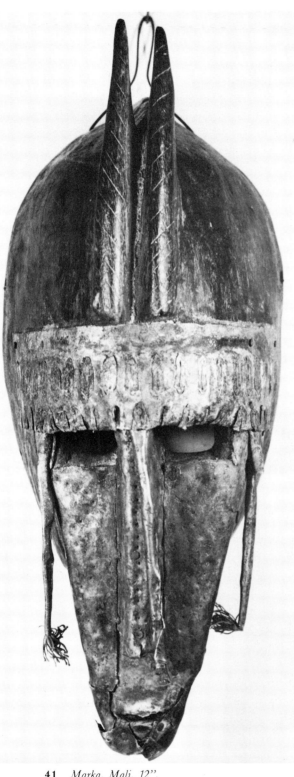

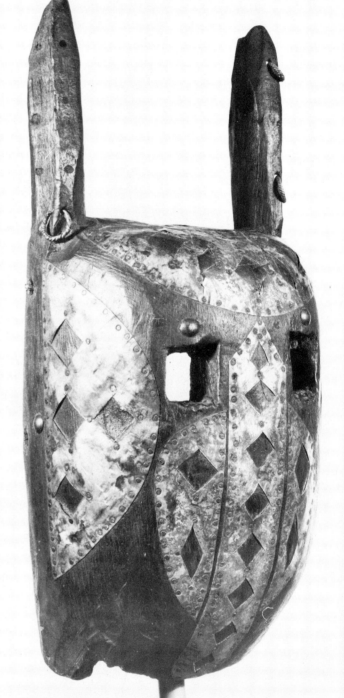

41 *Marka, Mali, 12".*
Typical of Bambara influence on the Marka, this mask is similar in construction to the Kore masks, with a large forehead and a long, angular nose. The most characteristic deviation from the Bambara style is the cover of metal sheeting worked in repoussé, with three metal bars attached to the forehead and red cotton at the end of each. The Ndomo society used this mask in two rituals, one of the circumcision ceremony of adolescents, the second when circumcised men advanced from one grade to another.

41

42

42 *Marka, Mali, 16 3/4".*
This is a rather unusual and less well-known type, but the N'Tomo influence is evident except for the hammered-metal appliqués covering the mask.

43 *Malinke, Mali, 13½".*
A typical Malinke mask, this has the same bold configurations as the Bambara masks, with a hemispherical forehead, an angular nose, and a square mouth.

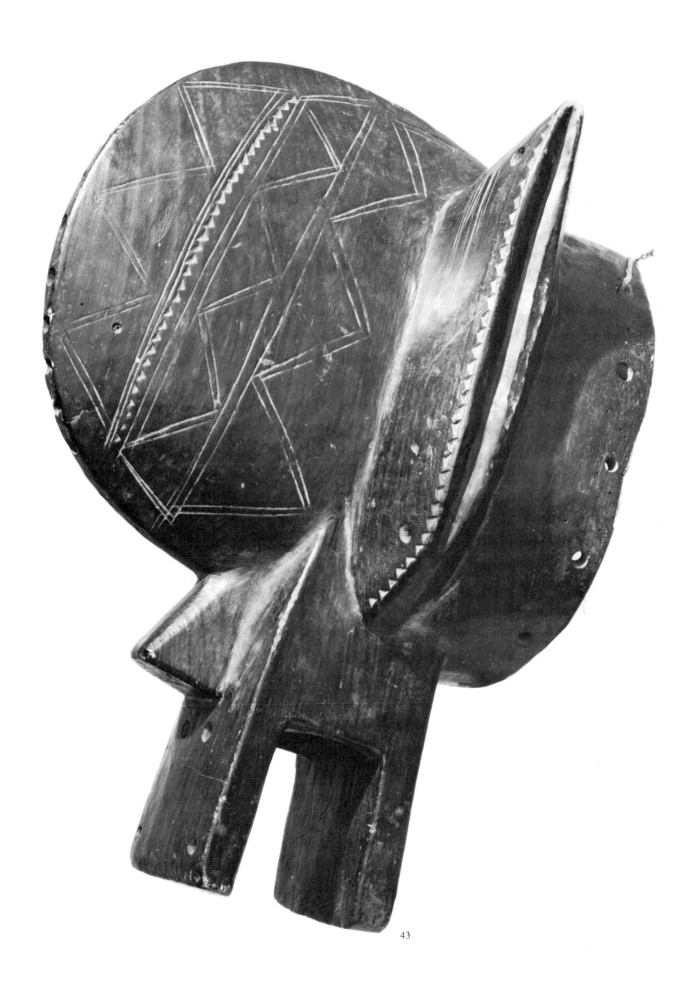

43

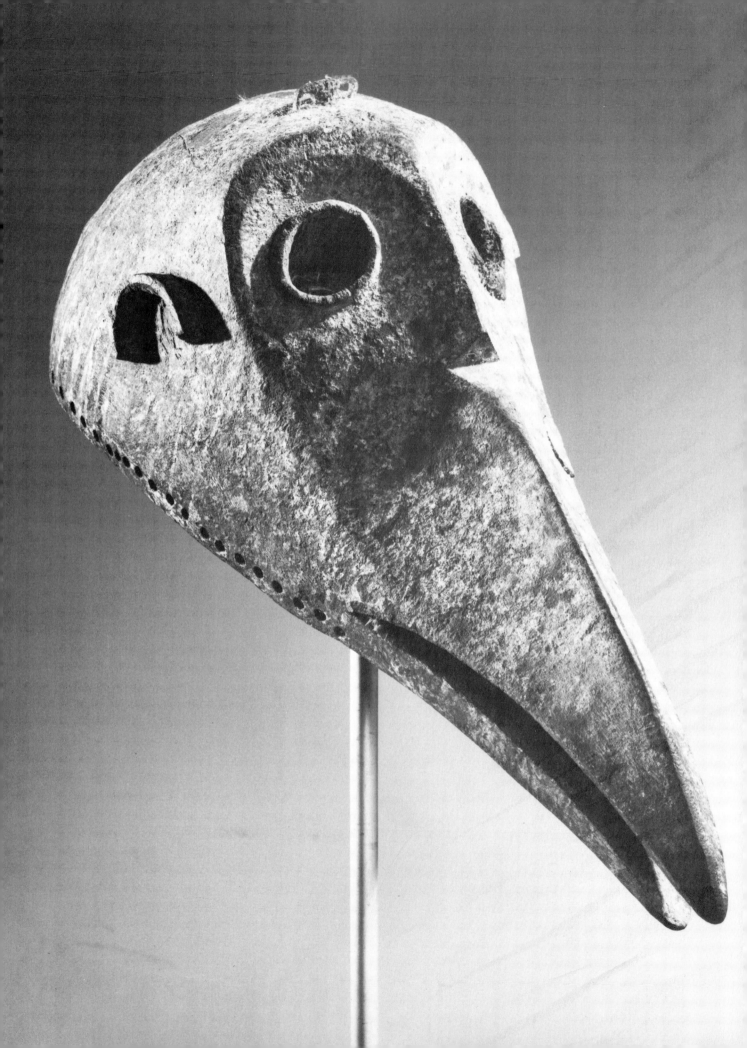

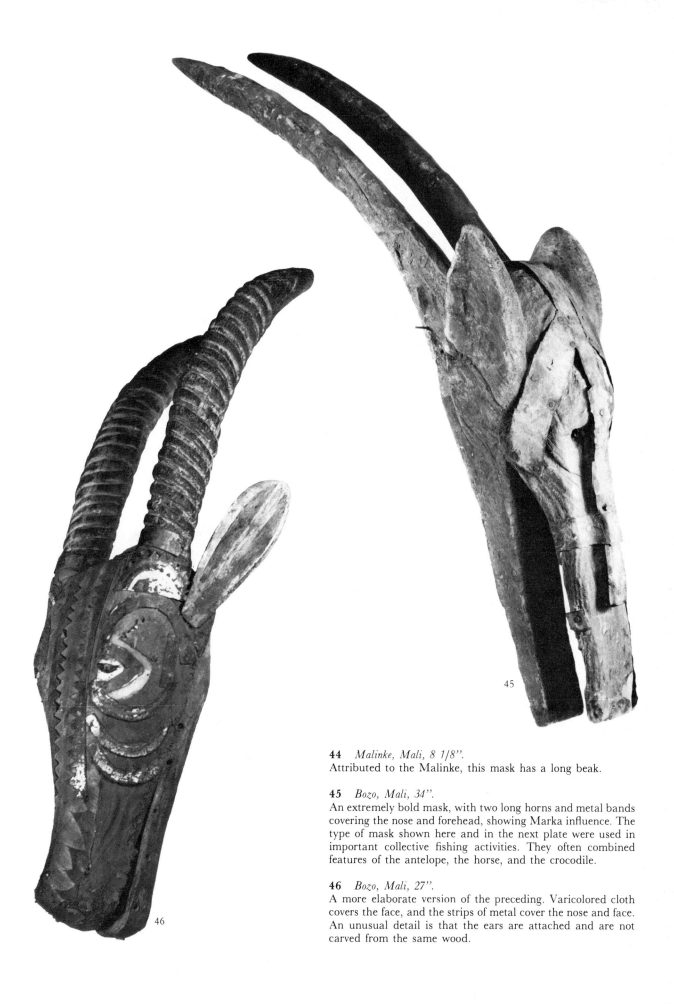

45

44 *Malinke, Mali, 8 1/8''.*
Attributed to the Malinke, this mask has a long beak.

45 *Bozo, Mali, 34''.*
An extremely bold mask, with two long horns and metal bands
covering the nose and forehead, showing Marka influence. The
type of mask shown here and in the next plate were used in
important collective fishing activities. They often combined
features of the antelope, the horse, and the crocodile.

46 *Bozo, Mali, 27''.*
A more elaborate version of the preceding. Varicolored cloth
covers the face, and the strips of metal cover the nose and face.
An unusual detail is that the ears are attached and are not
carved from the same wood.

46

44

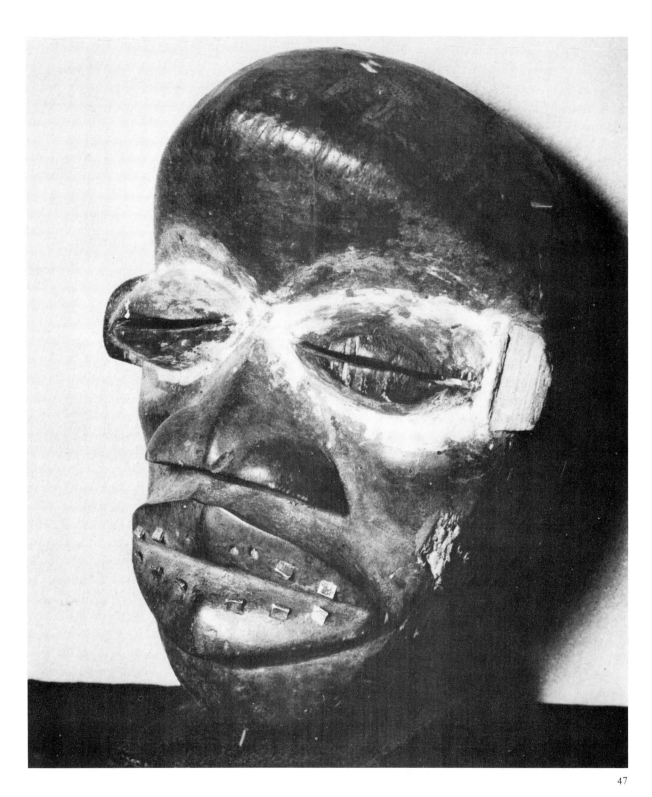

47 *Guere-Wobe, Liberia, 12"*.
Definite Negroid features are shown, which is rather un-
usual in African art. The masks shown in Plates 47 through
60 were used by the Poro secret society. In addition to the
Guere-Wobe under whom we have grouped a number of
masks, other tribes, such as the Mano, Kono, Gio, Geh,
Kran, Kpelle, Bete, and Bassa with slight differences share
the main stylistic characteristics. Each mask represented a
spirit *(ge)*, and had its own name and special role assigned to
an officer of the society. The masks were worn in group

ceremonies dedicated to the tribe's tutelary ancestor. In this
group performance several different masks represented the
elders, the young, the clown, the authority of law and order,
the guardian of the earth, the forces of nature, and fertility.
The tribe also used a great sacred mask mounted on stilts.
(The present mask is attributed to the Tura tribe.)

48 *Guere-Wobe, Liberia, 9½"*.
Here the Negroid features are reduced to a more geometric
form. The forehead is ornamented with vertical incisions.

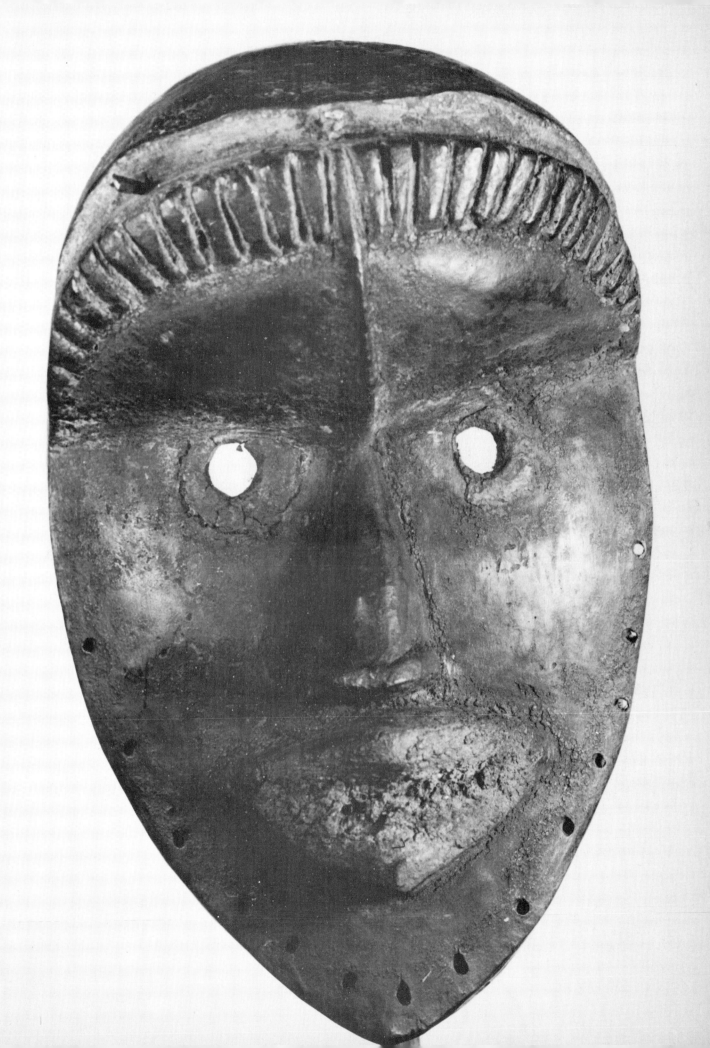

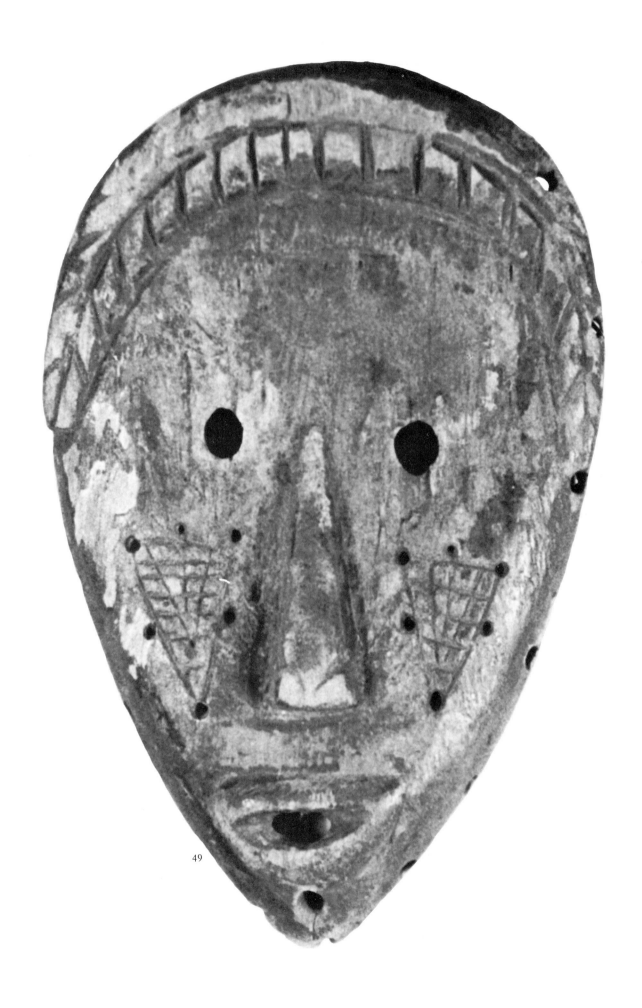

49

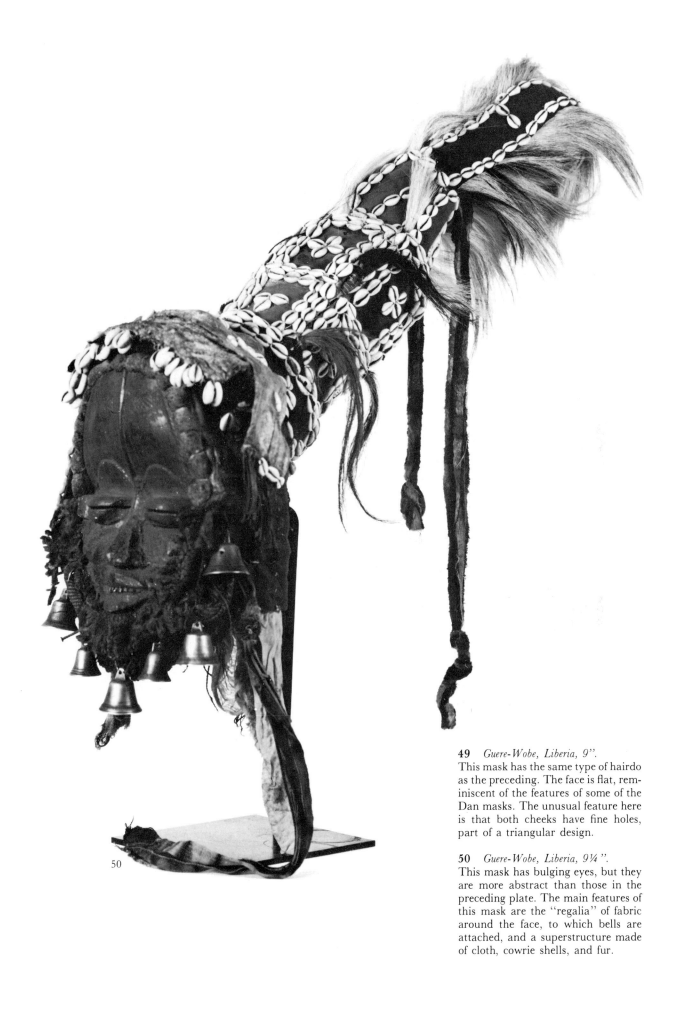

50

49 *Guere-Wobe, Liberia, 9''.*
This mask has the same type of hairdo as the preceding. The face is flat, reminiscent of the features of some of the Dan masks. The unusual feature here is that both cheeks have fine holes, part of a triangular design.

50 *Guere-Wobe, Liberia, 9¼''.*
This mask has bulging eyes, but they are more abstract than those in the preceding plate. The main features of this mask are the "regalia" of fabric around the face, to which bells are attached, and a superstructure made of cloth, cowrie shells, and fur.

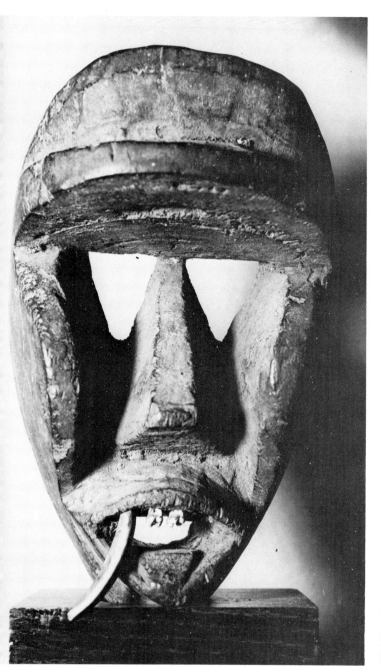

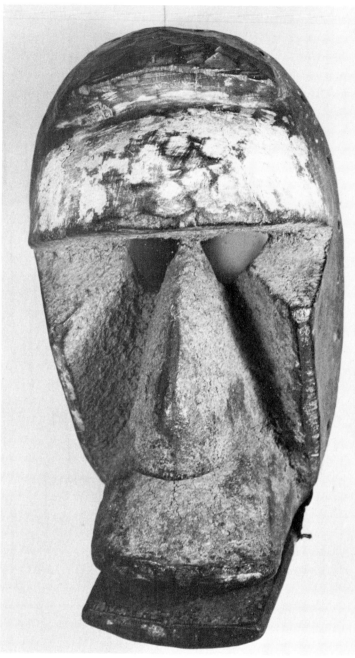

51 52

51 *Guere-Wobe, Liberia, 9½ ''.*
This mask has triangular shapes for the eyes, nose, and
cheeks and a massive round forehead.

52 *Guere-Wobe, Liberia, 10¼ ''.*
The same geometrizing trend as in the preceding mask is
evident, except that here the jaw is hinged.

53 *Guere-Wobe, Liberia, 14''.*
This is the *koposki* mask, which combines human features
with the beak of a hornbill (symbolic of fertility). It is
classified as a Guere mask, but the Niabwa also used it. A
very elaborate headpiece (not shown in the illustration)
made of feathers and cowrie shells was attached to the mask.
The mask thus acquired a very impressive appearance. It
was known to be able to perform miracles and to cast spells.
It was also used to encourage communal work. (It is also
known as the *to la-ge* mask.)

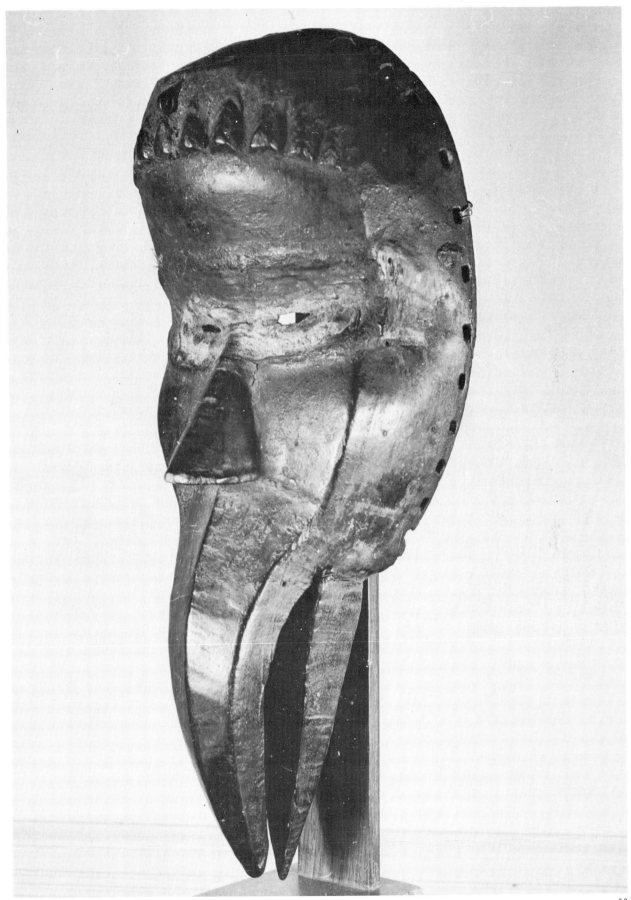

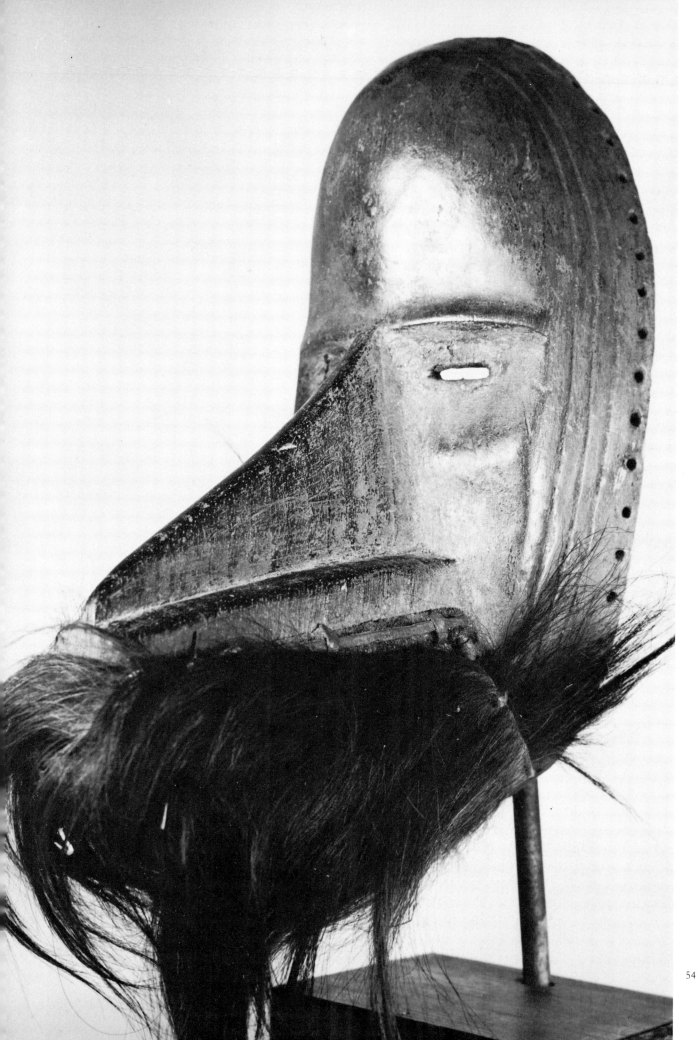

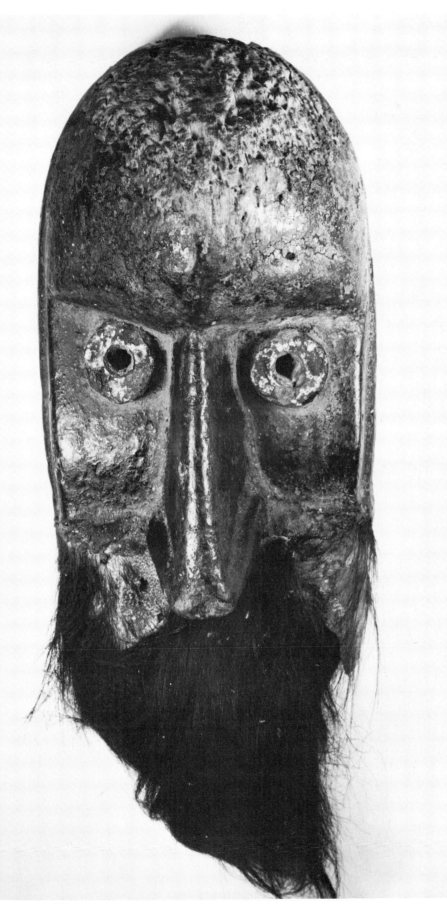

54 *Guere-Wobe, Liberia, 12".*
This has an accentuated beak with monkey fur attached to it.

55 *Guere-Wobe, Liberia, 12".*
The same type of mask as the preceding, but with tubular eyes and a rather flat beak. Again monkey fur is attached. This mask was worn by the person who collected foodstuffs for the festivals of the Guere and levied taxes for the benefit of the elders of the village.

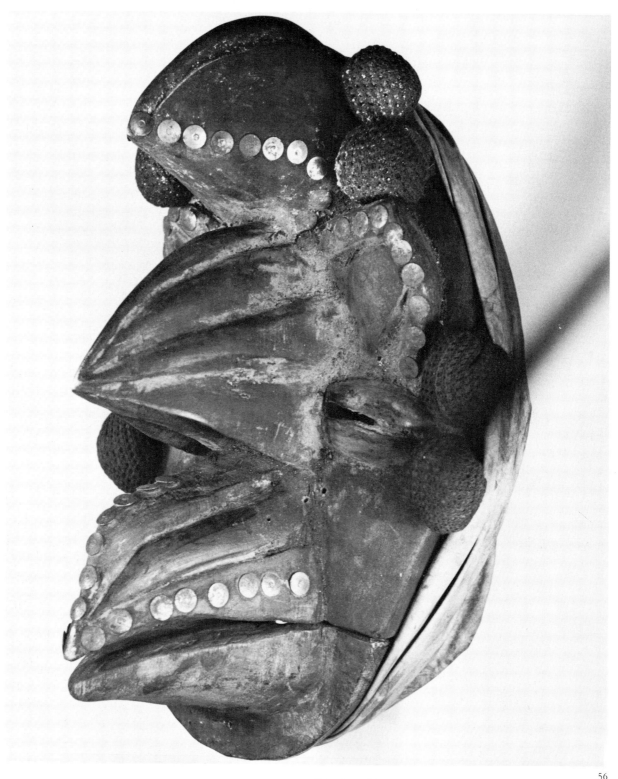

56 *Guere-Wobe, Liberia, 10½ ".*
This shows the inventiveness of the artist, who used the beak form for the chin, the nose, and the forehead. Nails ornament the mask, and bags of magical substances are attached to it. It was used by an officer of the Poro society who acted as a judge in settling disputes.

57 *Guere-Wobe, Liberia, 13".*
A mask with protuberant tubular eyes (probably inspired by the warts of the warthog) and six horns. Above the nose there is a slit through which the dancer could see. A raffia "beard" is attached to the mask. Some masks of the Dan and the Guere, like this one, were placed on the ground as depositories of the protective spirits. It was believed that by certain ritual acts the petitioner could appropriate their power for his own use or protection.

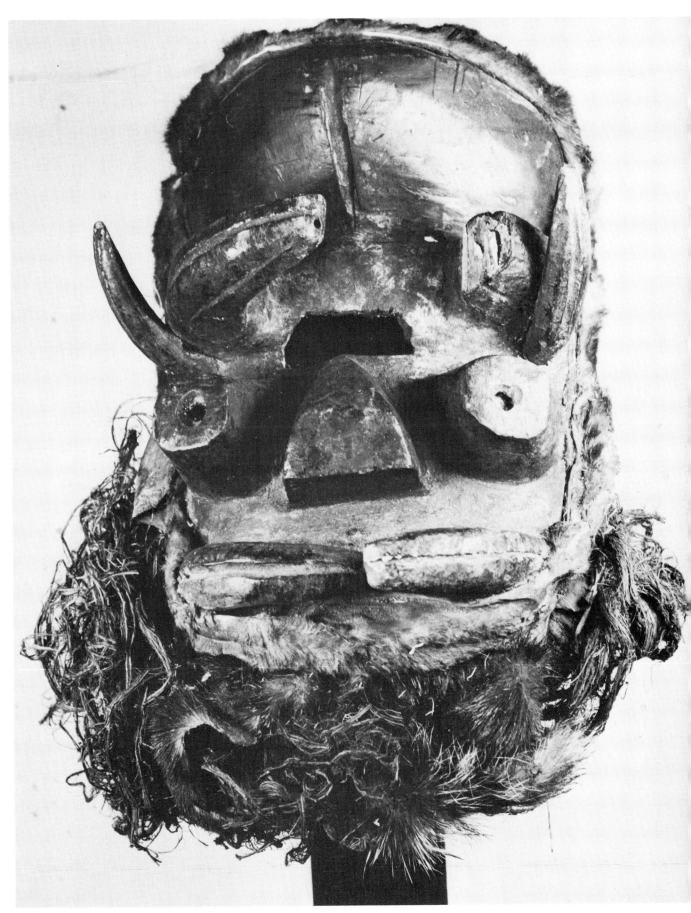

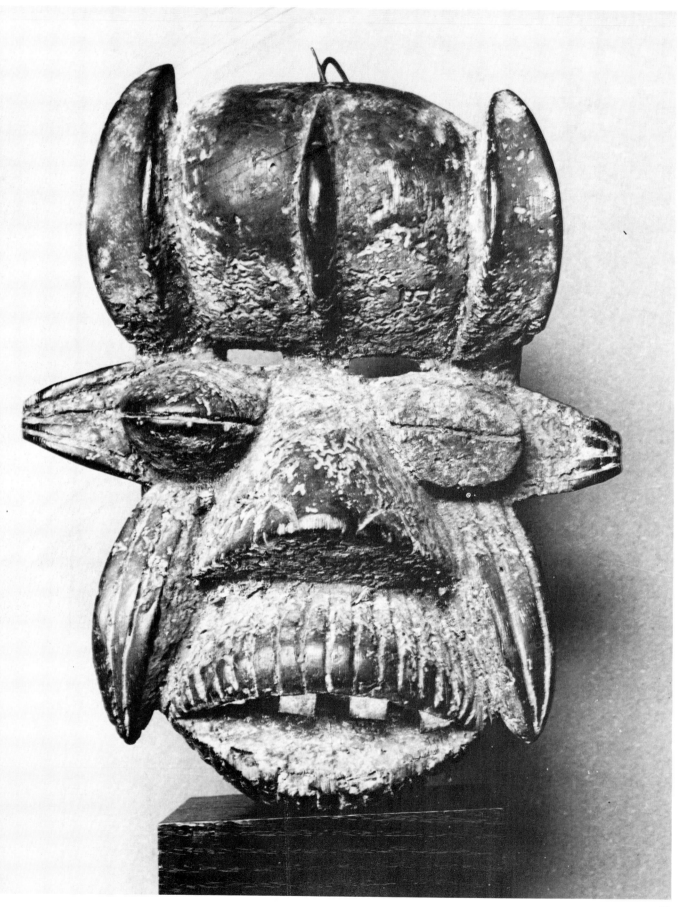

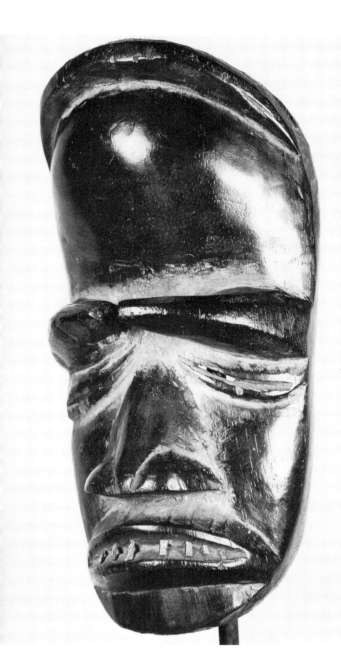

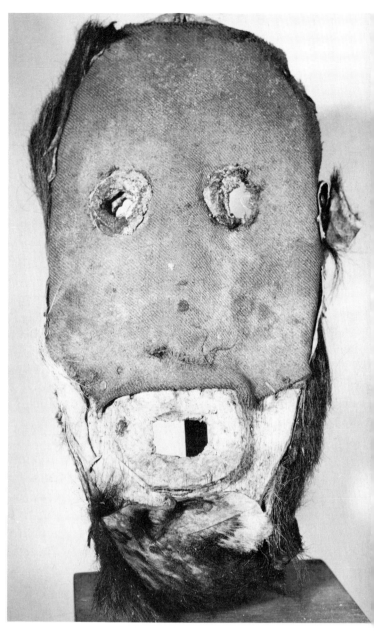

59 60

58 *Guere-Wobe, Liberia, 14".*
A mask with six horns and bulging eyes with peepholes above them. The remarkable feature in this mask (similar to Plate 56) is that the discipline of the artist enabled him to create a well-balanced configuration.

59 *Guere-Wobe, Liberia, 14".*
This combines various features already mentioned with a large forehead below which are two horns.

60 *Guere-Wobe, Liberia, 9½ ".*
This is unlike the other Guere masks. A red cloth covers the face, and fur is attached to the mask. The eyes used to have metal rings (now missing, but the glue is still visible). This mask was designed for the prevention of disease and for use in exorcism rituals.

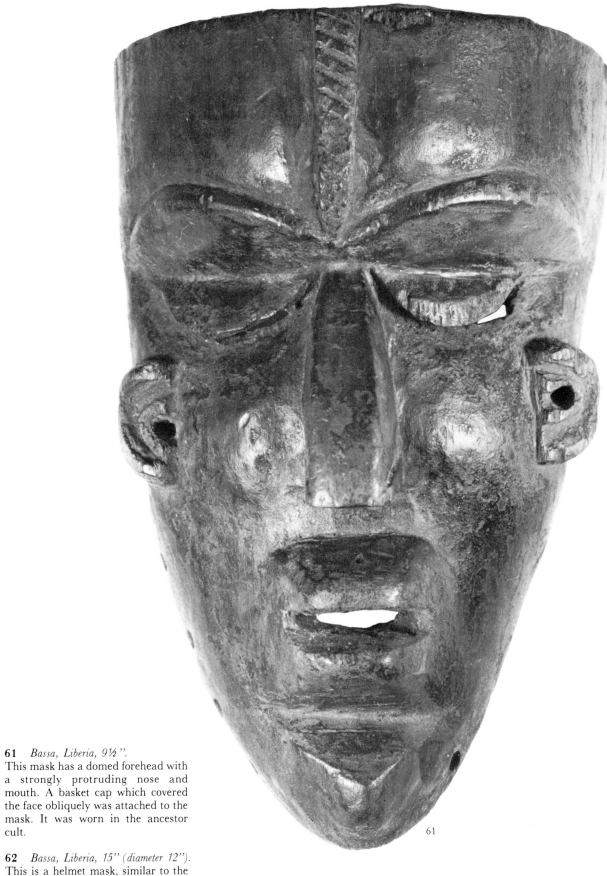

61 *Bassa, Liberia, 9½".*
This mask has a domed forehead with a strongly protruding nose and mouth. A basket cap which covered the face obliquely was attached to the mask. It was worn in the ancestor cult.

62 *Bassa, Liberia, 15" (diameter 12").*
This is a helmet mask, similar to the Mendi (Bundu) helmets, but less refined.

61

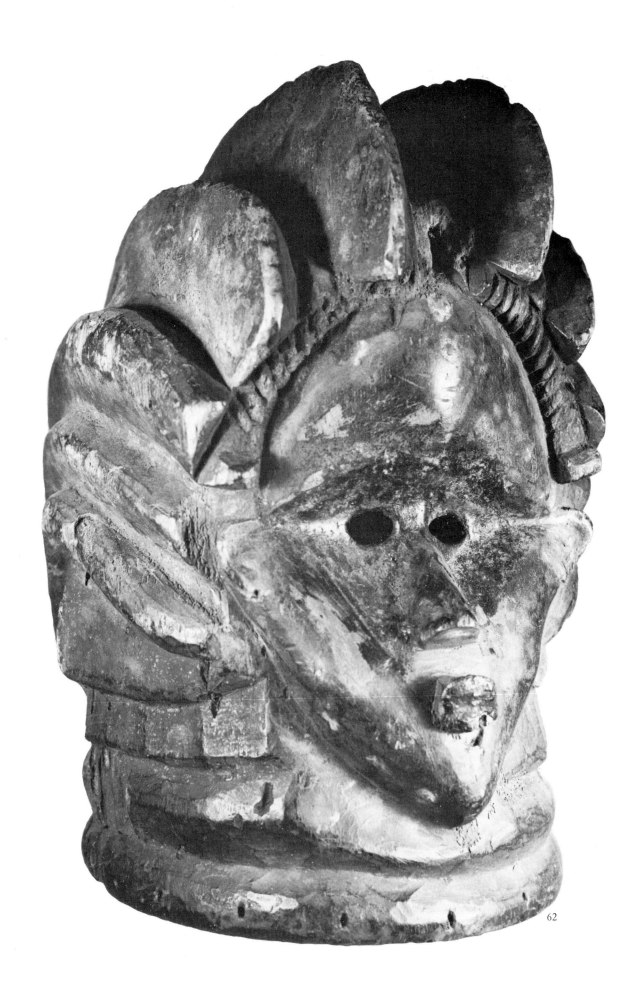

62

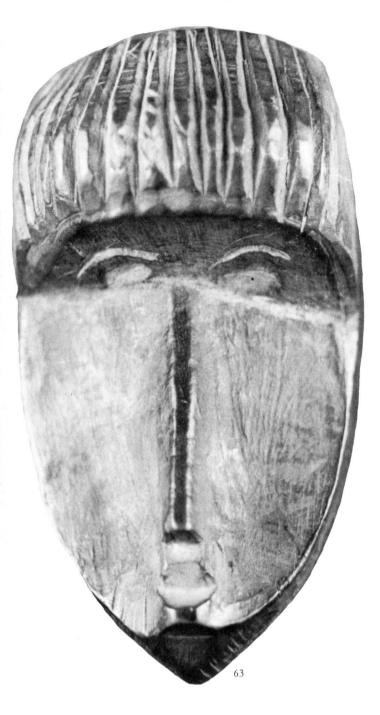

63

63 *Bassa, Liberia, 4".*
This is a miniature mask *(ma)* showing another formation of the hairdo typical of the Bassa style. These small masks, carried by individuals among the Dan and the Guere as well as the Bassa, incorporated the spirit of the parental ancestor and were consulted in case of sickness. Often smaller renditions of larger masks, they were believed to partake of the power of the latter.

64 *Grebo, Liberia, 27½".*
This mask is rather abstract, with bulging eyes, a long block for the nose, and a rectangular, boxlike mouth showing the teeth.

65 *Kra, Liberia, 4".*
This is a small brass mask in the lost-wax casting tradition.

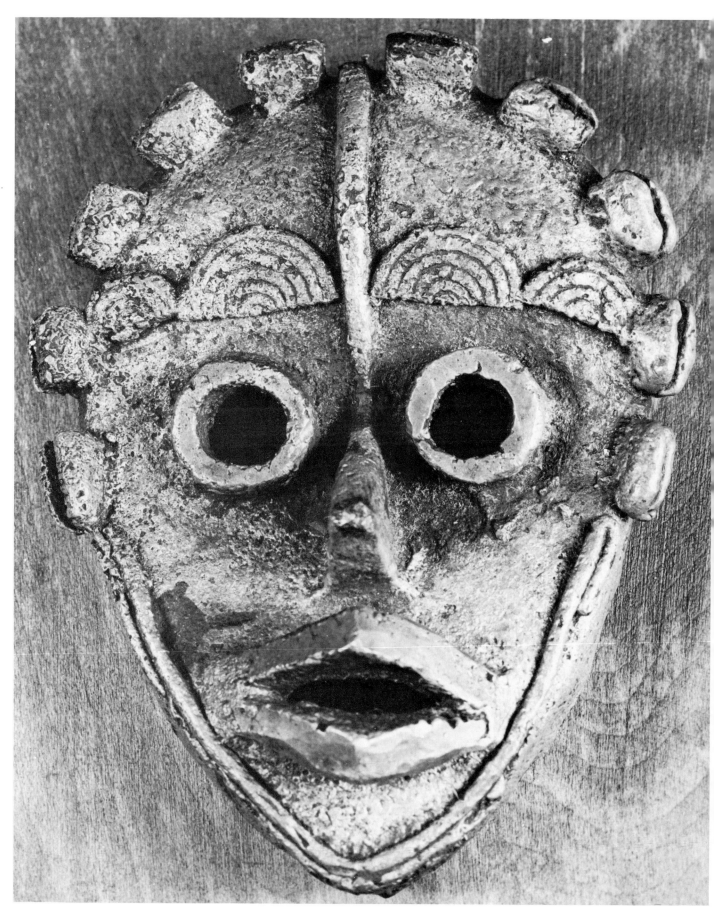

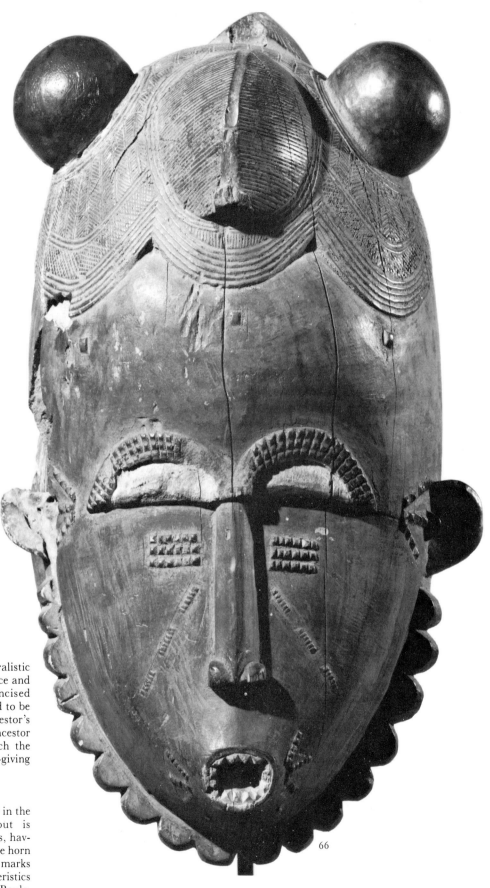

66 *Baule, Ivory Coast, 10".*
A classic example of the naturalistic style of the Baule, with long face and nose, small mouth, and incised hairdo. This mask was believed to be the abode of a personal ancestor's spirit and was used in the ancestor cult. With the proper approach the petitioner could acquire its life-giving spirit.

67 *Baule, Ivory Coast, 13".*
This shows the same sensitivity in the human facial expression, but is different from the previous ones, having strong Negroid features. The horn formation and the scarification marks on both sides have the characteristics of the Yaoure subgroup of the Baule.

66

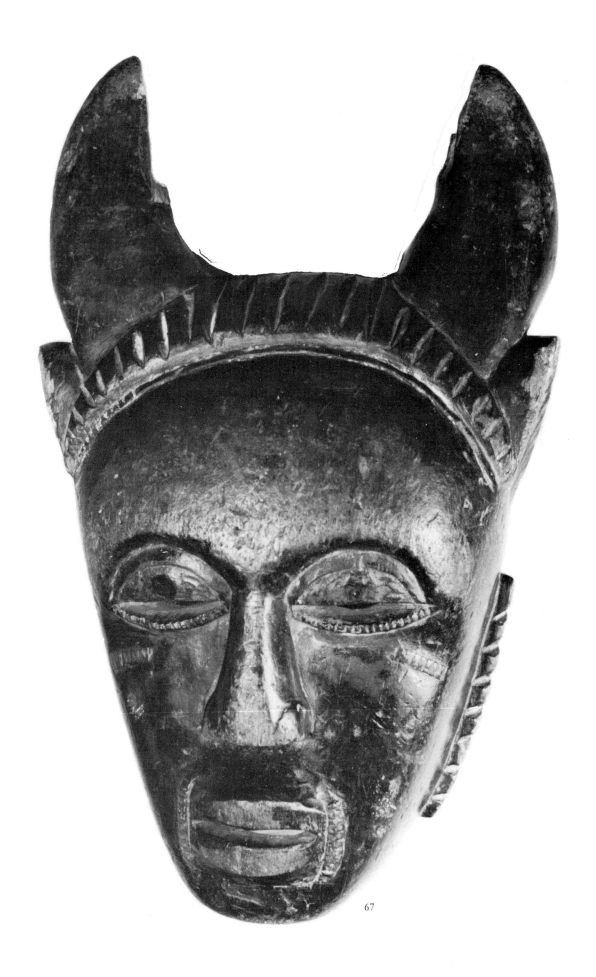

67

68 *Yaoure, Ivory Coast, 15".*
The masks of this Baule subtribe have
a stronger emphasis on sophisticated
stylization. Typical of this type of
mask is the zigzag pattern on both
sides of the face. It has a human face
and an animal placed between the up-
turned horns. It is reported (though
this is rather untypical of African
masks) that the features of these
masks were supposed to resemble
deceased individuals. The non-
Negroid features, however, would
seem to contradict this theory. The
mask was also used in commemora-
ting a person who had left the village.

69 *Baule, Ivory Coast, 18".*
Representative of a second group of
Baule masks, this *kple kple* mask is one
of the great abstractions in African
art. The face is flat; the eyes have an
oval frame; the mouth is rectangular;
and the mask has two horns. The
round head is said to stand for the
sun, and the horns for the buffalo, the
symbol of fecundation. The mask was
used at commemorative, agricultural,
and burial ceremonies. It is also
associated with the Goli group.

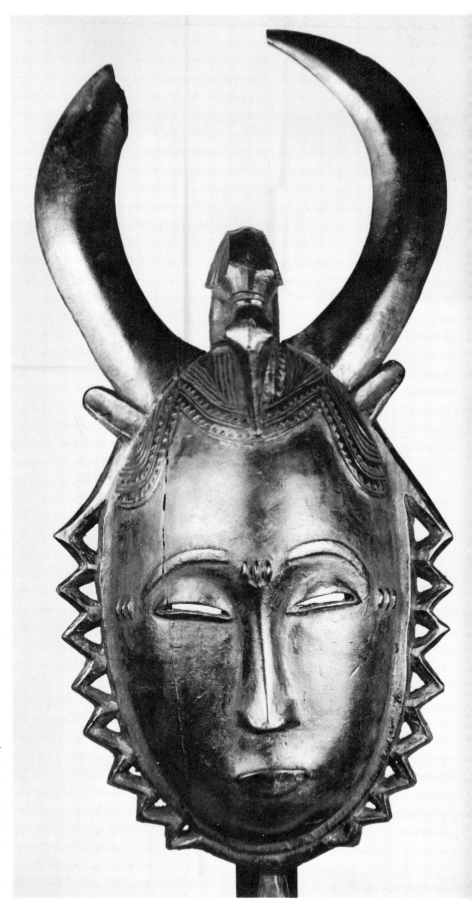

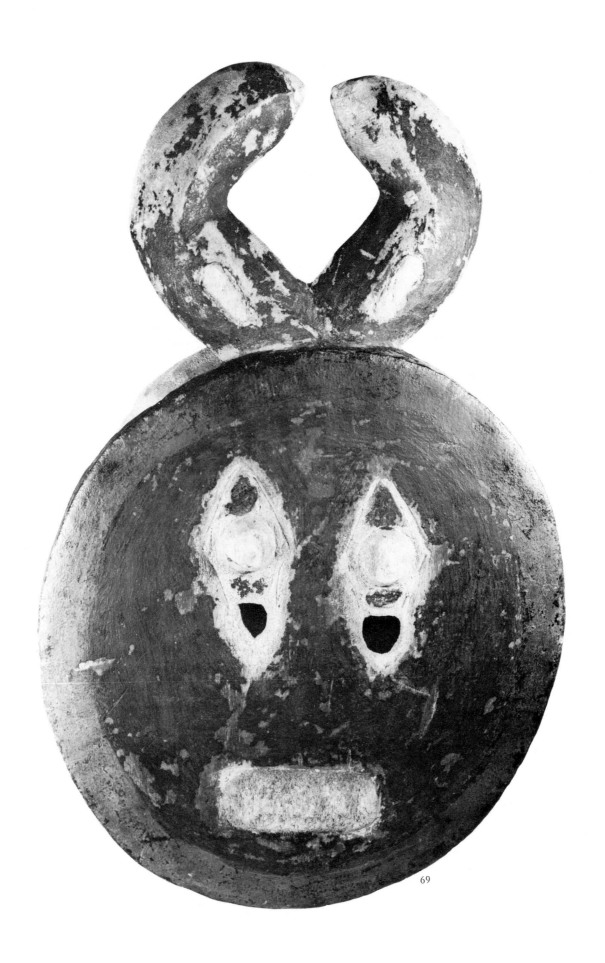

69

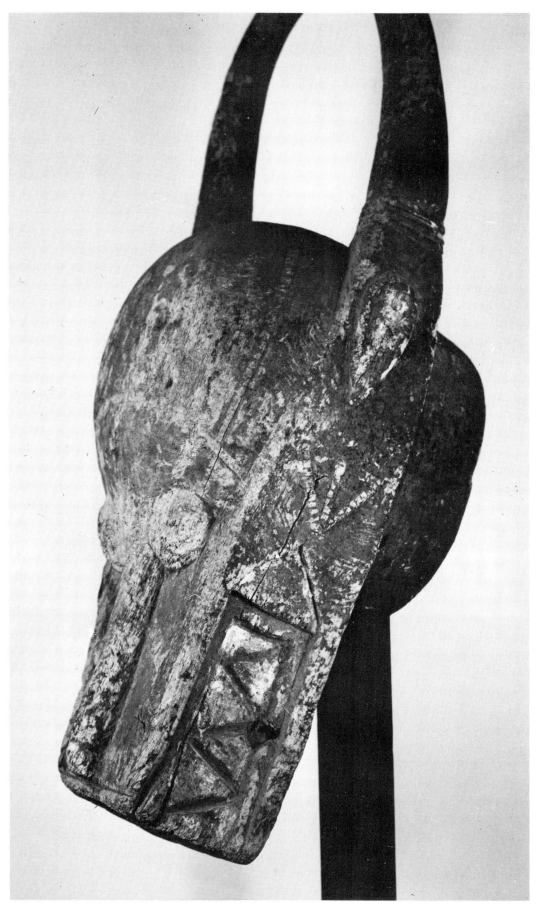

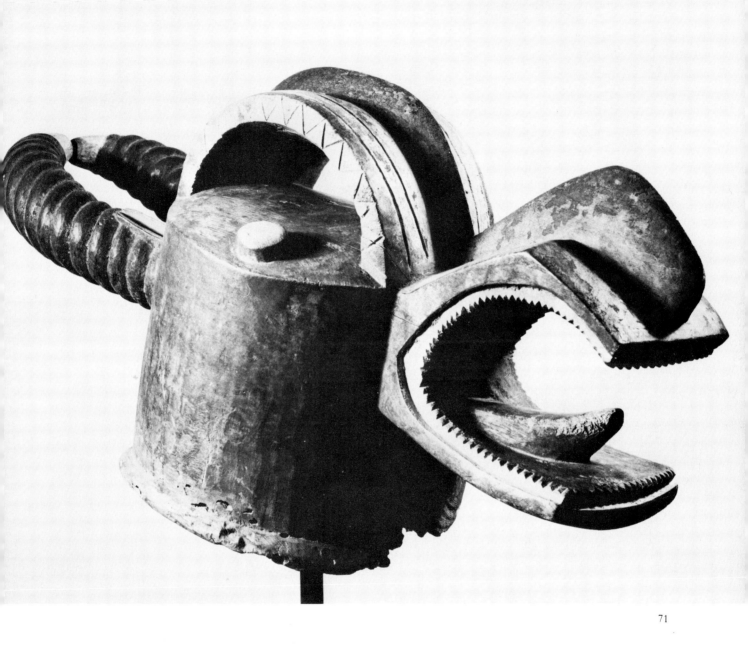

70 *Baule, Ivory Coast, 26" (diameter 8").*

This mask and the next represent buffalo or bush cows and were used in the Goli (Guli) ceremonies. The dancer wore the mask horizontally and looked through the mouth. This *egwe* helmet mask is the most typical example, with a closed mouth and a peephole in the middle of the jaws. Each important village had a clan under the protection of a local divinity known as *do, die, goli (guli)*, or *kloro* and materialized it in the mask. Usually *goli* or *guli* was its denomination. The animal represented was considered either the son *(guli)* or the messenger *(goli)* of the great divinity Nyamie, the goddess of the sky who controlled the rain.

71 *Baule, Ivory Coast, 27" (diameter 11").*

The same type as the preceding, but with an open mouth.

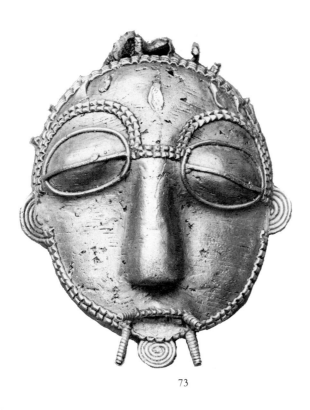

73

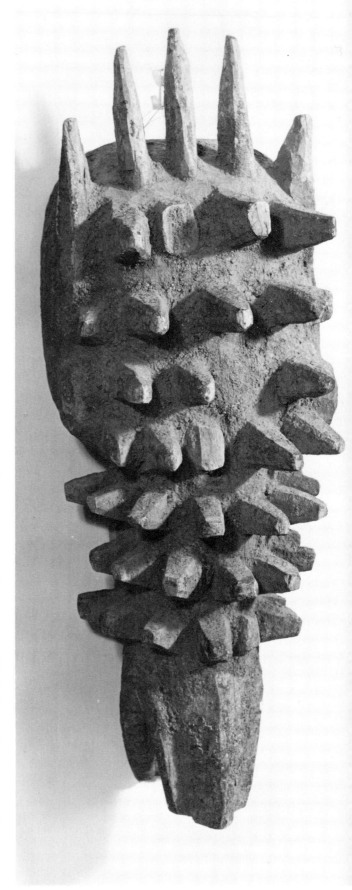

72 *Baule, Ivory Coast, 22" (diameter 9").*
This mask, which does not belong to any of the three Baule styles above, represents a boar's head and was used in the Goli dances. The different protrusions do not correspond to any anatomical feature; they are rather artistic inventions of great abstraction and force. The masked dancer incarnated the spirit of the dead.

73 *Baule, Ivory Coast, 3½ ".*
This small gold mask, used as a pectoral, belongs to the Ashanti-Baule lost-wax casting tradition. It was regarded as a "portrait" of a slain chief or king, and carried as a commemorative, protective ornament.

74 *Senufo, Ivory Coast, 14".*
This and the following three are Senufo face masks. This is the *kpelie* (also know as *kulie* or *kodelle*), a delicately carved mask of smaller size combining human and animal features, with leglike formations on the bottom and protrusions on both sides. The row of palm nuts on the flat protrusion at the top symbolized the wood-carving profession. It was used by the Lo society, which governed the social life of the tribe. There were societies for boys, adolescents, and adults. Masked dancers performed at each initiation. The *kpelie* mask concretized a supernatural spirit living in the invisible realm who responded to the supplications of worshippers. It was used at harvest festivals to thank the ancestor for a good crop. In the funerary rites, held for the purpose of leading the spirit into the land of the dead, it represented the deceased. It was also used to chase away harmful spirits from the village and to fight sorcerers.

75 *Senufo, Ivory Coast, 9 3/4".*
Of the same type, but with a double face.

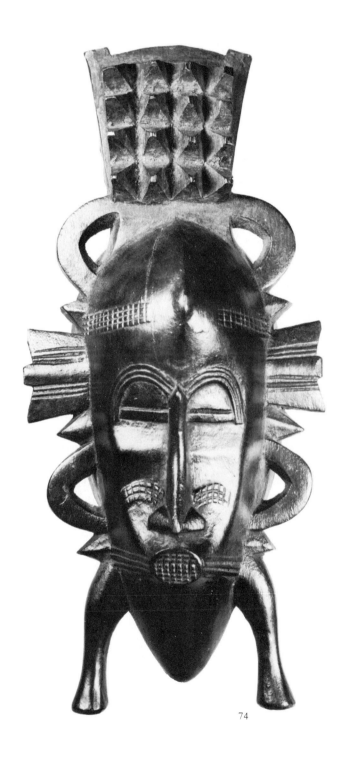

74

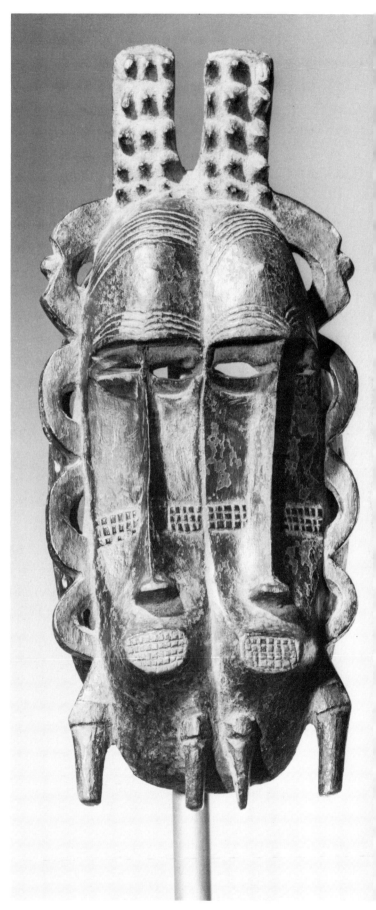

75

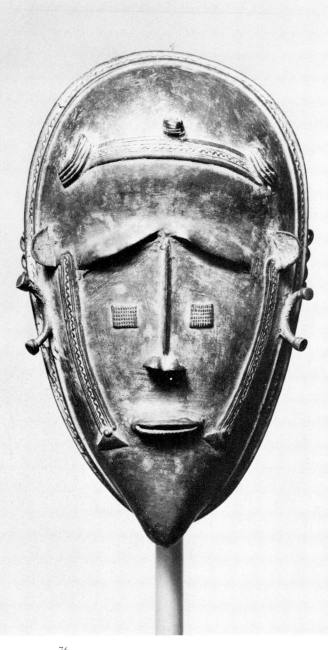

76

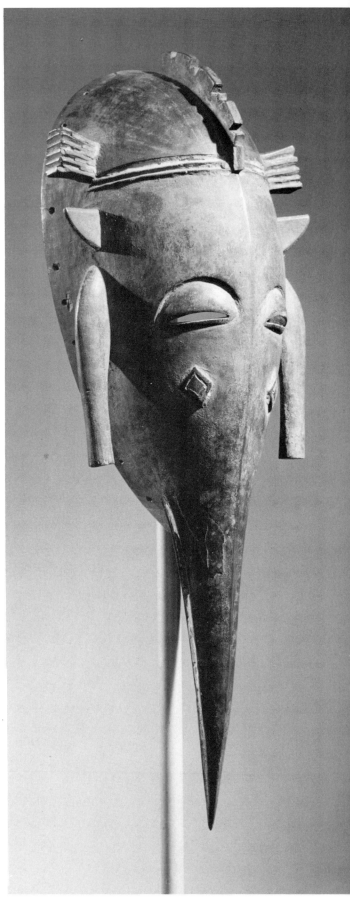

76 *Senufo, Ivory Coast, 8¼".*
Simplified, cast in brass, and probably of more recent production.

77 *Senufo, Ivory Coast, 16".*
This combines human features with a bird's beak.

78 *Senufo, Ivory Coast, 15" (diameter 9").*
Plates 78 through 83 are Senufo helmet masks. This is the *waniugo* mask of the Korobla (or Korubla) society with an open jaw and two metal disks for eyes. It had two different functions: one at funerals and the other at initiation ceremonies. In certain rituals it was worn to repeat the deeds of the hero founder, Yirigne.

77

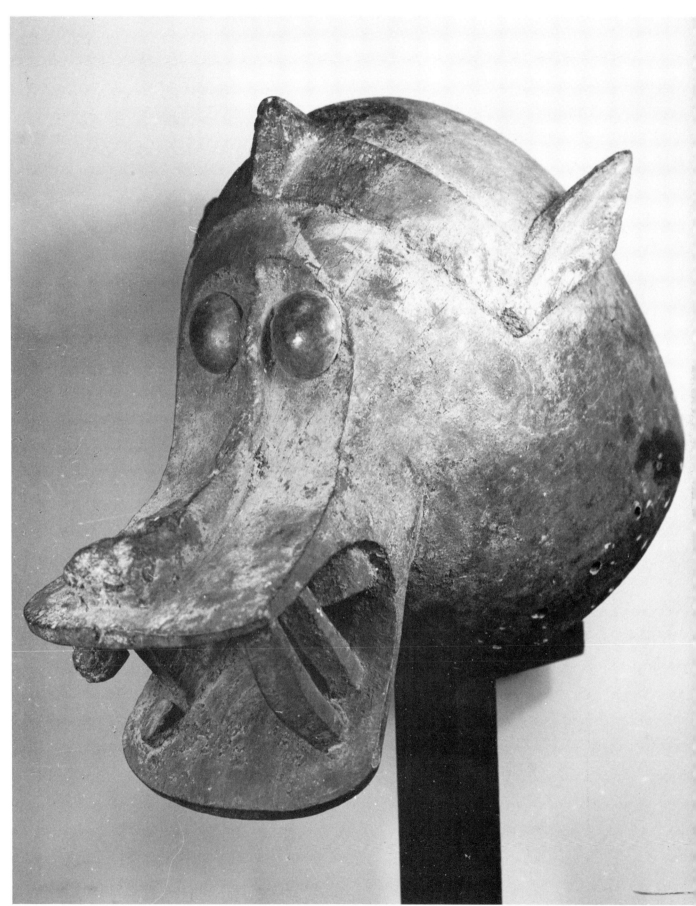

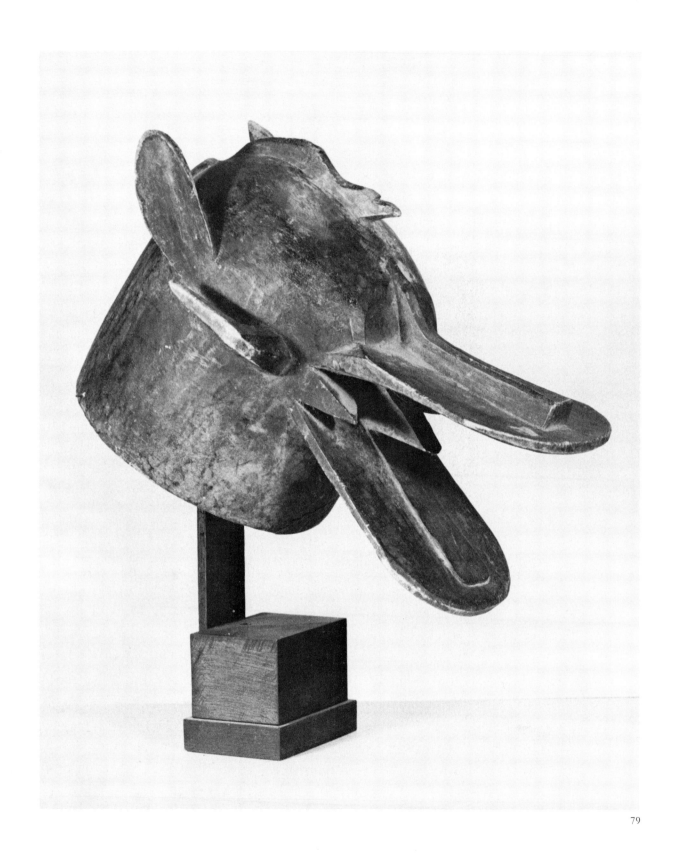

79 *Senufo, Ivory Coast, 17" (diameter 9").*
A hyena *(hanamto)* mask similar in style to the preceding.

80 *Senufo, Ivory Coast, 35 5/8".*
This is also known as the *waniugo* helmet mask. It has a crocodile jaw, antelope horns, warthog tusks issuing from the top and sides, and a chameleon and a bird on top. The combination of animal features symbolized the chaotic conditions of the primordial universe. The mask was used by a group of dancers in the fields to represent mythical monsters. It had many other liturgical functions and assisted at funerals.

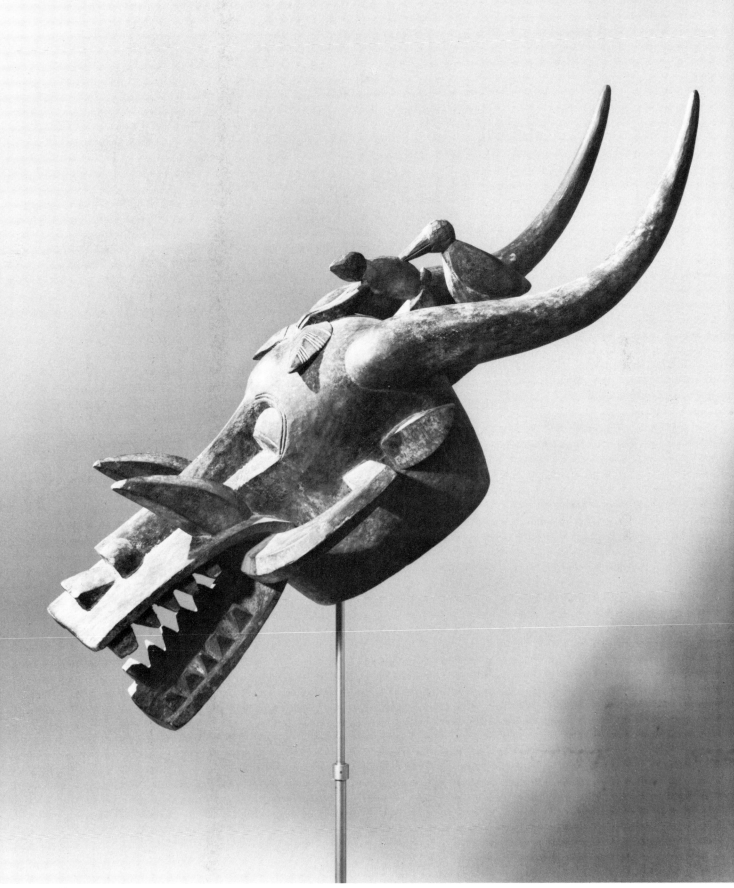

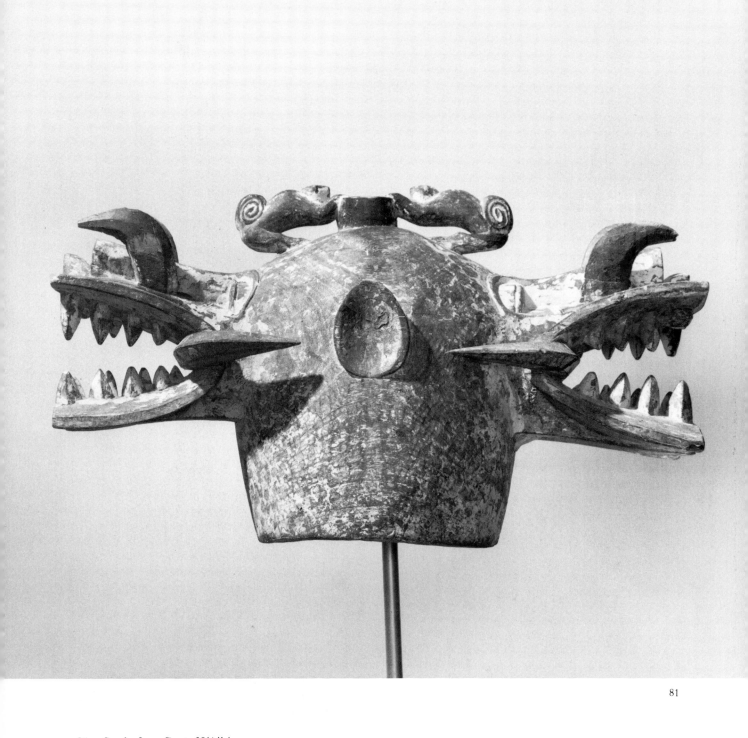

81 *Senufo, Ivory Coast, 25½" long.*
This antelope mask, similar in style to the preceding but without horns, has two heads back to back.

82 *Senufo, Ivory Coast, 34".*
Though not a helmet mask, this *kagba* mask is very similar in style to the *waniugo* mask, except that the *kagba* is more slender and does not fit over the head. A tentlike structure, with a two-sided roof and fibers hanging down on both sides, was attached to the mask to hide the boys undergoing initiation. It thus served as an ornament over this structure,

under which the initiated entered the secret society's enclosure.

83 *Senufo, Ivory Coast, 29½" (diameter 9½").*
The *deguele* helmet mask, with square holes for the eyes, is different from the preceding helmet masks. A spiral pole ending in a human head surmounts the mask. (Some superstructures have a standing figure.) The dancers of the Lo society wore this mask at the funerals of important members of the society.

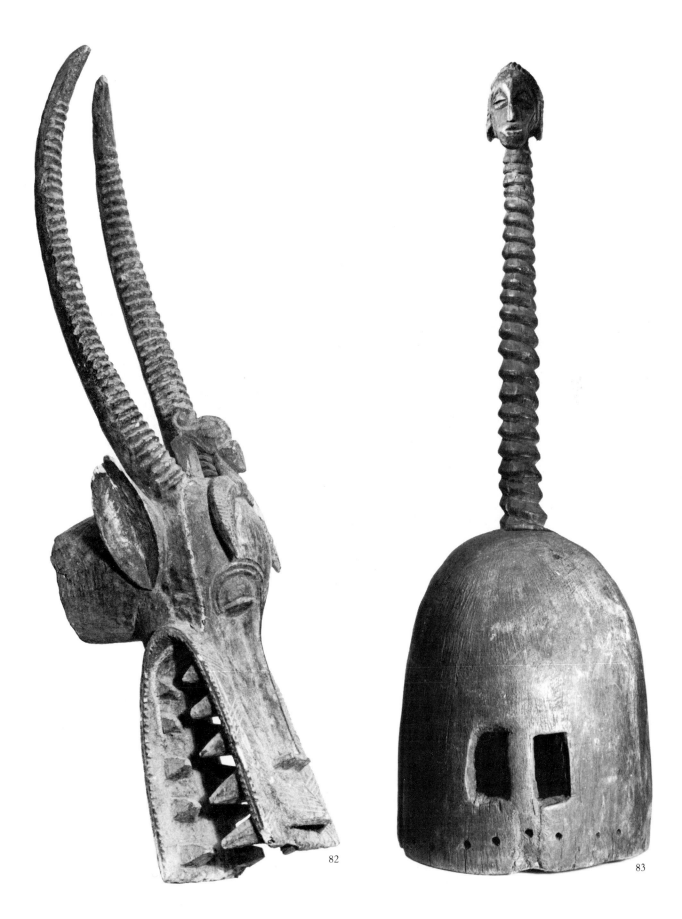

82

83

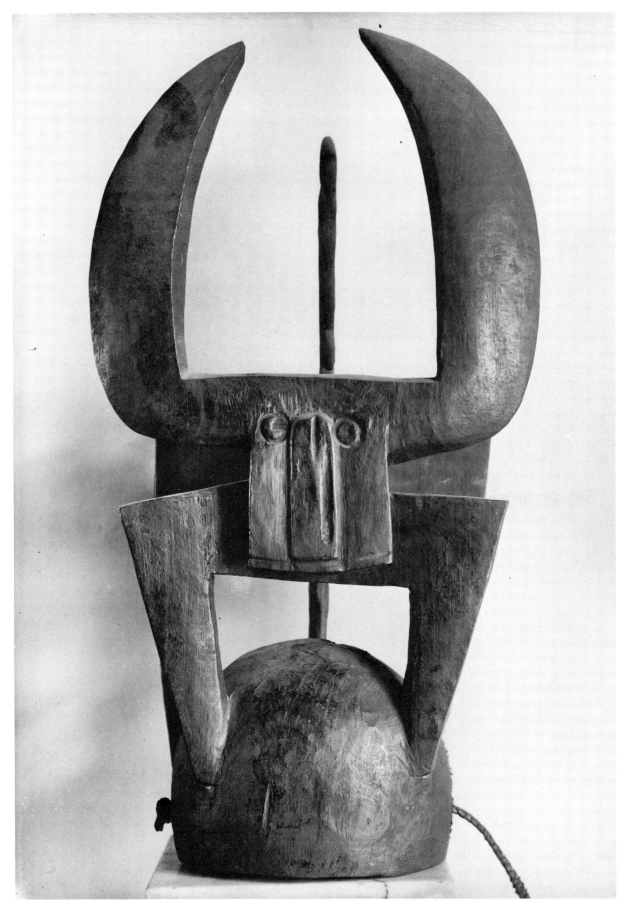

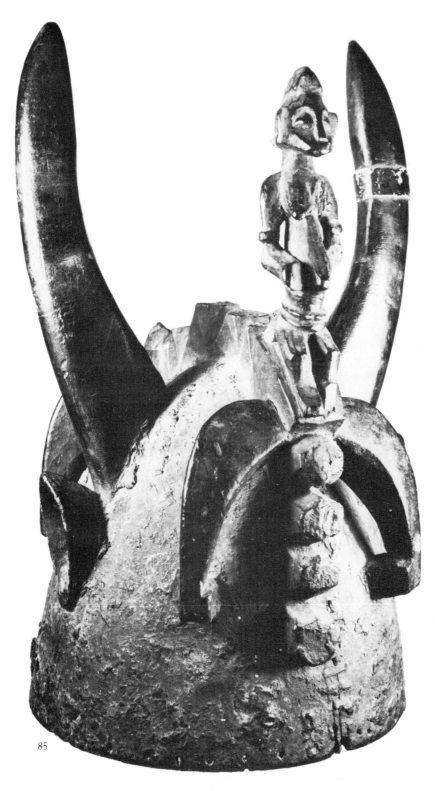

85

84 *Senufo, Ivory Coast, 18".*
Plates 84 through 87 show Senufo headdresses. This is a buffalo headdress with a stylized human face in the middle of the superstructure. There are two flat horns, and the base is hollowed out to form a cap.

85 *Senufo, Ivory Coast, 12¼" (diameter 8").*
This has a standing human figure on the top, two upturned and two downturned horns on each side, and four round protrusions.

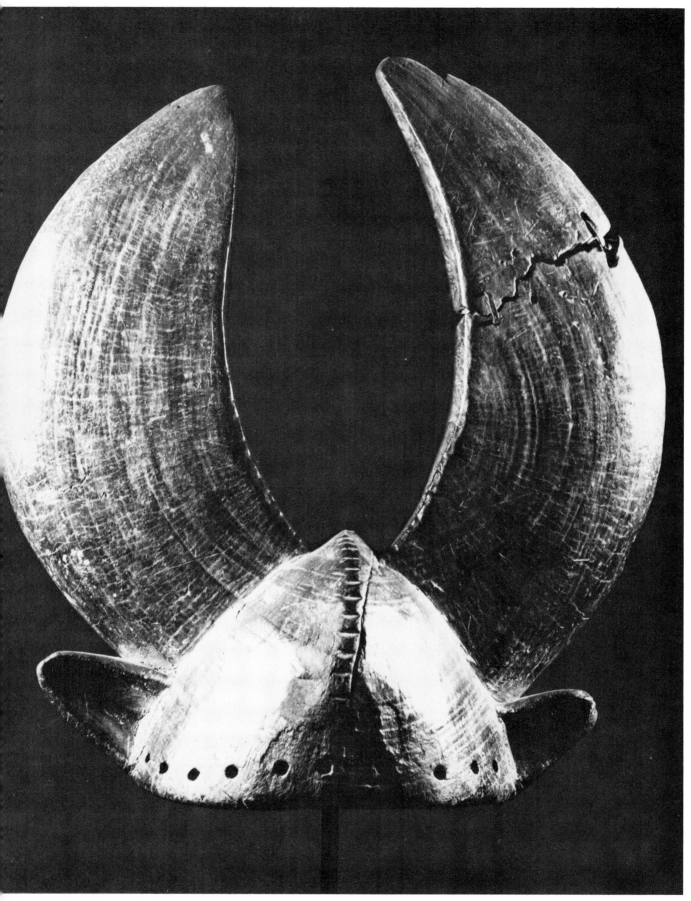

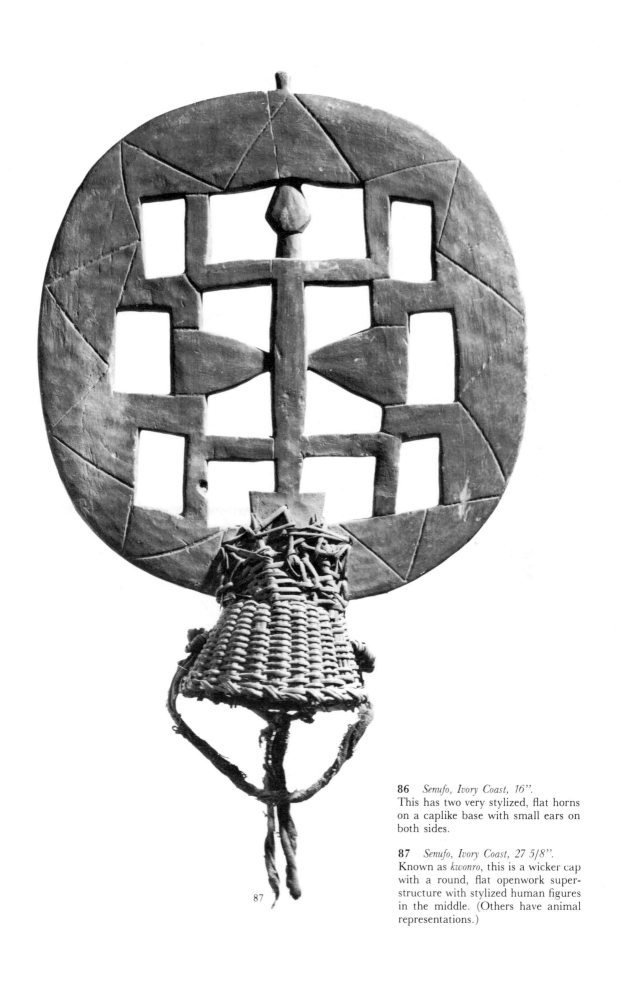

86 *Senufo, Ivory Coast, 16".*
This has two very stylized, flat horns on a caplike base with small ears on both sides.

87 *Senufo, Ivory Coast, 27 5/8".*
Known as *kwonro*, this is a wicker cap with a round, flat openwork super-structure with stylized human figures in the middle. (Others have animal representations.)

87

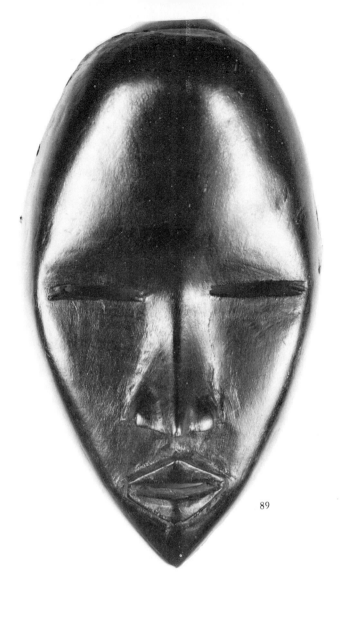

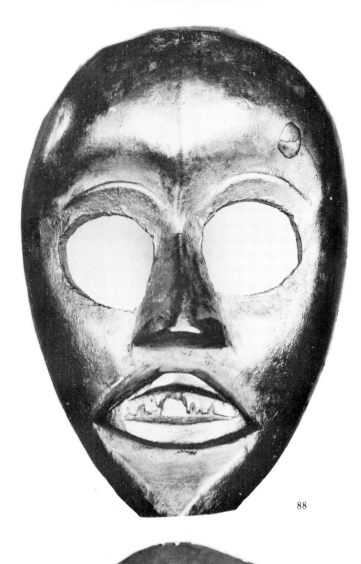

89

88

88 *Dan, Ivory Coast, 8½".*
Typical of Dan masks, with their idealized human faces and smooth, polished surfaces, this is in the classical style, with round eyes.

89 *Dan, Ivory Coast, 7 3/4".*
An extremely simplified mask with slit eyes.

90 *Dan, Ivory Coast, 9¼".*
A rather unusual mask in asymmetric form with oval eyes.

91 *Dan, Ivory Coast, 9".*
Also with slit eyes, this has scarification marks on the face.

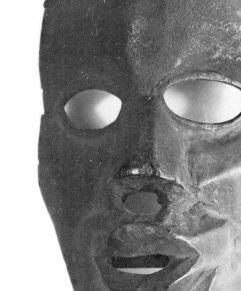

90

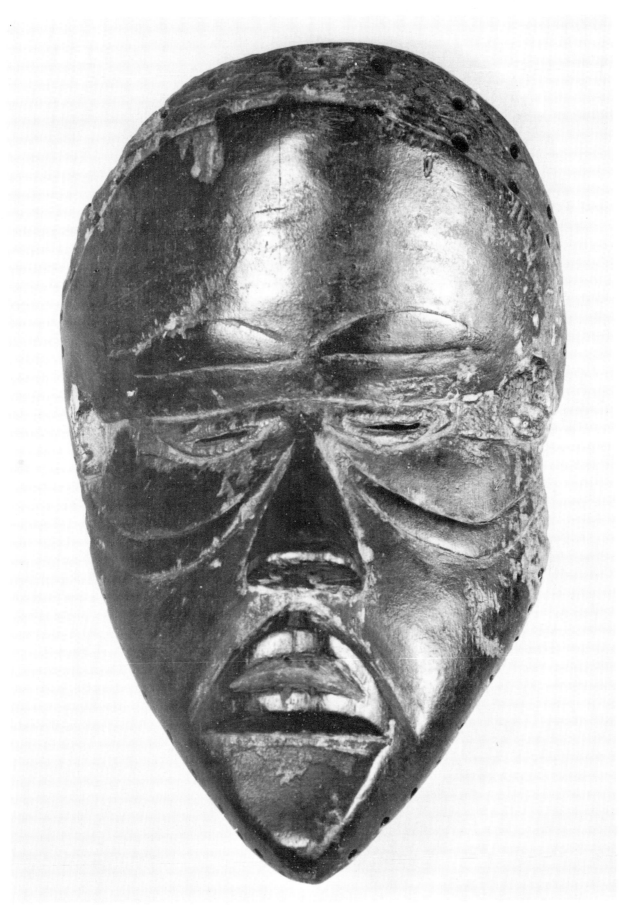

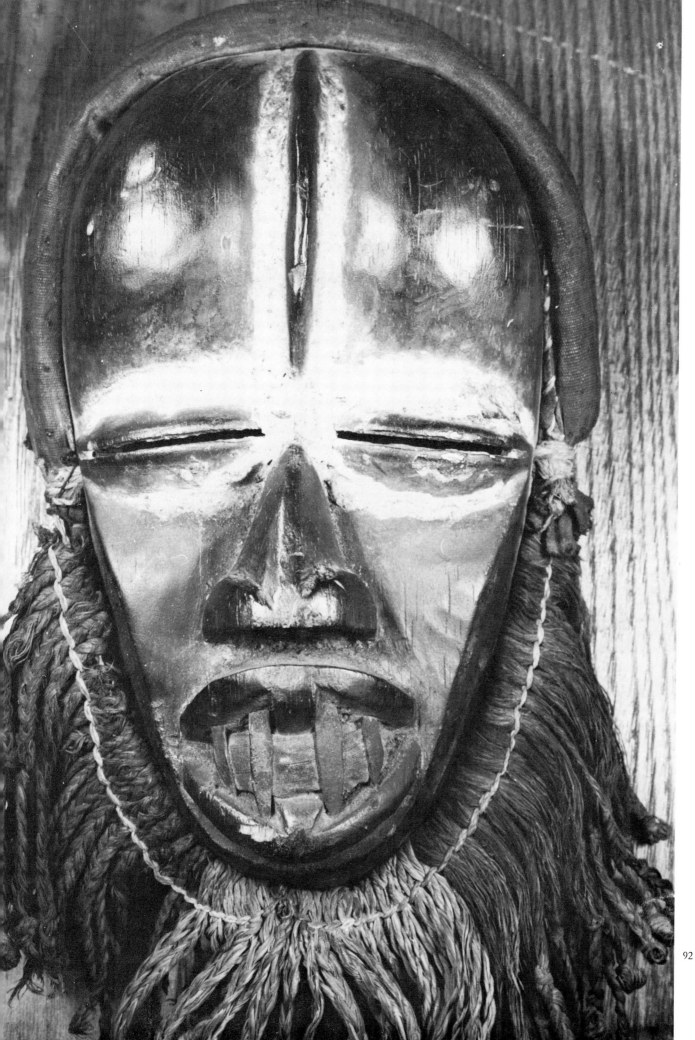

92

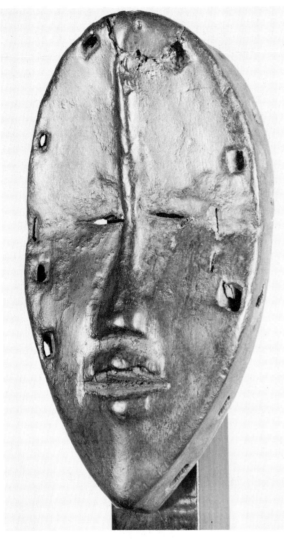

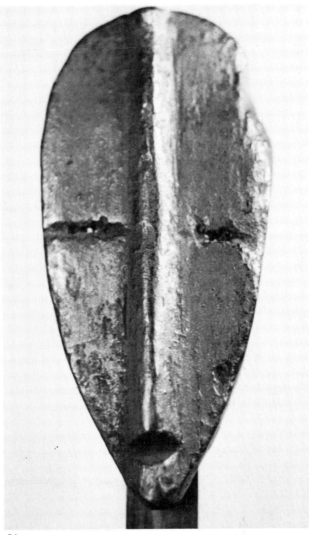

93 94

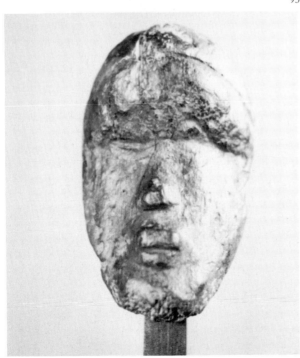

92 *Dan, Ivory Coast, 8½ ''.*
With a beard woven of raffia and metal spikes for teeth. Shows the Guere influence in the eyes. Worn by a "runner" to warn the village of fire in the fields.

93 *Dan, Ivory Coast, 5''.*
A miniature amulet mask *(ma)* related to those of the Guere-Wobe group (see Plate 63 and its caption). The eyes, stylized into two slits, meet at the junction of the planes.

94 *Dan, Ivory Coast, 4''.*
Another *ma* mask consisting of a flat surface with a straight, vertical ridge for the nose and small incisions for the eyes and mouth.

95 *Dan, Ivory Coast, 3½ ''.*
Similar to the *ma* mask, but this time a naturalistic style prevails.

96 *Guro, Ivory Coast, 11½".*
The human masks of the Guro are characterized by a long face, prominent forehead, and elongated nose. This one has an elaborate, three-prong hairdo and scarification marks on the face.

97 *Guro, Ivory Coast, 18 3/8".*
Plates 97 through 102 show Guro animal masks. The best-known are the *zamble* (or *zamle*) masks with crocodile jaws and antelope horns. It has polychrome patterns. It was worn vertically by members of the Zamble society at funerals and at night to hunt sorcerers. Lately masked dancers have been wearing such masks at popular amusements.

98 *Guro, Ivory Coast, 20".*
Of the same type, but with bold, slender horns. The polychroming has been effaced.

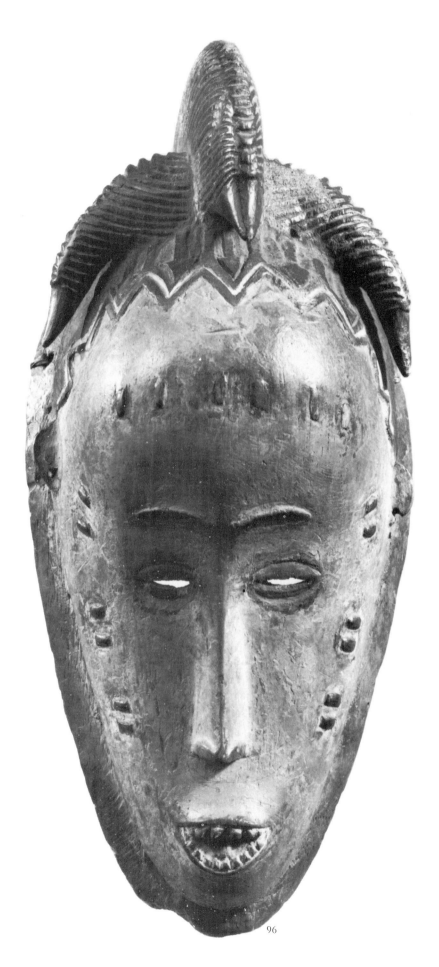

96

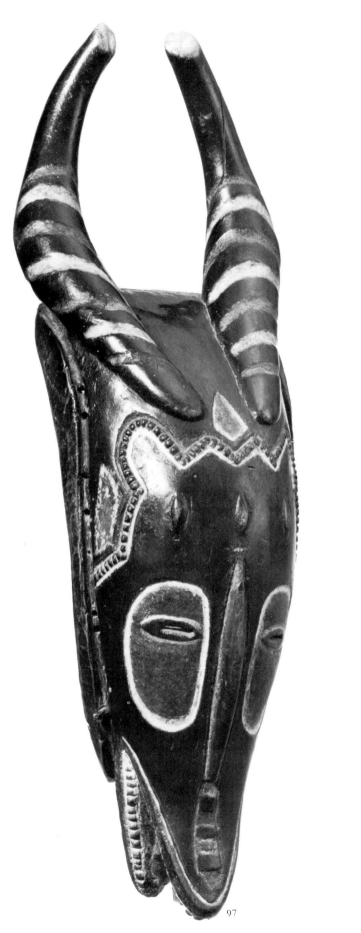

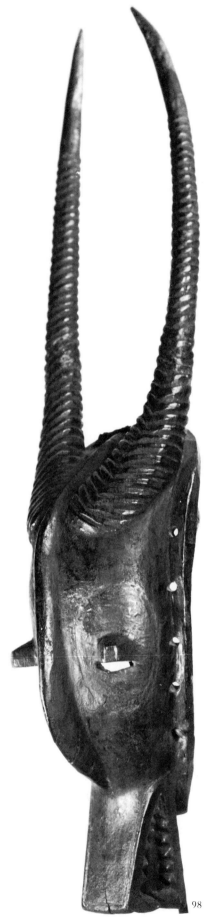

97

98

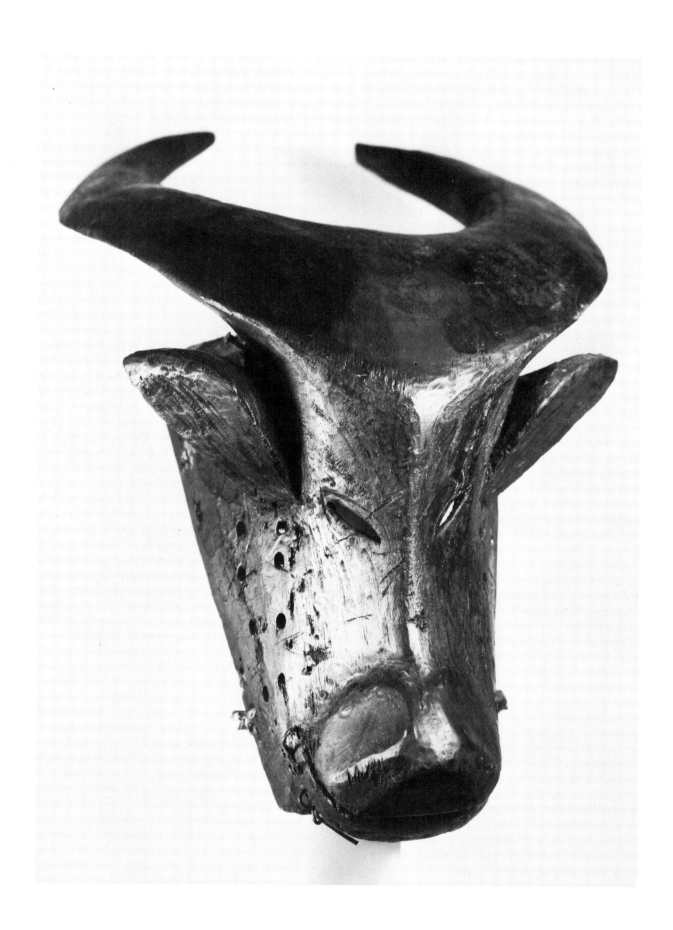

99 *Guro, Ivory Coast, 14½ ''.* A buffalo head of massive construction.

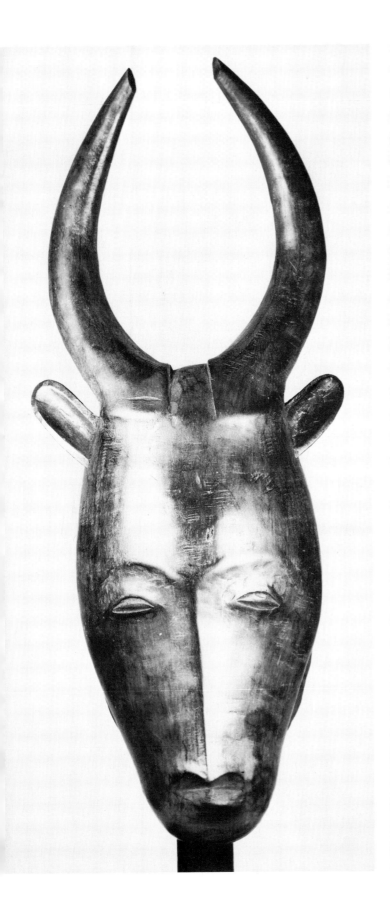

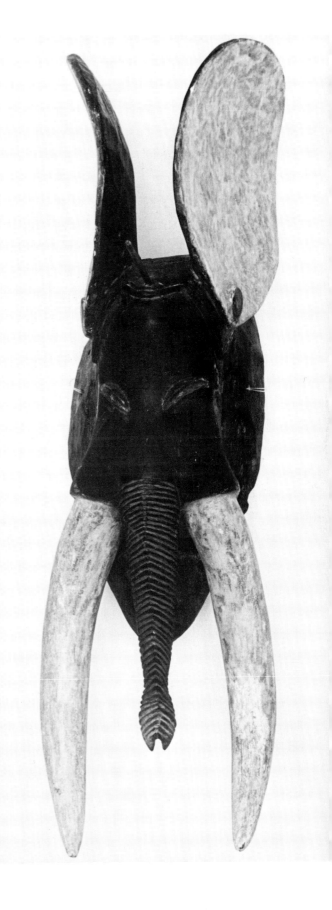

100 *Guro, Ivory Coast, 13"*. Probably an antelope head. **101** *Guro, Ivory Coast, 29½"*. A rather stylized elephant mask.

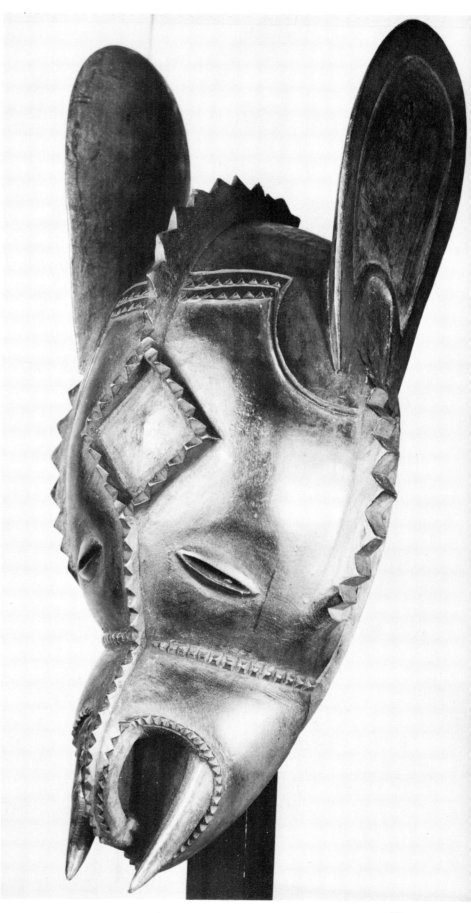

102 *Guro, Ivory Coast, 12½".*
Another elephant mask with decorative elements.

103 *Bwa (Bobo-Ouele), Upper Volta, 16".*
The tribe's best-known type of mask. It represents a buffalo, the tutelary spirit (Do), with a triangular jaw and circular horns and designs. It was worn by the Do society at memorial festivities for the dead.

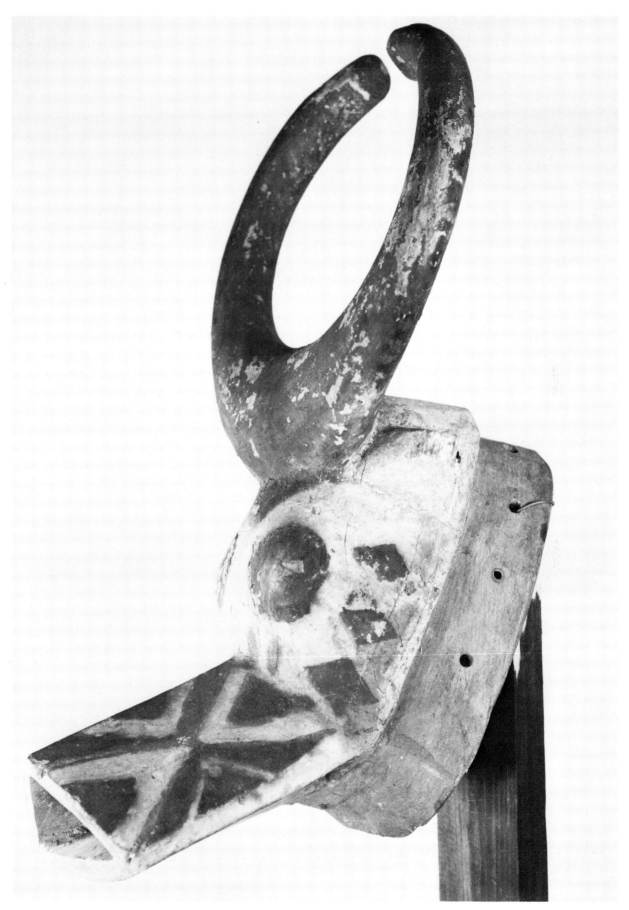

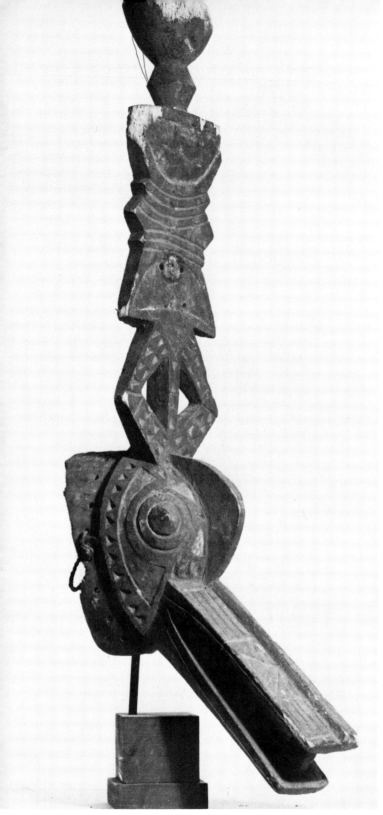

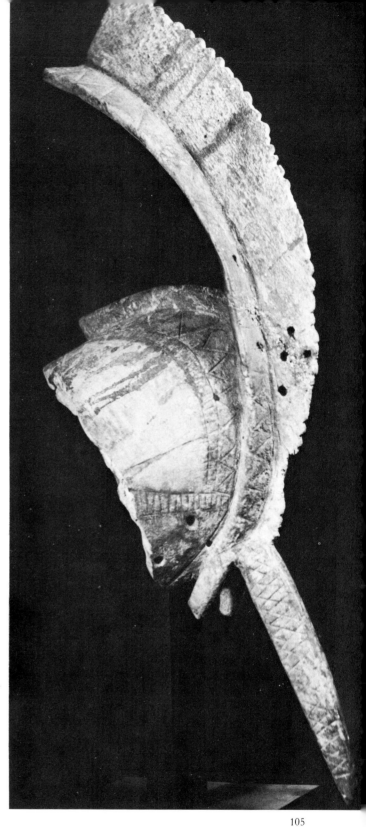

104 *Bwa, Upper Volta, 25".*
The same type of mask, with concentric rings for the eyes and a planklike superstructure (both typical elements of the Bobo-Fing mask). This *doyo* mask was worn in honor of Do, the son of God, who was responsible for the creation of the universe. The secret societies used the same mask at

agricultural festivities—at the beginning of the farming season, etc.

105 *Bwa, Upper Volta, 20".*
A sweeping construction with a bold upper part combined with a straight beak to represent a bird.

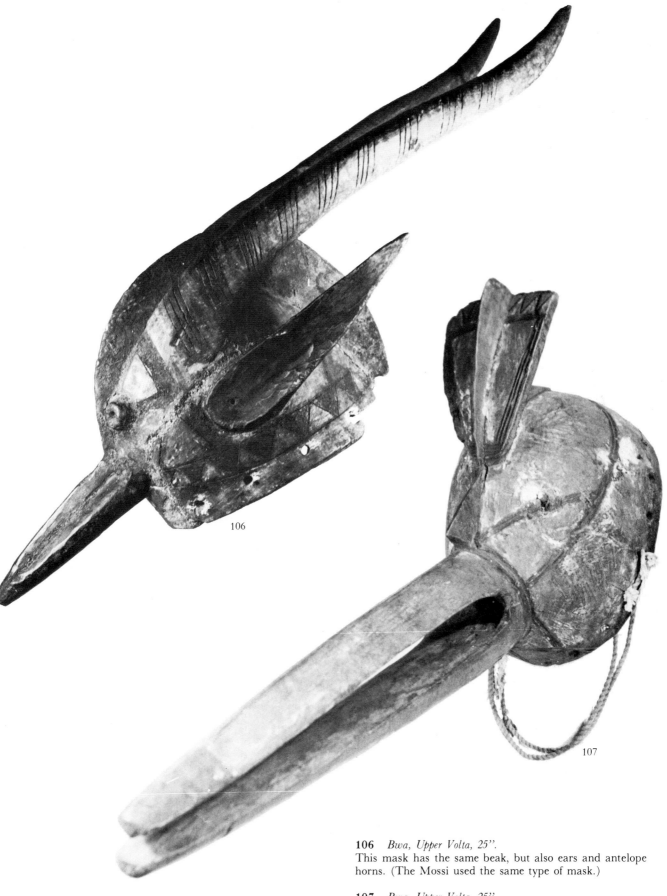

106 *Bwa, Upper Volta, 25".*
This mask has the same beak, but also ears and antelope horns. (The Mossi used the same type of mask.)

107 *Bwa, Upper Volta, 25".*
This represents a hornbill with a long straight beak, open in the middle. The same type of triangular shape on the forehead as Plate 105, only less curved.

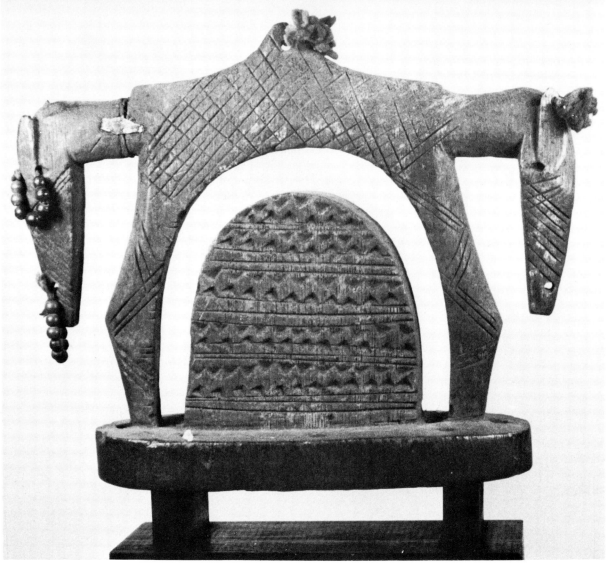

109

108

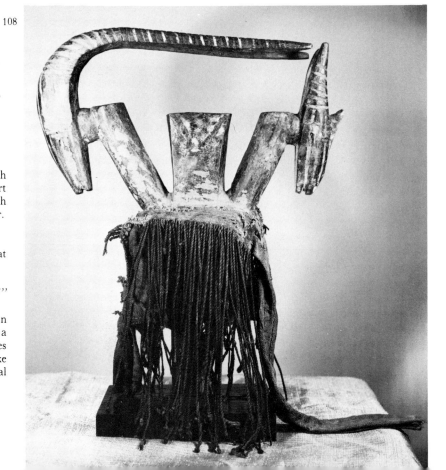

108 *Bwa, Upper Volta, 13½ ".*
A finial of two antelopes, one with
long horns and the other with short
horns. The cords hanging from both
sides covered the face of the dancer.

109 *Bwa, Upper Volta, 6½ "*
A similar headdress with a somewhat
different design.

110 *Bobo-Fing, Upper Volta, 17"*
(diameter 8").
Plates 110 through 113 show human
face masks of the Bobo-Fing. This is a
semihelmet mask, with strong masses
for the nose and mouth and a crestlike
hairdo. It was used at agricultural
rites.

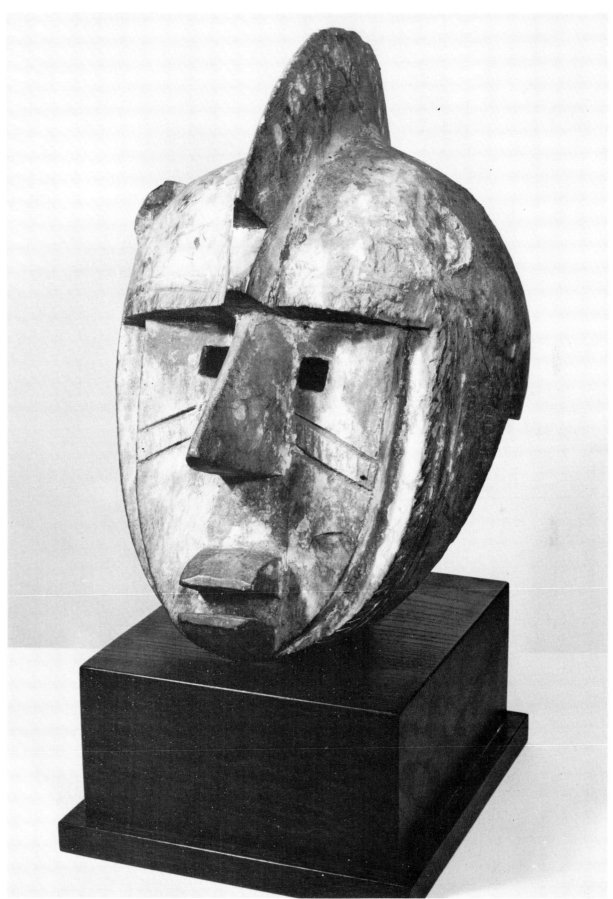

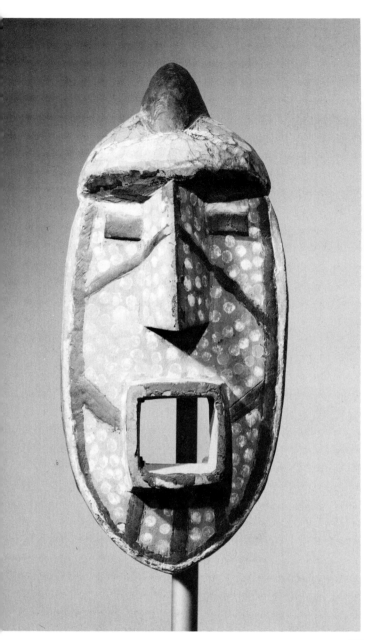

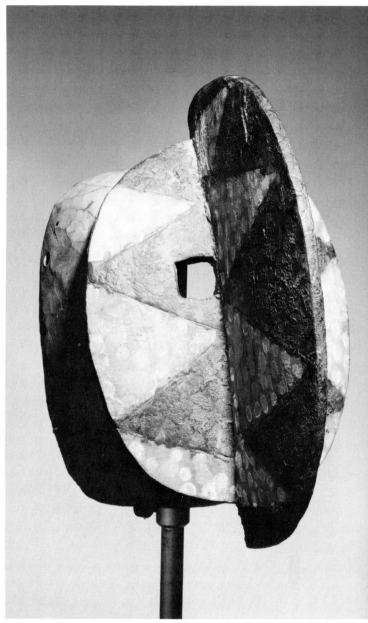

111 112

111 *Bobo-Fing, Upper Volta, 10 7/8".*
Again we find an abstract, polychromed nose and mouth.

112 *Bobo-Fing, Upper Volta, 9 3/8".*
Here we can recognize only the eyes and a large vertical structure probably standing for the nose but extended from the forehead to the chin.

113 *Bobo-Fing, Upper Volta, 43".*
This mask, reminiscent of some of the Bambara masks, has slender horns. It is entirely carved from one block of wood.

114 *Bobo-Fing, Upper Volta, 25".*
Plates 114 through 116 represent the Bobo-Fing masks that feature planklike superstructures. This one, the best-known Bobo-Fing mask, has a flat, owl-like face with concentric rings for the eyes and a small beak with geometric polychrome designs.

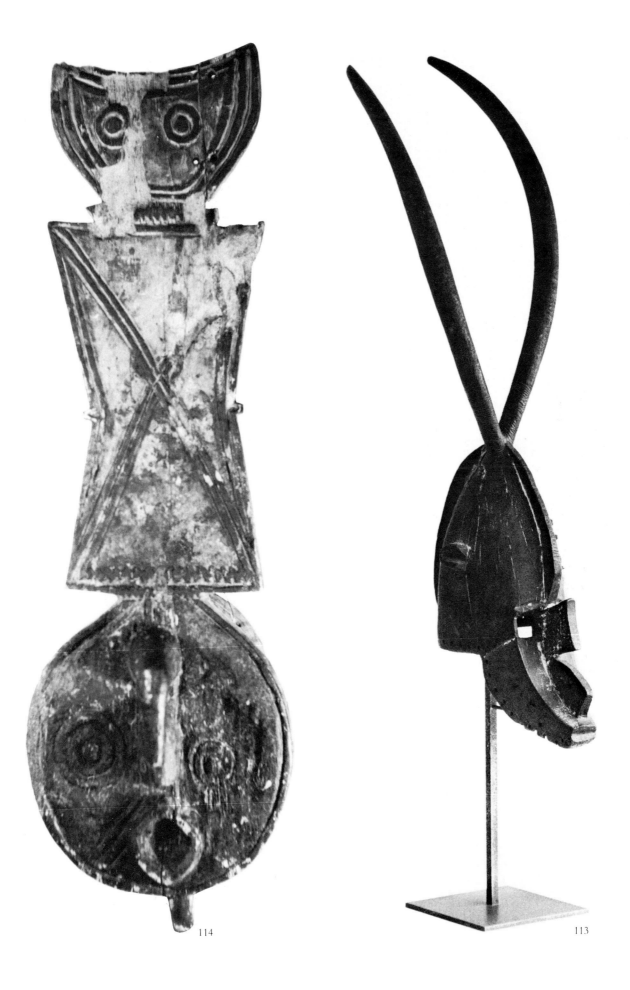

114

113

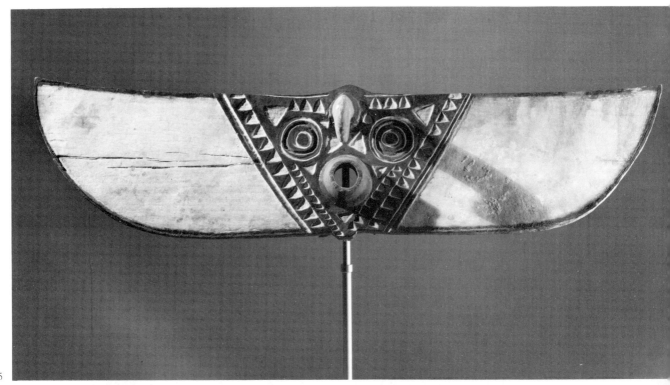

115

116

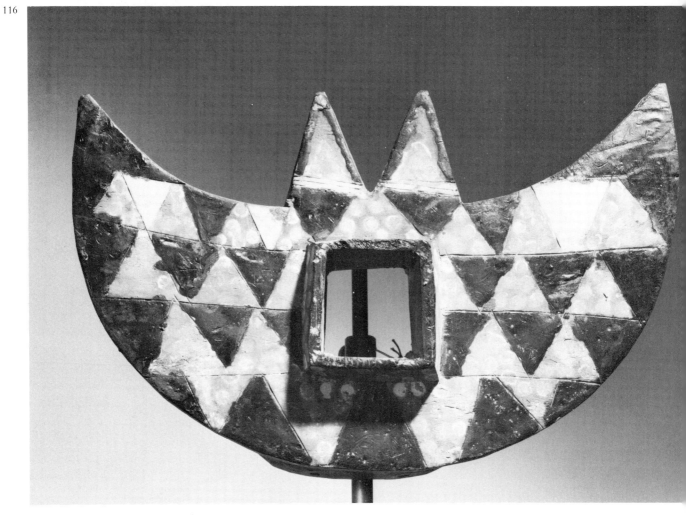

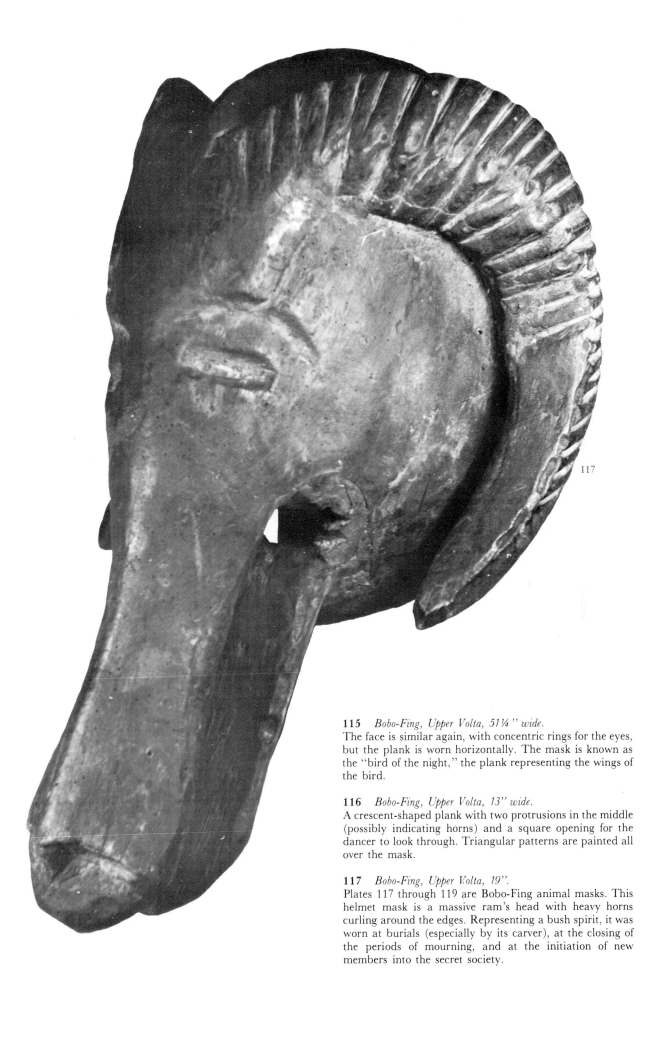

117

115 *Bobo-Fing, Upper Volta, 51¼" wide.*
The face is similar again, with concentric rings for the eyes, but the plank is worn horizontally. The mask is known as the "bird of the night," the plank representing the wings of the bird.

116 *Bobo-Fing, Upper Volta, 13" wide.*
A crescent-shaped plank with two protrusions in the middle (possibly indicating horns) and a square opening for the dancer to look through. Triangular patterns are painted all over the mask.

117 *Bobo-Fing, Upper Volta, 19".*
Plates 117 through 119 are Bobo-Fing animal masks. This helmet mask is a massive ram's head with heavy horns curling around the edges. Representing a bush spirit, it was worn at burials (especially by its carver), at the closing of the periods of mourning, and at the initiation of new members into the secret society.

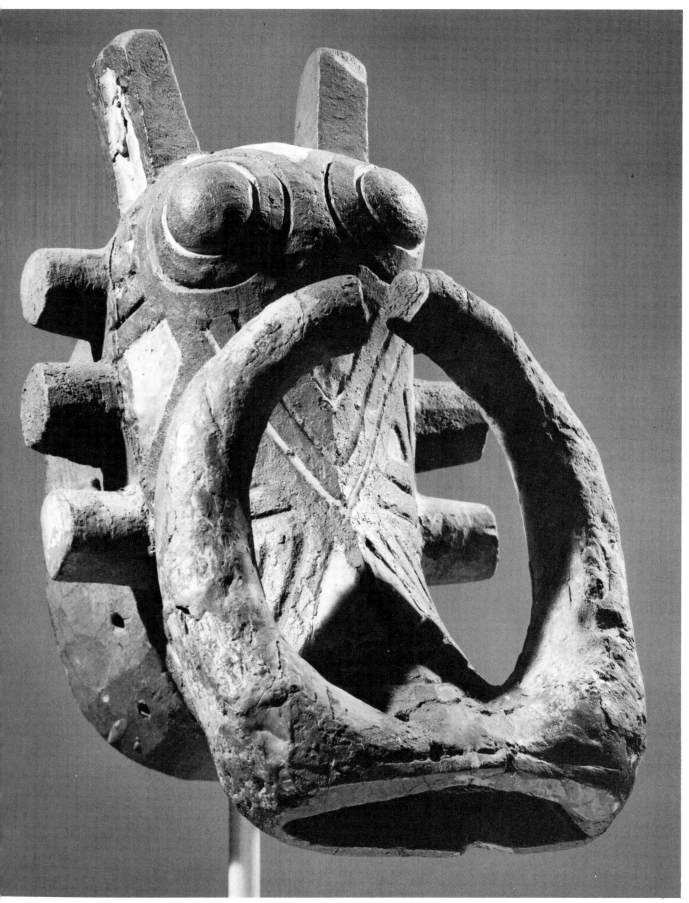

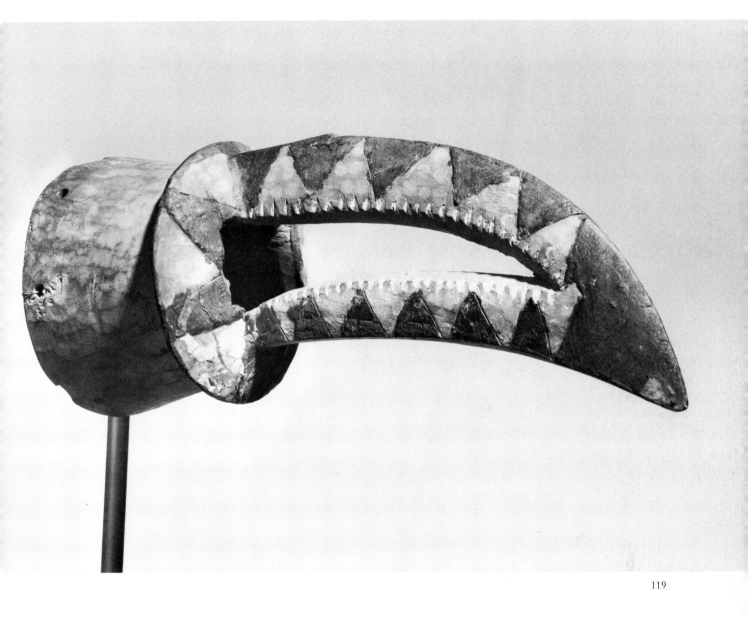

119

118 *Bobo-Fing, Upper Volta, 14 1/8"*.
This helmet mask is an extremely bold head of a warthog, with
six protrusions (probably the warts of the animal) on each side
and a very bold horn formation in front. The eyes are again
concentric circles. It represented a bush spirit, the tutelary
spirit of the village.

119 *Bobo-Fing, Upper Volta, 13 7/8"*.
The entire mask represents a strong bird's beak, probably a
hornbill's, and is similar to the Bwa mask shown in Plate 107.

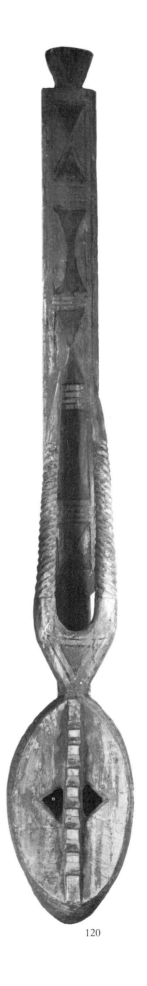

120 *Mossi, Upper Volta, 52".*
A typical Mossi concave-face mask *(yatengo;* sometimes there is
a standing figure on top; convex-face masks are called *wango).*
This one has a bold concave surface for the face, a straight,
vertical ridge down the middle, with notched triangular cuts,
and a planklike superstructure painted in geometric patterns.
This mask was used at the annual festival *(m'peku)* of the
ripening of certain fruits, the offering of propitiatory sacrifices
to the (female) earth deity, and at the burial of old men. Some
masks were considered female; others, male. This distinction
recurs throughout fertility rites for the earth.

121 *Mossi, Upper Volta, 30 3/8".*
A rather unusual mask with deep concavity (similar to some
Dogon masks) and two bold protrusions, probably representing
the wings of a bird.

120 121

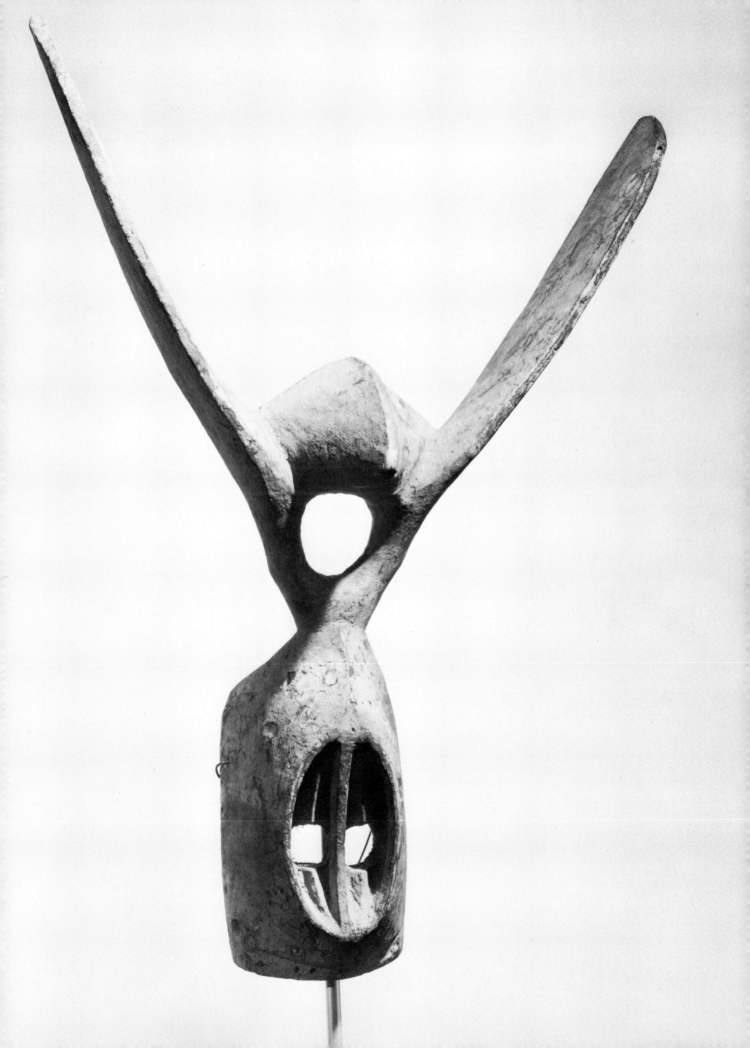

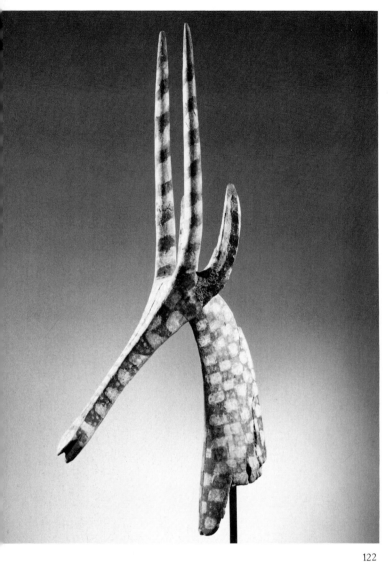

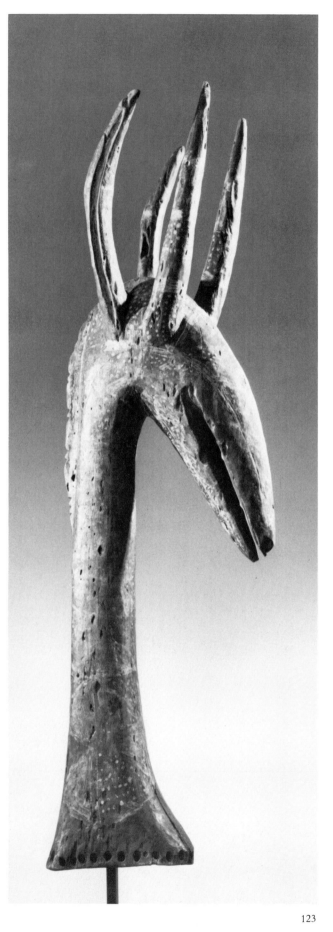

122 *Korumba, Upper Volta, 42 3/8".*
The best-known Korumba headpieces represent the head and
neck of the antelope. This one has long horns with rings painted
on them, short ears, and a polychrome design of squares. It was
worn by the Nonose society at the end of mourning, in order to
drive away the spirit of the deceased, which could harm the
living. The same mask was also worn at agricultural festivities
and by dancers acting out the role of mythical teachers who
came from heaven.

123 *Korumba, Upper Volta, 39 1/8".*
This has shorter polychrome horns the same size as the ears. It,
too, was used by the Nonose society.

124 *Korumba, Upper Volta, 38".*
This plate and the next show the less well-known helmet masks
of the Korumba. This one has two polychrome planks as the
superstructure, one in front, the other in back. It was worn ex-
clusively by the family of the deceased at his burial and at the
feast of the dead.

125 *Korumba, Upper Volta, 32" and 34".*
Two helmet masks in different styles. The faces are merely in-
dicated and topped by roughly carved poles, each ending in a
human head with two horns. Same use as for the preceding
plate.

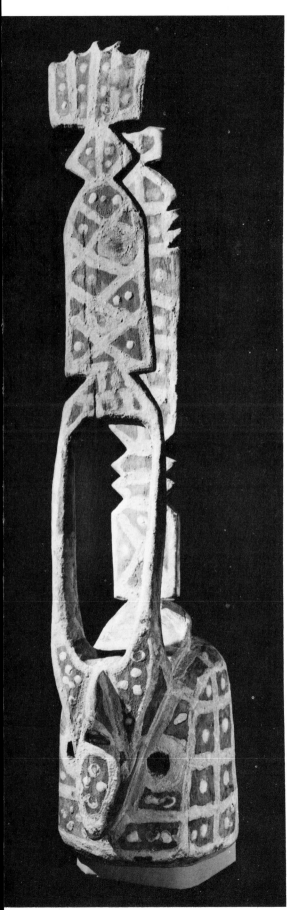

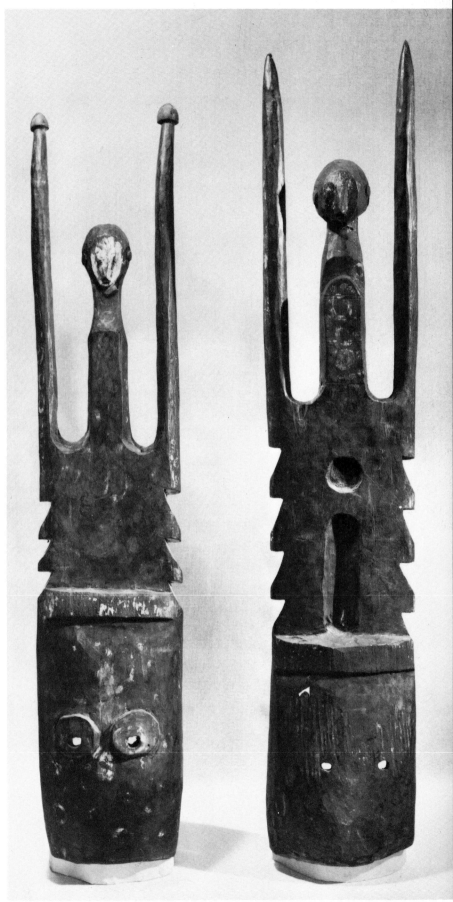

124 125

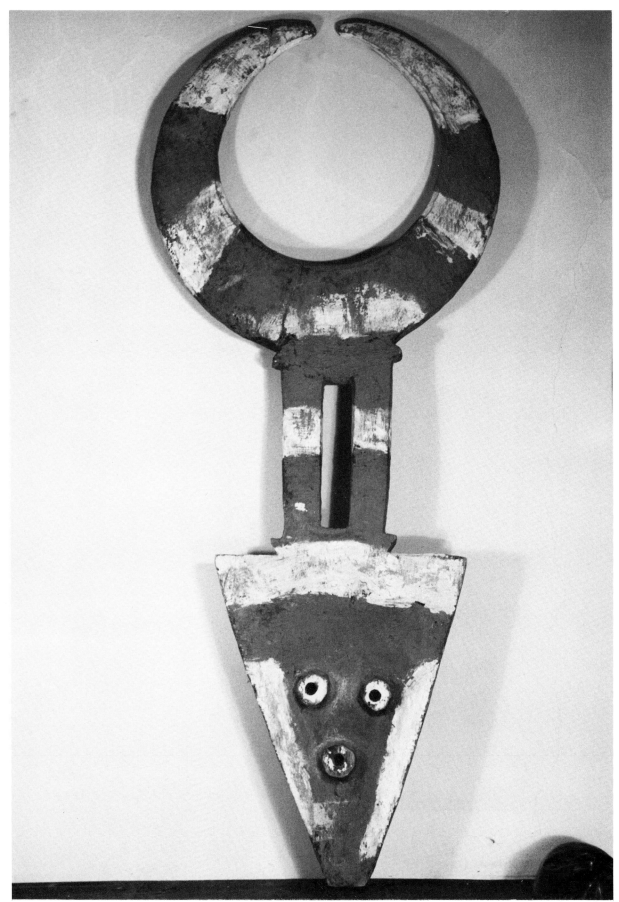

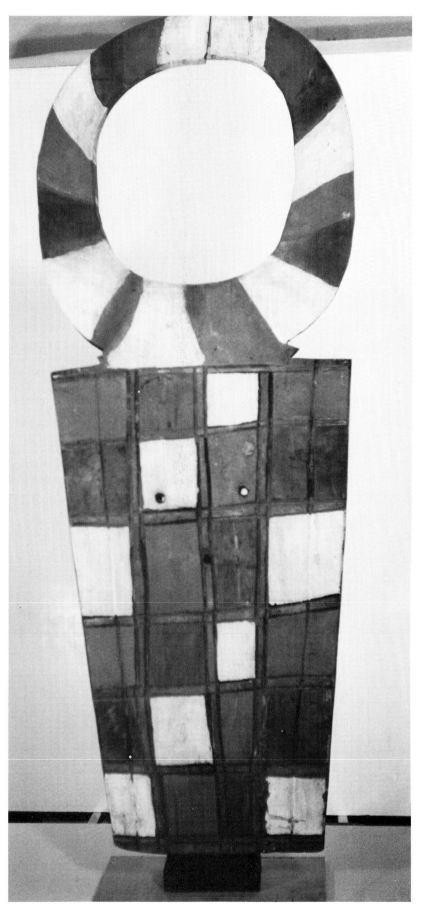

126 *Gurunsi, Upper Volta, 46".*
A plank of abstract design, six feet tall, with crescent horns and three tubular polychrome protrusions for the eyes and mouth. This represented the moon, a female figure, to the Nafara, a tribe from the Ivory Coast and Ghana, in their Bedu full-moon dance. The mask in Plate 127 represented the sun (male) in this ceremony. By using the two masks together (reminiscent of the *tyi wara* male and female antelopes performing together), the tribe associated the fertility of the earth with procreation. The Kulango of the Ivory Coast used the two masks at the end of the harvest. It is noteworthy that both the moon and the earth have female attributes.

127 *Gurunsi, Upper Volta, 53".*
This is different in structure, with round "horns" and three holes merely indicating the eyes and mouth. Strong rectangular patterns are painted on the mask. See Plate 126 for use.

128 *Kulango, Ghana, 22".*
The Kulango live partly in the Ivory Coast. This is known as the *aban* mask.

129 *Ashanti, Ghana, 3½".*
A small brass mask used for weighing gold.

130 *Ijaw (Ijo), Nigeria, 35¼".*
An *imole* water-spirit mask, with the jaw of a crocodile, a human face in the middle, four-legged animals on both sides, and, underneath, what appears to be a fish tail with a hollowed-out wooden cap. These masks were worn over the head horizontally, so that when the wearer walked in the water to appease or petition the spirit, the mask appeared to float. The masks were a combination of the features of human beings and the crocodile, shark, sawfish, hippopotamus, or some imaginary animal. Various societies, such as the Sekiapu of the Ijaw and the Obukele of the Abua Ibo, were organized to conduct these water-spirit ceremonies.

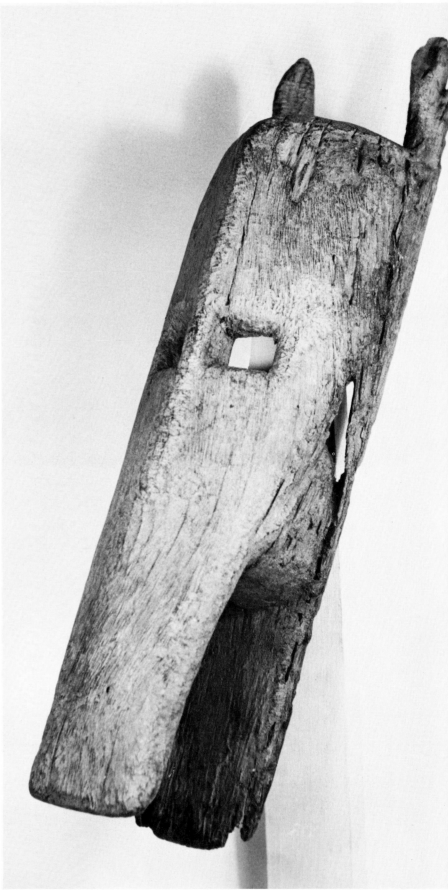

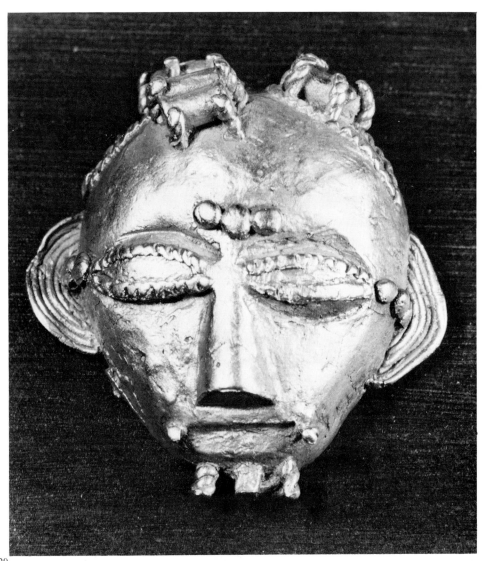

129

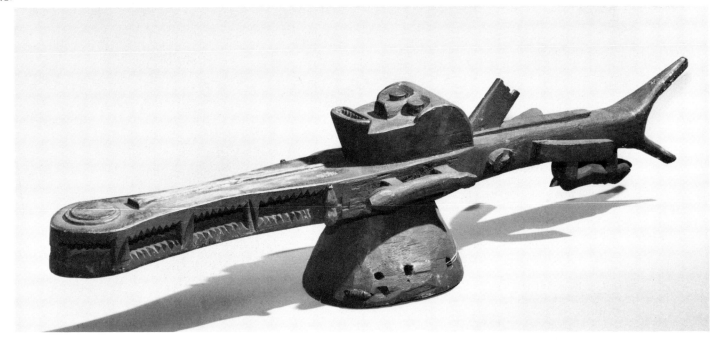

130

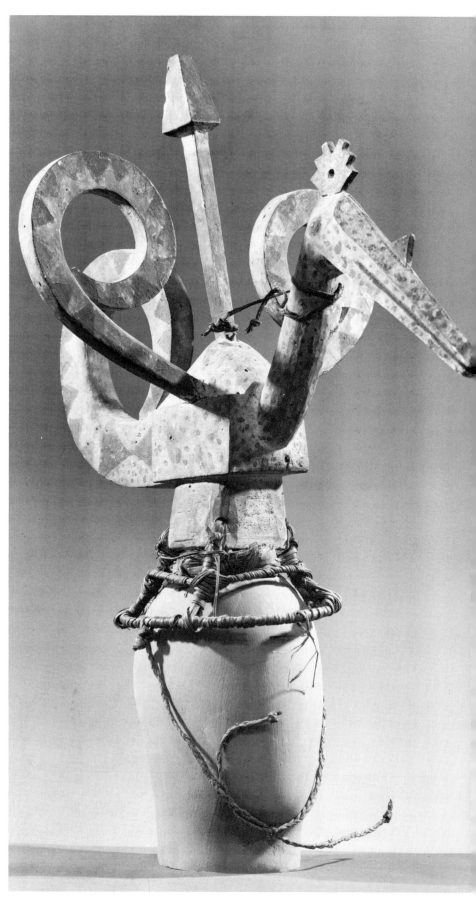

131 *Ijaw, Nigeria, 20½".*
A rather unusual headdress, with a basketwork cap, representing a fantastic polychrome birdlike creature.

132 *Ibibio, Nigeria, 8¼".*
Plates 132-135 are examples of the naturalistic Ibibio masks with idealized human features. This one has slits for the eyes reminiscent of some Dan masks. Plates 132, 134, and 135 are various masks used by the Ekpo society to honor their ancestors and to enforce the law.

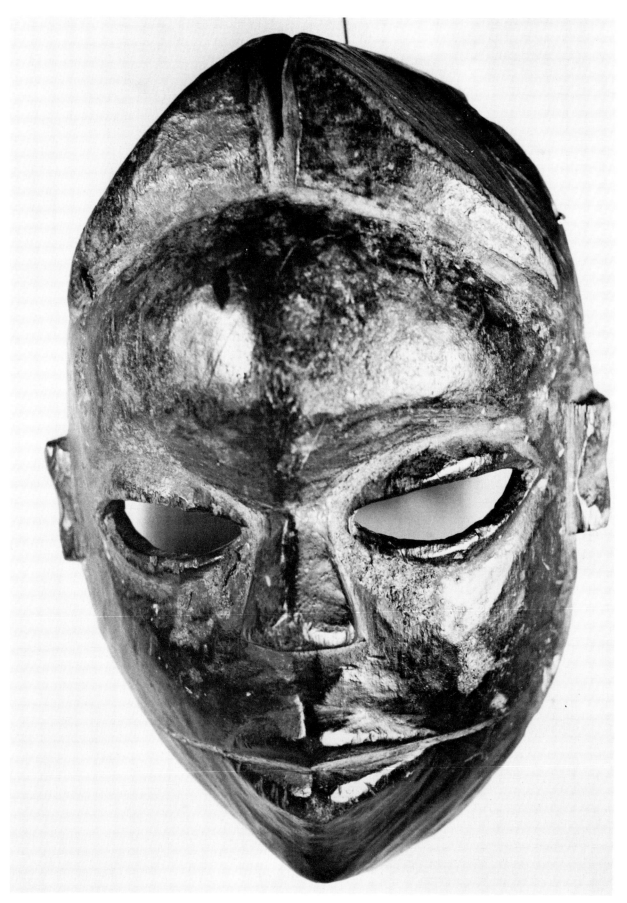

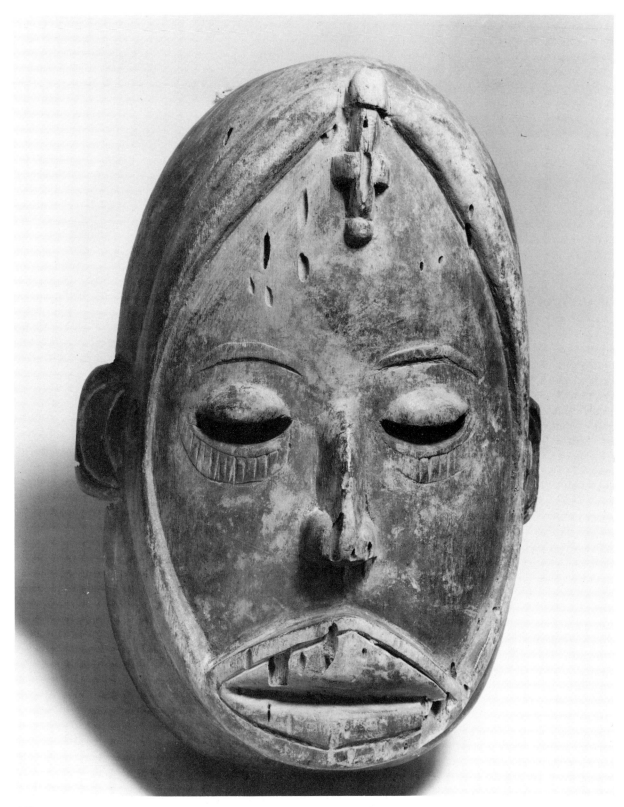

133

133 *Ibibio, Nigeria, 12".*
Here the naturalism has developed toward more stylization. The eyes are half-closed; the mouth is framed by a groove; and on the forehead is apparently an animal in low relief.

134 *Ibibio, Nigeria, 8½".*
This has strong Negroid features and an elaborate, stylized hairdo. This mask of the Ekpo society, used by the Ibibio mutual aid officer, is also attributed to the Ogoni. It has a movable jaw, in some examples showing the teeth, which consist of small sticks of wood implanted in the lower jaw.

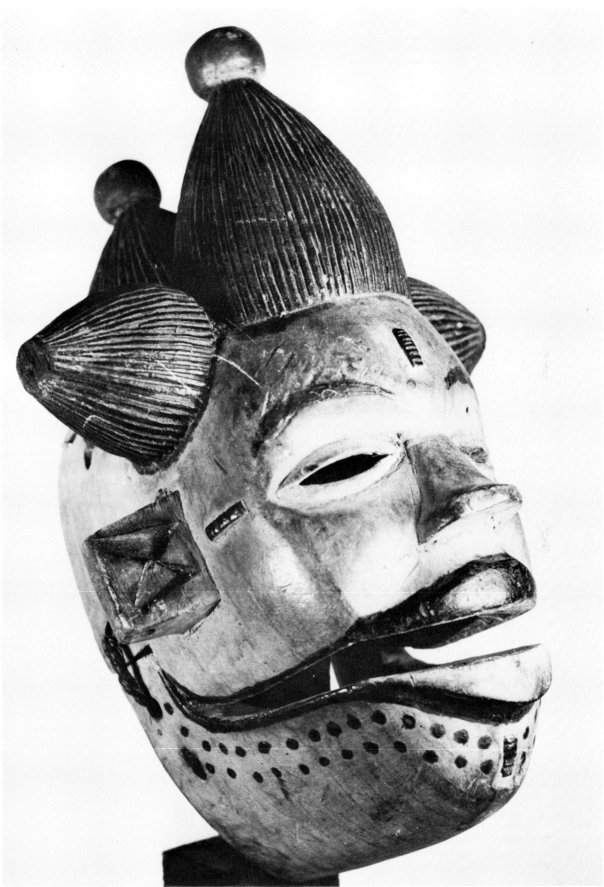

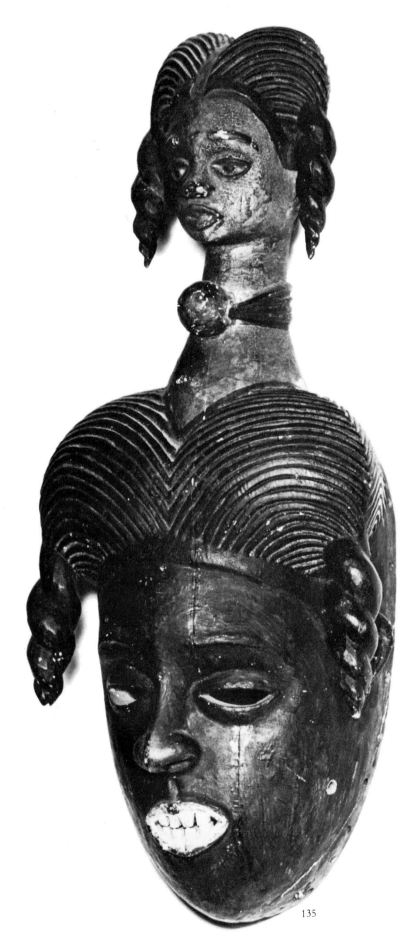

135 _Ibibio, Nigeria, 18½"._
This bears a strong resemblance to the Ibo maiden-spirit masks (see Plates 140-142) except that it is not white. The small head above has the same hairdo as the one below.

136 _Ibibio, Nigeria, 12½"._
Horns like those of the Ekoi masks (Plate 185) are pegged onto the mask. The projection on the top is carved from the same piece of wood as the mask itself.

135

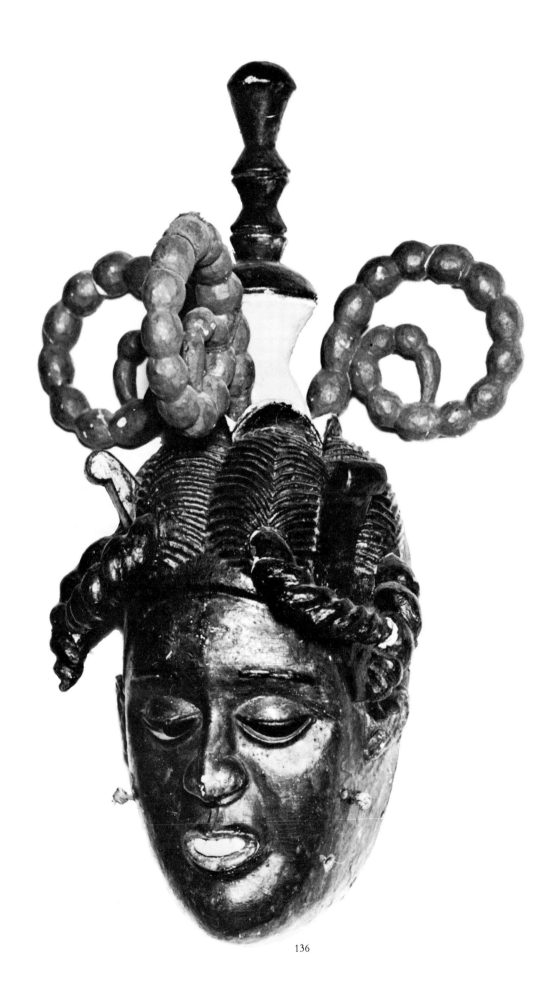

136

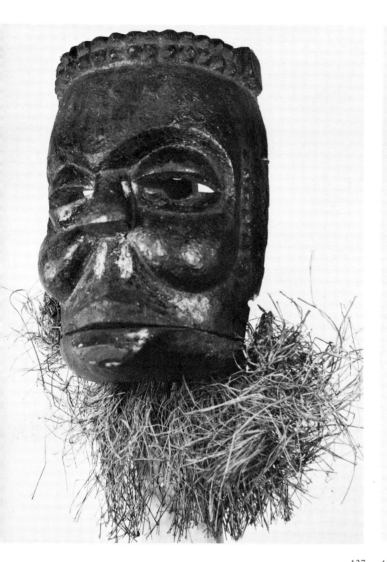 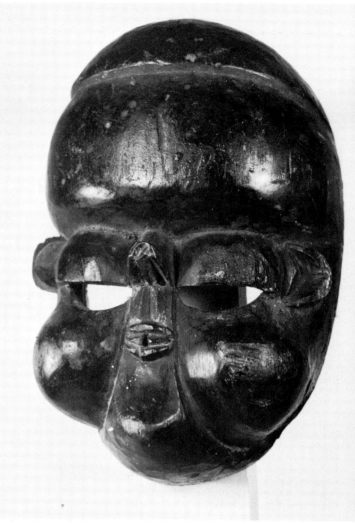

137 138

137 *Ibibio, Nigeria, 12½".*
Bold, exaggerated, sometimes frightening features distinguish the second style of Ibibio mask (Plates 137-139). This mask, supposed to represent the spirit of the underworld, has a bold expression and a movable jaw to which raffia is attached.

138 *Ibibio, Nigeria, 11".*
This mask showing bone disease in the nose is typical of a great many.

139 *Ibibio, Nigeria, 12".*
This large-eyed mask is decorated with red seeds, feathers, and a hornbill beak.

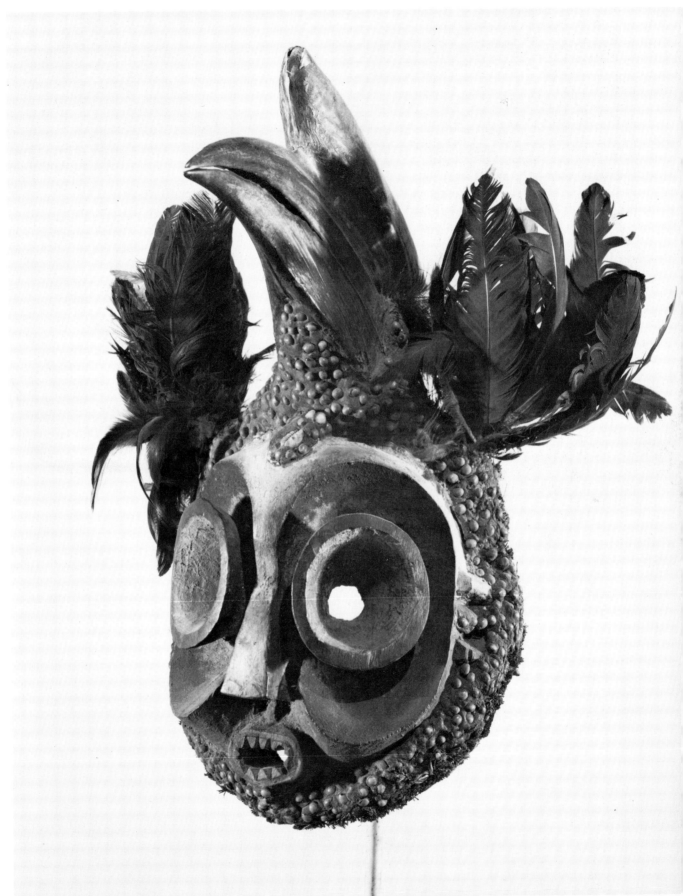

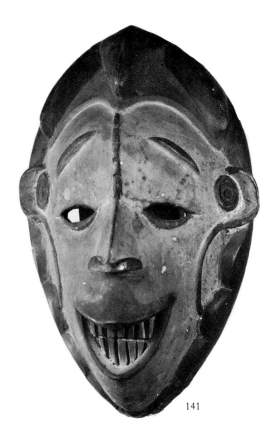

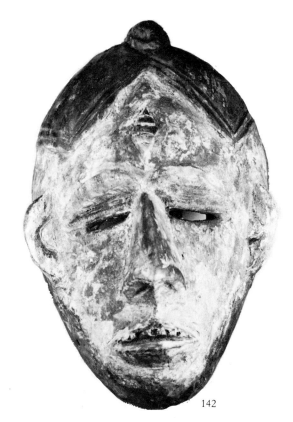

141

142

140 *Ibo, Nigeria, 10½".*
Plates 140-142 show the white-colored *aghogho* face masks of the Ibo (or Igbo), which represent the maiden spirit. The present mask is a rather naturalistic type, with three prongs forming part of the hairdo. White was the symbolic color of the dead. The *aghogho* mask was used by the Mmwo society. Masked dancers costumed in brightly colored patchwork pants and blouses, with their hands and feet covered, appeared at funerals. The masked dancers did not merely represent, but were believed to be, the spirits of the dead. They disguised their voices, aiming, as in so many African burial ceremonies, to induce the dead man's spirit to enter the spirit world *(ebe mno)* so as to avoid any harm to the survivors. The same mask was also used at the beginning of the dry season. Representing the delicate beauty of woman, the dancers appeared wearing false breasts, associating human fertility with the fertility of the land. Senior members of the tribe also used the masks for police duty.

141 *Ibo, Nigeria, 9".*
This is the same type of mask (the white color has darkened), with ornamental painted patterns and an open mouth showing the teeth.

142 *Ibo, Nigeria, 10½".*
This has a rather idealized (we may say spiritualized) expression, which the Ibo call *oko rosia nma*, meaning "good-pretty."

143 *Ibo, Nigeria, 16".*
This plate and the next show three-quarter-length helmet masks used by the Mmwo society. This one has a crested top, probably a kind of hairdo. Most of the maiden-spirit masks are by their refined facial expression feminine in character, but this one has an extremely sensitive mouth, half-closed eyes, and long nose, with a serene expression strikingly similar to late classic Maya stucco heads.

144 *Ibo, Nigeria, 37".*
This mask has a complex superstructure of four different animals.

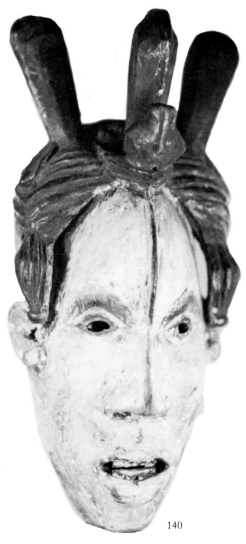

140

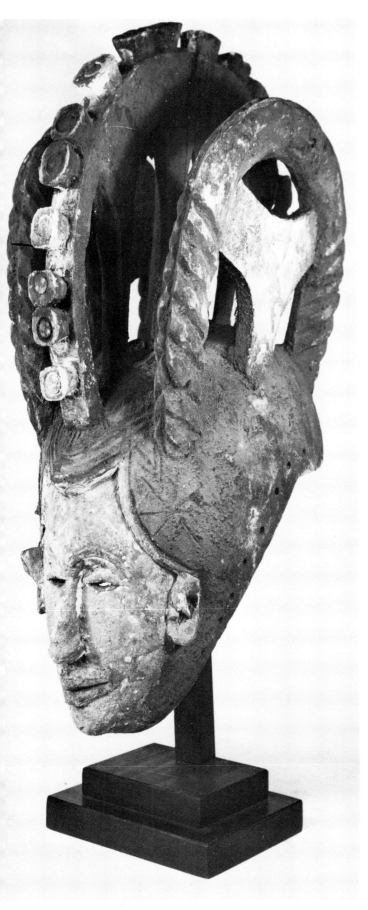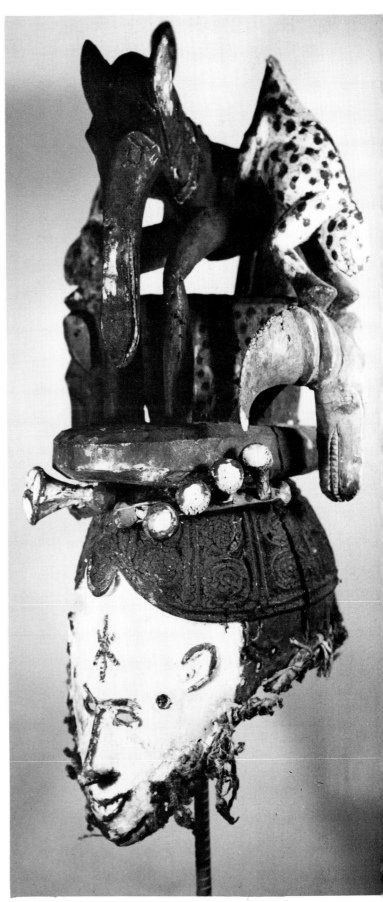

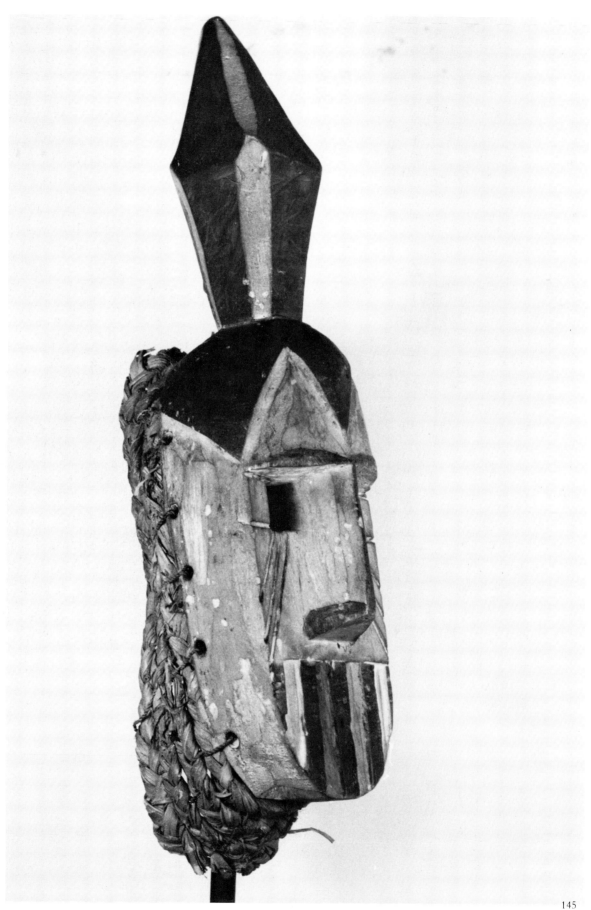

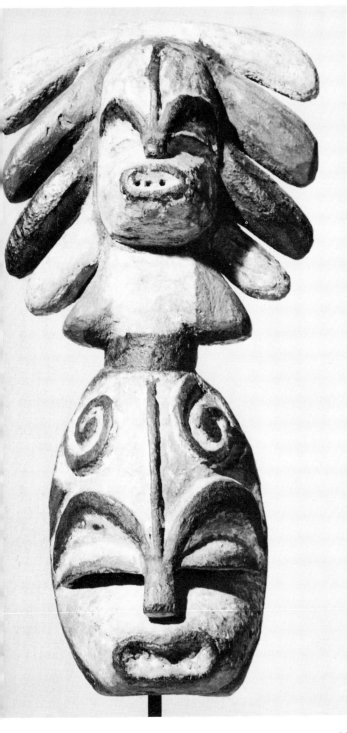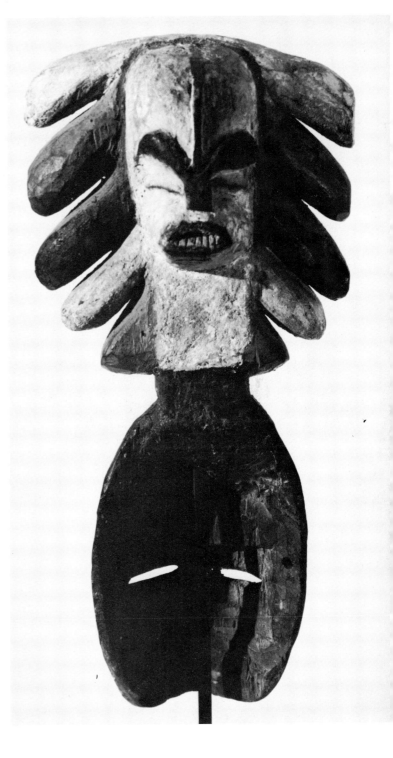

146

145 *Ibo, Nigeria, 12".*
This mask and the following one are *mba* masks, which usually had a flat board for the superstructure. The present one, known as *mmwo ogbegu* or *achali*, is different but still in the same class. The white color has been rubbed off. On the chin is a pattern of black and white vertical lines. Woven raffia was attached to the rim of the mask. The Ibo often added this to make their masks thrust forward.

146 *Ibo, Nigeria, 18 3/4".*
Both sides of a boldly carved *mba* mask with a Janus-faced superstructure. Each side has a different face, and there is a hairdo on both the front and the back.

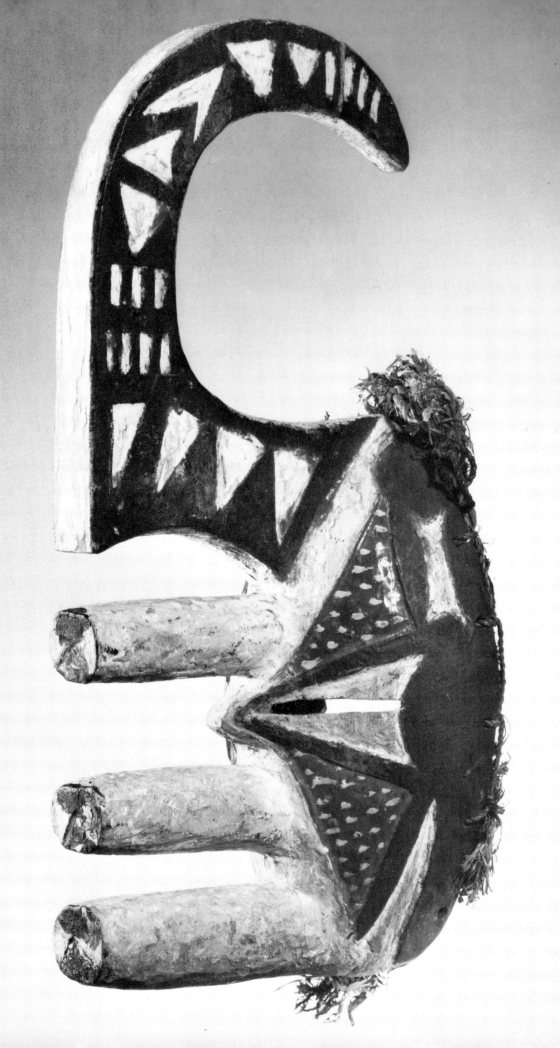

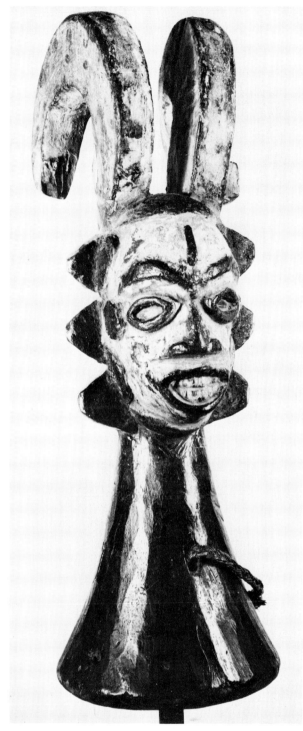

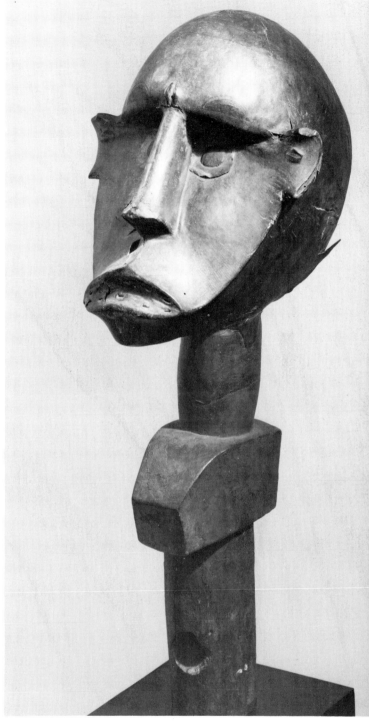

147 148 149

147 *Ibo, Nigeria, 12¼ ''.*
The *mmaji* (or *maji* or *ma ubi*) masks of the eastern Ibo are en-
tirely different. This is a highly abstract mask with three
peglike projections, possibly indicating teeth, and a curved
form thrusting upward from the forehead to indicate the
blade of the machete used at the cutting of the yam. The
mask was also used at the beginning of the rainy season.

148 *Ibo, Nigeria, 13''.*
Plates 148 and 149 are Ibo headdresses. This one has a
white face and hornlike ornaments on top of the head.

149 *Ibo, Nigeria, 22½ ''.*
From the Owerri region, this was attached to a cap placed on
the dancer's head in the *ogbom* play.

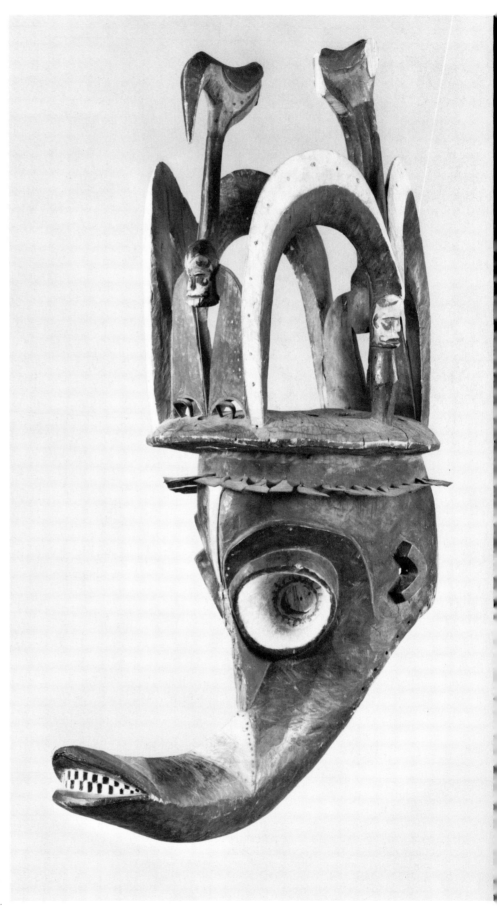

150 *Ibo, Nigeria, 35½ ".*
This mask and the next are unusual and do not fit into any of the above categories. This one has an elephant trunk and a superstructure composed of carvings of birds, small animals, and human faces.

151 *Ibo, Nigeria, 11".*
This one has lozenge-shaped eyes, a triangular nose, round protrusions, and a hairdo.

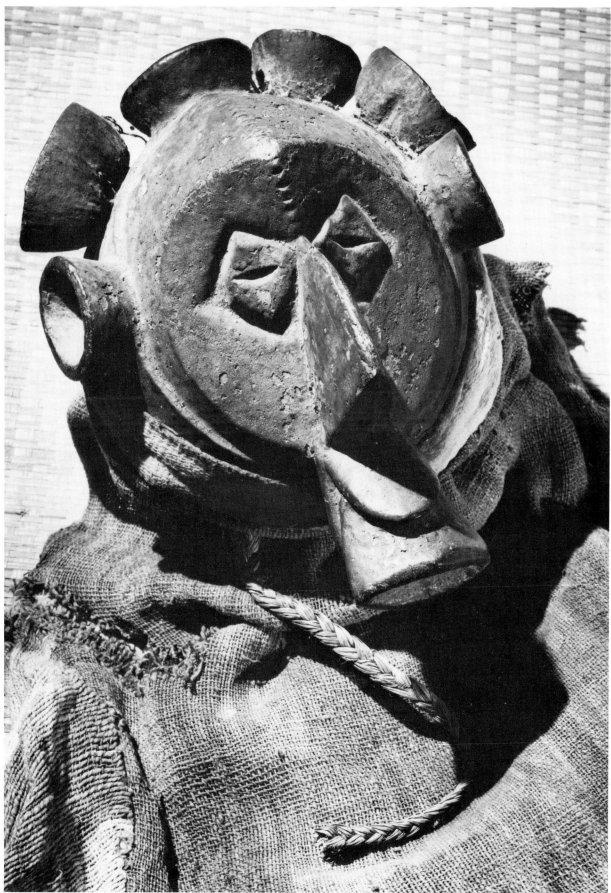

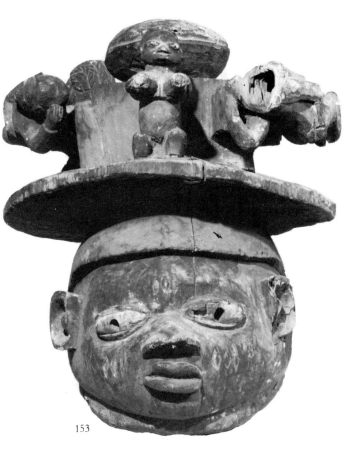

153

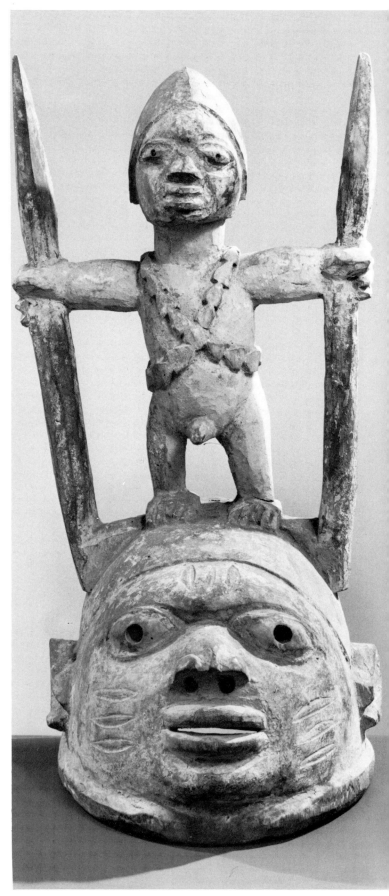

152 *Yoruba, Nigeria, 17 3/4".*
Plates 152 and 153 are Gelede society masks, worn horizontally like a cap. They have strong Negroid features and are often painted with imported oils. (Like most of the face coverings of the Yoruba, they are headdresses, parts of elaborate costumes which covered the masked person's body in different secret societies.) This one shows a standing figure on the top of the mask holding two poles. The members of the Gelede society wore these masks on various occasions: to promote fertility at agricultural festivals honoring the god of the earth (Ala), also petitioning the benediction of ancestors; to "placate the witches," when masked men impersonated women, wearing artificial breasts and padding their bodies; and at funerals.

153 *Yoruba, Nigeria, 16".*
Here the superstructure consists of a female figure in front, recumbent men on both sides, and four small animals on the back.

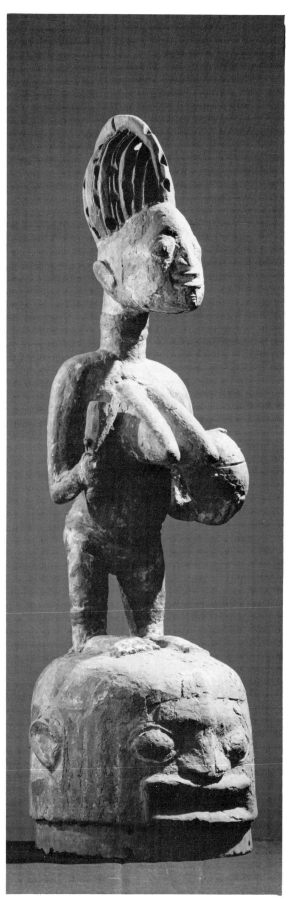

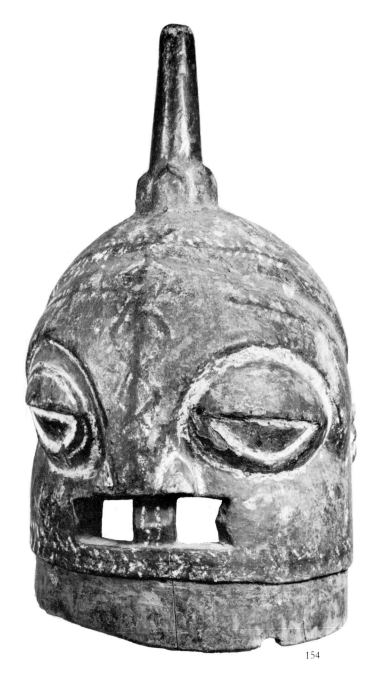

154

154 *Yoruba, Nigeria, 16" (diameter 9½ ").*
Plates 154 and 155 are helmet masks for the Epa festivities. This is one of the simplest masks, with a strong, angular mouth, prominent eyes, and painted red and white lines.

155 *Yoruba, Nigeria, 31 5/8".*
This shows a standing figure, with prominent breasts, holding a bowl in her left hand. (Some Epa masks have several layers of figurines, sometimes with an equestrian figure and his attendants in the middle.) This mask, which represented the spirit of the dead, was dedicated to growth in general and to fertility.

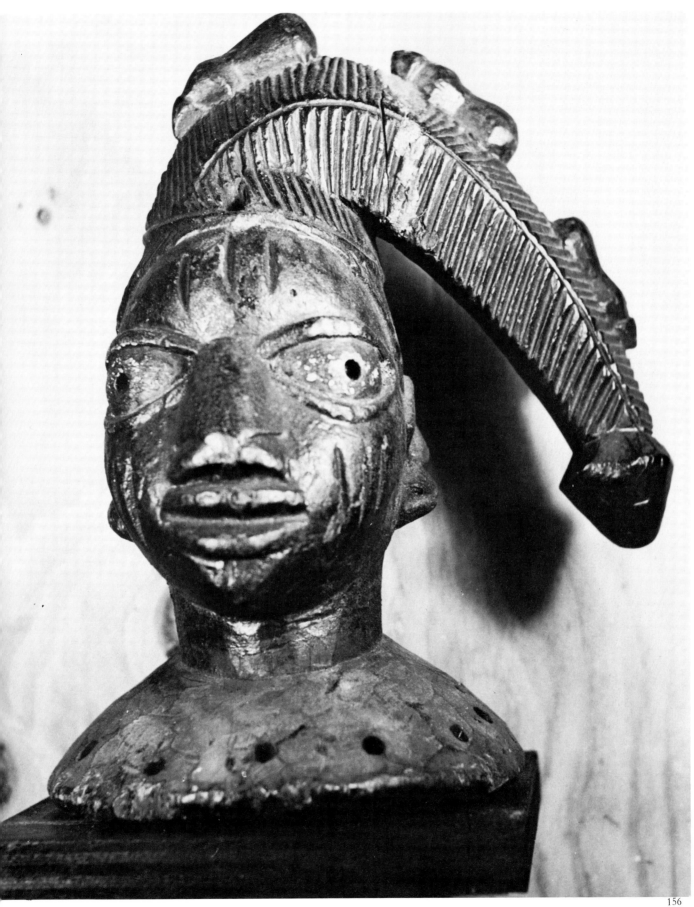

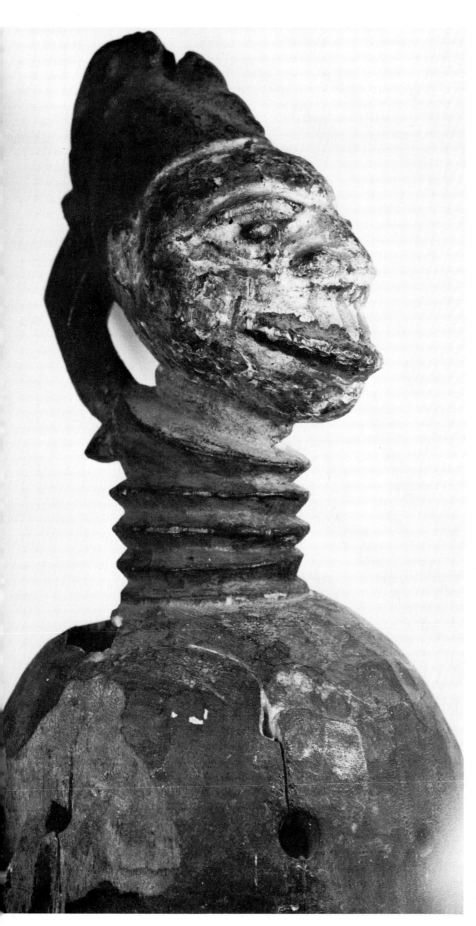

156 *Yoruba, Nigeria, 12".*
Plates 156 and 157 are headdresses of
the Egongun society. It is called *ere
egongun olode*. Egongun literally means
"bones," referring to those of the
ancestor. The dancers, believed to be
possessed by the spirit of the
deceased, spoke in disguised voices.
They performed at funerals, at rites to
promote the fertility of the
community, and at the founding of
villages. Some headgear had a tuft of
hair descending from the left
(suggesting a phallic connotation
similar to that found on some Eshu
statues), but according to legend it
was associated with a mythological
"master of the hunters" and the
buckteeth of the hare. Each village
had its own Egongun society dedi-
cated to its own particular ancestor.

157 *Yoruba, Nigeria, 12".*
This headdress, probably worn by the
Egongun, has a wooden cap for the
base, surmounted by a neck
composed of ringed rows and a head.

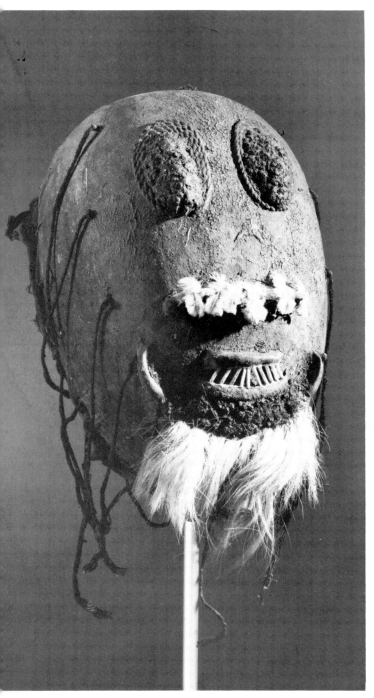

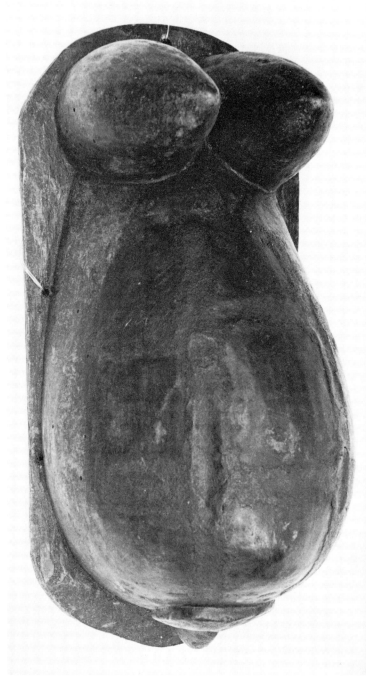

158 159

158 *Yoruba, Nigeria, 13½".*
Plates 158-161 do not fit into any of the above categories.
This is a painted mask made of a calabash with hair, cloth,
leather, and fur attached to it.

159 *Yoruba, Nigeria, 19".*
This body mask for men, created by the Yoruba in
Dahomey, consists of two enlarged breasts and a prominent
belly. It is worn by members of the Gelede society and used
at female fertility rites.

160 *Yoruba, Nigeria, 39".*
This is a headdress made of multicolored beads, with a face
and a torso on the top. The veil hung over the face and
mouth of the divine king to signify his isolation and
differentiation from the common people.

161 *Yoruba, Nigeria, 42".*
Another rendition of the same idea except that instead of a
veil covering the king's face, here the beadwork represents a
human face. There is another face above, and various figures
on both faces, topped by a bird. This work may correspond
to our concept of a king's crown.

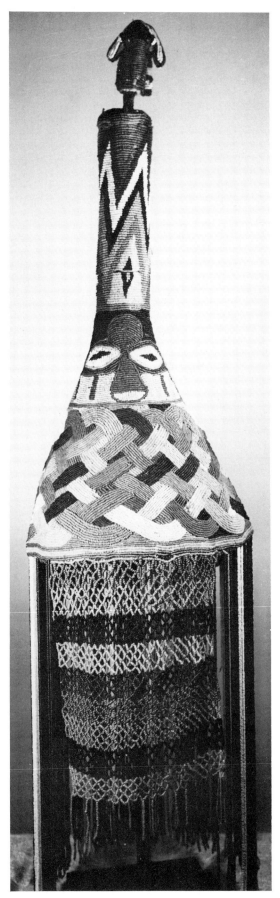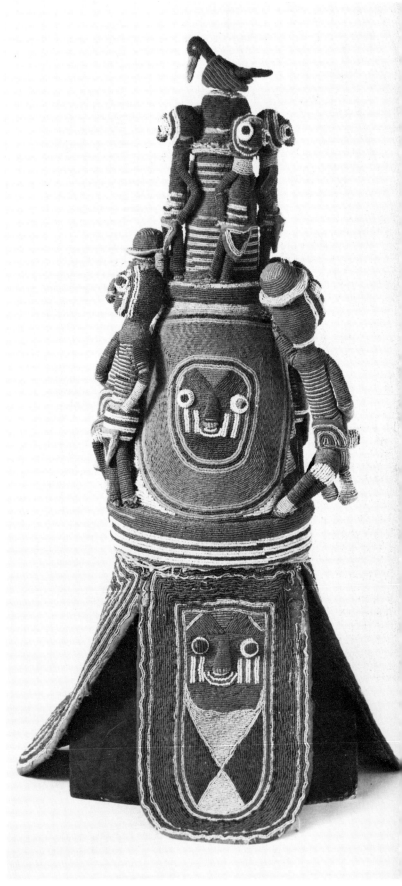

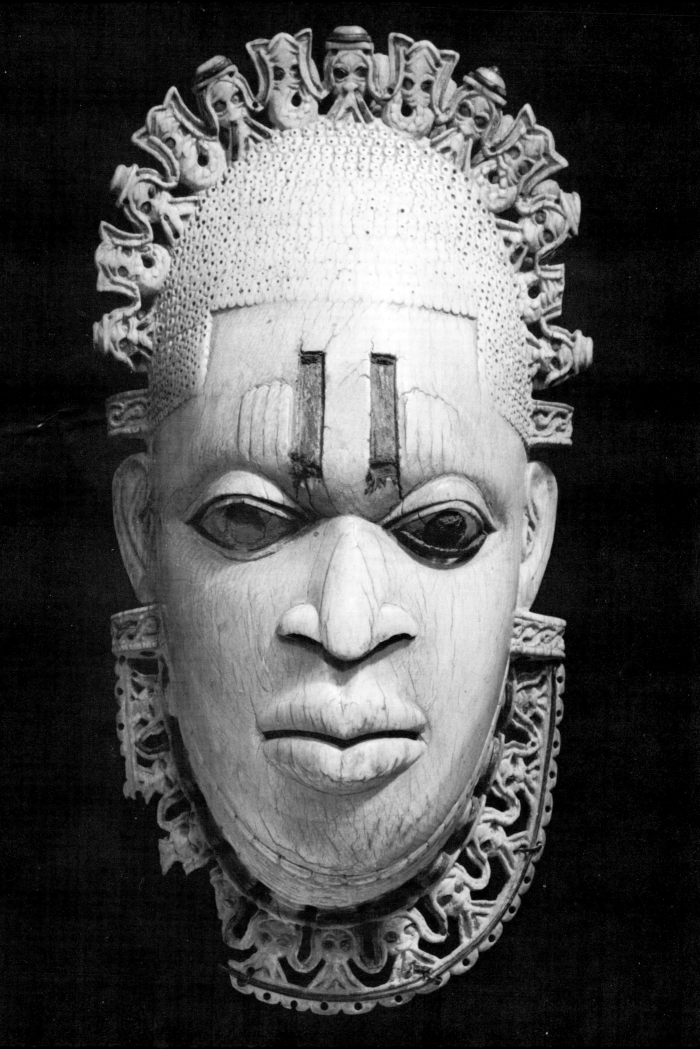

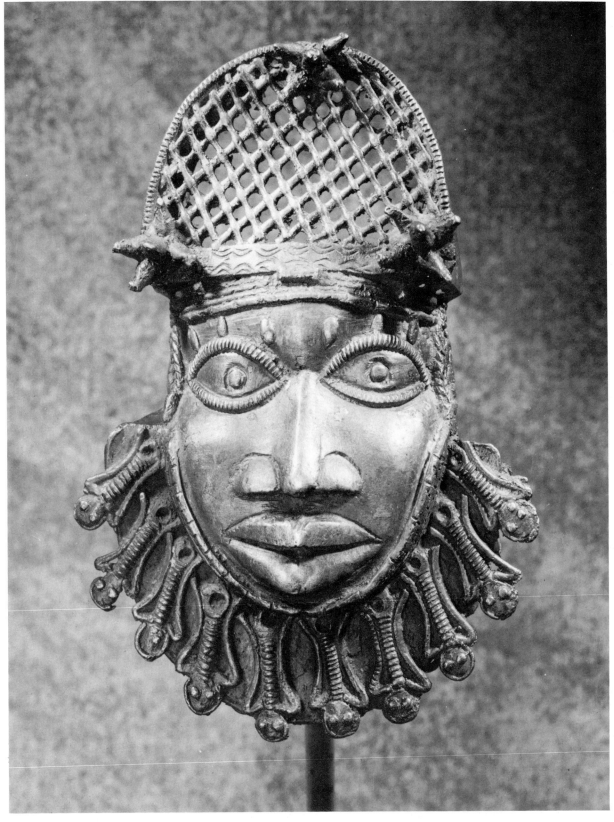

162

163

162 *Benin Kingdom, Nigeria, 9 3/8''.*
An ivory mask used as a pectoral by the king (*oba*). Stylized
heads of bearded Portuguese border the mask.

163 *Benin Kingdom, Nigeria, 7''.*
A brass mask used as a buckle.

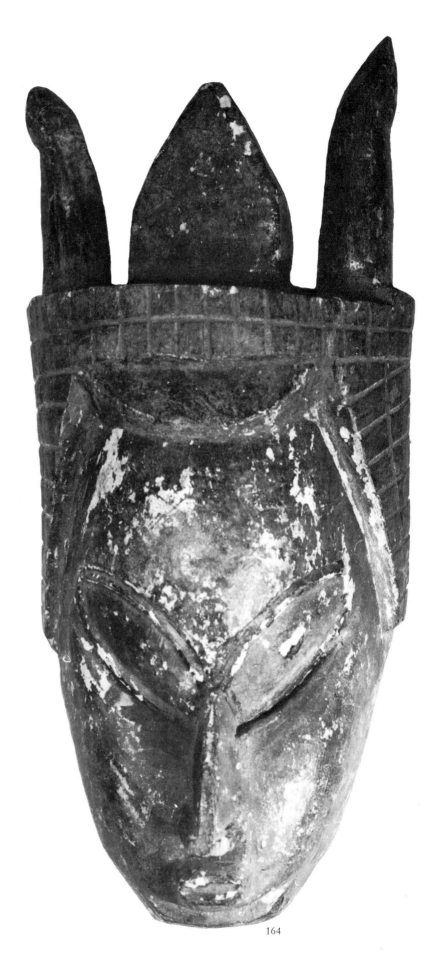

164 *Bini, Nigeria, 14".*
A highly stylized face mask with slit eyes and a hairdo ending in three protrusions.

165 *Idoma, Nigeria, 8 3/4".*
A simple face mask similar to some of the Ibo masks, with scarification marks on the face and concentric-ring designs for the hairdo.

164

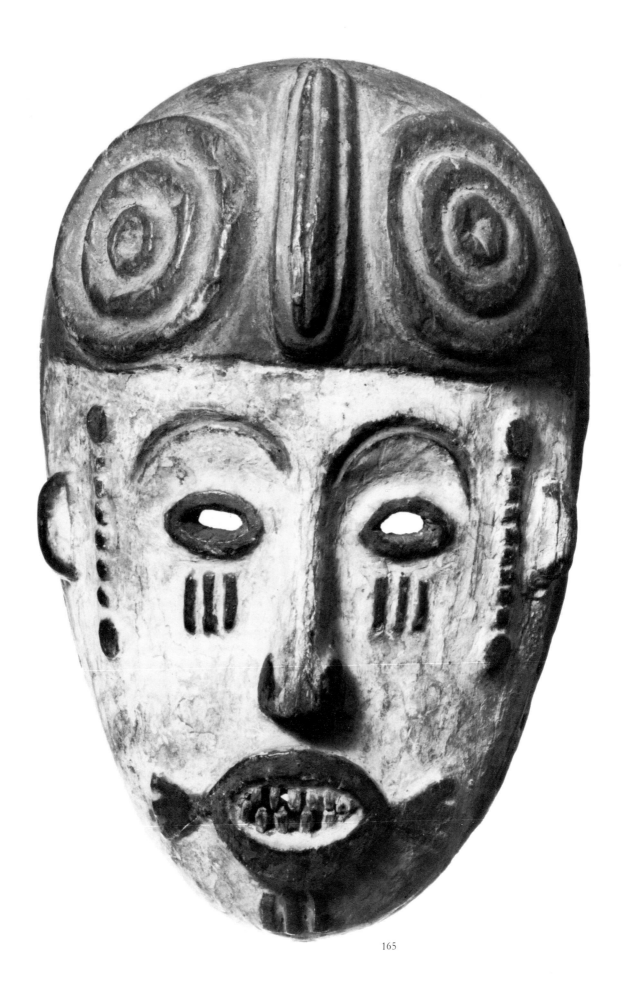

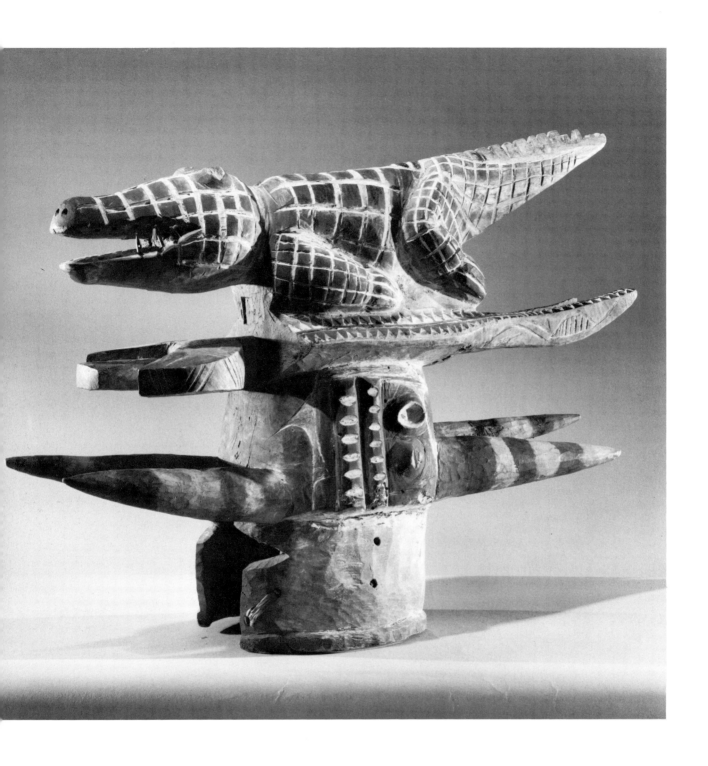

166 *Idoma, Nigeria, 26½" long (19¼" high).*
The Eku headdress, combining the representations of a
crocodile, a snake, and a bush cow. It was used at funerary
rituals, suggesting the connection of mythical animals with the
survival of the soul of the deceased.

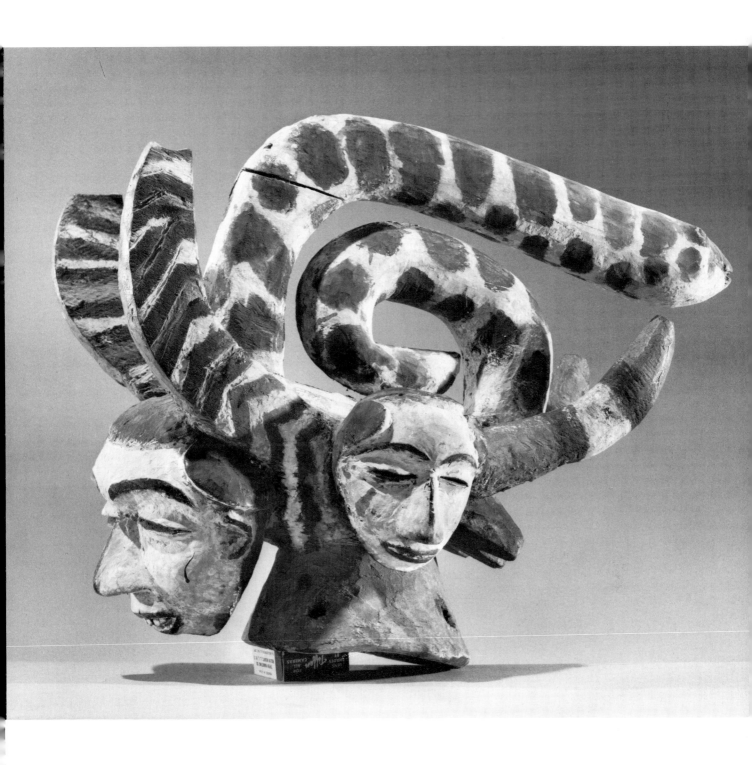

167 *Idoma, Nigeria, 18 3/4" long (13" high).*
Another headdress, combining the features of the snake with
three human faces. Same use as for the preceding plate.

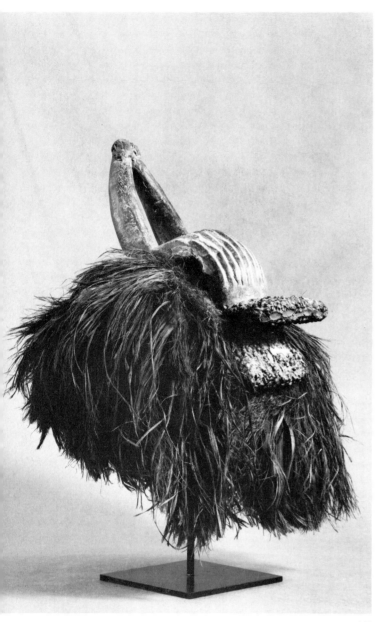

169

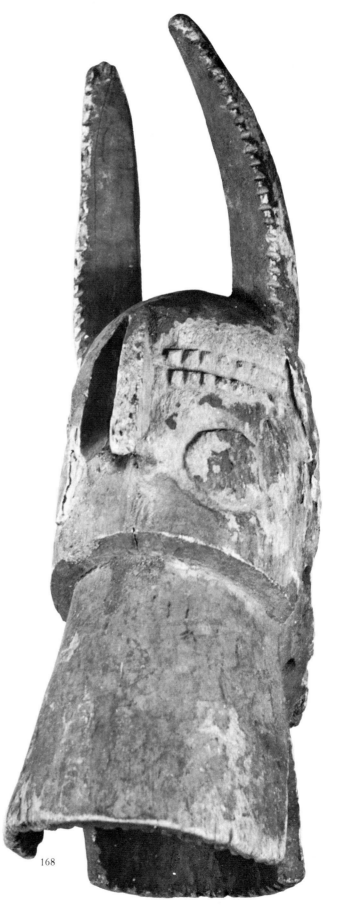

168

168 *Mumuye, Nigeria, 21''.*
An animal mask with horns and open jaws. It was used two days each year to honor the spirit of the dead.

169 *Jompre, Nigeria, 17''.*
Similar to Plate 168, with horns and open jaws. Seeds are pasted onto the jaw, and the rim of the mask has a raffia attachment.

170 *Igbira, Nigeria, 13 1/8''.*
A face mask with abrus seeds on the forehead and the face.

170

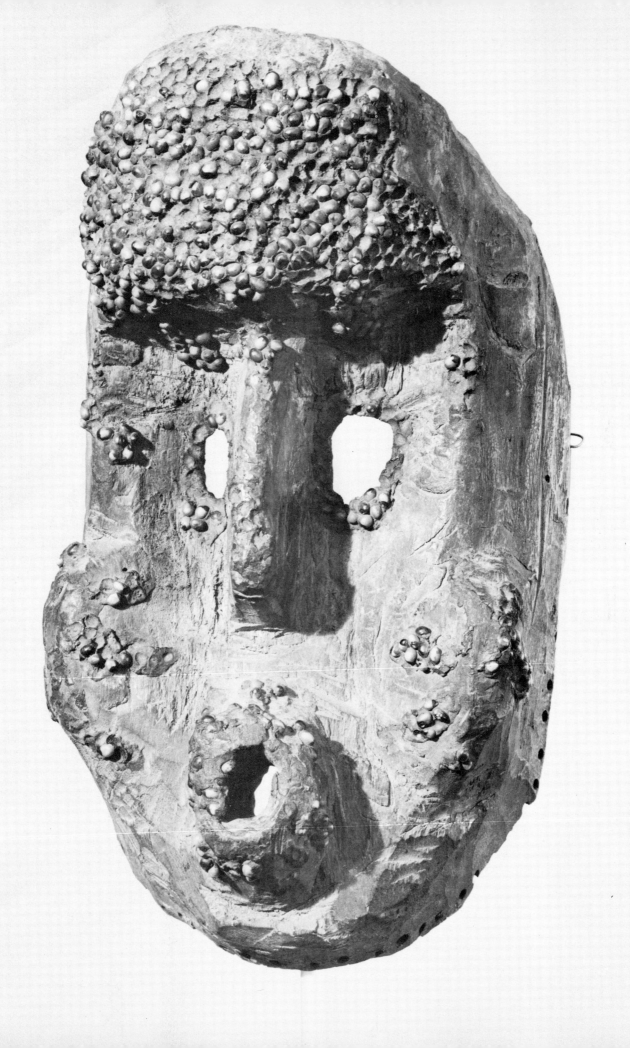

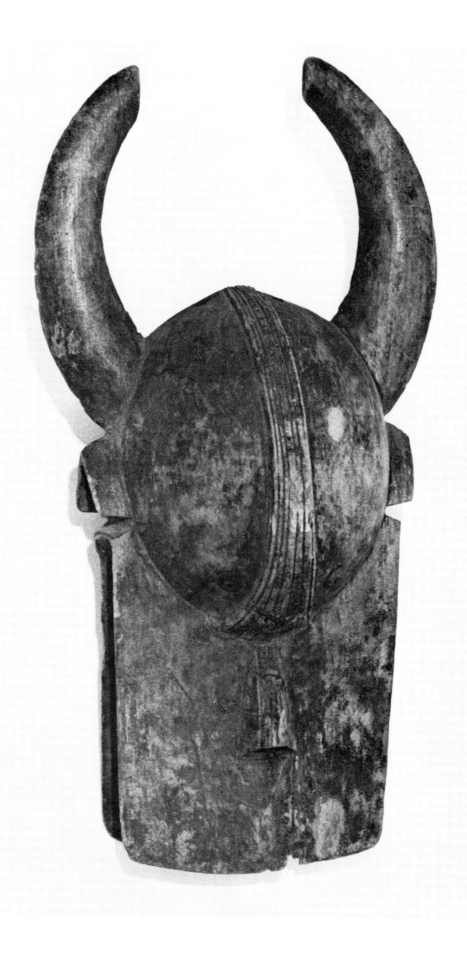

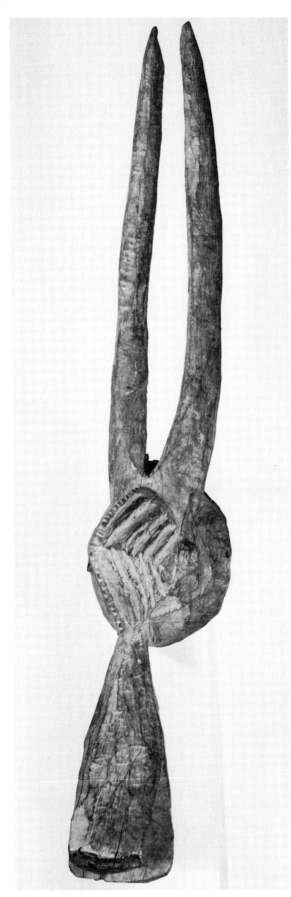

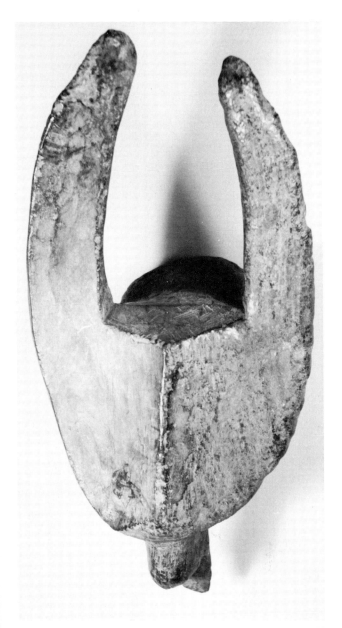

172

171 *Chamba, Nigeria, 31".*
This is an extremely simplified bush-cow mask with a domed forehead, large open jaws, and circular horns painted red. The Tsara society used it to guide the soul of the deceased into the land of the dead. Other functions of the mask were to protect the village from evil spirits and to ward off sickness.

172 *Mama, Nigeria, 16½".*
Plates 172 and 173, masks used by the members of the Udawaru secret society in their *mangam* cult, exhibit great abstractions. Worn on the top of the head, the masks looked upward. This is a buffalo mask. The entire animal head and horns are reduced to two flat shapes. The *mangam* cult used these masks at the funerals of chiefs, but the same masks also functioned at various agricultural ceremonies, also to channel the life forces for the increase and well-being of the community.

173 *Mama, Nigeria, 23½".*
An antelope with slender horns and an unusual form for the jaw.

173

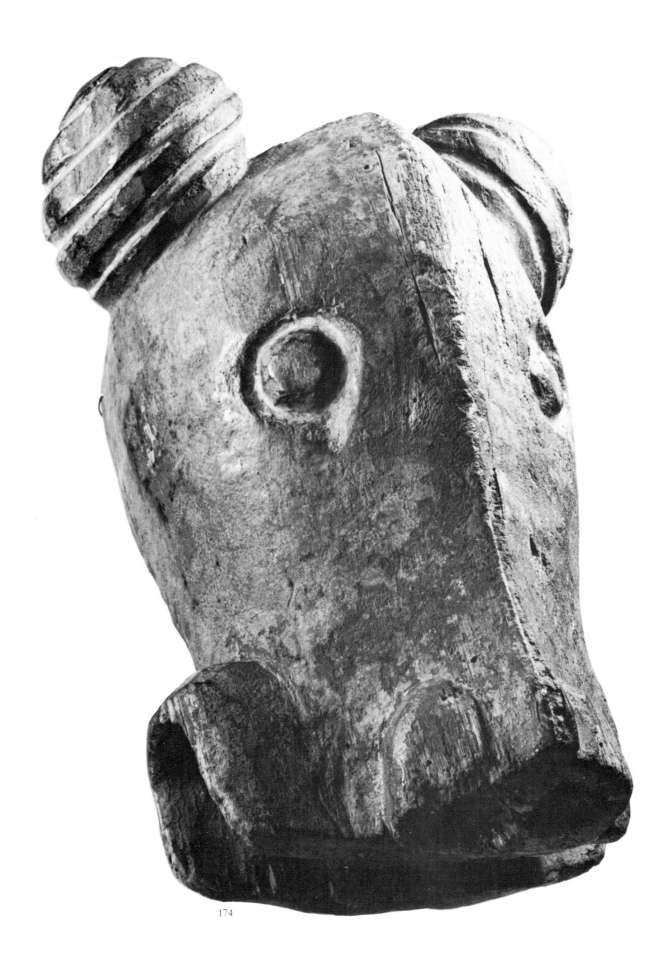

174

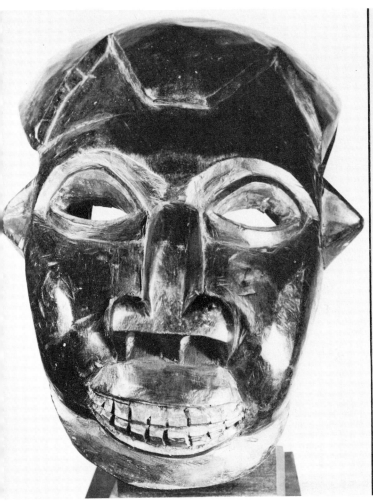 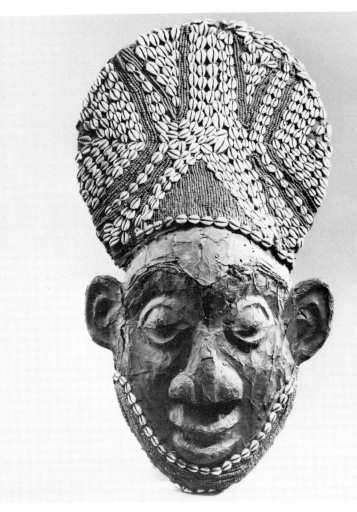

175 176

174 *Bekom, also Bamileke, Cameroon, 15".*
A cow mask with an open jaw and knobbed horns. It had a special role at the annual sacrificial rites. The Manjong warrior society used it, and it was also connected with agricultural activities.

175 *Bekom, Cameroon, 15".*
A human-face mask. Worn in sacred rituals dedicated to the common mythical ancestor of several local tribes who was associated with the migrations to their present region (there are similar masks among the Bamum and Bamileke).

176 *Bamum, Cameroon, 26".*
A helmet mask with Negroid features. Cowrie shells and beads ornament the hairdo and chin. The Bamileke and the Bamum wore this mask at the beginning of the hunt and at the new-moon ceremonies.

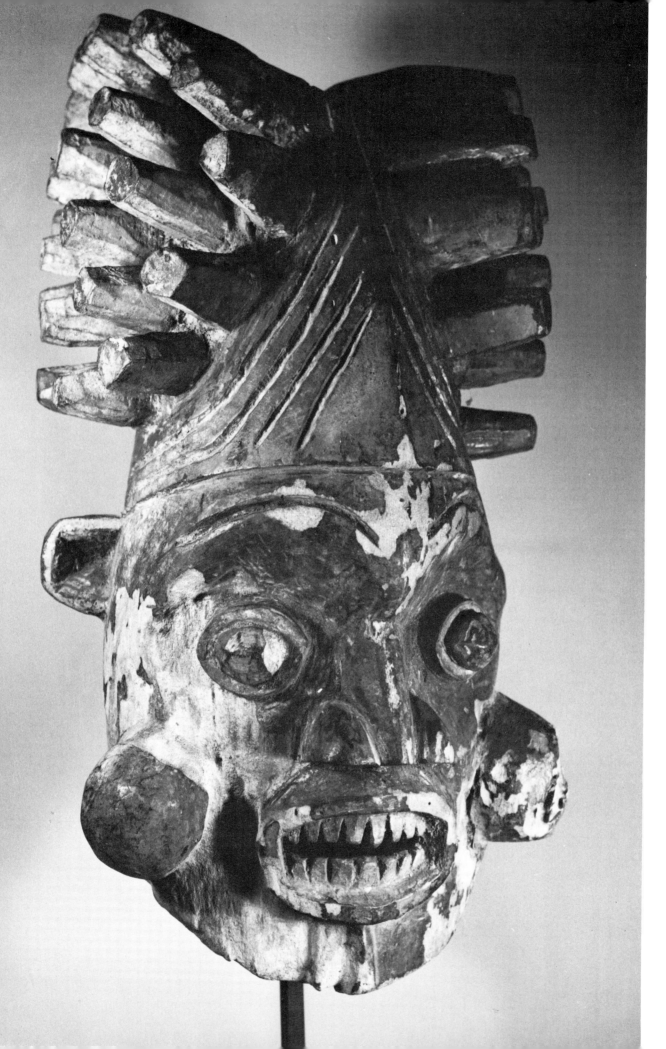

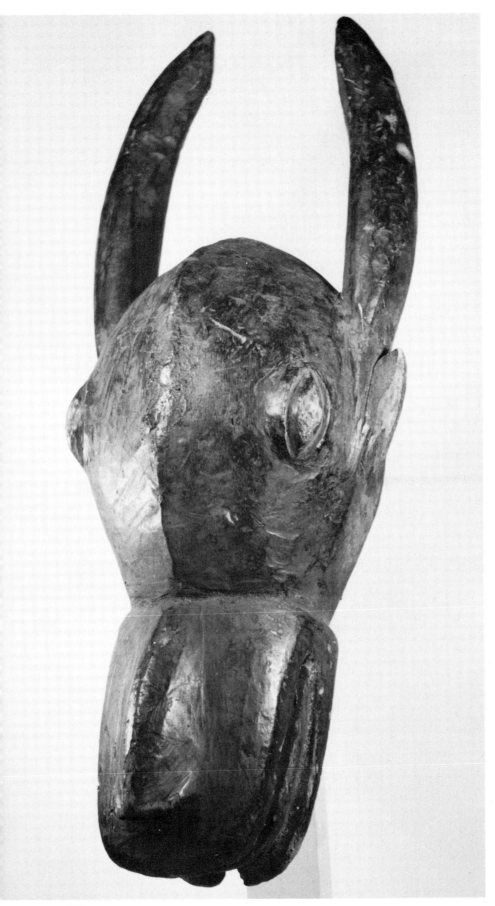

177 *Grassland area, Cameroon, 20".*
A very powerful mask with projections from the face and also from the head (probably a hairdo).

178 *Grassland area, Cameroon, 26".*
A bush-cow mask of great simplicity.

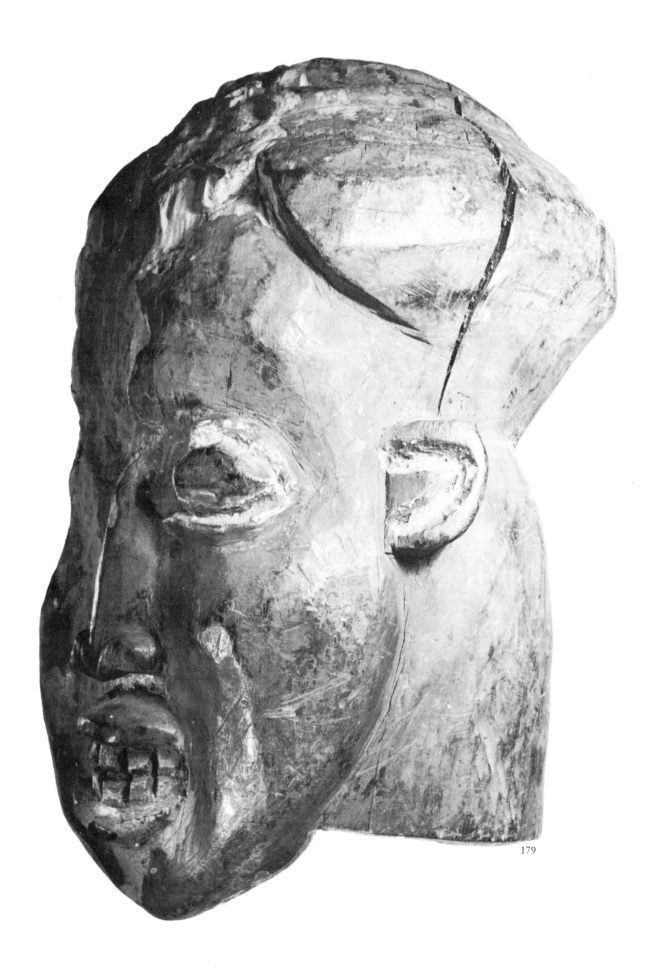

179

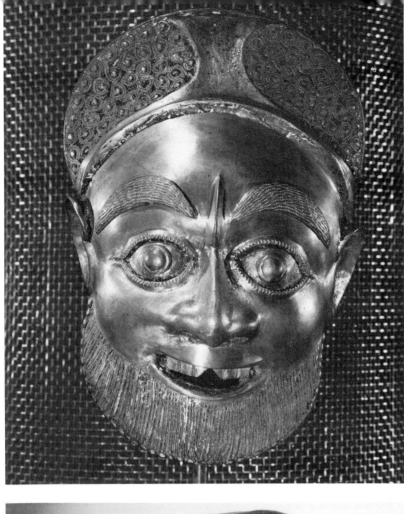

181

180

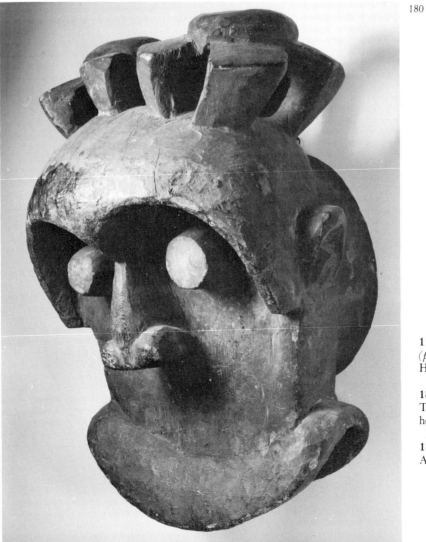

179 *Grassland area, Cameroon (probably Bekom), 14" (diameter 9").* Helmet mask.

180 *Bekom, Cameroon, 17".* This has a large jaw, a bulging forehead, and protuberant eyes.

181 *Grassland area, Cameroon, 7".* A small brass mask.

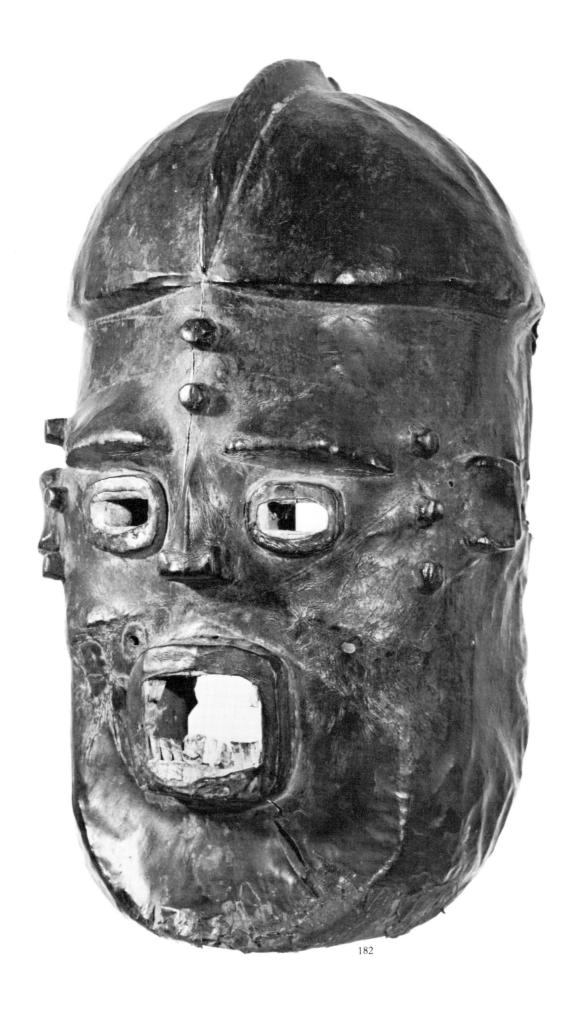

182

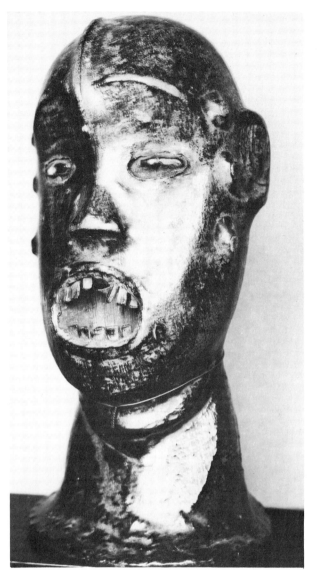 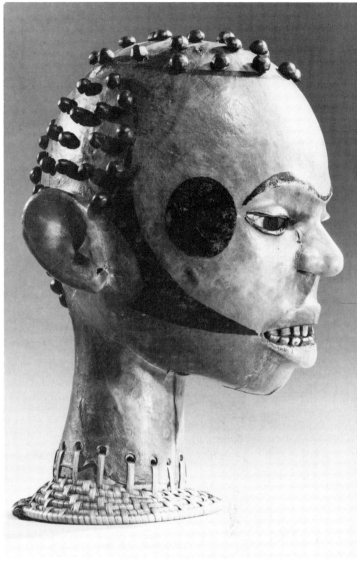

183 184

182 *Ekoi, Cameroon, 18".*
A face mask with an open mouth and scarification marks in relief. This is also attributed to the Widekum tribe.

183 *Ekoi, Cameroon, 10".*
A more typical work for the Ekoi is this carved head covered with animal skin, to which human hair was often attached to make the mask more naturalistic. This mask, like those in Plates 184, 185, and 188, was worn on top of the head. The

Egpo rituals clearly stated that the ancestor was responsible for the vital force and the fertility of the earth. The present mask was also used for social control and for the supervision of the group's sanitary conditions.

184 *Ekoi, Cameroon, 11".*
This shows a very strong naturalism of more recent origin. (It is also used in Nigeria by the Ejagham.)

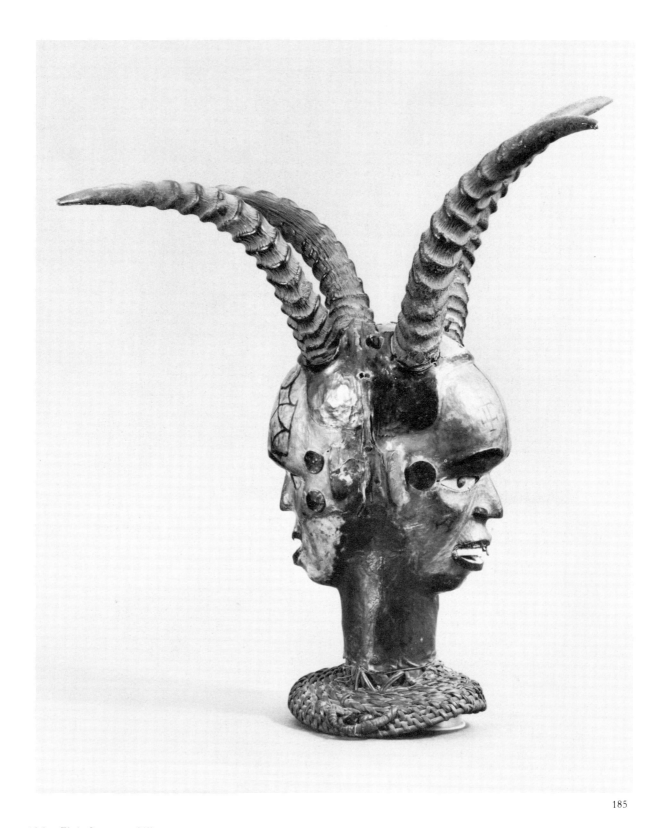

185 *Ekoi, Cameroon, 21".*
This is still within the tradition, but it has a Janus head and four real antelope horns inserted into the wooden skull. (Also used in Nigeria by the Ejagham.)

186 *Ekoi, Cameroon, 17" (diameter 13").*
This helmet mask, covered with animal skin, has a triple face (the third face is not visible in the picture). The skin is tanned into light and dark colors, symbolizing life and death, respectively, and representing the dual aspect of man's existence. Sometimes one face (male) was in white, symbolizing heaven, and the other (female) in white or yellow, symbolizing mother earth.

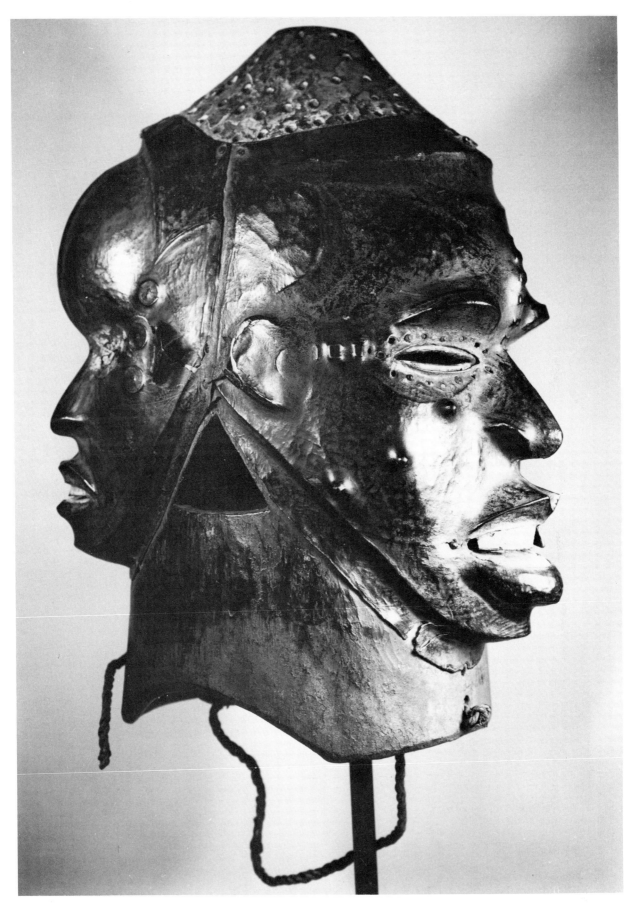

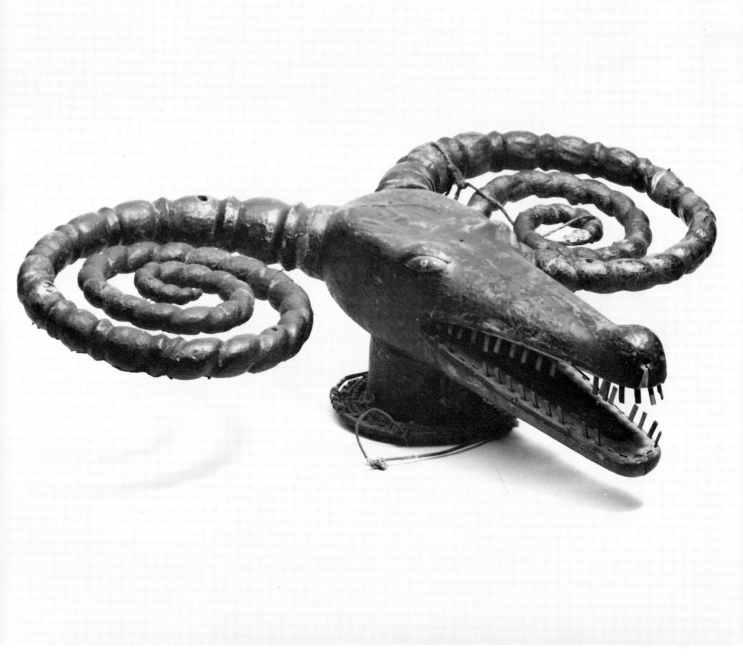

187 *Ekoi, Cameroon, 34" wide.*
This animal head, with a basketwork base and highly elaborate horns, is still within the Ekoi tradition.

188 *Ekoi, Cameroon, 13".*
This headdress is a whole figure, with movable arms and legs, covered with animal skin.

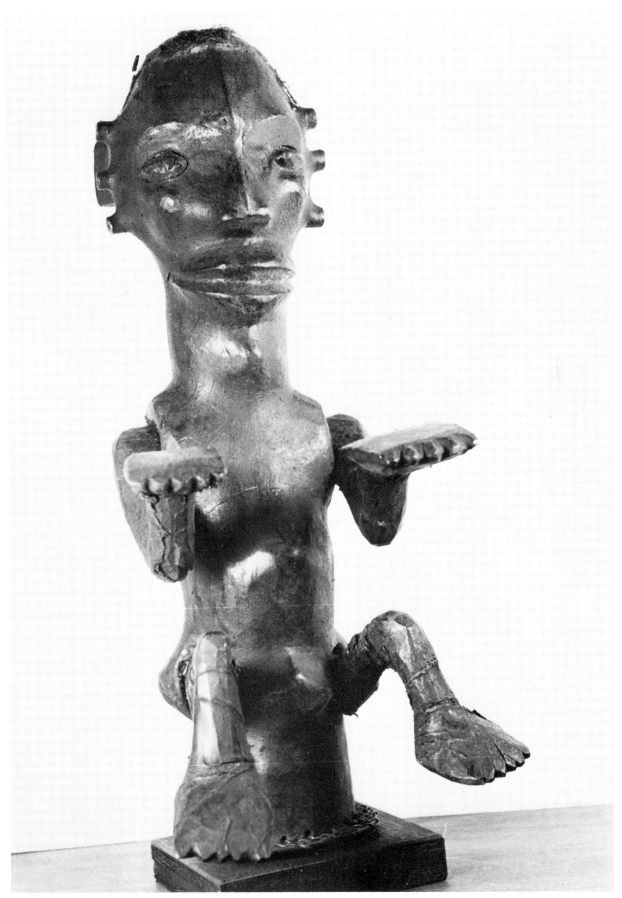

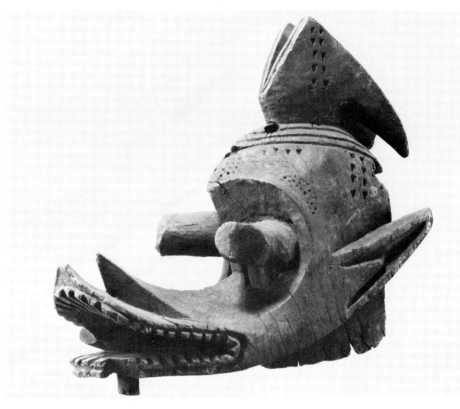

190

189

189 *Mambila, Cameroon, 16".*
This mask, like others of a similar
style, represented either a cow called
suah dua or a dog called *suah buah*. The
polychrome mask has a wide-open
beak and bulging eyes. It was worn
twice a month at the waxing and the
waning of the moon and for the
promotion of the welfare of the
community. It was also used at
sowing and at harvesting festivals.
The Keaka tribe also used the same
type of mask, but for them the animal
represented a forest spirit.

190 *Mambila, Cameroon, 17".*
This is of the same subject as the
preceding, but more angular masses
interplay with the round forms.

191 *Mambila, Cameroon, 17½".*
This is a very unusual helmet mask
with an oval mouth and eyes.

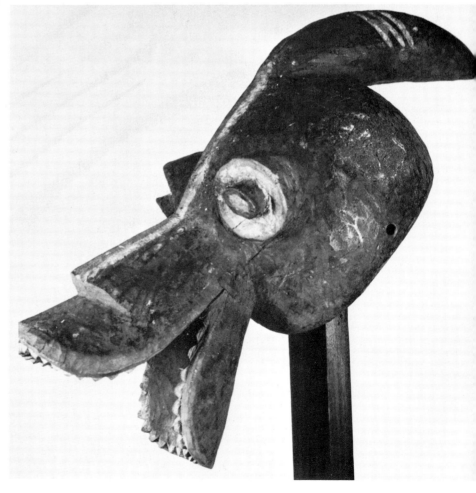

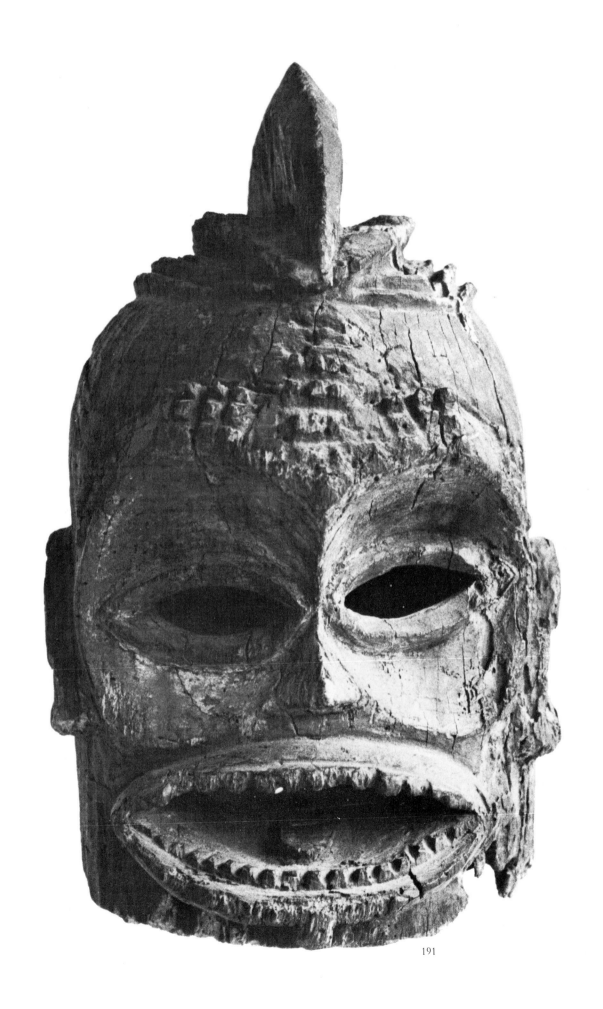

191

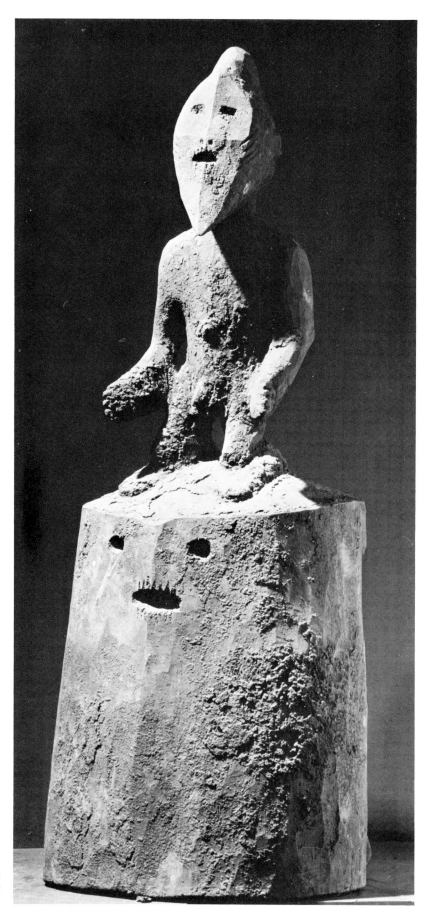

192 *Keaka, Cameroon, 36".*
This is a helmet mask with a figure,
carved from the same block of wood,
standing on the top of it. Both the face
of the mask and that of the figure are
composed of flat planes.

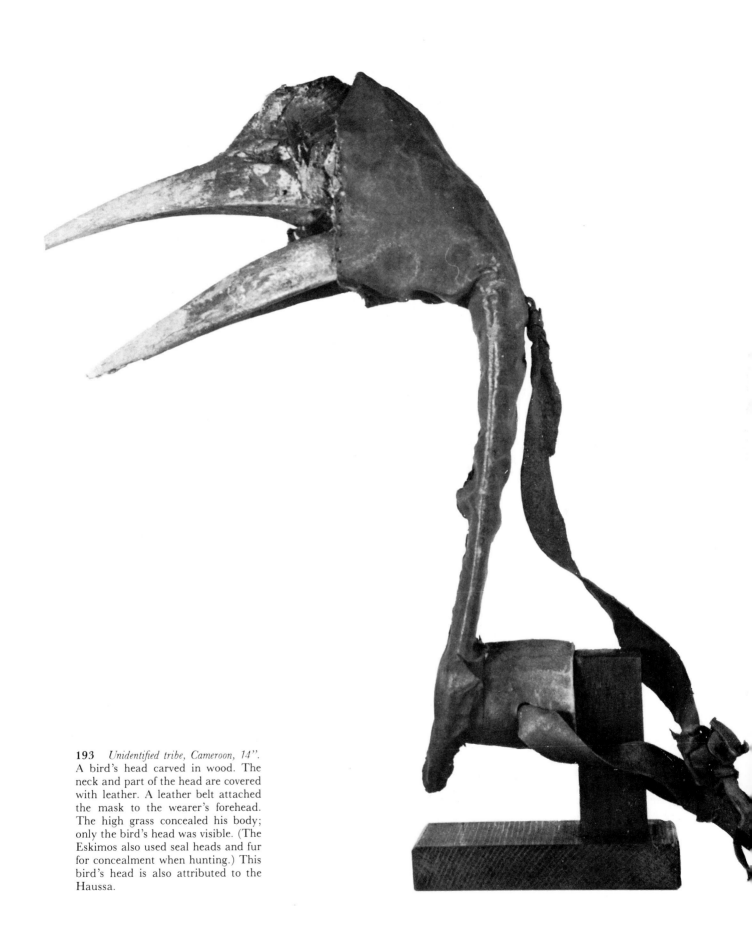

193 *Unidentified tribe, Cameroon, 14".*
A bird's head carved in wood. The
neck and part of the head are covered
with leather. A leather belt attached
the mask to the wearer's forehead.
The high grass concealed his body;
only the bird's head was visible. (The
Eskimos also used seal heads and fur
for concealment when hunting.) This
bird's head is also attributed to the
Haussa.

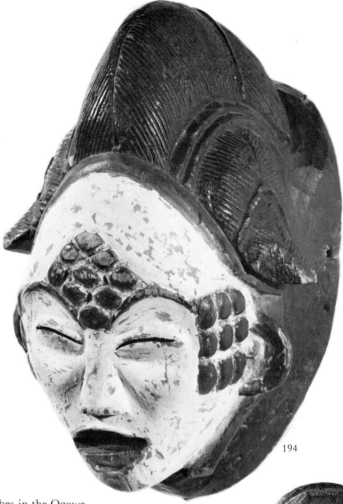

194

194 *M'Pongwe, Gabon, 8½".*
This mask, used by various tribes in the Ogowe
River area, has a face painted white with kaolin,
scarification marks carved in relief, slit eyes, red-
painted lips, and a high-piled hairdo which
resembles the hairdo of the women living in this
region. The mask has an unusual Oriental ex-
pression, but no such influence has been es-
tablished. Known as *duma* or *mvudi*, it represented
a female guardian spirit in the initiation of
adolescent girls, funerary rites, ancestor cults,
and also in dances of the full moon. At the burial
ceremonies of the Punu society the mask
represented a female ancestor. In the Mukui
society the masked persons, sometimes on stilts,
performed at the dance of the full moon.

195 *M'Pongwe, Gabon, 7".*
This is painted black and lacks the scarification
marks.

196 *Adouma, Gabon, 11".*
Adouma masks show great geometric abstrac-
tion. The face is flat, the domed forehead convex,
and an angular nose is set in at a right angle,
reminiscent of the structure of the Toma masks
(Plates 6-9). This example has a stained design
on the flat face.

197 *Ambete, Gabon, 14 5/8".*
This shows great similarity to the Adouma
style except that the forehead is shortened,
and the flat surface is more elongated.

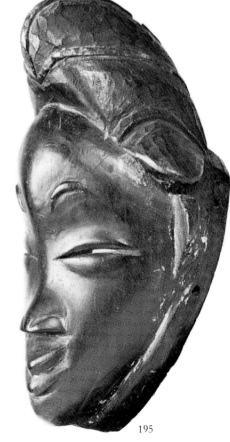

195

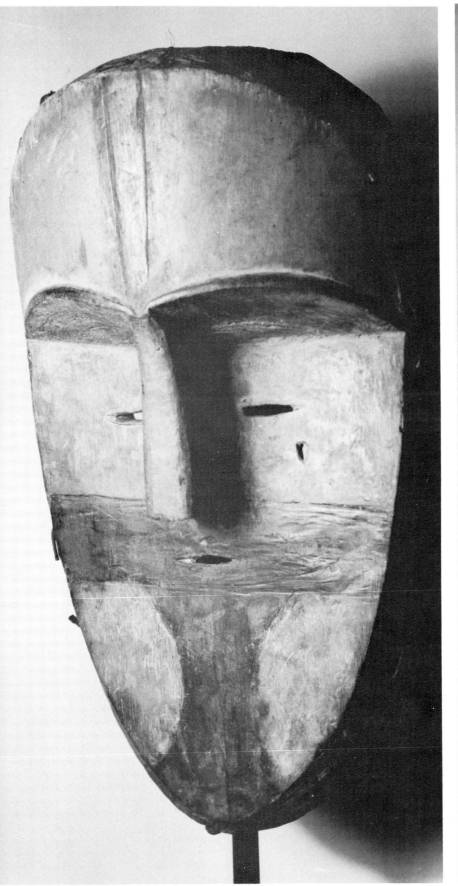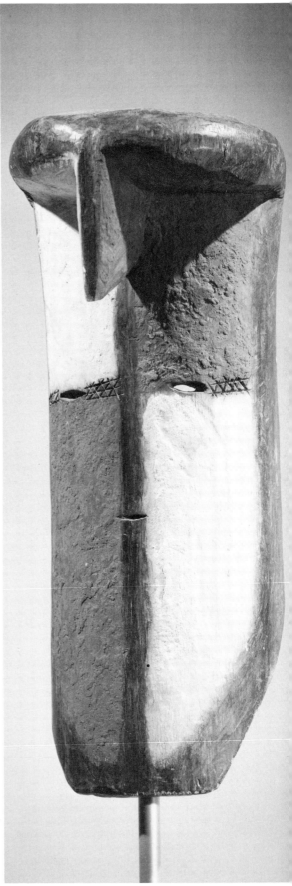

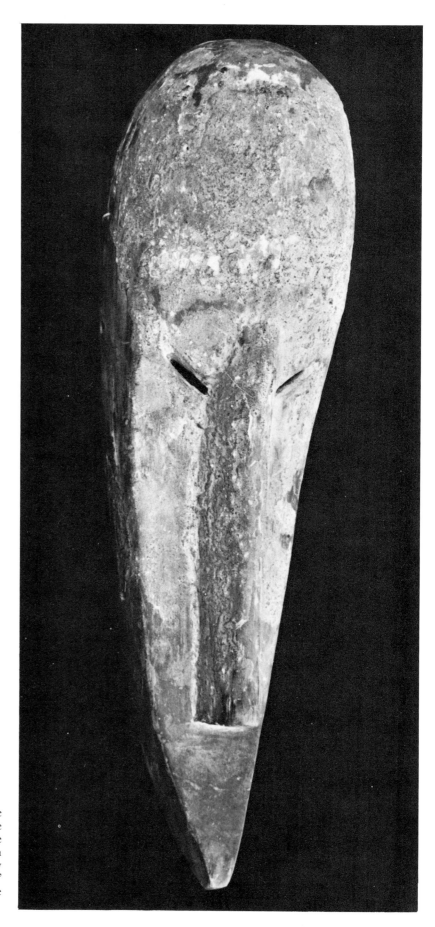

198 *Fang, Gabon, 22".*
The statuary of this tribe is notable for its refined, bulbous forms, but the masks are of different styles. This one is a very elongated human face with a long nose and a pointed chin. Used by the Ngi society, it acted as a "police" power to assure the adherence of the community to the law.

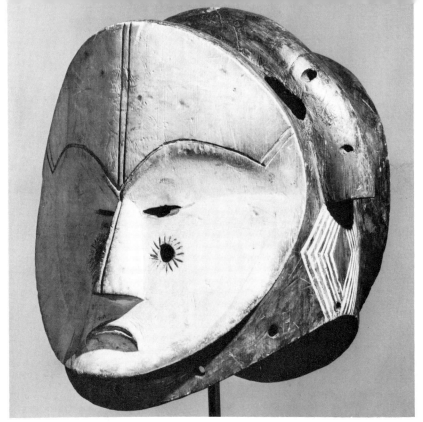

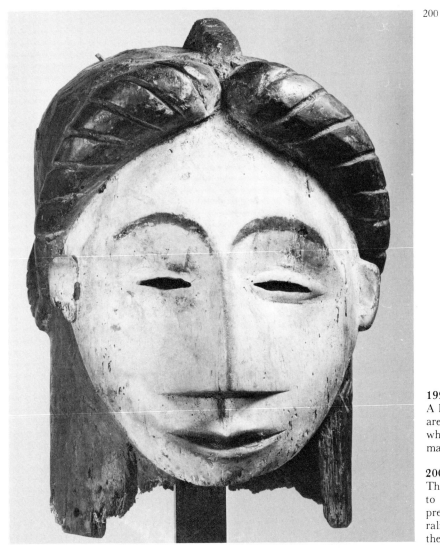

199 *Fang, Gabon, 11 3/4".*
A helmet mask with two faces (there are others with four faces) painted white, with unusual scarification marks (round with radial lines).

200 *Fang, Gabon, 13".*
This Janus helmet mask, in contrast to the highly abstract style of the previous masks, tends toward naturalism and in many respects recalls the style of the M'Pongwe masks.

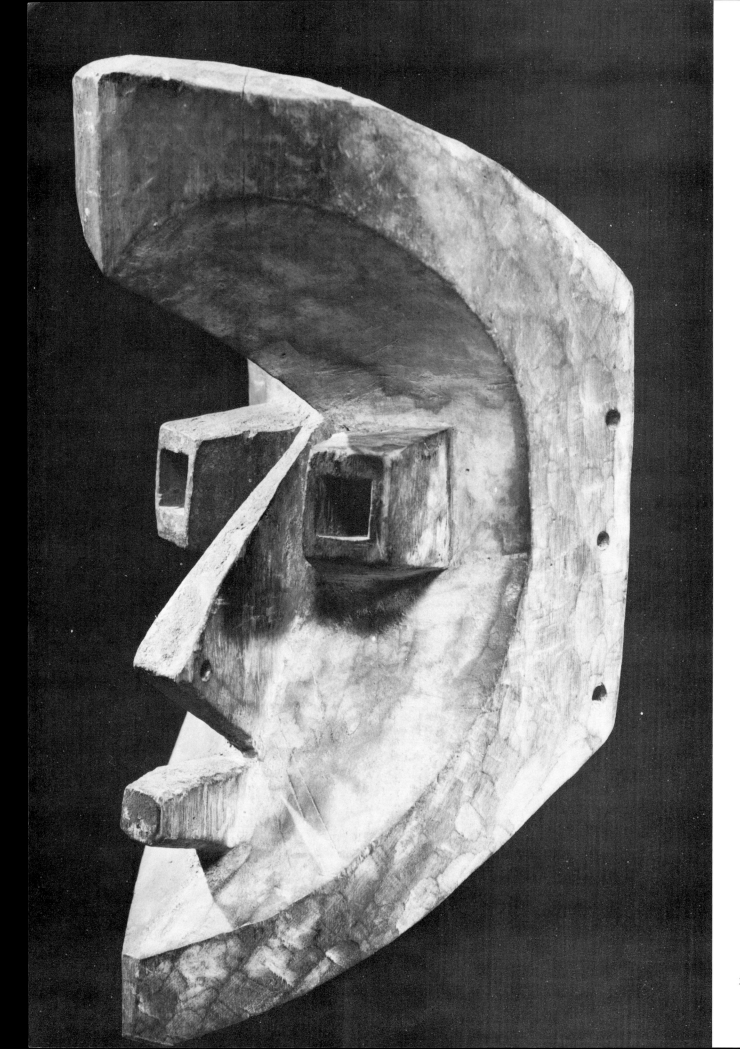

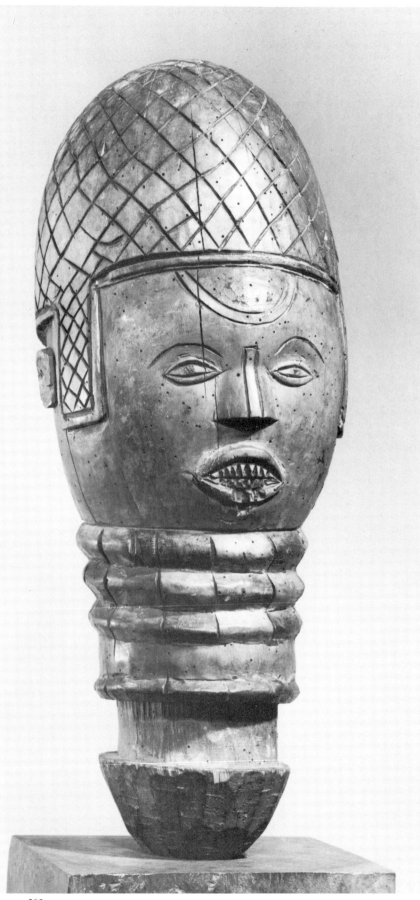

201 *Mahongue, Gabon, 24".*
This mask, known as *elimba*, has bold, angular forms, two square protrusions for the eyes, one for the mouth, and triangular forms for the nose and forehead.

202 *Kuyu, Congo, 23 3/4".*
A clublike polychrome headdress known as *kebe-kebe* attached to the head of the dancer, who was completely covered with a white cloth and appeared to be about eight feet tall. He portrayed the primordial ancestral father and mother standing under the protection of the great mythical serpent, *ebongo*. (This mask is also used by the Babochi.)

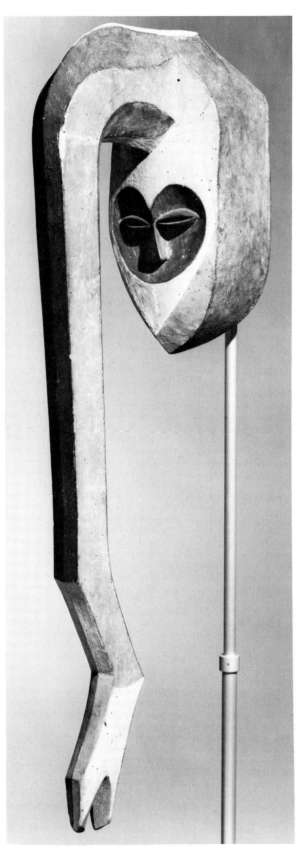

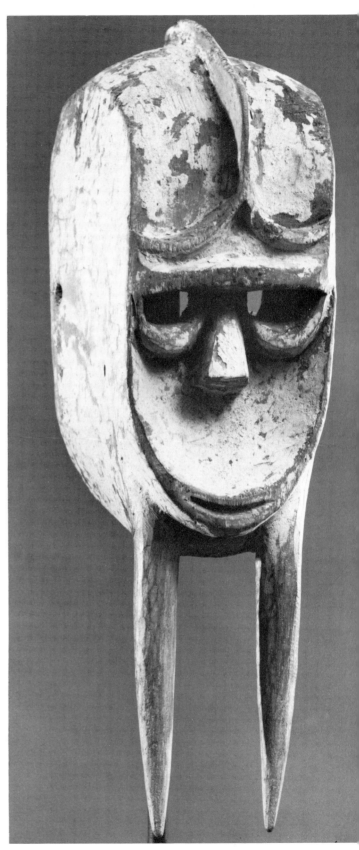

203 *Bakwele (Kwele), Congo, 30 1/8".*
This tribe is known for its highly abstract face masks. This one has a heart-shaped face, with slits for the eyes and an appendage, perhaps representing the trunk of an elephant.

205 *Bakwele, Congo, 15".*
This has a face and eyes of an entirely different shape from the preceding masks and two downward-pointed protuberances.

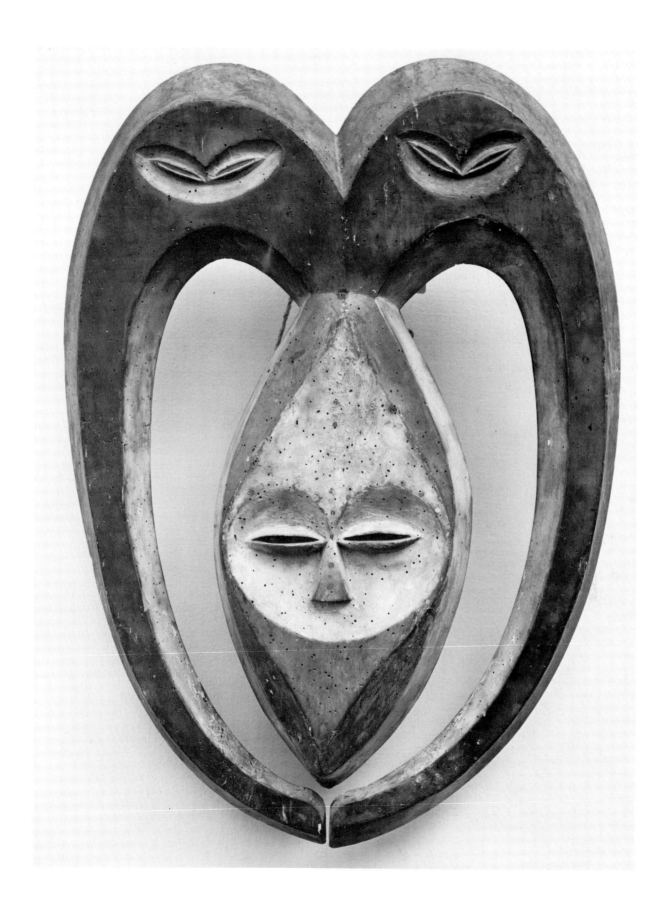

204 *Bakwele, Congo, 20 3/4''.*
This has slits for the eyes and two other pairs of eyes on the structure that frames the face.

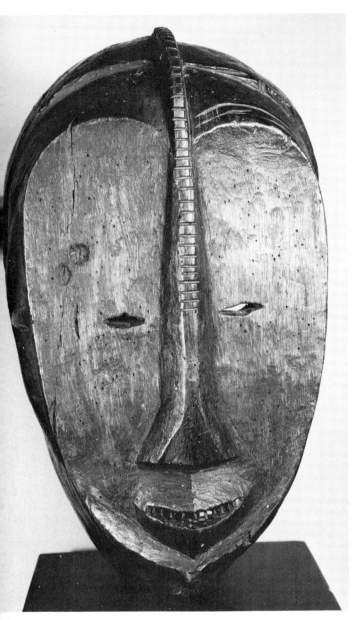

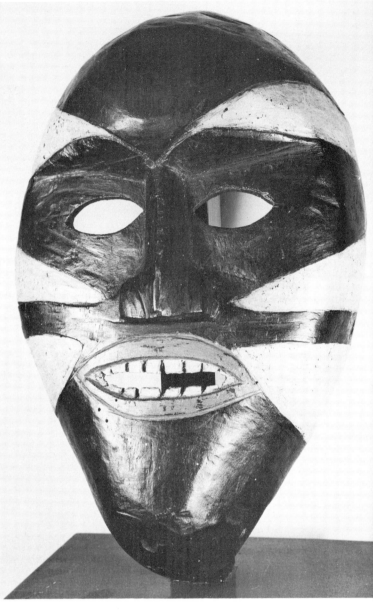

206 *Bavili, Congo, 11''.*
This mask with an elongated nose shows great similarity to the Fang masks (see Plates 198-200).

207 *Bavili, Congo, 14''.*
This mask is in an entirely different style, with bold painted designs.

208 *Bateke (Teke), Congo, 16''.*
This is a discoid mask. The face is composed of two semicircular forms, with clearly defined eyes, nose, and mouth. On the rest of the surface are geometric patterns, each with its own symbolic significance. The sky, the stars, a half-moon, a rainbow, and so on, are represented. (This mask is also attributed to the Tsaye.)

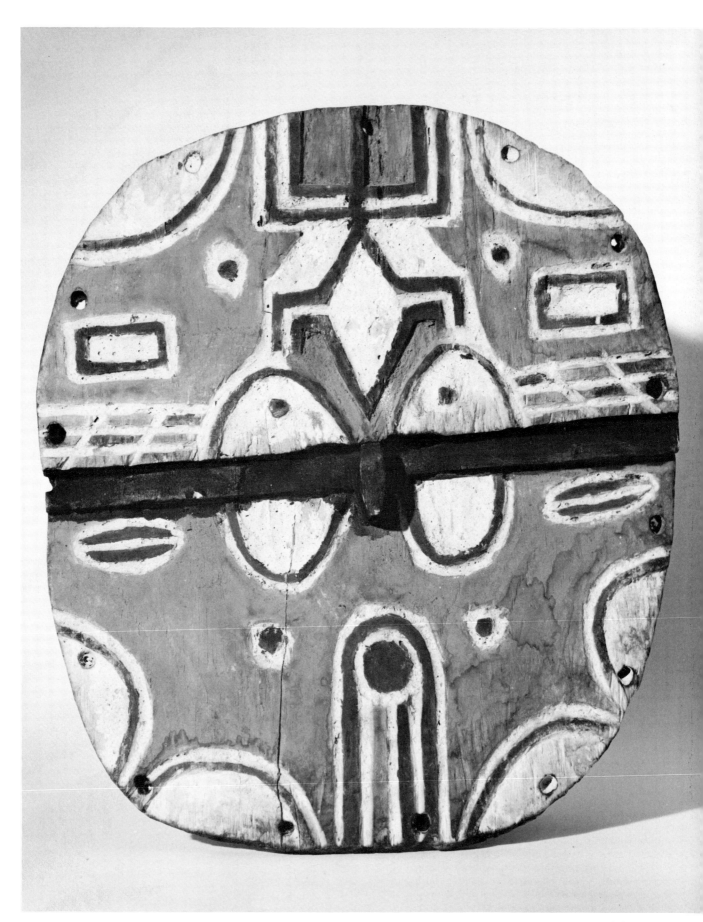

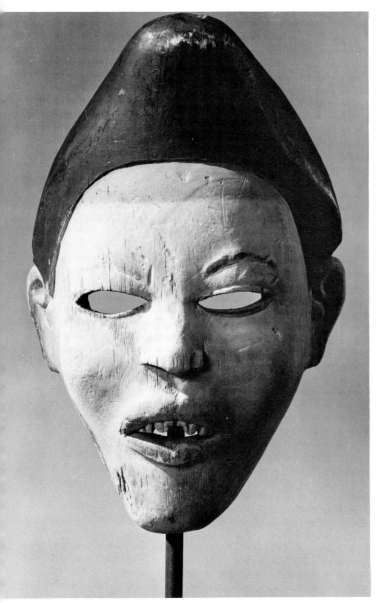

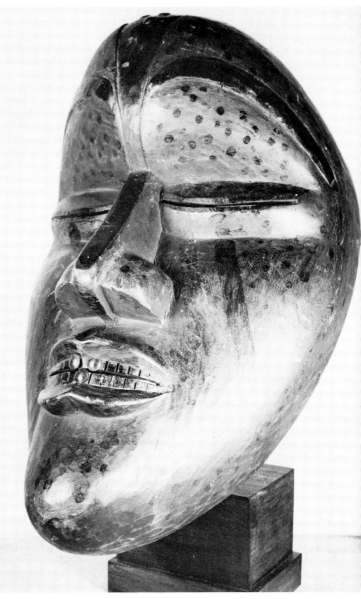

209 210

209 *Bakongo (Kongo), Zaire, 10".*
A rather smooth, stylized, white-faced mask with a conical black hairdo reminiscent of some of the M'Pongwe masks (see Plates 194 and 195). The filed-down teeth are a typical feature of Bakongo statuary.

210 *Bakongo, Zaire, 16".*
A much bolder structure with a domed polychrome forehead and three nails driven into the teeth.

212

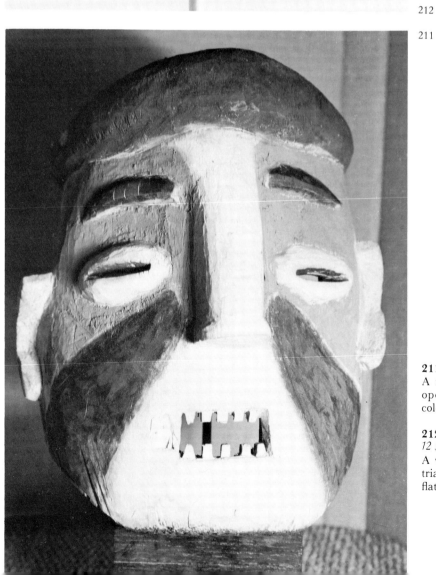

211 *Muserongo, Zaire, 11½".*
A mask with heavy features and an
open mouth showing the teeth,
colored in earth-red and white.

212 *Balwalwa (Lwalwa), Zaïre,
12 5/8".*
A very well coordinated structure of
triangular shapes with an interplay of
flat and round forms.

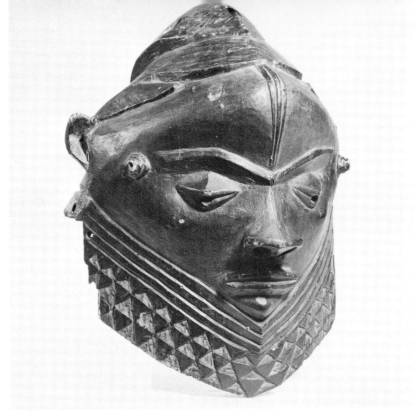

213 *Bapende (Pende), Zaire, 15".*
The most typical Bapende style is the *katundu* mask used in the *mbuya* dance. These masks have a domed forehead, long stylized eyebrows, a short turned-up nose, and heavy eyelids. The face is usually painted red, and the hairdo is made of black-dyed raffia with white raffia attached to the rim of the mask. Some masks also have a long wooden appendage looking like a beard. The *katundu* mask is used to celebrate the termination of the initiation ceremonies. Fifteen to twenty masked boys, each representing an ancestral spirit or a culture hero, performed the dances. A camp guardian also used the mask to frighten away outsiders, mainly women.

214 *Bapende, Zaïre, 15".*
This is of a similar style, except that the hairdo is carved of the same wood as the mask itself, and it also has a chin with incised triangular designs.

215 *Bapende, Zaire, 12" (Diameter 12").*
This *giphogo* helmet mask is different in style from the previous Bapende ones. It has a big, straight nose like a finger and an extended rim which rested on the wearer's shoulders. It was kept in a hut and used at festivals dedicated to the fertility of the people. It was also used to cure the sick and was associated with the chieftainship.

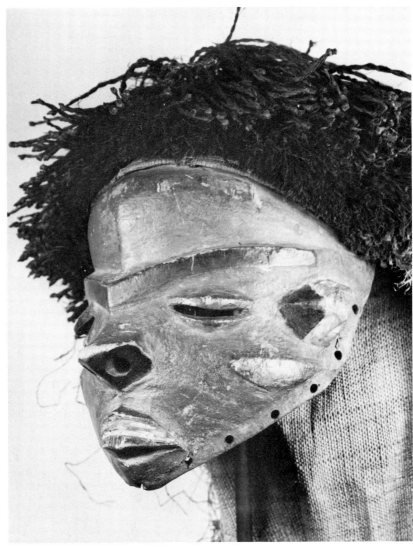

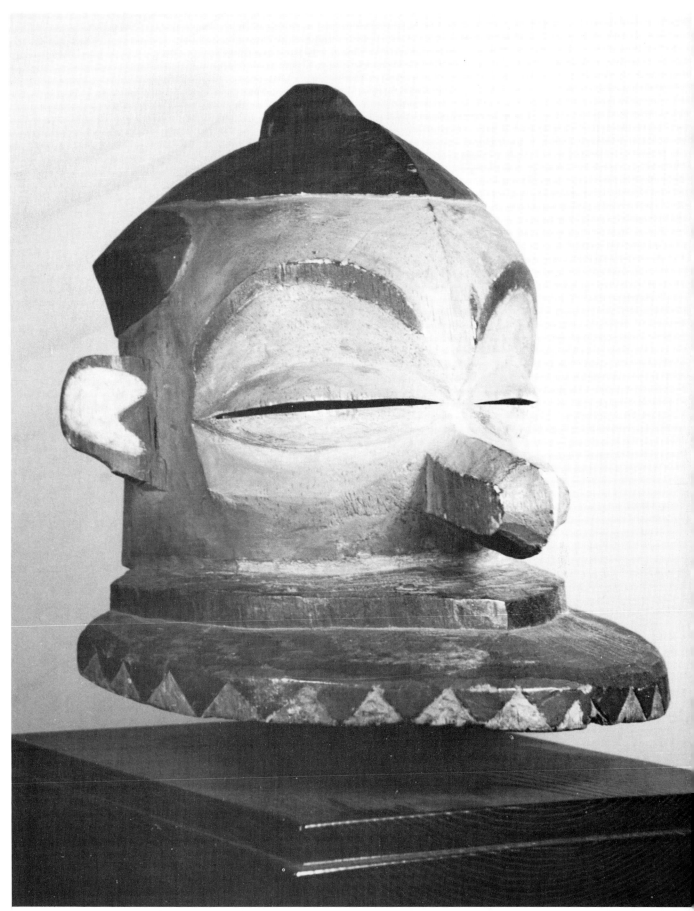

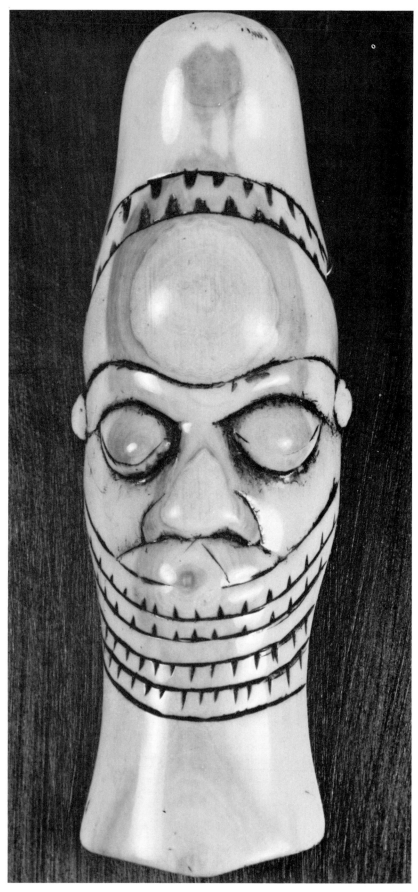

216 *Bapende, Zaïre, 4".*
This small ivory mask, *ikoko (ikhoko),* used as an amulet, has a beardlike extension. The mask, which had a cord, rested on the neck as a protection against malevolent spirits. It was given to the sick to cure them.

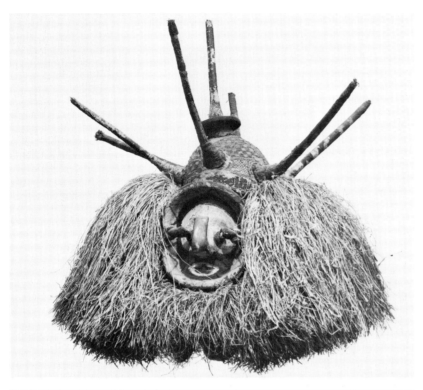

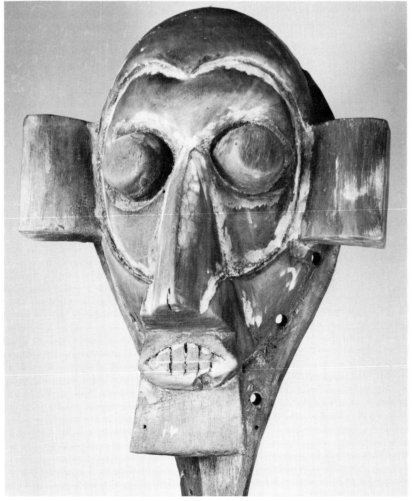

217
218

217 *Bayaka (Yaka), Zaïre, 24".*
This is the best-known *nkisi* mask, with an upward-hooked nose and an open mouth exposing teeth. It is surmounted by a superstructure with slim protuberances made of twigs, fiber and cloth. Other masks of this type have richly ornamented structures, either in abstract form or representing animals or human beings. This mask was worn by the initiated of a secret society after their return to the village from their seclusion. They appeared in pairs, and it was customary for the villagers to grant their wishes.

218 *Bayaka, Zaïre, 12".*
This is a *nkisi* mask proper (without the superstructure), but the nose is different from the preceding. All the *nkisi* masks have a handle as shown, with two projections that possibly indicate ears and one that looks like a beard.

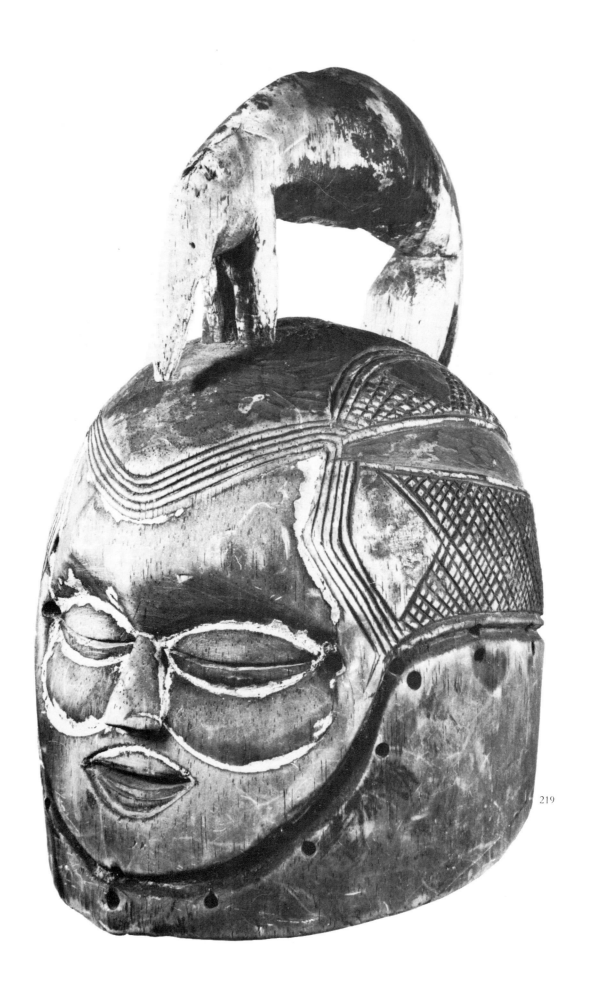

219

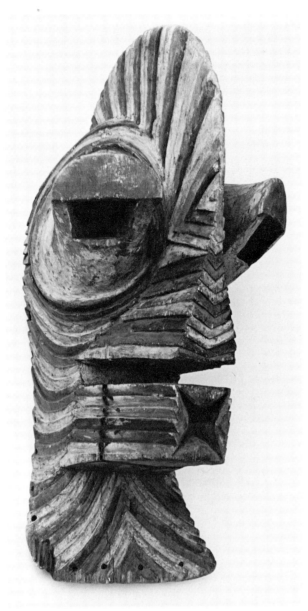

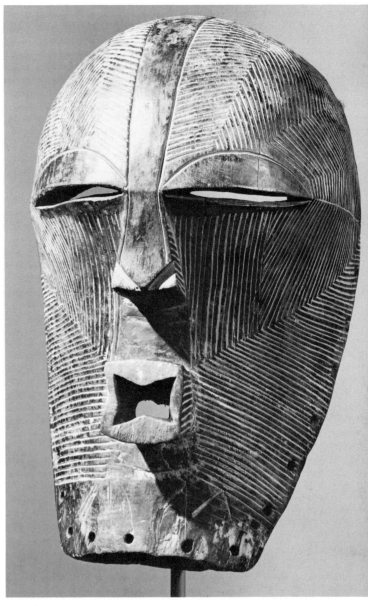

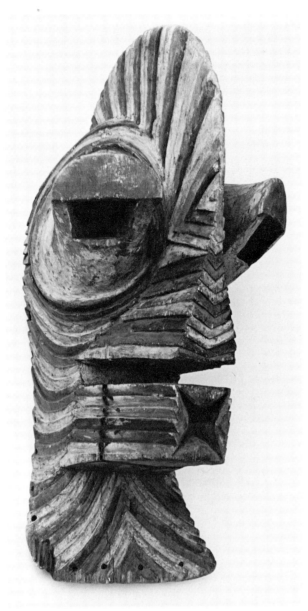 intentionally...

220

221

219 *Basuku (Suku), Zaïre, 14½" (diameter 9").*
This is a *hembe* helmet mask surmounted by an animal. The holes indicate where a large raffia collarette was attached.

220 *Basonge (Songye), Zaïre, 26½".*
This is the *kifwebe* mask, attributed also to the Baluba tribe. Impressive shapes, the nose forming part of a crestlike hairdo, enlarged eyelids, a protruding, boxlike mouth, and lineal ornamentation, often in red and white, on the entire surface characterize this mask. It embodied supernatural forces. The Kifwebe society used it to ward off disaster or any threat. It was worn at ceremonies honoring a dead chief, at

the installation of a new chief, and at the welcoming of important visitors to the village. It had the capacity to heal by means of the supernatural force it was supposed to incorporate. The ritual of exorcism consisted of holding the sick man's mask while a magician acted as if he were casting it into the fire.

221 *Basonge, Zaïre, 17½".*
A similar mask, but the above characteristics are more subdued. There are also masks of the same type with round faces.

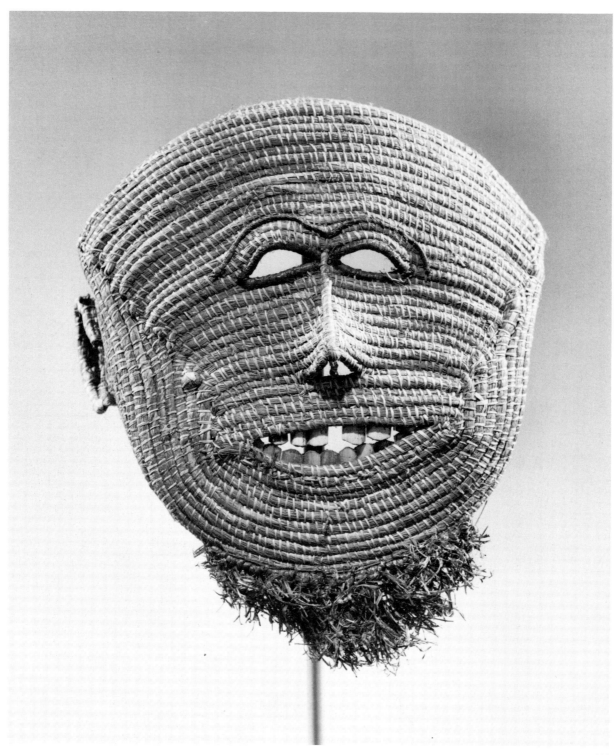

222

222 *Basonge, Zaïre, 10¼ ".*
A rather unusual mask made of bamboo and raffia basketwork.

223 *Bakuba (Bushongo), Zaïre, 14".*
This is the well-known *mashamboy (mwash-a-mbooy)* helmet mask which, according to the scholar Torday, was invented in 1350 A.D. This mask is made of beads, cowrie shells, cloth, and raffia. (Contemporary artists have adopted the principle of using different materials in one work in the "assemblage" style.) This example (unlike the majority of these masks) has a trunklike appendage supposed to symbolize the royal power. The mask, representing Woot, the first ancestor, was used in initiation ceremonies to evoke the myth of creation. It also served to enforce the law.

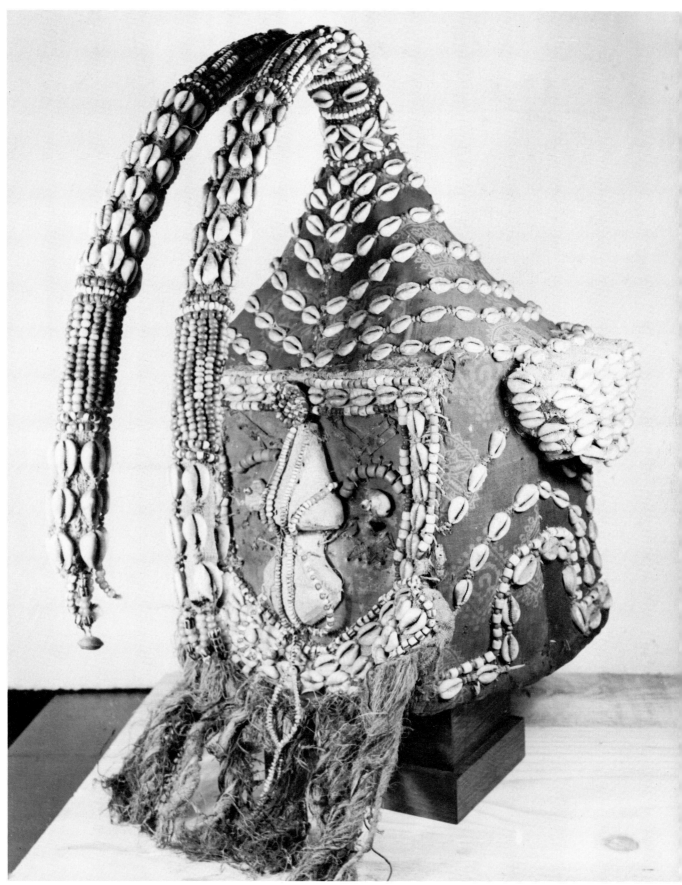

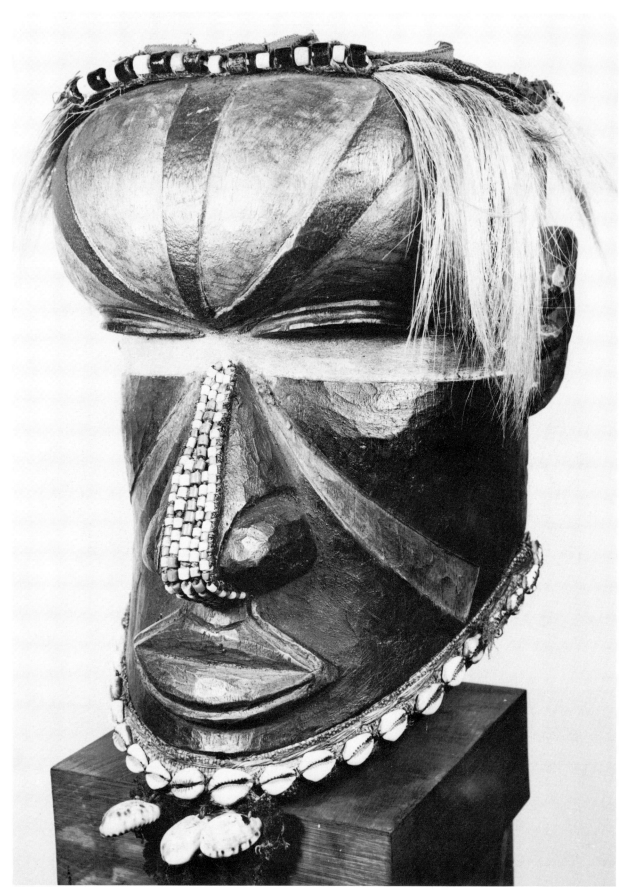

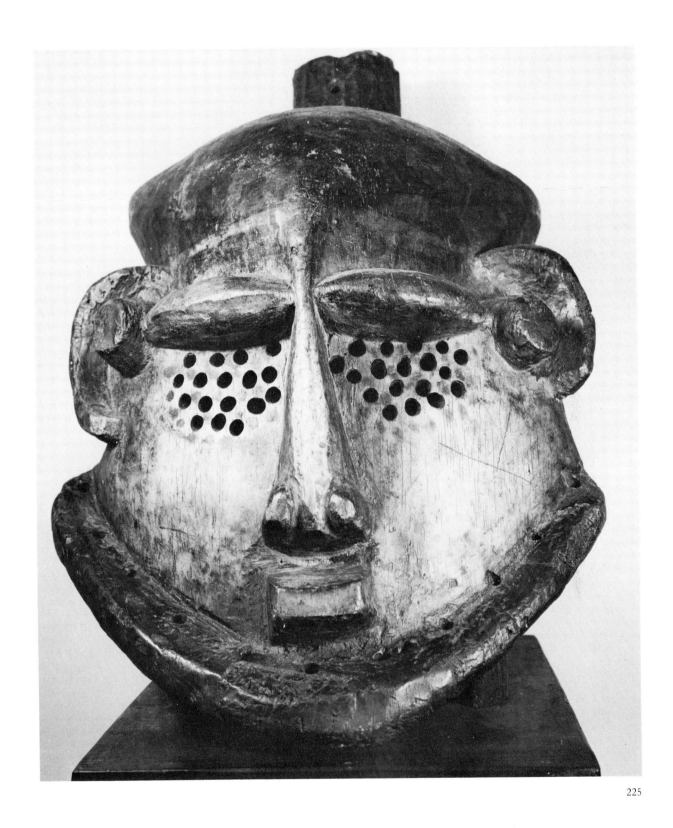

224 *Bakuba, Zaïre, 13" (diameter 10").*
This is the *bombo* helmet mask, with a bulging forehead, a
bead-covered nose, cowrie shells on the rim of the mask, and
fur on the top. The face has engraved designs. Used in initia-
tion ceremonies, it represented Woot's brother, who was
credited with having started the ceremonies.

225 *Bakuba, Zaïre, 18" (diameter 12").*
This is another version of the *bombo* mask, with a number of
holes for the eyes.

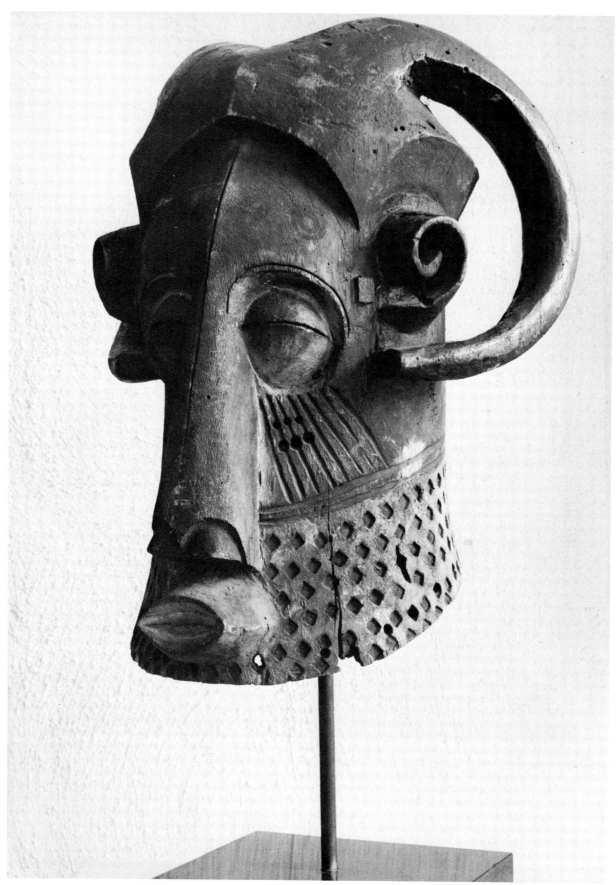

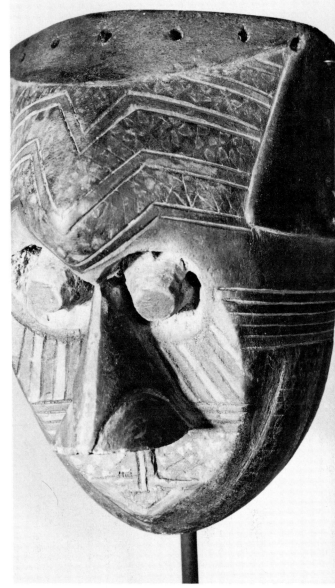

227

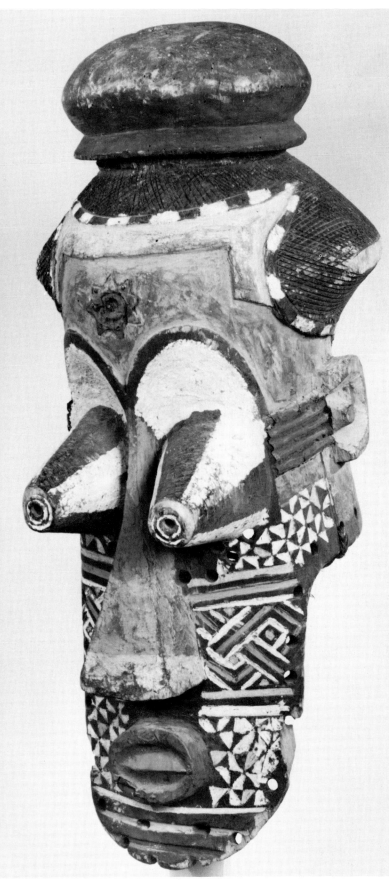

228

226 *Bakuba, Zaïre, 19" (diameter 9").*
An extremely interesting *bombo* mask with curved horns on each side. This mask is very similar to the Baluba helmet mask in the Tervuren museum, Belgium.

227 *Bakuba, Zaïre, 10".*
A face mask with holes around the bulging eyes. The domed forehead and the face are richly ornamented with incised, painted patterns.

228 *Bakuba, Zaïre, 32".*
Attributed also to the Bena Biombo, this helmet mask has more protuberant eyes (but this time without the holes), the typical Bakuba shaved hairdo, and an elaborate design all over the face.

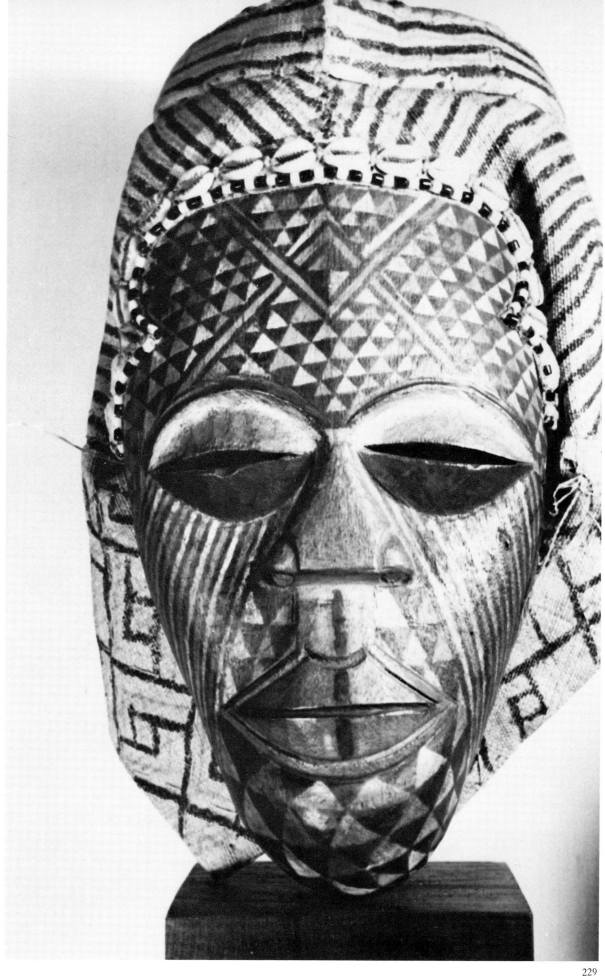

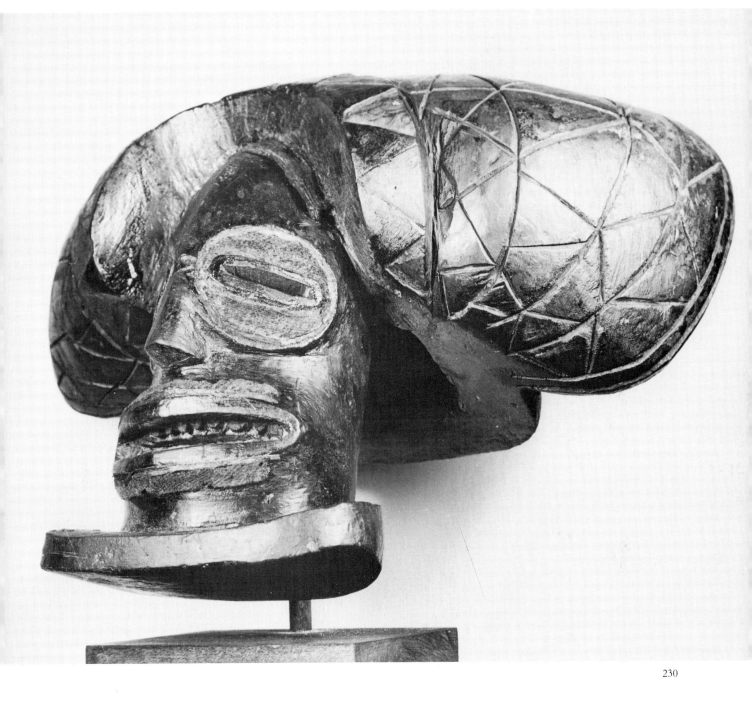

230

229 *Bakuba, Zaïre, 12½".*
Known as *shene-malula* or *ngaady-a-mwaash,*, this mask representing Woot's spouse is sometimes attributed to the Baluba or Bena Lulua. Triangular patterns are painted over the surface. Beads and cowrie shells border the raffia hoodlike cover attached to the mask.

230 *Batshioko (Batchokwe, Tshokwe), Zaïre, 9" high (14" wide).*
This is a carved rendition of the large mask *cikungo*, ordinarily made of a basketwork of twigs covered with bark cloth or burlap and painted. Usually a circle frames the eyes, and the mouth is prominent.

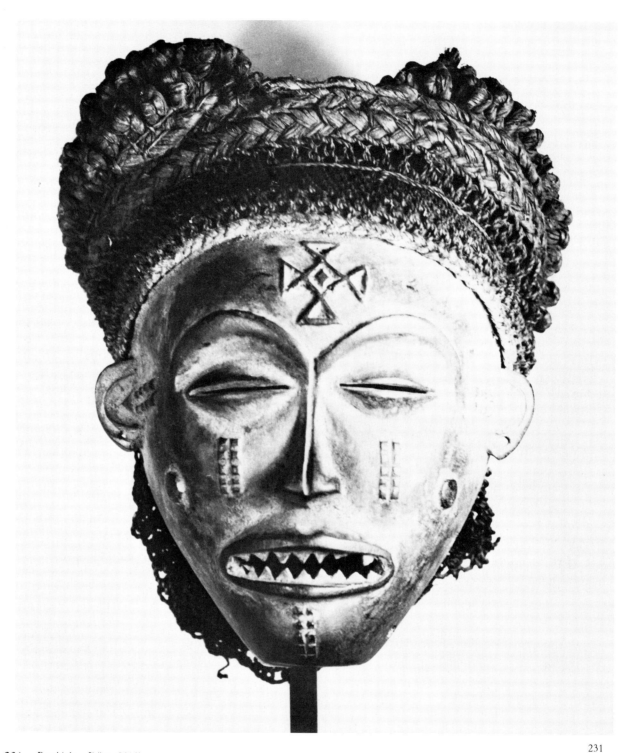

231

231 *Batshioko, Zaïre, 9½ ".*

Known as *mwana pwo*, this mask is usually stained a reddish color. There is a cruciform tribal mark on the forehead and two different ones on the face. The eyes are slits. The hairdo, woven of fiber, extends to cover the back of the head. This mask was used in the *makunda* initiation rites. The men wore knitted garments to which were attached artificial breasts representing the maiden (*mwana pwo*). It is rather striking that thousands of miles away the Ibo also had maiden-spirit masks and also used artificial breasts. (The Yoruba and Dogon had the same custom but without the concept of the maiden spirit.)

232 *Basalampasu (Basala Mpasu, Salampasu), Zaïre, 23½ ".*
(Frontispiece).

This mask, covered with metal foil, has pierced eyes and a different metal covering the open mouth. The hairdo is made of twigs, and braided raffia is attached to the chin. It was used at festivals to promote the well-being of the community and at circumcision ceremonies.

233 *Basalampasu, Zaïre, 30½ ".*

This is made of a netlike, knitted fabric with raffia hanging down below. Cone-shaped protuberances form the hairdo.

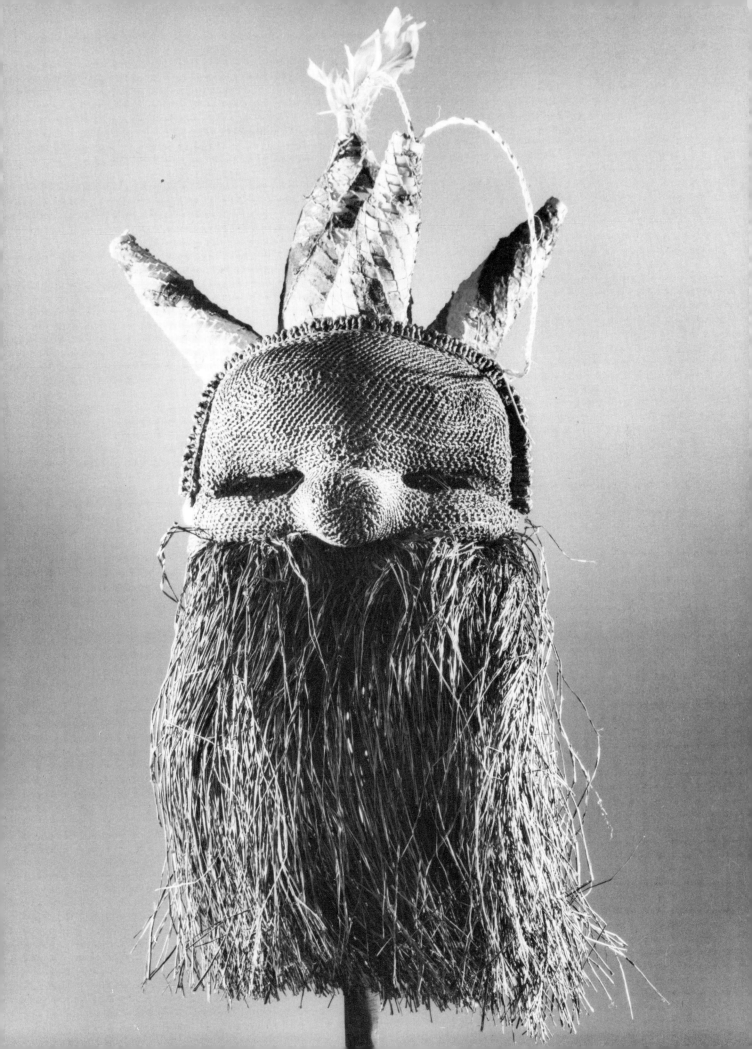

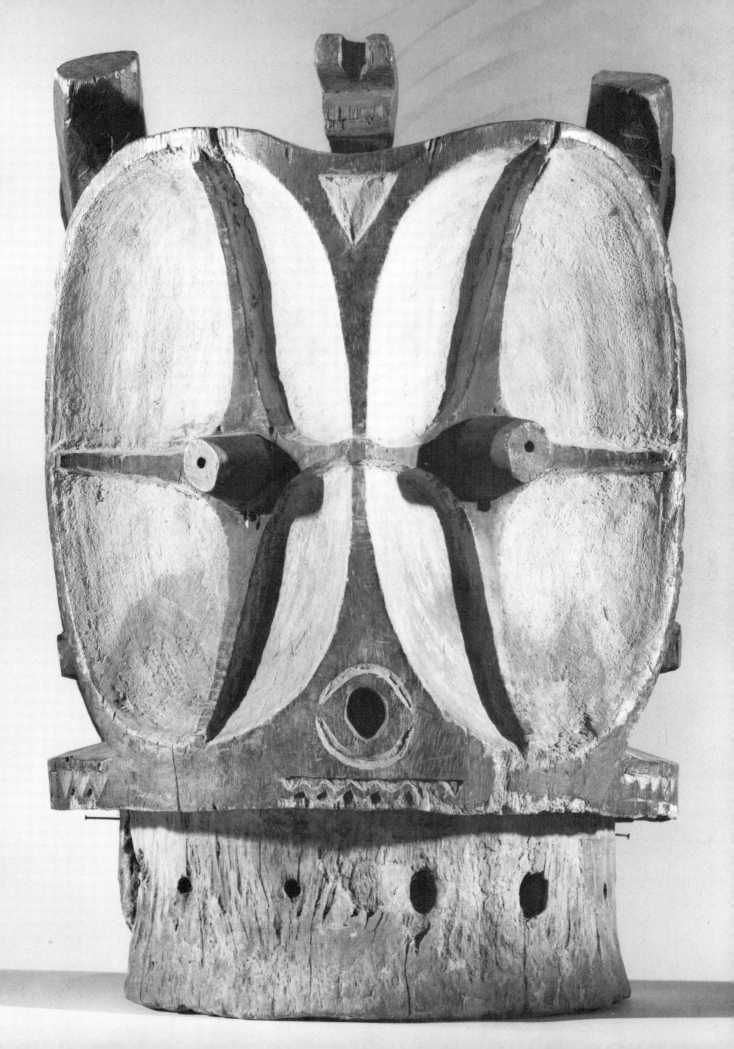

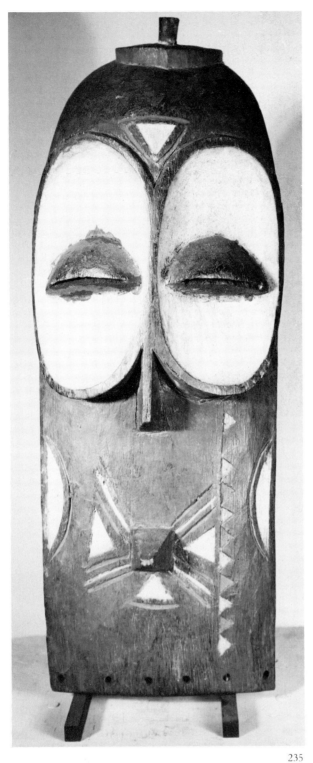 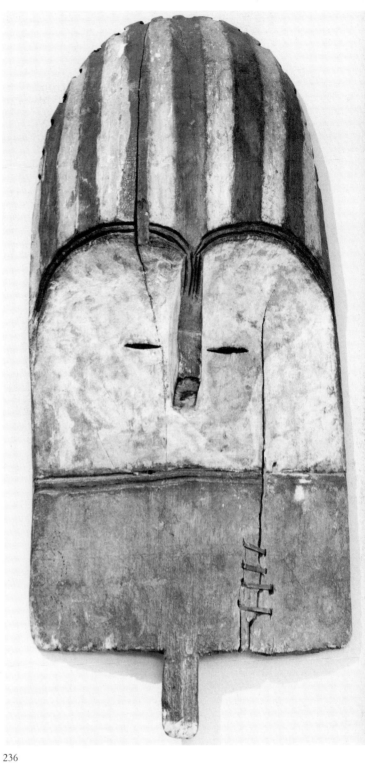

234 *Wabembe (Bembe), Zaïre, 18 3/4".*
A helmet mask with four "faces," large concave oval forms divided in the middle by a cruciform relief.

235 *Wagoma-Babuye (Goma-Babui), Zaïre, 16".*
An example of the best-known masks of these tribes, the shieldlike carvings. This one has two white concave oval

shapes where the eyes are located. The mouth protrudes.

236 *Wagoma-Babuye, Zaïre, 13 7/8".*
Another version of the shieldlike structure with slit eyes. The nose continues without any indentation into the forehead, which is painted with vertical lines.

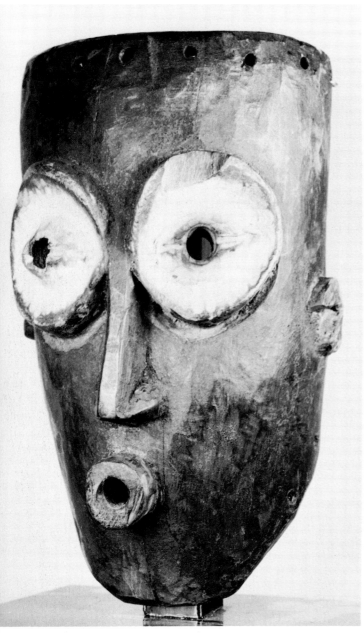

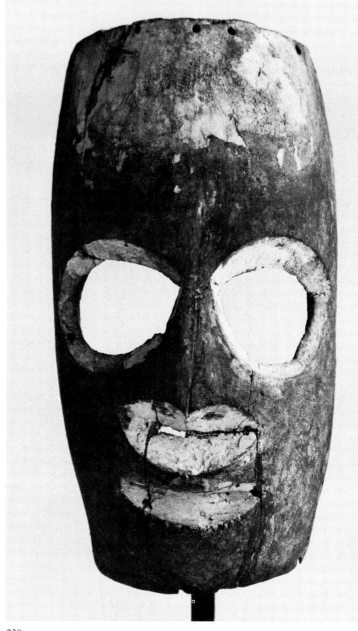

237 *Wagoma-Babuye, Zaïre, 9½".*
A face mask, again white and concave, but with round eyes and a protruding mouth. (Also attributed to the Baholoholo.)

238 *Wagoma-Babuye, Zaïre, 13".*
A different and unusual version. Instead of being convex, the eyes are large holes ringed by white paint, which also covers the mouth.

239 *Warega (Lega, Balega), Zaïre, 14".*
This is of ivory, with a dark yellow-brown patina, an

engraved dot design on the face, and a fiber "beard" by which it was carried in the initiation ceremony of the Bwami society. It was known as *lukungu*, an insignia of the highest grade, *kindi*. Often a well-polished wooden mask was substituted at the *kindi* level for an ivory or bone mask.

240 *Warega, Zaïre, 7½".*
The elongated forehead is darker in color than the rest of the concave face, except for the eyes carved in relief. The holes indicate where the raffia "beard" was attached. This wooden mask, the *lukwakongo*, was the insignia of the second highest grade, *yananio*.

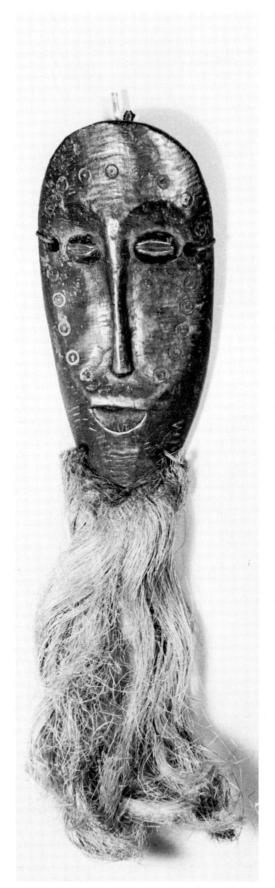 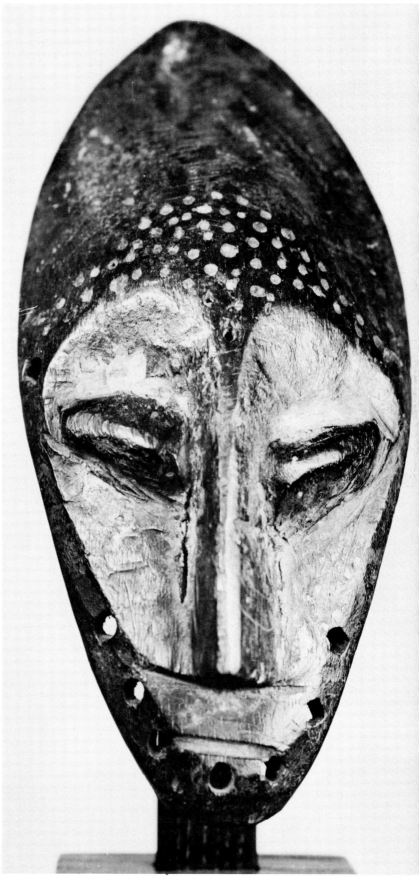

239 240

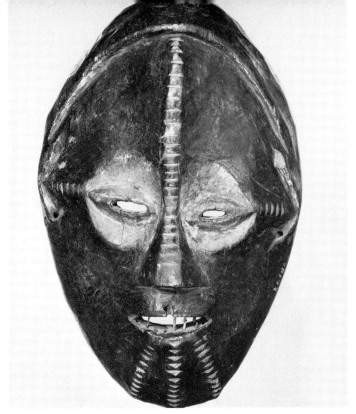

241

242

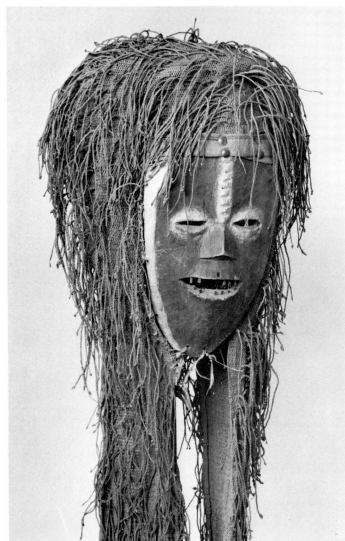

241 *Ngbandi (Bwaka), Zaïre, 16''.*
This shows the typical vertical scarification marks made by small cuts on the forehead, nose, and chin.

242 *Ngbandi, Zaïre, 16''.*
This has the same markings on the forehead (as do most of the tribe's statues). This mask is attached to a knitted hood with small cords, probably in imitation of human hair.

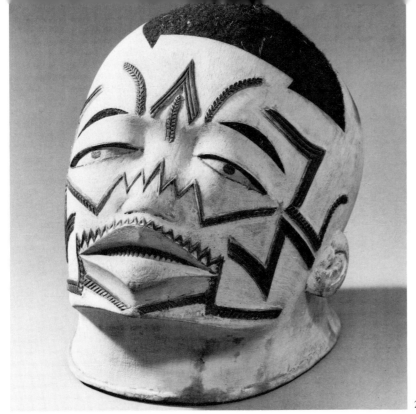

244

243

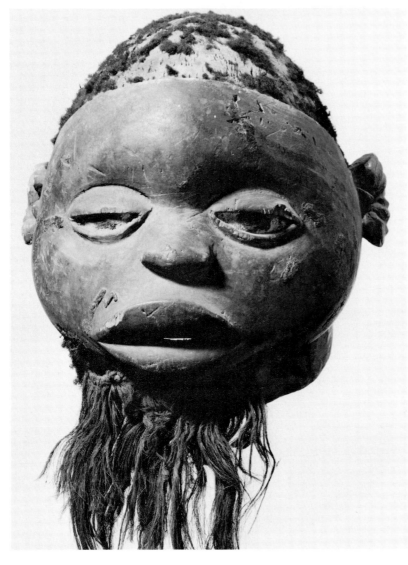

243 *Makonde, Tanzania, 12".*
A headdress with extremely natural-istic Negroid features. Human hair accentuated the naturalistic style also observable on some Ekoi heads covered with animal skin.

244 *Makonde, Tanzania, 9 3/8".*
Probably a more recent type, but the many scarification marks all over the face are of interest.

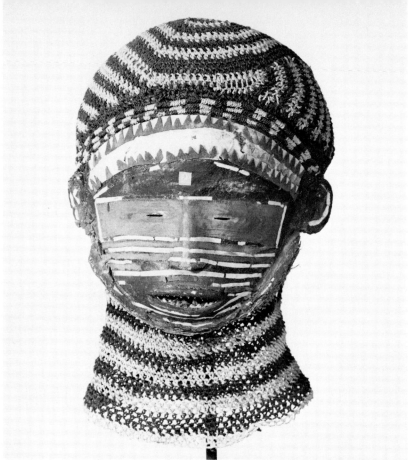

246

245

245 *From eastern Zambia, 15".*
Reminiscent of some Batshioko masks, this is made of coarse bark cloth placed on a twig frame and painted.

246 *From Zambia, 16".*
A helmet mask with a crocheted network covering the head and neck. (Again, many Batshioko masks have a similar netting covering the neck.) The rest of the mask is made of fiber and cloth.

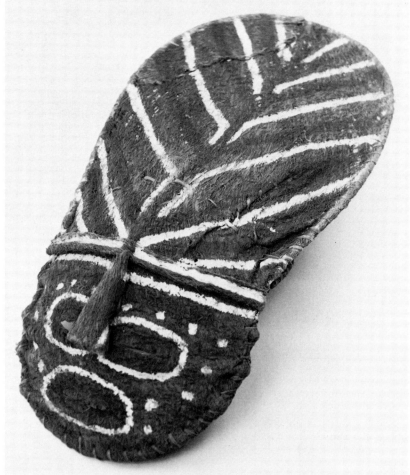

SUPPLEMENT:
THE MASK IS STILL DANCING

All photographs in the Supplement are by the author.

In December 1974 my wife and I undertook our fourth trip to Africa, visiting various villages on the Ivory Coast, mainly in the Dan, Baule, and Senufo countries. Since old masks of these tribes are illustrated in this book, it is of great interest to see the stylistic differences in the ones used today and to show their present function.

Dan (Yacouba) country. About an hour's drive on unpaved roads from the town of Man, we reached the village of Deoule, where we paid our respects to the village elders and the chief of dance and arranged with them for a dance. The next day, in a shaded place under the so-called palaver tree, three chairs were placed for us and the chief, who sat there with calm dignity, the people around watching the dance with reverence. We waited more than half an hour listening to the drumming which came from the house where the dancer was being dressed, a procedure which could not be witnessed by anyone except the chief of dance. The dancer appeared fully dressed (Fig. A), wearing a typical black Dan-style mask: eyes framed by metal, red lips showing teeth, a superstructure on top. We were told that the name of the mask was Guata-Gue. The dancer wore a blue blouse, richly embroidered with red, yellow, and green designs, and a raffia shirt. His legs, feet, and hands were fully covered according to ancient tradition so as not to show any part of the natural body, the masked dancer supposedly representing a nonhuman spirit. His dance consisted of extremely brusque movements of the legs and even more of the arms and shoulders.

The next day, we went to the village of Ziondrou-Zibiao, nearly two hours from Man, where a dance by a single Guere acrobat was arranged. Before the performance started, music and incantations were heard from the house which we were facing, then the acrobat, his assistant, and two small girls seven or eight years old came out. It was of special interest to us that the girls had painted faces (Fig. B) very similar to the mask-substitute used by boys entering into initiation ceremonies. The dance consisted of the acrobat tossing each of the little girls into the air, at one point stabbing a knife in the air before catching the girl.

At Touba, where a reception was organized for the President of the Republic, we saw another dancer wearing a black Dan mask (Fig. C) with a richly embroidered crown-like superstructure and a black and white striped cloth over a rich raffia skirt. There was another mask (Fig. D) made of a black knitted material, with an embroidered cap and side-hangings. A stilt dancer performed in a reddish mask, which we could not identify with any known style. There were also dancers without masks but with highly elaborate caps, their clothing and leggings richly embroidered with colorful designs.

Among the spectators there was a lady whose face looked like a Dan mask (Fig. E) and another whose coiffure was clearly in the style of Baule statues.

239

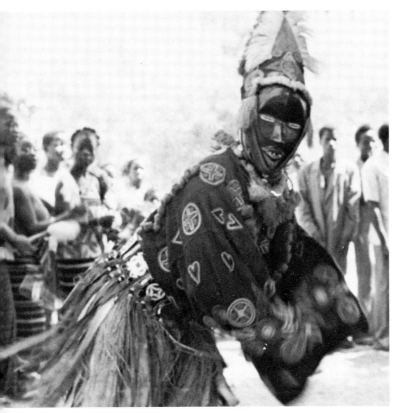

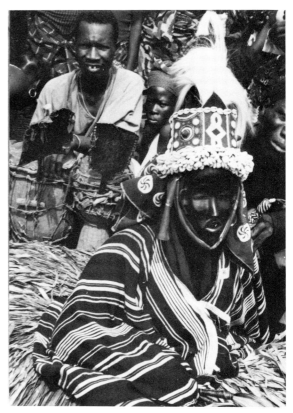

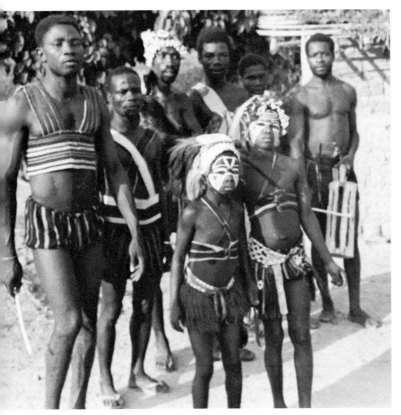

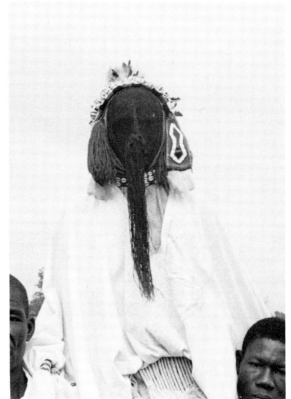

A C

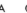

B D

E

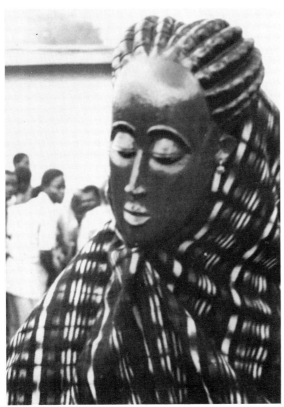

F

Baule Country. On the next day, the Prefect of Bouake, Mr. Jean Koffi, invited us to join him at a celebration in his honor in the small city of Sakassou, about two hours' drive from Bouake, famous for being the burial ground of the great Baule king Anougbre, and the depository of his treasures.

Several masked dances were performed. Two dancers wore reddish-brown masks with a black coiffure, probably carved by the same hand (Fig. F). The traditional masks of this type are light black and have a more abstract expression. The mantles of the two dancers were made of black cloth with white stripes, and both wore raffia skirts and had their feet and hands covered. The mask in Fig. G had a most unusual superstructure, consisting of a woman entwined with a snake. We received only evasive answers as to the meaning of this figure, which probably has some mythological significance.

There was also a dancer with a small animal mask (Fig. H) similar in concept to the traditional Baule Goli mask, and another dancer wearing a typical Guro mask (*zamble* style; Fig. I). Each dancer had one or two helpers, for in their rapid giratory movements they sometimes appeared to lose their direction.

In our return from Sakassou to Bouake, we visited the village of N'Guessan-Pekoukro, where we witnessed these dances: One dancer who wore a bush-cow mask, a collarette of vegetation, and a cowhide on his back, was whipped while dancing (Fig. J). Another dancer wore a typical Baule type of mask (Fig. K) painted with white oil color, red lips, and black hair, topped again by a female figure with a snake, but less elaborate than that in Fig. G. Another dancer had his face covered with a brown fabric having round rings for eyes, his dress consisting of two raffia skirts (Fig. L).

Senufo Country. On the northern part of the Ivory Coast, in wide-open savanna country, lies the town of Korhogo, where we saw several carvers copying the old Senufo prototypes (Fig. M) for the commercial market. One unusual small mask (Fig. N; 16" long, the neck 2½" in diameter), very similar in design to the *kagba*, was placed over the neck of a statue, this small mask serving as its head. One man was carving a Baule-Yaoure style mask (Fig. O). He confessed that, although he was a Senufo, he adopted this style because there was a demand for it.

About an hour's drive from Korhogo is the village of Dielokaha, where we saw the panther-men dancing (Fig. P). They were wrapped in coarse cloth with monochromatic small round patterns (probably to imitate the skin of the panther) combined with tiny zigzag signs. This cloth covered the dancer's face, body, legs, and hands. Each held two little twigs in his hands. Two young boys, later joined by an adult, performed complex, tense acrobatic dances, surrounded by singing groups and various musicians.

In the same village, later in the afternoon, we

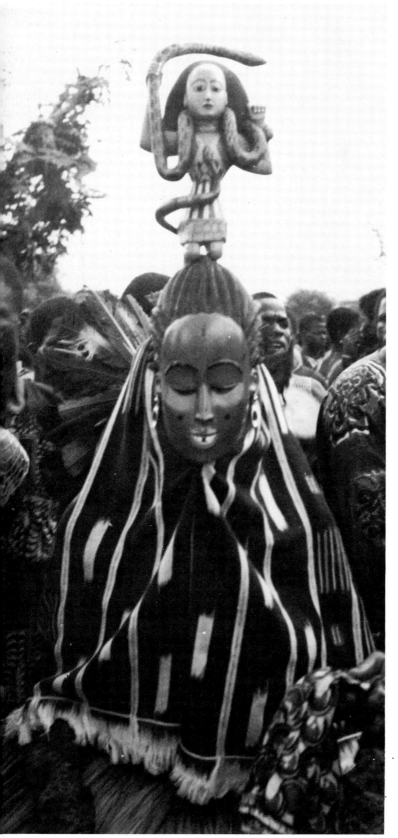

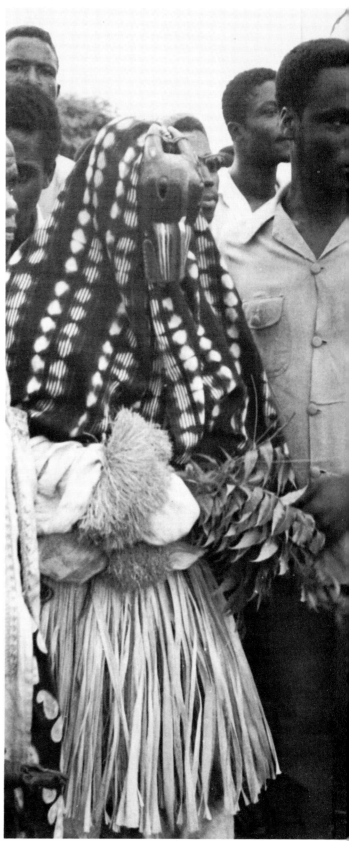

G H

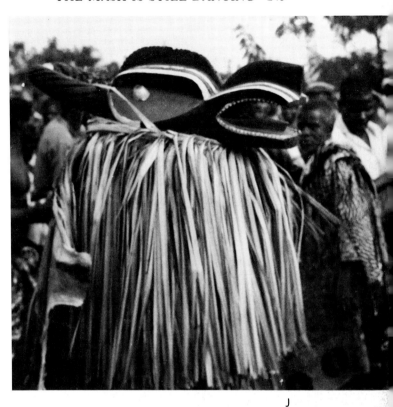

J

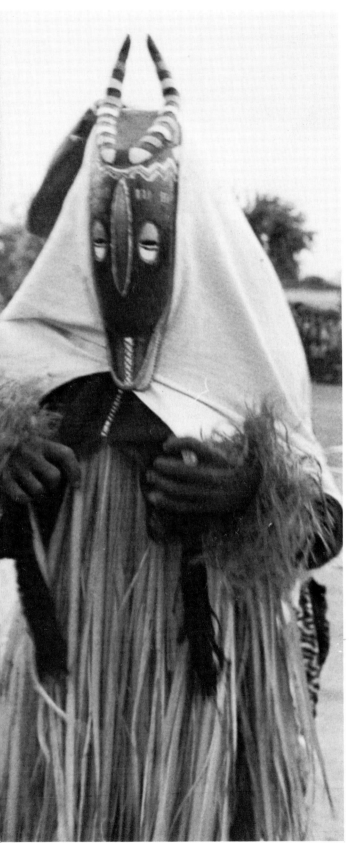

I

witnessed a funeral conducted by three men masked in reddish-brown cloth, which also covered their whole bodies, and raffia collarettes and skirts. We were not allowed to photograph them. We found it remarkable that the dance at a funeral was just as frenzied, just as amazing in energy output, as the dances for joyful celebrations.

Dahomey. Our main study in this country was the snake cult and Legba statuary. Leaving Cotonou, we met on the road two dancers on stilts, one wearing a brown mask with an extremely naturalistic facial expression, including a moustache (Fig. Q), the other a white mask, probably representing a white man, with a grinning expression (Fig. R). Their clothing was made of fringes of brown fabrics, and the stilts were attached to their legs with foam-rubber padding. Their acrobatic balancing dance was really remarkable.

Analysis. According to official information in travel literature, 60% of the population of the Ivory Coast and 70% in Dahomey and Upper Volta are animists. Most of the literate people we met were either Moslem or belonged to various Christian denominations, but even they still seem to have a deeply rooted emotional attachment to the ancient tradition, including a belief in taboos and malevolent and benevolent spirits. The dances we witnessed, however, were officially called "folkloric," and thereby desacralized.

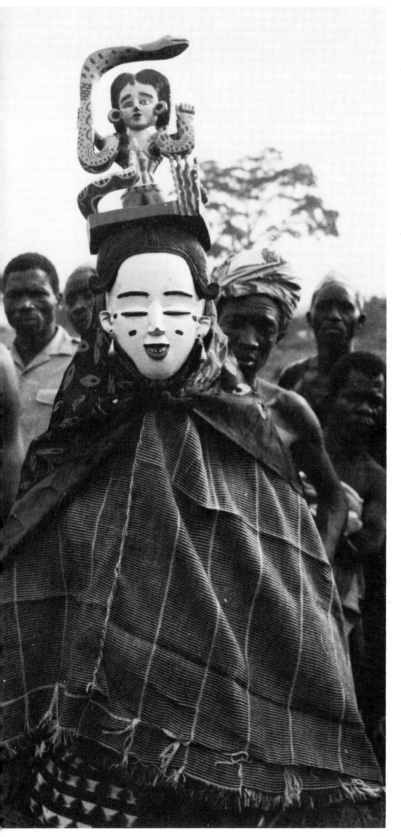

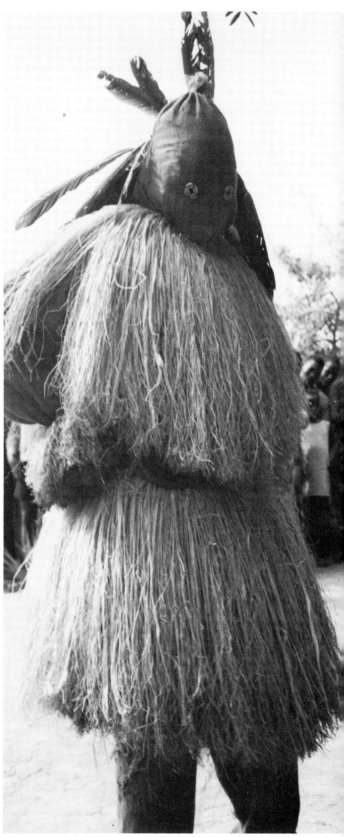

K L

M

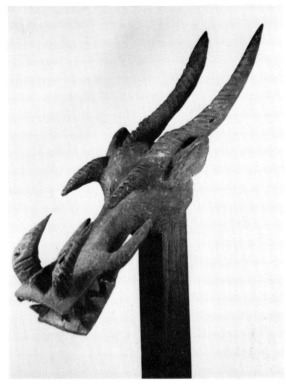

N

The dancer appeared in a wide space, his movements jerky, brisk, often jumping, accompanied by drummers producing a penetrating rhythm. The dancing mask fascinated us, its mysterious effectiveness creating the impression that it was the *mask which was dancing*, and not a masked man.

We thus witness not a break in the tradition but a shift from the sacred to the profane. All the roots of the dance are deeply imbedded in the local tradition. It is difficult to draw a clear line of distinction between the ritual dances and those for public display, at least in their formal aspect. It is only the frame of reference or intent which makes the difference for the people, but not having yet learned what "public" performance is, they cannot help but perform the same dance in which they have been trained for ritual purpose.

One important change is the newer, generally more vivid, coloration of the dance masks. In the marketplaces where dealers currently sell decorative modern carvings and copies of old statues and masks for the tourist trade, no vividly colored new masks are offered, probably because they would not sell. But the motivation for the new colored village dance masks is not commercial. What is paid for by the visitor is not the art work, but the dance itself, which is not new but traditionally unaltered. Thus the added color is part of a new standard of "beauty," no doubt introduced under the strong influence of the bright printed cottons and commercial colors now widely used in Africa.

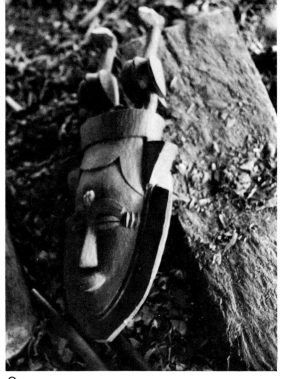

O

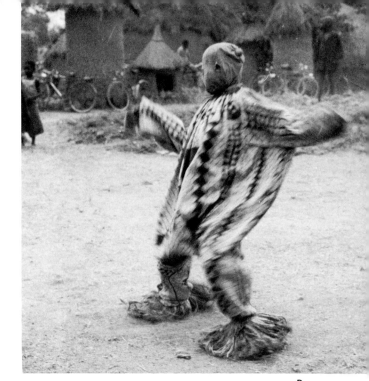

P

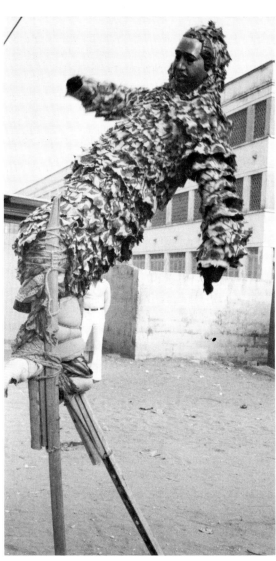

Q

246

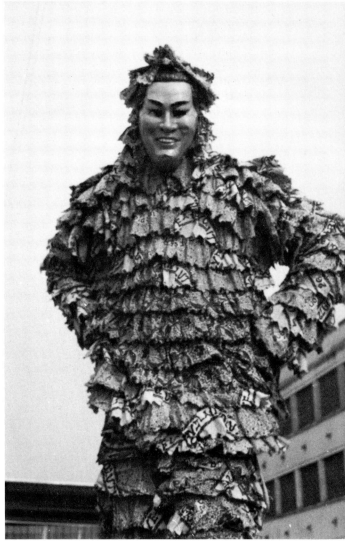

R

BIBLIOGRAPHY

In view of the fact that the author has provided an exhaustive bibliography in his book *African Sculpture Speaks* under the headings African Art, Anthropology, Myth-Magic-Religion, Psychology, Art Appreciation and Philosophy of Art, and Comparative Material, we have avoided repetition here by not listing the basic documentary evidence. We shall list (in chronological order) only some of the books and papers (essays and monographs) that the author has published in journals, in which he explores in greater depth and detail the concepts and subjects discussed in this volume.

BOOKS

African Sculpture Speaks. 4th ed. (first paperback printing). 1975. Da Capo Press, Inc., N.Y. 492 illus.

African Sculpture. 1958. Dover Publications, Inc., N.Y. 164 illus.

ESSAYS

"Art Appreciation, a Projection," *Etc., A Review of General Semantics*, Chicago, Vol. XII, No. 1, Fall 1954.

"The Artistic Quality of African Sculpture," *Tribus*, Linden Museum, Stuttgart, Vol. 6, 1956.

"Plastic Aspects of African Sculpture; The Theory of Tension," *Etc.*, Vol. XIV, No. 3, Spring 1957.

"Creativity and Guidance in the Fine Arts," *Etc.*, Summer 1960.

"The Phenomenological Approach to the Perception of Art Works," *The Centennial Review of Arts and Sciences*, Michigan State University, East Lansing, Vol. IX, No. 3, Summer 1965.

"Geometric Art and Aspects of Reality," *The Centennial Review*, Vol. XI, No. 4, Fall 1967.

MONOGRAPHS

"Warego Ivories," *Zaire*, University of Louvain, Vol. V, No. 10, December 1951.

"Bakota Funerary Figures," *Zaire*, Vol. VI, No. 5, May 1952.

"Bakuba Cups," *Midwest Journal*, Lincoln University, Jefferson City, Mo., Vol. IV, No. 1, May 1952.

"Circle-Dot Symbolic Sign on African Ivory Carvings," *Zaire*, Vol. VII, No. 1, February 1953.

"Initiation Ceremony and African Sculpture," *American Imago*, South Denis, Mass., Vol. 10, No. 1, Spring 1953.

"African Names and Sculpture," *Acta Tropica*, Basel, Vol. 10, No. 4, December 1953.

"African Snake Symbolism," *Archiv fur Volkerkunde*, Vienna, Vol. IX, 1954.

"African Phallic Symbolism," *Zaire*, Vol. IX, No. 10, December 1955.

"Shango Sculpture," *Acta Tropica*, Vol. 12, No. 2, 1955.

"Aspects of African Art for the Museum," *Cahier d'Etudes Africaines*, Paris, No. 5, 1961.

"African Sculpture and Cubism," *Criticism*, Wayne University, Detroit, Vol. IV, No. 4, Fall 1962.

"The Ashanti Akua'ba as Archetype, and the Egyptian Ankh. A Theory of Morphological Assumptions," *Anthropos, International Review of Ethnology and Linguistics*, St. Augustin, Vol. 58, 1963.

"The Yoruba Ibeji Statue," *Acta Tropica*, Basel, Vol. 27, No. 2, 1970.

"The Mossi Doll, an Archetypal Figure. A Morphological-Phenomenological Investigation," *Tribus*, Yearbook No. 21, November 1972.

"A Sculpture from Mopti. A Phenomenological Investigation into the Plastic Aspect and Meaning of an African Carving of Undetermined Style," *Archiv fur Volkerkunde*, Vienna, Vol. XXVI, 1972.

"The African Attitude toward Sickness. Its Relation to Sculpture," *Acta Tropica*, Basel, Vol. 31, No. 4, 1974.

"Notes on the Dogon Sculpture (The Ecology of Dogon Sculpture)," *Ethnologische Zeitschrift*, Zurich, Vol. 1, 1975.

CREDITS:
COLLECTORS AND PHOTOGRAPHERS

PUBLIC COLLECTIONS

Courtesy of The American Museum of Natural History, New York: Plates 163, 181.

Courtesy of The Brooklyn Museum: 2 (Ella C. Woodward and A. A. Healy Funds), 5, 50, 66, 161 (Caroline A. L. Pratt Fund and Others), 194, 201 (Frank L. Babbott Fund), 208 (Gift of Dr. and Mrs. Abbott Lippmann), 209, 214, 241, 242, 243.

Grand Rapids Art Museum, Grand Rapids, Mich.: 74.

Museum für Völkerkunde, Vienna: 3, 7, 25, 151 (photos by Fritz Mandl); 124, 125 (photos by Edeltraut Mandl).

Courtesy of The Museum of Primitive Art, New York (photos by Charles Uht): 6, 16, 20, 22, 23, 26, 35, 36, 37, 43, 44, 64, 73, 75, 76, 77, 80, 81, 87, 96, 97, 111, 112, 115, 116, 118, 119, 121, 122, 123, 130, 131, 147, 149, 150, 152, 155, 158, 162, 165, 166, 167, 169, 170, 176, 184, 185, 187, 190, 197, 199, 202, 203, 204, 205, 212, 217, 221, 222, 232, 233, 234, 236, 244.

PRIVATE COLLECTIONS

Anonymous collection: 19, 101, 159, 198, 220.

Arman: 1, 88, 92, 109, 113, 171, 191, 192, 238; (photos by Harry Shunk) 8, 226.

Mr. and Mrs. Brent Ashabranner: 196.

Mr. and Mrs. Herman Binder.

Mr. and Mrs. William Brill: 9, 86, 139.

Mr. and Mrs. Julian Brody: 245.

Mr. and Mrs. Park A. Chambers, Jr.: 65.

Mr. and Mrs. Hayward Cirker: 28.

Michael Cox: 126.

Mr. George L. Dahl: 229.

Dr. Bernard Fine: 210.

Mr. and Mrs. Henrique Fix: 98.

Dr. Richard France: 89, 207.

Gallery 43: 228.

Mr. and Mrs. David Goldburg: 29.

Mr. and Mrs. Chaim Gross: 54, 62, 108, 144, 160, 177, 186.

Lord and Lady Desmond Harmsworth: 195 (photo by Studio Egham).

Dr. and Mrs. Alexander Honig (photos by Peter Honig): 10, 42, 71, 85, 148, 219.

M. and Mme. René Lavigne: 146 (photo by Jean von Muhlenen).

Dr. and Mrs. Leroy Lavine: 224.

Mr. Syd Levitt: 105.

Wayne Long (photos by Bob Forester): 72, 182, 223, 246.

Mr. and Mrs. Kurt Mann: 41.

Mr. J. Jerome Marlin: 227.

Mr. and Mrs. Charles M. Meech: 100.

Mr. Mace Neufeld: 134, 156.

Mr. and Mrs. Simon Ottenberg: 145.

Mr. and Mrs. John D. Pare: 12, 31, 127, 142.

Mr. and Mrs. Sam Pearlstein: 82.

Mr. and Mrs. Saul Putterman: 52, 218.

Mr. and Mrs. Jesse Ratner: 38.

Mr. and Mrs. Young M. Smith, Jr.: 213.

Mr. and Mrs. John L. Stainton: 230, 231.

Dr. Jack V. Wallinga: 135, 136.

Justice and Mrs. G. Mennen Williams: 17, 153.

Ernst Winizki: 133, 180, 200.

PHOTOGRAPHERS

Andre Cillardin: 4, 45, 83, 110.

Dr. Pascal James Imperato: 24, 39.

Jesse Ratner: 15, 38, 79, 82, 104, 127.

Other photographers are mentioned above in connection with the collections.

Illustrations not separately enumerated are either from the author's or the Segy Gallery's collection, photos by the author.

Unknown collections: 47, 51, 53, 58, 68, 84, 95, 102, 129, 175, 183, 206, 225, 235, 237. (Photos by the author)